Rock of Ages | Sands of Time

Rock of Ages | Sands of Time

PAINTINGS BY **Barbara Page**

TEXT BY **Warren Allmon**

FOREWORD BY **Rosamond Wolff Purcell**

PUBLISHED IN ASSOCIATION WITH
THE PALEONTOLOGICAL RESEARCH INSTITUTION
ITHACA

THE UNIVERSITY OF CHICAGO PRESS
CHICAGO AND LONDON

BARBARA PAGE is an artist living in Trumansburg, New York.

WARREN ALLMON is the director of the Paleontological Research
Institution in Ithaca, New York.

The University of Chicago Press, Chicago 60637
The University of Chicago Press, Ltd., London
© 2001 by The University of Chicago
Illustrations copyright 2001 by Barbara Page
All rights reserved. Published 2001
Printed in Hong Kong

10 09 08 07 06 05 04 03 02 01 1 2 3 4 5

ISBN: 0-226-64479-0 (CLOTH)

Library of Congress Cataloging-in-Publication Data

Allmon, Warren D.
 Rock of ages, sands of time/paintings by Barbara Page; text by Warren Allmon;
 foreword by Rosamond Wolff Purcell.
 p. cm.
 Includes bibliographical references.
 ISBN 0-226-64479-0 (cloth: acid-free paper)
 1. Page, Barbara—catalogs. 2. Fossils in art—Catalogs. I. Page, Barbara. II. Title.

ND237.P1668 A4 2001
759.13—dc21

00-048848

This book is printed on acid-free paper.

The paintings reproduced in this volume will be installed as a permanent exhibition
in the Museum of the Earth at the Paleontological Research Institution in Ithaca,
New York.

Contents

Foreword

BY ROSAMOND WOLFF PURCELL

Along the shores in Nova Scotia or Lyme Regis, in desert ditches of Kenya, on a riverbank in India, in the woods of upstate New York or a field in Calgary, an ordinary person with a well-aimed downward glance will find petrified fragments of organisms lying on the surface or embedded in ancient rock. I am one of those occasional hunters who thrills at the sight of a common ammonite, fossil fern or chalk nodules that look like, but are not, ancient feet or paws. In museum collections I come across ichthyosaur ribs that seem cast in bronze, Jurassic limestone brushed almost casually, as if it were the surface of loose sand, by insect wings, the bones of frogs jumping, the shadows of chitinous crabs. With or without scientific interpretation, fossils become transporting devices—the sight of a crinoid or trilobite leads to thoughts about chasms of time, not to mention mysteries of metamorphosis of blood, fur, scales, or feathers into stone. Under the right light, as a photographer, I believe I've witnessed signs of life in fossils where there are none, transitory passages reminiscent of a strip of film stock still-paused and flickering as transient light brushes across the surface of the slab.

It is in the nature of institutional collections to separate fossil vertebrate remains from the fossil invertebrates and both of these from fossil insects and to store each group in different parts of large buildings. Outside of viewing petrified mass burials from one locality, at the La Brea Tar Pits, for example, in the museum, where some felicitous Solnhofen slab containing frogs, dragonflies, and the wing of a flying lizard cannot in good conscience be split between two storage sites, the visitor has to travel upstairs and down in order to juxtapose even a few paleontological specimens from different phyla but from the same era—let alone the same matrix. For *Rock of Ages, Sands of Time*, Barbara Page has done all the walking for us—the sorting and the reconstructions too. She has broken through the temporal and spatial barriers established by the storage according to taxonomies to regain a holistic perspective. Artists often depict scenes from Deep Time as realistic landscapes full of site-specific live animals and plants, but Barbara Page's scenes come from the fossil record itself.[1] Relying on scientific evidence and on her imagination, she has brought together organisms from different localities to create a narrative thread that carries one painted panel along to the next and each period forward to the present.

In casting about for historical antecedents to Barbara Page's work, I pull two names from the strata of recent cultural history. The first is Joseph Dinkel, the artist who worked between 1825 and 1845 for the famous nineteenth-century biologist Louis Agassiz to produce most of the drawings for Agassiz's *Poissons Fossiles*, a monumental book of lithographs of every class of fossil fish ever known. The second is the Sicilian artist Agostino Scilla (1629–1700). While Dinkel worked loyally, even slavishly, over many years to depict as faithfully

1. Martin J. S. Rudwick, *Scenes from Deep Time: Early Pictorial Representations of the Prehistoric World.* Chicago: University of Chicago Press, 1992. Also, the work of Marianne Collins, an artist well known for her reconstructions of animals based on scientific evidence of fossil reconstructions. Her illustrations are featured throughout *The Book of Life*, General Editor Stephen Jay Gould. London: Ebury-Hutchinson, 1993.

as possible every fish set before him by his honored master, Scilla answered to no one. He used his considerable skill instead to render and to understand the nature of the fossils he'd found. Agostino Scilla was a seventeenth-century painter/paleontologist who believed absolutely in the organic nature of the sea urchins, corals, fish, and sharks' teeth he described in a series of masterful pencil drawings, now kept alongside his collection of fossils in the Sedgwick Museum, Cambridge UK. Although, as Hugh Torrens writes, "it would be wrong to see . . . collecting in the sixteenth and seventeenth centuries as 'scientific'. . . . " Italy's long coastline contains many fossilized sharks' teeth and echinoids that are 'easy' to understand, as they both resembled and compared to living animals.[2] So Scilla had a certain advantage when it came to reading the rocks. But, as an artist, he also trusted his own eye. Nor did he care whether or not his own collection came from the Old Testament's Deluge—Noah's Flood (to this day an unfortunately popular explanation for the origin of all fossils). "What I do know," he writes, "is that the corals, the shells, the sharks' teeth, the dog-fish teeth, the echinoids, etc., are real corals, shells and bones that have indeed been petrified. . . . It seems to me impossible to arrive at any sort of knowledge of the truth if I abandon the path my eyes show me."[3] He observed that sharks' teeth were petrified in a row, attached to one jaw, and were therefore teeth, not *tongues* [see Page's four panels, *Carcharocles megalodon* (14–11 million years ago)]. As I have had the privilege of photographing both Scilla's drawings and the fossils so depicted, I have scrutinized both the science of the original and the art (and artistic license) of the figure. These drawings reveal more about the fossils than do the fossils themselves, not because Scilla invented extraneous details, but because he had the advantage of viewing the specimen over time and, I like to imagine, also under more than one light source. He transformed every modulation in the now mostly dingy specimens into information delicately, precisely rendered.

When it comes to depicting details from the fossil record, Page, whose work also conveys the spirit of an independent thinker, has been able to take longer informational steps than Scilla. She will show us a composite portrait of Permian deposits taken from various localities in one small panel. Scilla knew how to look at what he held in his hand. What did he know of such concepts as the Mesozoic, Deep Time, or periodic extinctions? He knew nothing of the coal deposits in Pennsylvania, the Solnhofen limestone of Germany, the Cretaceous extinction, the life style of the sauropods or any other lithified land animal, let alone the various scenarios governing the origin of life. The past three centuries have yielded up millions of paleontological specimens, not to mention superior technology for studying those finds and—not insignificant here—spawned a noisy human history full of ongoing political and religious debates; controversies about the veracity and effects of cataclysmic episodes of the earth history; reconstructions of the ecologies, relationships, and biological natures of extinct animals. Not a few of these debates take place in the public arena. Many more fossils are available to Page than were to Scilla. But Scilla had the luxury to act as an artist and, as far as the profession went at the time, a scientist.

With *Rock of Ages, Sands of Time*, Page is, of course, in fine company of artists and researchers who have reinvented scenes of prehistoric life. But these days the artist paints, the paleontologist studies fossils, and their professional vocabularies have diverged. Just as an artist may find an important fossil visually

2. Hugh Torrens, "Early Collecting in the Field of Geology." *The Origin of Museums.* Oliver Impey, Arthur McGregor. Oxford: Clarendon Press, 1986. 207.

3. Rosamond Purcell and Stephen Jay Gould, *Finders Keepers: Treasures and Oddities of Natural History Collectors from Peter the Great to Louis Agassiz.* New York: W. W. Norton, 1992. 85.

unremarkable, so a scientist may fail to see the value in deductions made in tranquility by an artist. This is a shame, for as we must know by now, the artist and scientist share the ability to form valuable if different hypotheses based on the same physical evidence. Art is used as a model or a mirror by the scientists all the time. On July 4th, in the *New York Times*, I read two articles; one in which biologists take the unraveling of a tapestry of animals as a model for damage inflicted on ecological systems, and a second in which an anthropologist studying ancient Greek art and fossil remains has found a connection between the two that show how much, in fact, the Greeks knew about the organic nature of the bones.[4]

If paleoecology is the science practiced to reconstruct the environments of fossil remains, so the painter practices aesthetic reconstruction by using a different set of allometric tools. While sustaining a prescribed sequence of events—much abridged from the original—Page has had to forge an atmosphere of serendipitous continuity within what we all know to be a most discontinuous history, by using characters whose pictorial values are perhaps not always commensurate to their longevity. For *Rock of Ages, Sands of Time*, Page has produced a natural prehistorical flipbook of creatures in the throes of life, their transitory gestures preserved—swimming, sailing, capturing prey. It is as if each bivalve, alligator, or sail-back that swam or flitted or thundered before the lens was caught by a time-lapsed mechanism and recorded onto the most remarkable film stock ever invented—film that resisted fire, flood, and even weathered mass extinctions in some kind of time-capsuled carriage, developed only now by the artist into a formal constructed view—frames; edited, juxtaposed, and rejoined for the sake of the fourth dimension. And although

we are looking at the portraits of stony permanence, seen at random—now a flipper, now a fin—many of these organisms express both the millisecond of a gesture and the eons of that gesture turned to stone. I have the impression that these fossils are, even as improbably viable fragments—beaks, footprints, fronds, bark, shell—still moving.

The artist's instinct for movement (even from the dead) and knowledge of the varying perspectives gained from her observations of aerial views, plants, and underwater life endows this work with movement and energy. Page treats each panel as a separate historical view, often containing fossils from more than one locality and from various sources of inspiration. Somewhere I saw a set of Victorian picture cards that (no matter which card was placed beside which) formed a visually unbroken narrative of the moment, a kind of a perpetual panorama of people walking along the river bank or through the park. The boy flies his kite or, if you shift a card, he walks his dog and the kite string becomes a leash. A couple walks along a riverbank. Choose a card and they step onto a bridge, choose another and their progress descends to the water. No matter what the options, the couple will follow a plausible path and when all the cards are laid down, the landscape will move in a circle, ending up where it began, in a simultaneous sweep. The fossil record, on the other hand, miscellaneous, unevenly distributed, full of gaps and bonanza abundances, comes to us free of cultural baggage, and there isn't much, given the eventful large extinctions and the sheer diversity of preserved organisms, that will appear at the end as it did in the beginning. While the larger subject of the cards forming a perpetual scene evokes the coziness of stasis, details from the fossil record just zip on by. Although these panels represent phases of the story of life forms rising and

4. John Noble Wilford, "Greek Myths: Not Necessarily Mythical," review of *The First Fossil Hunters* by Adrienne Mayer, *New York Times*, 4 July 2000, sec. D1.

William Stevens, "Lost Rivets and Threads and Ecosystems Pulled Apart," illustration Parker Fulton. *New York Times*, 4 July 2000, sec. D4.

sinking, the effect is quite unlike the stories told by the interchangeable Victorian cards. This is not a ride on the merry-go-round. The Cambrian will not show up in the Cretaceous, nor will the denizens of Mazon Creek find themselves at the same gathering as the sail-back, crabs, and ferns of the Permian.

The panels flow from one to next both chronologically and aesthetically. They move along like a musical score of which we hear only edges of intermittent notes. Occasionally a snake, plant, coral, turtle, bird, or fish representing both one life and death as well as the life and death of an entire species is spread across several panels. At 190–185 million years ago (mya) a pregnant ichthyosaur lies frozen. At 209–206 mya a crocodile attacks the tail of a turtle that occupies the 212–210 mya time slot. And at 179–177 mya, a shark has swallowed many belemnites. There is an elegiac quality to these scenes of thwarted lives of predators with prey. Time moves forward on several fronts. There is much information both within and between each panel, but often as if by chance slippage, elaborate details occur along the margins (see the dice-like discs of the *Mystriosaurus bollensis* of 168–165 mya as they barely break the bottom of the frame). The background sometimes flows across several panels as certain animals disappear while others persist.

The painted stretch between the *Pteranodon* (92–89 mya) and the *Centrosaurus* (80–77 mya), has, among many others, the effect of unbroken movement—partly because the artist has included coincidental forms and rhythms that occur across millions of years and between unrelated species. The compound eye of the *Pteranodon* is echoed by the innermost coil of the ammonite—in the panel next door—while the spiked edges of the shell of the

turtle *Archeon* (84–82 mya) thrust back almost three million years to reflect the jagged teeth and gills of a ferocious fish, *Xiphactinus audax*, and forward through a field of faint gastropods toward a future disturbance banded with strata that echo the tones of its spikes.

The graceful shatter of one long-limbed leaping feathered dinosaur from the Cretaceous period extends over three panels, symbolic of the life span of the species. I study the composition of this *Caudipteryx zovi* (125–123 mya)—legbones, vertebrae, jaw bone, broken spine, rough bubble-like skin, oval disc-like teeth, vague paddle or fin shapes as if from fish or sea lizards, sea grass or crinoids, pale snails and a tantalizing wing-shaped limb at the upper edge of the painting, the top end complete only as a general darkening of the stone behind. Perhaps, upon dying, the animal fell into deep water. If it ended up on the sandy bottom, crystals slowly replacing its organic remains, decomposition would have been arrested and it would look like this.[5] That the skeleton falls across several panels underscores the levels and passage of time, the relative paucity of the fossil record and the guile of the artist as director of the scene.

Whatever theoretical webs the paleontologists weave that the artist must accommodate, it takes a painter familiar with art history to understand the fourth dimension. By taking risks, by trusting in moments of private inspiration, artists are accustomed to being out of step, out of place, and always 'out of time' when it comes to the passage of hours, months and days. By allowing the *Caudipteryx zovi* and the more recent skull of the *Pteranodon* (92–89 mya) to float across three or four panels in a leisurely drift, by calmly completing beak or wing or jaw across two panels that might otherwise be cut off by the edge

5. Pat Shipman, *Life History of a Fossil: An Introduction to Taphonomy and Paleoecology.* Cambridge: Harvard University Press, 1981. Offers a thorough description of the science of recreation of the death of fossils.

of the frame, Page paints as if there is *all the time in the world* when it comes to completing the aesthetic gesture, based, as she puts it, on "compositional necessity or a quirk of the imagination." When I look at a *Pteranodon* stretched across four million years I feel that I am patting my head, rubbing my stomach, and simultaneously conjuring forth the little I too might know of the fourth dimension.

The organisms in Page's work often look like something other than what they are: what looks like a fully extended and swimming ammonite (actually a tooth whorl of a shark) sails across its pale ground like a paper kite (271 mya), the head shield of a giant eurypterid and its lateral pieces of shell scattered like armor from one of Hannibal's battle elephants (403–401 mya). And the bark of the giant clubmoss *Lepidodendron* (299–298 mya) looks like the coast of Africa. Even the industrial sickle-shaped claws of sauropod *Plateosaurus* (214–213 mya), modeled in clay to rise two inches above the surface of the panel as if in mid-excavation, look like a sculptor's *idea* of giant claws—a quality that many museum large vertebrate specimens also share. Excavated bone *does* feel like metal, or wood, or plaster, and in their abstracting amputations, pieces of dinosaurs and small fragments of shells look a lot like Art.

That shapes in stone resemble other things is scarcely an original notion. For centuries people found landscapes, cities, saints, and animals in the rocks. Picture stones resembling human anatomy (an ear, a heart, a hand) were seen as deliberate representations made out of the *vis plastica* life force by God. Both tricks of rock formation or fossilized remains, misunderstood as being organic in origin, picture stones were well documented and their source and cause debated from classical times until the mid-nineteenth century. In Europe *glossopetrae*, or fossil sharks' teeth, as Richard Fortey puts it, "the most enduring parts of the most enduring predators in the sea," were popularly thought to be stones formed by thunder or serpents' tongues . . . "although [they are] more like the tongues of woodpeckers," wrote Pliny in the first century AD.[6] Ammonites were considered coiled-up snakes 'generally without the heads' and, in China, certain brachiopods that resembled spread wings were called stone swallows. In the sixth century AD these swallows were thought to fly about the mountain at night, the smaller ones juvenile birds, the larger their parents.[7]

From China, land of the feathered dinosaur (*Caudipteryx zovi* described above), a geological text by Yun Lin Shih Phu dated 1133 quotes a sixth-century writer (Li Tao Yuan) as describing the "Stone-Fish mountain" in Hsianghsiang Hsien in the province of Thanchow. In the dark rocks streaked with mica veins full of fossil fish were fish that looked as though they had been carved or painted. In a beautiful passage, the writer elaborates on the site: "digging down several feet one can unearth slabs of blue stone . . . called 'the cover of fish stone.' Below this the stone is bluish gray or whitish and removing layer by layer you come upon the shapes of the fishes. They look like false carps, their scales and antenna are as perfect as if drawn by ink." Yun Lin Shuh Phu writes that sometimes the fish seemed to swim after each other as in a school, that sometimes they seemed 'injured or indistinct,' obscured by river reeds. Sometimes among hundreds of specimens only one or two were clear; sometimes they were 'coiled like dragons.' The author writes that the perfection of

6. Richard Fortey, *LIFE: A Natural History of the First Four Billion Years of Life on Earth.* New York: Knopf, 1998. 257.

7. Facts here and below regarding early Chinese fossils from *The Early History of Paleontology* published by the British Museum of Natural History in 1976, and from Joseph Needham, *Science and Civilisation in China*, vol. 3. Cambridge: Cambridge University Press, 1979. 617–621, 641.

the intact fish—of nature imitating art—led to a brisk business in their forgery as 'artists' rushed to imitate nature. To discern a false carp fossil from a genuine one, one had only to scratch or burn the stone and sniff.[8]

Page's painting of the *Knightia eocaena* (55–54 mya) reminds me of the ink carp from Stone Fish mountain. And *Dapedium politum* (203–202 mya) with its flinty scales and needle teeth intact swims across a gray blue surface like the mountain rocks. If we scratch these stones will they smell like fish? Barbara Page's paintings depict both intact and degraded fishes and leaves, starfish, claws and vertebrae. She shows us plenty of dragons. The pale intact carapace of *Progonochelys* (212–210 mya) with flecks of dust or bone chips between the scutes lies on top of the reddish rock while behind, in the bedrock, the faint stars of broken plants set off the highly defined mountainous detail of the reptile's dorsal cover.

The deeper into the rock Page goes, the more subtle is the relationship between matrix and specimen, as though under the top layers, the bones and shells are no longer made of stone but of pigment, while the shadowy shapes that extend back into the rock hint of a world in which everything is an illusion.

Cast and imprint, part/counterpart, positive, negative: when the stone is split, fossils appear as shadows, indentations, broken bulges. White crinoids (the animal that looks like a flower—*Melocrinus nobilissimus,* 400–399mya) surrounded by gastropods and broken strings of discs from other disintegrated stems undulate gracefully across gray stone; these panels have the translucence of a large-format black and white negative—the positive crinoids here seem to appear in translation. The effect of constantly changing light—both night and day—often seems to emanate from within the rocks: the pallor of the late Jurassic limestone, the sunset red from the Permian, thick gray of Precambrian

and early Tertiary, and variegated pebbles and chalk from the Cretaceous—to name just a few.

As muddy footprints lead to the perpetrator of a crime, so the tunnels of vanished snails in stone, horseshoe crab tails dragged through the sand, crocodile footprints in mud or those of a woman and child in petrified ash lead to deductions about daily life millions of years ago. We want desperately, of course, to see ourselves implicated in all of life so that when, finally, after hundreds of years, we show up in the fossil record, even as small primates (*Aegyptopithecus*, 33 mya) many of us draw a sigh of relief—at last! We have arrived. How did Life manage for so long without us? When, in 1892, the paleontologist Eugen Dubois found the skull cap and femur of Java Man (*Homo erectus*), whom he erroneously dubbed as the missing link between man and apes, he placed the sacred evidence in a wooden case, in a closet, under lock and key. When I first visited the Dubois collection in Leiden, the keeper placed the bones theatrically before me on red velvet, a gesture that (however ironically performed) underscores the controversial nature of the history of human fossils as well as the non-velvet rankings we assign to pig teeth, horse jaws, echinoderms, and incidental dendrites—although all of these may be, if not historically, then at least more *visually* compelling than *Homo erectus*.

When Johann Jacob Scheuchzer (1672–1733) identified the fossilized giant salamander on the banks of a Swiss lake as the remains of an original witness to Noah's Flood, *Homo diluvii testis*, he was mistaken (see panel 7 mya, ribs of *Andrias scheuchzeri*). Most of us haven't been around long enough to merit being turned to stone, even for our sins. Here today, gone tomorrow; that's our fate. We marvel at preserved leathery human victims pulled from peat bogs (200 AD), at Shackleton's nineteenth-century explorers frozen in the arctic

8. *The Early History of Paleontology*, 10.

ice, at the citizens and dogs from Pompeii blasted by ash by the eruption of Vesuvius in 79 AD. Oxygen and moist earth, signs of life and also of decay, will eventually destroy even these preservations; the fingerprint whorls on the bodies pulled from the tannic seal of the bogs smooth away and even disappear after a few years in open air. If the ice melts, the explorers will rot at last, and even the petrified ash from Italian dogs chips under the tourist's hand. Set against the certainty of dissolution of our own flesh and bones, we begin to grasp how extraordinary it is to see a mere fish, the 203–202 mya *Dapedium politum* with every needle tooth intact, as measured against the footprint of *Australopithecus afarensis* (4 mya). We are disappointed when human fossil remains turn out to be younger than we'd hoped. We want to see ourselves mirrored far back in deep time. We want to see a human imprint everywhere; it is difficult to contemplate stretches of time that *had nothing to do with us*.

Page is most sparing with her human references. The footprints of *Australopithecus afarensis* in the Laetoli ash appear in Lucy's stead as if, when it comes to signs of human life, this artist opts for traces rather than for entire skeletal remains. The reddish matrix and white-traced fossils of the Mazon Creek formation reminded Page of pictographs found in the rusty red rock of the southwest United States. In the spirit of cultural and natural convergence she saw in the arrow-shaped sea cucumber (*Achistrum* 311 mya) a reference to the drawings of arrows and prey made by early hunter-artists. When creations of nature resemble human artifacts, it is a joke that works in both directions. Page makes several more sophisticated references in her painting to the work of contemporary artists. With a passage of tangled graptolites (485–484 mya) she pays homage to the "blackboard" paintings of Cy Twombly. In her work the jagged tear of the Taconic Orogeny (460–459 mya) was inspired by the paintings of Clyfford Still and rough biomorphic shapes from the Silurian by the work of Terry Winters.

As the composer, Page planned each episode, keeping certain tactics in reserve, meting out content and colors when called for. "The importance of the Cambrian," Richard Fortey writes, "is not as a potpourri of zoological strangeness, but rather as a key to understanding the state of the animal world close to its birth."[9] Page, noticing that signs of life during the early Cambrian were indeed dim and difficult to come by, created an 'ecological atmosphere' of sponges, trilobites, and worms—both iridescent and obscure. She came up with tiny orange floaters and an *Anomalocaris* with its fussy can-opener head (or tail—depending on whom you choose to believe according to the status of a recent argument among experts . . .) and set them into the gray and dirty aquarium of the Burgess shale.

Page is a careful artist. Her brushwork varies, as she puts it, from 'lean to lush' with occasional use of mixed media: pastels, pencil and the addition of glass, earth and pebbles to signify moments of extinction. But even panels crowded with incident show a kind of restraint. She deliberately holds her colors in reserve for the future, using them sometimes for purposes of scientific accuracy, for marking time, sometimes as alchemical portents. She uses black, for example, when signifying a future geological condition "when something was going to change." She uses white twice, for the Silurian salt beds and the final plaster panel, and "saved the lemon yellow for the Sohlnhofen," spending color when color was due. I like the notion of hoarding and spending pigments according to seismographic events. Parenthetically, I wonder too at the role that alchemy plays in every painter's world. Painters do use weird substances in their work, like eggs and arsenic and pulverized mummy bits. Even a Victorian

9. Richard Fortey, *LIFE*, 253.

lady, Miss Elizabeth Philpott, a well-known collector of fossils from Lyme Regis, drew the head of an ichthyosaur with sepia ink ground from local fossil squids.

Page admits to feeling her greatest sense of freedom of expression as a painter when working on panels associated with periods of catastrophic upheaval or extinction. At the time of the Taconic Orogeny, 460–459 mya, for example, she could relax from her conscientious depiction of fossils and just *paint*. She was free to depend more completely on her intuition and less on the prescribed appearance of things. Apparently, accounts of great upheavals affect the mood of scientists too. As Richard Fortey writes of the KT extinction, "even the driest of scientific prose cannot resist an apocalyptic flavour when describing the meteorite event and its aftermath."[10]

"The most plausible causes of extinction are interactions between continental fusion and climatic change. . . . "Some scientists would prefer there to be a uniformity of causes, even of extinction—declining sea levels, cooling climates, catastrophic impacts," writes Michael Benton.[11] Whatever the causes, we are fascinated by catastrophic change. At the end of the Permian (250 mya), mountains were formed, land flooded, shorelines dropped. There were glaciers, storms, and volcanic eruptions; the level of carbon dioxide rose, smothering life. While the Permian extinction involved the worst all-around annihilation of marine and terrestrial animals and of many plants, at the boundary between the Permian and the Triassic, a few of our ancestors—the therapsid reptiles which gave rise to true mammals around 210 mya—did survive and the painter of *Rock of Ages, Sands of Time* for a few million years, at least, got a break.

When continents collide, an abundance of organic material vanishes from the fossil record leaving the museum's coffers from those eras bare as well. Without the usual indicators—skulls, shells, footprints—Page chose to paint in a metaphorical fashion, expressing general effects of volcanic eruption, glacial till, layers of sand, mountains rising, and translucent salt beds. She worked with rapid energetic bursts, incorporating mica chips and pebbles in the mix and "fat rolls of paint for the Siberian traps." She rejoiced in disturbances that lasted for at least five million years (five panels), and especially in not knowing what would happen next in her own work. "The more chaotic the geological disturbances," she told me, "the more relaxed I become."

We are taught that extinction for some life forms provides opportunity for others. Like all good mammals who survived the effects of the meteorite at Chixulub at the end of the Cretaceous, the artist passed through each extinction, resourcefully, with flying colors.

This artist has made forays into the land governed by science. It's like the reign of the dinosaurs when mammals were small and good at hiding. Paleontologists occupy a vociferous and volatile niche; the artist lives along the edges, operating usually on non-verbal hunches. Artists are supposed to know how to use their eyes and consult their own archives of associative references—sensual, sentient, art historical, literary, cultural, fact and fiction—whatever it takes to get the job done. It's worked, after all, since the first handprints and wounded bison on the walls of Les Eysies and Lascaux.

Let's go back again and scan the forty-five million years preceding the end of the Permian as painted by Page. The background/matrix colors in the panels (287–274 mya) are warm, bathed in the atmospheric light of a slow sunset.

10. Richard Fortey, *LIFE*, 108.

11. Michael Benton, "Four Feet on the Ground," from *The Book of Life*, General Editor Stephen Jay Gould. London: Ebury-Hutchinson, 1993.

They are reminiscent of the color of "red beds" from Texas (270 mya), in which many amphibians and reptiles were fossilized. This dual association of reflectivity is made metaphorically richer by the addition of an orange skeletal leaf and the vestigial presence of a *Dimetrodon*, whose heat-controlling back shield alternatively soaked up the sun or kept the body in the shade. It is as if the sail of the reptile reflected the light of future disaster onto the rock. And the leaf, the sun. According to the date associated with each panel, these animals are still up and roaming. According to the matrix they're long gone. All times and several localities turn on in one scene. The paintings show what is happening in conjunction with the extreme old age of future—action, omen, disaster and preservation—all in one. These panels (287–274 mya) are executed in the same way as all the others, as a memorial of intertwined organisms sunk into a metamorphic morass that is, in effect, still a few million years down the road. This sequence of paintings also has a particularly strong musical effect—red mixed sand and marbled matrixes in a sustained passage of 11-million-year measures. First comes the intact heavy amphibian *Seymouria baylorensis* diving in an arc, then the frail broken neural spines of the *Dimetrodon limbatus*, the lateral sections of the huge leaf set in counter point against three of the spines, followed by free-flowing *Glossopteris* leaves attenuated as if in an oil slick; a swirling soup of animal, vegetable, mineral. Here is a passage among many in *Rock of Ages, Sands of Time* where we feel the basic beat of the panels, the modulation of the background, and the syncopated rhythm of the bones.

Artist's Note

Reconstructing the Past

At the age of six or seven I began drawing with precision on a large scale. In a designated patch at the local ice skating rink, I practiced three turns, figure eights, and serpentines. Forwards. Backwards. Inside edge to outside edge. My objective was to lay three consecutive tracings of each prescribed figure directly on top of one another. At test time the judges would shuffle around in their rubber overshoes and padded coats inspecting the incised lines for scratches and wobbles. Then the Zamboni would rumble out of its cave onto the ice, eat up the snow and simultaneously discharge a thin layer of hot water which quickly congealed into a pristine glass surface. The evidence was erased but a favorable verdict from the judges brought tangible rewards in the form of red ribbons or gold buttons. I still have those small trophies buried in a box somewhere, but whatever accomplishment each represents has long since been forgotten.

Whether etching lines into that smooth white surface had anything to do with my career choice is a moot question. The skating experience is a convenient lead into a life ruled by the vagaries of circumstance. A more likely source of motivation is my acute sense of time passing. Our marks and memories fade quickly, and those we can retrieve often skew the record. In an attempt to stanch our losses, some of us are afflicted with the need to chronicle our experiences. Long ago I started keeping a journal with commentary, quotes from books I was reading, sketches, photographs, and scraps of paper. My attempt to record the present as it slides into the past continues sporadically to this day. Volumes accumulate in stacks, unedited and rarely opened. Occasionally I leaf through them to take a quick trip down memory lane or find some information. How and when did the *Rock of Ages* project begin to take shape? A journal entry for February 1993 describes an idea for a one-of-a-kind book made out of various grades and colors of sandpaper interspersed with photographs of eroding bedrock. But the foundations were laid much earlier in my career. I have a strong sense of my body moving in space—perhaps that is the true legacy of skating lessons. Examining the world from different points of view is a consistent theme in my work. My early paintings were abstract aerial landscapes in desert colors; I was a pilot before I was a painter. Down at ground level my love of gardening prompted me to do large watercolors of lush life-size botanical subjects, or rocks and reflections caught in the shallows of streams. Moving below sea level, I conjured up imaginary reefs or tackled tropical fish, cramming just one, with eyes as big as butter plates, on a large canvas as if into an aquarium that is too small. I was on a vision quest but hadn't yet found a power spot.

A period of discouragement led to a series of expressionist paintings titled *Natural Disasters*, where I evoked the destructive side of nature—volcanic explosions, sandstorms, avalanches. More than once the pathway came to a dead end. At times like this I turned my focus inward to the habitat of my imagination. In fits and starts, searching for clear direction, I produced collages as

opaque as the mutterings of the oracle at Delphi. Mine is a profession where you proceed on blind faith to an unspecified destination. John Berger, an eminent art critic, points out that "at the moment of revelation when appearance and meaning become identical, the space of physics and the seer's inner space coincide: momentarily and exceptionally the seer achieves an equality with the visible." Only in retrospect can I rationally connect the threads of intuitive choices and haphazard ramblings that resulted in this project.

My original plan to make an "artist's book" using sandpaper to offset images of water working against rock didn't work for technical reasons. I decided to make my own "sandpaper." When the pieces were stacked one on top of another, the edges of the painted sheets reminded me of strata in roadside cuts. Painting itself is a layering process. Theoretically I could work endlessly on one canvas, continuously burying each layer of imagery under another coat of paint. The analogy with geological processes was not lost on me. How remarkable that Earth has her own diary, written in rock. Many of the pages are missing, folded, shuffled, or torn. Some are scattered in the wind; others have been collected and stuck in drawers. Fossils are the Rosetta stone we use to decipher her language.

One of the joys of a career in the arts is the possibility of getting up one morning with an inspiration and throwing all else aside to bring it to fruition. Sometimes this can be accomplished in a matter of hours. Sometimes it requires a lifetime. Every painter's dream is to have a compelling reason to pick up a brush.

I asked myself, "Why not resurrect a lost landscape in the form of a journal where a day in the life of Mother Earth lasts a million years? A record of the past as it slides into the present, a map where Father Time dictates the spatial dimensions?" Having no background in natural sciences, I began studying geology and the fossil record. It was a foreign country. Crinoids, brachiopods. . . *Hallucigenia*, *Wiwaxia*, and *Tullymonstrum*. Stephen J. Gould's *Wonderful Life* is a friendly introduction to early forms of life. Undaunted, I began to compose the piece, beginning back when there wasn't much happening. The book format went by the wayside when I realized what a laborious process it would be to bind it. My solution? Divide time into arbitrary units represented by a series of uniform panels and emphasize its continuity by placing the panels side by side with overlapping imagery. Of course the space required to exhibit the entire project suddenly became very large but this was not without precedent. In the 1970s Jennifer Bartlett produced *Rhapsody*, a complex piece with theme and variations, on 900 enamel plates, each one foot square. Expanding the scale of the project appealed to me. Long ago I copied into my journal a passage from "Of Exactitude in Science" by Jorge Luis Borges:

> . . . In that Empire, the craft of Cartography attained such Perfection that the Map of a Single province covered the space of an entire City, and the Map of the Empire itself an entire Province. In the course of Time, these Extensive maps were found somehow wanting, and so the College of Cartographers evolved a Map of the Empire that was of the same Scale as the Empire and coincided with it point for point. Less attentive to the Study of Cartography, succeeding Generations came to judge a map of such Magnitude cumbersome and, not without Irreverence, they abandoned it to the Rigours of sun and Rain. In the western Deserts, tattered

Fragments of the Map are still to be found, Sheltering an occasional Beast or beggar; in the whole Nation, no other relic is left of the Discipline of Geography (*A Universal History of Infamy*, 1972).

My string of small paintings would eventually add up to a large cohesive work. There would be a cast of characters worthy of a Cecil B. De Mille film, presented in order of appearance and as large as life. I set strict parameters for its production. Why regulate the process? There is a notion that freedom is a prerequisite of creativity. Yes, in a sense. I am free to make up the rules. The creative process needs rules to bend and boundaries to stretch. Otherwise it is the equivalent of playing a match where the other team already forfeited the game. Lone rangers in the studio play against themselves. Nothing induces a state of existential anomie faster than the freedom to do anything.

My project was divided into eleven parts corresponding to the geological periods. I did the research for one section at a time and recorded it in big sketchbooks. Determining the stratigraphic location of many organisms was a real headache. I found, for example, identical Monte Bolca fossils of the Eocene dated 57 and 40 million years ago in recent publications. Paleontologists do not usually speak about million year segments except in a casual way. They think in periods and epochs. I used the Definitive Time Scale 1989 as my timeline. It was superseded by the ASGO Phanerozoic Timescale 1995 version just after I completed the Paleozoic era, forcing adjustments in midstream. Before newly assimilated information vanished from my head, I made cartoons indicating the overall composition of a period, separating marine and terrestrial sequences. Finally I painted the panels one after the other, more or less in chronological order. Was there an evolution in style? Metaphorical references to geological processes crept in as a defining element, thanks to the vivid writings of John McPhee, collected in *Annals of the Former World*. His work was not only a source of essential information but also a model of an artist's personal encounter with the past through science.

For a painter, working within the boundaries of a rectangle is the usual order of business. This is an artificial construct so embedded in our culture that artist and audience rarely call it into question. By setting each panel adjacent to the next, I both acknowledged and defied the borders. Each panel became a single page in a sequence of chapters with changing characters and glitches in the plot. I soon could not see all the panels at once. Constructing the project was thus similar to the act of simultaneously unrolling and rolling a Japanese scroll. I never saw the end until I arrived there and by then the beginning was buried in boxes. In the middle of the project the words of James Hutton, founder of modern geology, came to mind: "The result, therefore, of this physical inquiry is, that we find no vestige of a beginning, no prospect of an end." Attempting to keep track of everything took over my days and overflowed into my dreams. Studio time was measured not in hours but in millions of years traversed—a shift in thinking that was conceptually expanding and psychologically belittling.

And so my curiosity cabinet with its comprehensive collection of the inventions of nature came into being. I spent more than eight years in the bone yards moving from conception to completion of the project. I often wondered if I would become extinct before it was finished.

Father Time and Mother Earth,
A marriage on the rocks.

—James Merrill, "The Broken Home"

Artist's Introduction

This series of paintings functions as a visual metaphor for an immense period of time. An eon. Five hundred and fifty million years—the estimated interval between the origin of macroscopic life on this planet and the recent conclusion of a millennium. Each of the contiguous panels represents the passage of a million years. Fossil flora and fauna make their appearance in chronological order. All of the organisms are depicted at true scale in the original eleven-inch-square paintings (and reduced by half for the purposes of this book). Intricate Cambrian anthropods, whose silhouettes still persist as an iridescent carbon film, float on the black shaley surfaces typical of the period. Feathery sea lilies—not actually plants, but animals—undulate in counterpoint to heavily armored Devonian fishes. Scattered bones of giant reptiles are molded in bas-relief and embedded in coarse-grained pigments, simulating the Texas Red Beds of the Permian period. Using geology as a matrix complements the slippery concept of the passage of time because the fossil record confounds our notions of permanence and ephemerality.

A total of 544 panels are grouped into eleven sections, which represent the eleven geological periods between the dawn of the Paleozoic era 543 million years ago and today—Cambrian to Quaternary. A whimsical collection of names, dividing a story written on rocks into chapters of variable length. The Silurian period lasted thirty million years and the Cretaceous eighty million. The duration of each period isn't absolutely etched in stone, since revision of the boundaries is an ongoing process. The so-called definitive Geological Time Scale 89 initially provided me with a useful chronology but is now out of date. While I was doing the research for this project, the Cambrian period lost 27 million years to an earlier era.

A distinct change in the tonality of consecutive panels indicates an abrupt transition between periods or within them. Some geological periods have boundaries which coincide with cataclysms. Others slide into one another without much commotion. Determining the sequence of deposition of strata is a tricky business since formations can be folded, eroded, buried, and recycled. Decoding the evolutionary history of fossil specimens has rendered their remains a useful means to calibrate the relative age of the rocks in which they are found. I have included representatives of widespread index fossils in my menagerie. Geological processes and climate changes are represented metaphorically. Following major extinctions, such as those which decimated thousands of species and the entire dinosaur clan, fossil impressions are scant or absent from the paintings. They are replaced by lavish amounts of pigment-laden pumice indicating volcanic upheavals, with glass beads representing catastrophic collisions with asteroids, or with lumps resembling glacial till.

Variation in background hue does double duty as a device for separating aquatic and terrestrial life from one another. I chose colors based on the type of rock in which particular fossils turned up. Mudstone, shale, sandstone and limestone in many tints. A muted rainbow of possibilities. Occasionally, com-

positional necessity or a quirk of the imagination called for particularly arresting panels to disrupt a sequence with a visual exclamation mark. Geological formations are rife with such aberrations. I made no effort to group fossils together according to specific localities where they were found. The geography of the past is as elusive as Atlantis. Continents drifted into each other, raising mountain chains and leaving oceans in their wake. Cambrian fauna roamed the Iapetus Sea and Jurassic dinosaurs had an address on a gigantic landmass called Pangaea.

One of the ramifications of this project is an exploration of the dichotomy between artistic and scientific methods of visualization, valuation, and verification. I began with the same source material that a paleontologist uses in research—fossil specimens. Earth scientists, through examination of this accumulated material and a dose of inductive reasoning, might attempt to decipher the path of evolution or reconstruct ancient ecosystems. Composing an objective and cohesive description of the distant past is an exercise in proximate causality. Theories can emerge, rise, shift, and disappear like tectonic plates. Some stand the test of time and become "facts." In a historical science such as paleontology or astrophysics, it is extremely difficult to conduct experiments. It is not yet possible to visit a black hole or take the temperature of a dinosaur. It is a matter of collecting data and interpreting it as carefully and rigorously as possible.

I sketched fossils in museums and paleontology collections from California to Cape Town. Back in the studio, I recomposed the pencil drawings with a tempered dose of imagination, and transformed them into dabs of paint. My interpretation of the data is subjective rather than analytical. Fossils are the net in which I catch time fleeing. Artistic license gave me permission to select whatever fossils beguiled my eye as long as I regarded their position in the stratigraphic column. My choice of specimens for a million years of fame was largely determined by their diversity, dominance, and salient characteristics, but a predilection for gastropods and turtles is probably obvious. In deference to scientific practice, I recorded the nomenclature and museum identification numbers of the organisms I sketched in preparation for designing the panels. Taxonomic names such as *Parasaurolophus* were impossibly taxing for me to pronounce, but others generated my nicknames for favorite fossil friends such as Seymour (*Seymouria baylorensis*) and Mach 2 (*Machaeroprosopus gregorii*).

Although the fossil images are identifiable to genus despite the painterly format, it was never my intention to illustrate their characteristics in the manner of a field guide. I wanted to construct passages rhythmic with their compelling shapes. My knowledge of the traditions of scientific illustration is limited. I find enchanting Mark Catesby's whimsical etchings in *Natural History of Carolina, Florida, and the Bahama Islands* as well as the sinuously elegant compositions in *Birds of America* by James Audubon. Lithographs in nineteenth-century scientific tomes such as *Paleontology of New York* (1847, 1852, and 1861) by James Hall were excellent resources for my research. The shallow perspective of natural history illustrations with little or no representation of the landscape is a characteristic shared with Modernist painting. Witness the primacy of the surface in the skeins of paint in "Autumn Rhythm" by Jackson Pollock or Mondrian's geometric rectangles of vibrant color floating on a white picture plane in "Broadway Boogie-Woogie."

A profound difference between scientific and artistic outlook revolves around the concept of time. Temporal structure is essential to the arts, particularly music, theater, and film. To artists, time is plastic, subject to manipulation

through repetition, flashbacks, slow motion, and fast forward. To the scientist, time is both measure and dimension. In the arcane universe of relativity, only a privileged few play with time warps. For the rest of us, Newton's concept of absolute time serves well enough. Particle physicists operate in nanoseconds and paleontologists in million-year segments. These extreme temporal quantifiers of scientific thinking boggle the imagination. A million years! The scope of our consciousness is hours and days that accumulate into years. Thinking about the next decade is long-range planning. A century passes for eternity. We use these arbitrary markers to post limits on the infinite stretch of time everlasting. *Rock of Ages, Sands of Time* is a translation of time into space. I arbitrarily chose to compress a million years into 121 square inches, noting that reductionism seems to be a hallmark of our culture. I caught myself somewhere between perceiving time as measure and time as spatially malleable. In the process of cutting the past into neat slices, I traded spatial perspective for perspective in time.

Condensing an eon into the present tense gives an immediacy to the long journey here. The original piece, with each panel laid edge to edge, stretches out more than five hundred feet. Nevertheless it is a yardstick that can't measure millimeters. Events such as recent ice ages so integral to the story of early man are unregistered blips in the whole scheme of things. The notion that evolution generally proceeds at a glacial pace is a concept almost impossible to fathom in a world so addicted to speed.

Painting itself is a static medium. Ideally, a completed painting remains in just the state the artist left it—the moment of time captured is, in a sense, timeless. A spectator can usually get a visual grasp on the image from one spot in just a few moments, although instant apprehension should not deny the pleasure of studying a painting for hours on end. Nevertheless, I wanted to break the traditional framework of painting and create an opportunity for active participation. *Rock of Ages, Sands of Time* is a challenging composition due to its exceptionally long and narrow format. I orchestrate pictorial flow with stylistic variations and visual interruptions between periods, changing tempo at will. The viewer's eye may dart through the piece, delighting in subtle shifts of color, or it may pause to determine whether the shadow of an ammonite is a painted illusion, or, perhaps, the result of light falling on forms fashioned in bas-relief. Detailed drawing, expressionistic brushwork, and textured modeling, remnants of art history and my idiosyncratic evolution as an artist, are inserted to avoid monotony and to build crescendos.

Just as underpainting gives depth to a final coat of paint, my images of fossils carry various cultural references. There are optical allusions to the work of artists past and present. The panels depicting Mazon Creek fossils in the Pennsylvanian period resemble petroglyphs found in the American southwest. A sequence of scribbles representing early Ordovician graptolites calls to mind paintings by contemporary artist Cy Twombly. Certain panels could stand alone as small non-representational paintings. In choosing to draw organisms at true scale in a small format, I built into the project an element of abstraction resulting from substitution of the part for the whole. The only recognizable part of a dinosaur, mammal, or fish may be a claw, a tooth, or a fin if the remainder falls outside the picture plane. The dramatic shape of the rear ventral plate of the giant sea turtle *Archelon* might possibly be identified by a specialist. Sometimes a footprint may be the only evidence indicating the existence of a particular beast. Fossil bones are frequently discovered in the same state of disarray as puzzle pieces. Neat reconstructions can take years. I didn't do any

Jurassic Park resurrections. This manner of presentation simulates the imagination, promotes a sense of discovery, invites speculation, and provides the pleasure of making connections. I try to combat our tendency to believe that large animals are more real than small ones. *T. rex* has captured the popular imagination in her big teeth. Just as fascinating to me is the imprint of a frail water strider in Solnhofen limestone.

The miraculous revelations of art and science were once thoroughly intertwined. Leonardo da Vinci moved easily from Mona Lisa to fluid dynamics. This past century, both disciplines drifted away from investigating the surface aspect of things and delved instead into arcane theory. Painting lost its perspective and physics was tied up in hypothetical superstrings. Artists and scientists withdrew into their respective hermetic environments, intellectually excluding each other and the majority of mankind. The creation of *Rock of Ages, Sands of Time* was a journey across the gap to investigate patterns and processes on the other side. I sifted through layer after layer of debris to uncover unfamiliar territory, learn a new language, and translate it into my terms. For many viewers, the layers of imagery present in my interpretation of natural history and earth science may go unnoticed, but the visual power of the paintings is not compromised. A wealth of content is presented, not with didactic intent but for provision of a visual feast, with the hope that it will make a lasting impression.

Time, Space, Rocks, and Life

Near the climax of the film *Raiders of the Lost Ark*, the evil Belloch points to the ark and says to Indiana Jones, "Indiana, we are only passing through history, but this *is* history." The line resonates. This object seems to capture the ineffable, to represent time incarnate. We are frequently moved by authentic (or apparently authentic) tangible pieces of the past: the Pyramids of Giza, the Shroud of Turin, the original Declaration of Independence, the contents of Lincoln's pockets on the day he was shot, Elvis' sequined suit. By seeing or touching such objects or simply being in their presence, we may somehow travel back in time, or bring time back to us; we may for a moment stop the unstoppable and comprehend the incomprehensible. We may make our own existence, which seems to speed by in a blur, verifiable; we can slow it down and render it orderly.

The quest to articulate and describe the meaning of time and history has challenged thinkers and writers for—well, throughout history and for a long time. Is time a thing? A substance through which we move? A phenomenon that itself flows and moves? Is history a tangible object or a construct of our minds? Is it a linked chain of events and people, or an unconnected assortment of independent items that we're forced to memorize in school? How do we measure our place in time? In history? How do we gain an understanding of time's most basic divisions—the past, present, and future?

"History" in common usage almost always means "human history." "History is the story of mankind," writes J. M. Roberts at the beginning of his massive *History of the World* (1993), "of what it has done, suffered, or enjoyed." Time and events before mankind are, in Roberts' view, "before history." H. G. Wells, among others, took a broader view; in *The Outline of History* (1921) he encompassed the entire history of the planet before and after the arrival of humans.

Yet whether it is restricted to humans or not, any study of the past faces similar challenges—historians (who deal with people and their actions), geologists, and paleontologists (both of whom deal with life and events before or apart from humans) alike must wrestle with how to measure time and how to describe past events. No concept of time is universal, but many and perhaps most recent thinkers on the subject would suggest that time is not a self-contained entity; it is a framework that contains sequences of events. Cicero wrote that "history is the witness that testifies to the passing of time." "Time passes," but what we really mean is, "events occur."

When we order events in time, we do so in two ways: one is simple and linear—"earlier" and "later"; in other words, "relative" time. The other is to order events of one type against events of another. Specifically, we take one set of events that seems highly regular (e.g., the ticking of a watch, or the revolutions of the Earth around the sun) as a basis for comparing and ordering other events (our activities in a day, the events in our personal lives, or the history of a nation). We define standard units of time in this way, and use the resulting systems to organize our thinking and record keeping. This is "absolute" or "numerical" time. Measuring events in years or seconds does not prohibit or replace relative time; "before," "during," and "after" are inescapable notions. We use both kinds of time every day.

We can think of geological time in exactly the same way, as expressible in both relative and numerical terms. We tell relative time in geology using a two-step process, the first of which is based on a simple principle: in a stack of layered rocks, the oldest layer is on the bottom. This idea, called "superposition," allows us to order the set of events represented by layers of rocks in one particular place along a timeline—their deposition at that spot as soft sediments,

and the life and death of the organisms they contain as fossils. The second step in the process connects a stack of layered rocks from one place with another stack from a completely different location. We do this by using fossils—the remains or traces of ancient life—and by assuming that fossils found in a layer here are approximately the same age as similar fossils in another layer there. By repeatedly comparing fossils from place to place, and continuing to use superposition to test their relative age, we build up a master sequence of fossils across space. Such a sequence not only allows us to determine the relative age of layers we might encounter in the future (rocks are dated by the fossils they contain); it also quite literally provides a history of life.

When these principles were first being developed in the early nineteenth century, names were given to sets of rocks containing distinctive fossils. The names usually were derived from a location where the rocks were first studied or particularly well exposed. This set of names developed into the Geological Time Scale—the master alphabet of geology. In addition to serving this practical purpose, it was also immediately realized that the Time Scale was a history of life on Earth. Thus, a quarter century before Darwin published *The Origin of Species* in 1859, the earliest geologists had established that life changes over time and has a history which can be at least partially uncovered.

It remained for the twentieth century to solve the problem of determining numerical time in geology. This turned out to be measurable not by examining highly variable processes such as erosion and deposition of sediments, changes in ocean salinity, or the cooling of the Earth (although all these were tried), but rather by the regular or "clocklike" behavior of certain atoms called radioactive isotopes. The rates of change or "decay" from one form to another in these atoms are measured in the lab, and then the amounts of each form are measured in mineral crystals in rocks. Arithmetic of the grade-school variety (Janie goes to the store which is three miles away; she walks three miles per hour; how long does it take her to reach the store?) yields the time since the mineral and rock formed. Combined, these methods of determining relative and numerical time in geology form the framework for telling the history of the Earth and its life.

Actually telling that history, however, is another matter altogether. How do you relate the story of the entire world over all time? The artwork that forms the basis for this book attempts to tell a portion of the history of life on Earth—the last 544 million years. In doing so, it stimulates us to think about every way the history of life has ever been told. It also tells us as much about geological and paleontological science as it does about art.

First of all, it is selective. All historical narrative must be, for not everything can be told. Not every event in the past left a trace. No single place can be known through all time, and no single time can be known at all places. Thus we must look at many places to reconstruct one time, and many times to reconstruct one place. There are also limits on the time and space and energy available for the telling. And not everything is judged to be equally "important." We choose what to emphasize based on our varying purposes and backgrounds. This work emphasizes some events and places and life forms more than others. It moves back and forth between sea and land, between plants and animals and rocks, and does not cover everything, everywhere.

Page's art also struggles with the simultaneous continuity of time and the discontinuity of our attention span. Time is continuous; it "has no divisions to

mark its passage," wrote Thomas Mann. But we have trouble reading a book with no chapters or paragraphs. So we divide it up and label the pieces, with selection and emphasis depending on our purpose. This work attempts to show the uniform flow of time; each panel represents one million years and has its place in an unbroken sequence spanning an eon. But like all histories, it is presented in divisions designed for the sake of convenience of reference and narrative, in this case the eras and periods of the Geological Time Scale.

Her work similarly struggles with scale, and with the processes of inference, induction, and deduction. Because the images it depicts are life-size (reduced by 50 percent for this book), this work gives something of an up-close perspective, what field geologists sometimes fondly call the "face-to-the-outcrop" point of view. But how do we get from this richness of detail to "the big picture"? This is one of the central problems of geology. This work of art does not explicitly depict "what happened"—the grand drama or narrative of Earth history—the motion of continents, or the rise of mountains, the fall of seas, or the evolution of life. Yet these things are not directly "seen" by any geologist or paleontologist either. They are inferred and hypothesized. We see in this work images of both the results of and the evidence for the processes and events we wish to understand, and it calls on us to ponder the process by which we try to obtain that understanding.

Why tell history? Why search for, and tell, the history of life on Earth, with paint or with words? Because we love a good tale. There is a poetic and an aesthetic to any grand story, any sweeping epic that is bigger than we are. Because we are capable of doing it. The act of history is itself a triumph of human thought. History is not passively read or seen; it is reconstructed and inferred and hypothesized. Thus, there is not only grandeur to the history of life, but also grandeur and elegance in the process we use in deciphering that history. Because we thrive on discovery. Splitting a rock and discovering a fossil instantly transports us back millions of years, as we gaze on what no human has seen before. Because we long to make sense of ourselves and our place in the world. There is satisfaction in telling a story that makes sense of who we are and where we came from. Discovering that the Earth and its life have a history is among the greatest accomplishments of the human intellect. Because we love a challenge as much as we love satisfaction. The unraveling of the history of life on Earth is not done; it is ongoing and will never be completed. We think we have the outlines, and can be justifiably pleased with what we think we understand, yet we are still constantly surprised with new discoveries, and we constantly surprise ourselves with new ideas about the meaning and significance of old discoveries. There are few nobler human enterprises.

The Cambrian

543 507

Imagine a world with no living thing bigger than a pinhead. That was our world for most of its history. The fossil record indicates that life originated on Earth between 3.5 and 4.0 billion years ago, perhaps no more than a mere half-billion years after the Earth itself first came into being. The oldest known fossils are microscopic single cells, probably bacterial, around 3.5 billion years old, and the record indicates that there was nothing much bigger or more complex than that for at least 2 billion years. Then, around 1.5 billion years ago or perhaps a bit earlier, more complex cells with internal structures such as a nucleus appeared. Within the next half-billion years or so, the three basic kinds of multicellular organisms—fungi, animals, and plants—branched off from one another. Sometime between 600 million and one billion years ago, multicellular animals first evolved. It is very likely that these first animals were very small. The first animals big enough to notice with our naked eye, had we been there to see them, did not appear on Earth until around 600 million years ago—at least 3 billion years after the origin of life.

Between 600 million and 540 million years ago, the existing small and relatively simple animals abruptly gave rise to all of the basic body plans of later animals. Many of these animal groups developed hard mineralized skeletons that were preserved as abundant fossils. This event is the most fundamental marker in all of geological time. It defines the beginning of an eon—the Phanerozoic (meaning "visible life"). It defines the beginning of the Paleozoic Era (meaning "old life"), and it defines the beginning of the Cambrian Period. All time prior to this event is usually referred to as simply "Precambrian"; the event itself is usually called "the Cambrian explosion."

The world of life that emerged from the Cambrian explosion did not look like our modern world at all. In the oceans, the most common animals were probably the trilobites—elegant but extinct relatives of modern lobsters and horseshoe crabs. Most other forms of sea life, although largely belonging to the basic large modern groups, would have seemed very strange to us. Our own close relatives looked like tiny headless minnows. There appears to have been no life at all on land.

The events of the early Cambrian are among the most active areas of modern paleontological exploration, and new findings are announced frequently. The picture of the Cambrian world that has emerged from recent research is one of numerous biological "experiments." With the possible exception of trilobites, few groups of animals became dominant. Life appears to have been trying out different designs, and some were to work out better than others.

This period was named after "Cambria," the Latin name for Wales, in recognition of the Cambrian rocks exposed there. Fossil-rich Cambrian rocks are also well-known in western and easternmost North America, central Europe, and in Asia. Much of our recent knowledge of the Cambrian world has been derived from the Burgess Shale, a layer of rock found in British Columbia and bearing exquisitely preserved fossils of soft-bodied animals. In China, an even older layer of rock, known as Chengjiang, has also yielded magnificent fossils of delicate Cambrian organisms.

543 *million years ago*

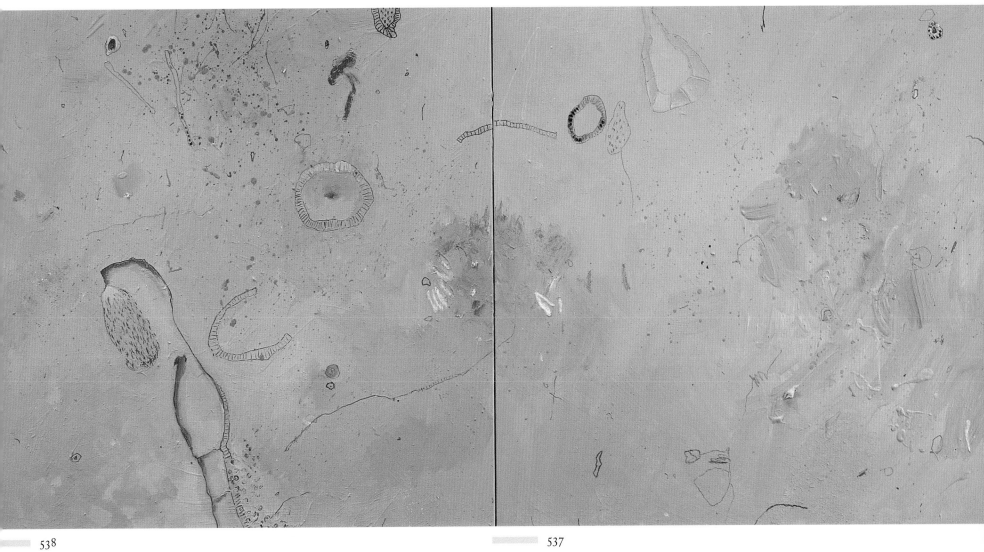

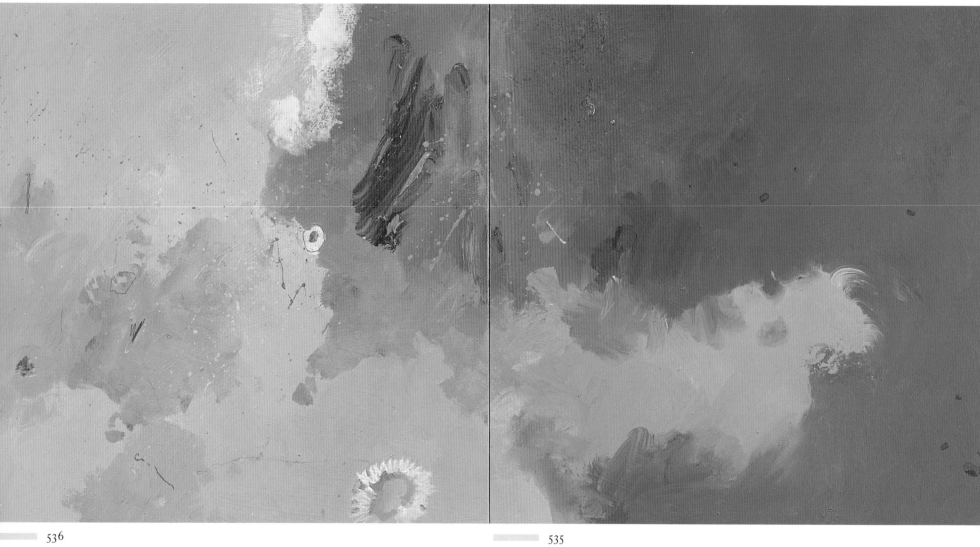

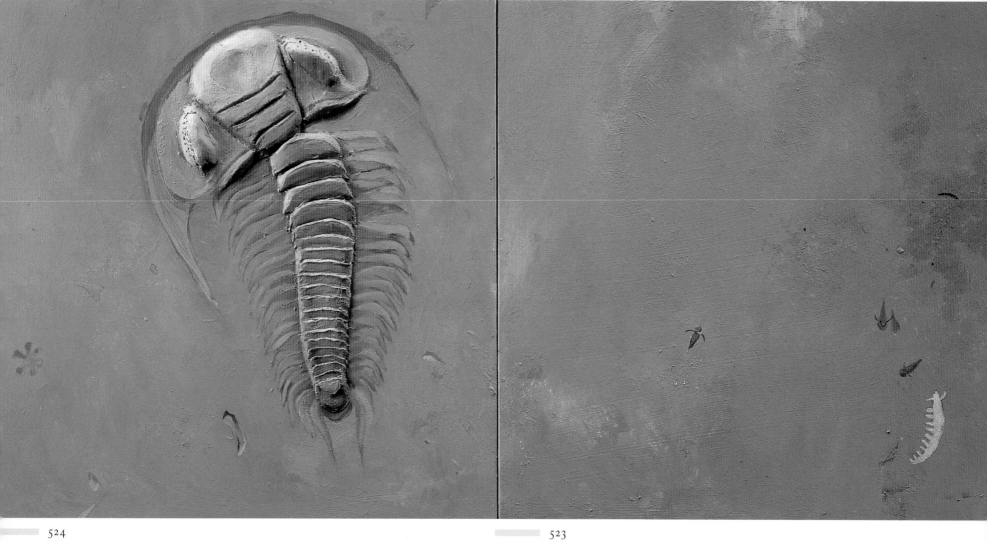

524

523

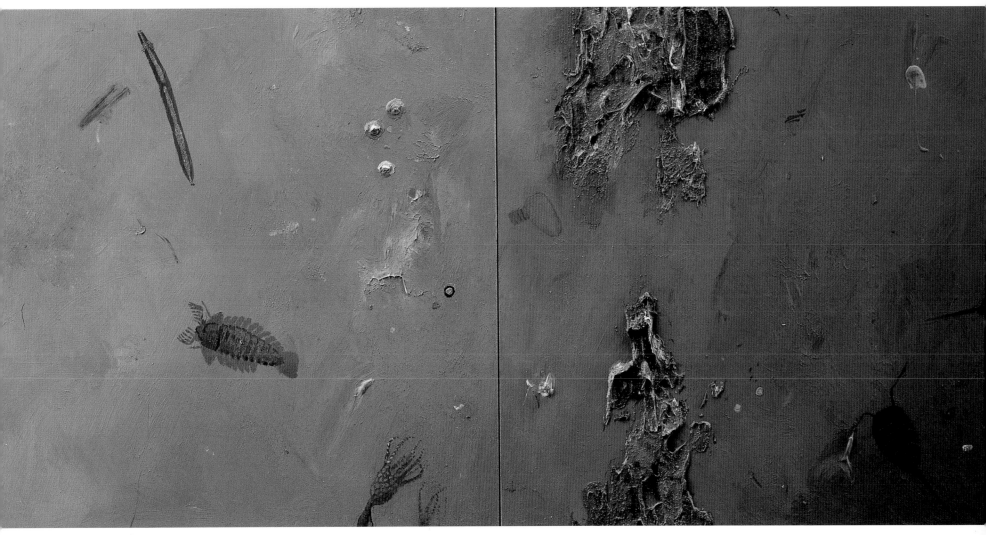

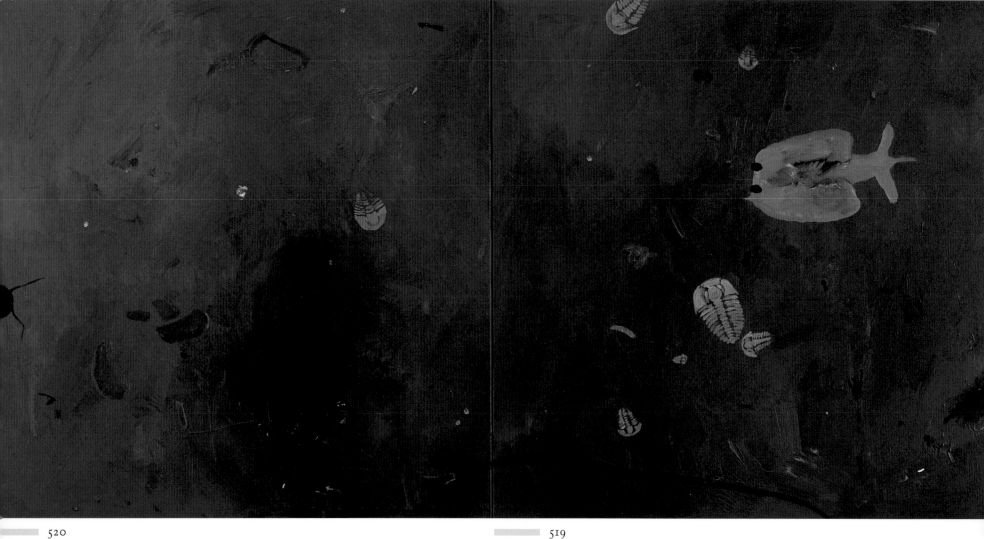

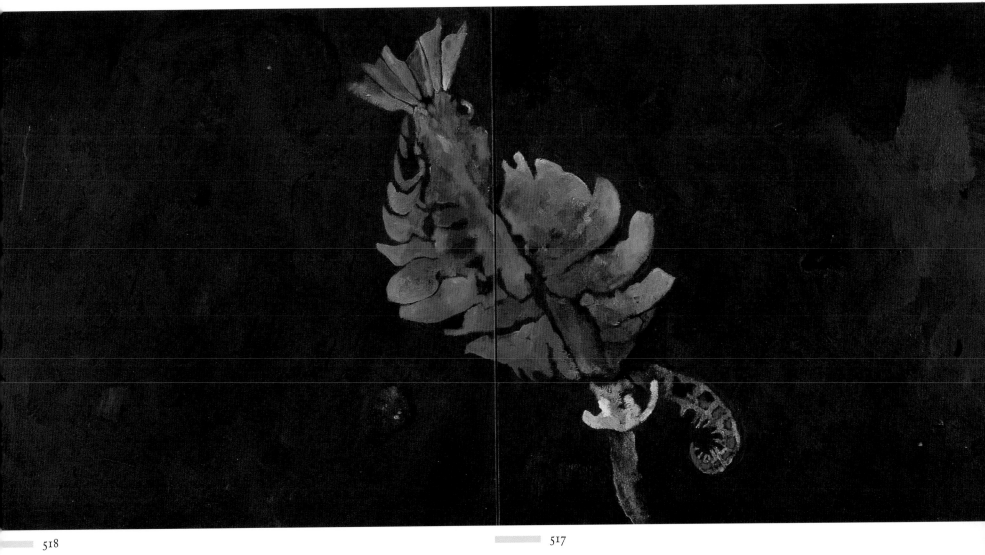

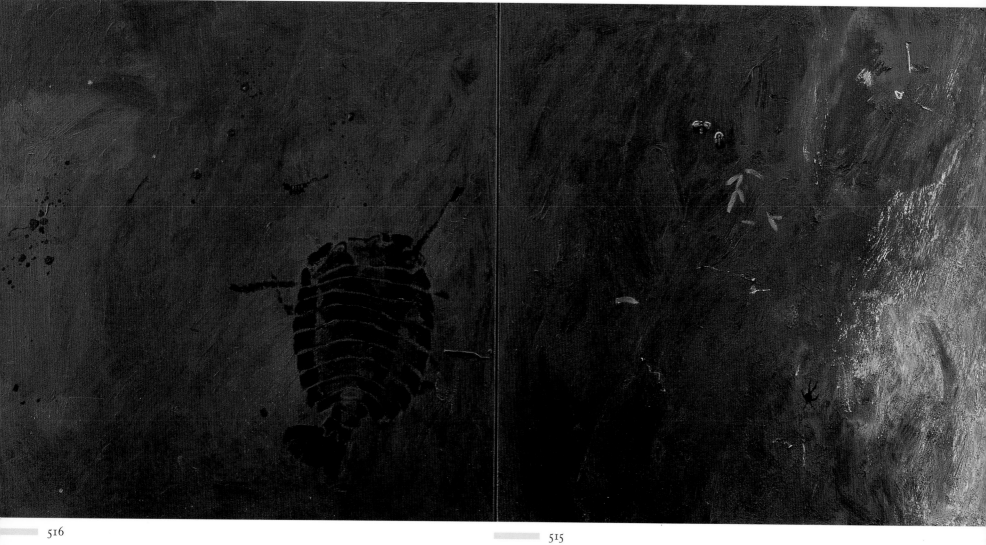

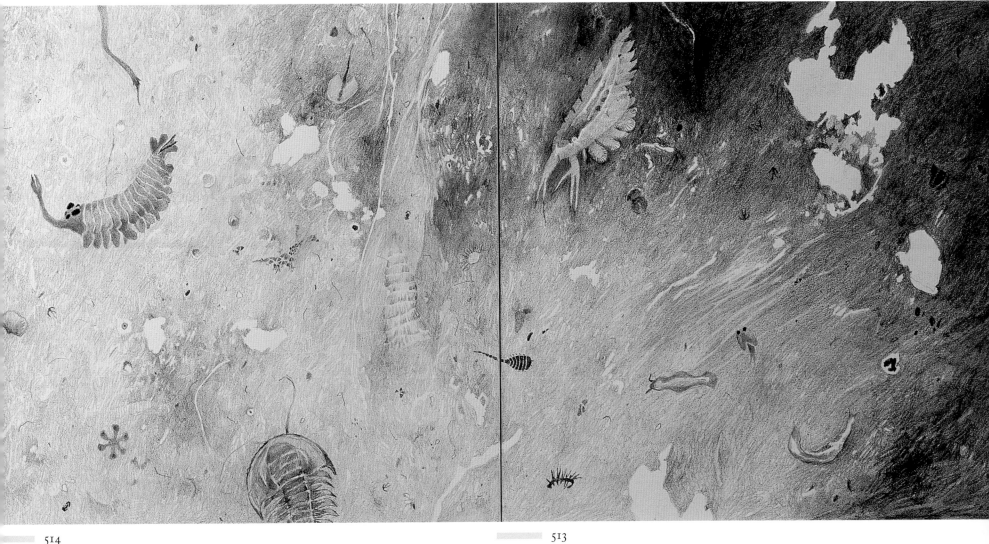

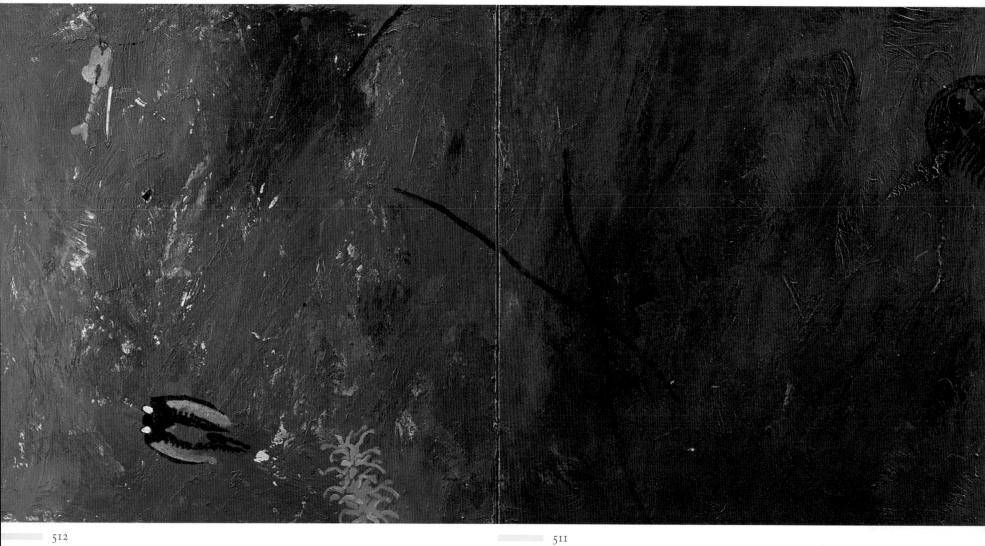

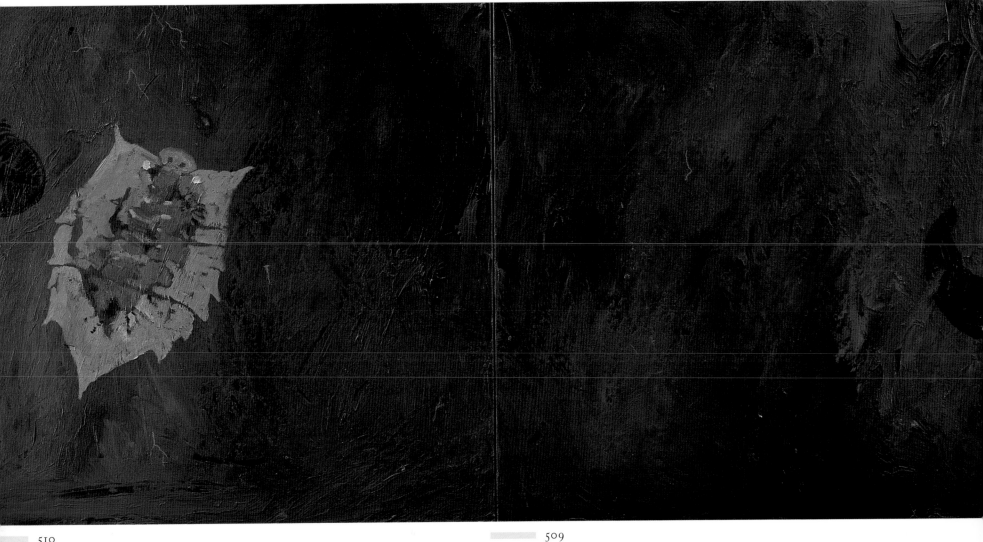

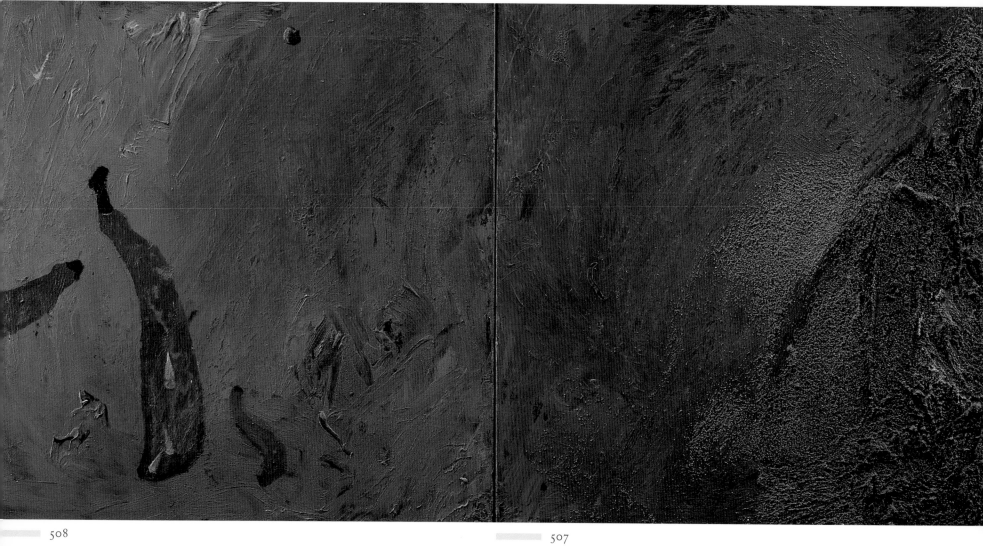

The Ordovician

| 506 | 439 |

There's almost no mistaking a Paleozoic rock, and that is because of the Ordovician Period. The Paleozoic Era lasts from the beginning of the Cambrian Period, around 543 million years ago, to the end of the Permian Period, around 245 million years ago. Despite this length of time—300 million years—it is very often possible for someone with relatively little geological or paleontological experience to distinguish a Paleozoic rock from one that formed later. This is because the life of the Paleozoic Era is so distinct from life in the post-Paleozoic. That pattern was established first in the Ordovician.

Striking as the Cambrian explosion was, the Ordovician witnessed an event of almost as great a magnitude. The experimentation of the Cambrian gave way to an Ordovician world dominated by a few groups of animals. Trilobites were still numerous, but now a cast of characters came to dominate life in the oceans—and remained in place for nearly 300 million years. This change is usually called the "Ordovician radiations."

Almost all of these groups of animals had originated in the preceding Cambrian Period, but in the Ordovician they increased dramatically in variety and abundance. Many of these animals would strike us as strange; they are not what we would normally find while beachcombing today. Brachiopods, or "lampshells," two-shelled animals outwardly similar to clams but with very different internal anatomy, expanded into hundreds of species and became the most diverse and abundant large animals in the seas for the remainder of the Paleozoic. Crinoids, delicate stalked relatives of starfish with the unfortunately misleading common name of "sea lilies," also exploded in number and variety. Two types of corals, called rugose and tabulate, diversified. Nautiloid cephalopods, relatives of living squid and octopus but with hard external shells, expanded enormously. (The only living nautiloid is the beautiful chambered nautilus, which lives today in the southwest Pacific Ocean.) Some species of Ordovician nautiloids were the largest animals in the world at the time, reaching 20 feet or more in length. The elegant but enigmatic graptolites, small animals that formed floating colonies, became extremely numerous. Graptolites were actually more closely related to backboned animals than to outwardly similar creatures, such as corals. Diverse and abundant during much of the Paleozoic, graptolites did not survive the era, but their varied saw blade-shaped colonies are important fossils for telling time in Ordovician and Silurian rocks. Rocks of Ordovician age also contain the first abundant fossil bone. Tiny skin plates of jawless fish testify that our ancestors were numerous if not yet spectacular.

It came in with a dramatic expansion of life, but the Ordovician went out with a catastrophic contraction, in one of the earliest but most severe of the many episodes of mass extinction that were to mark the history of life in the Phanerozoic. Near the end of the Ordovician, climates cooled significantly across much of the world. This was almost certainly associated with glaciers that developed on the southern supercontinent, known to geologists as Gondwana, as it moved over the south pole. Among the groups of animals that suffered particularly during this extinction event were trilobites, brachiopods, echinoderms, and corals.

The Ordovician is named after the Ordovices, an ancient tribe from Wales, where rocks of this age are well-exposed.

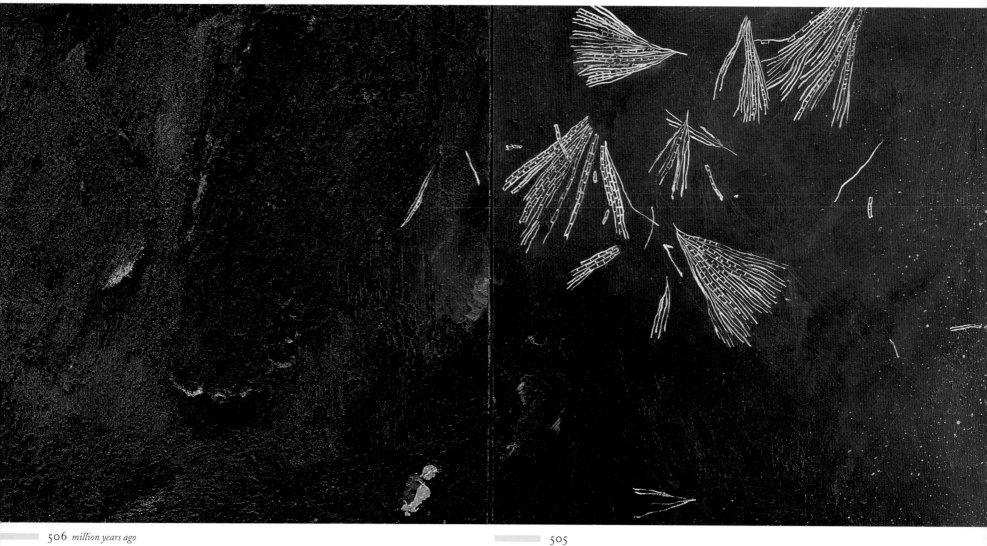

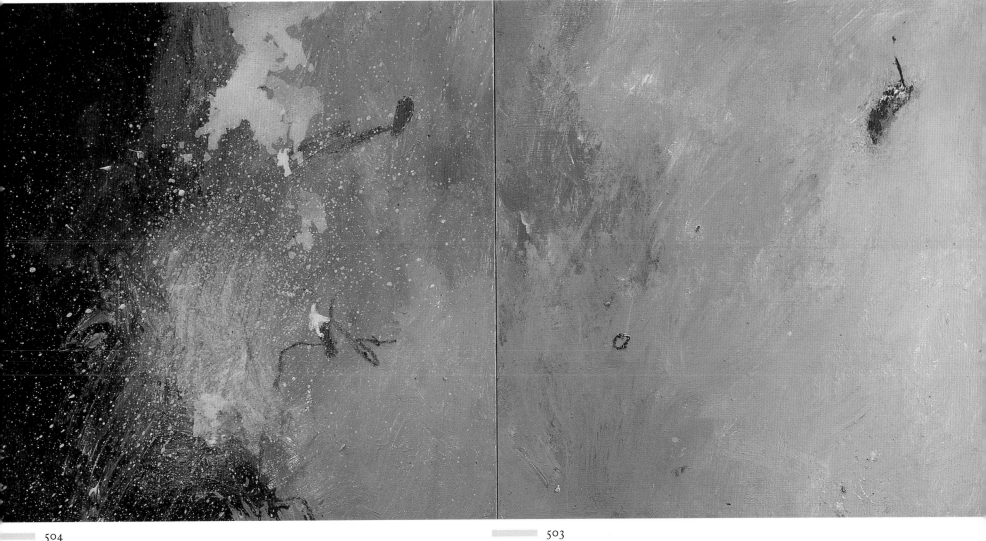

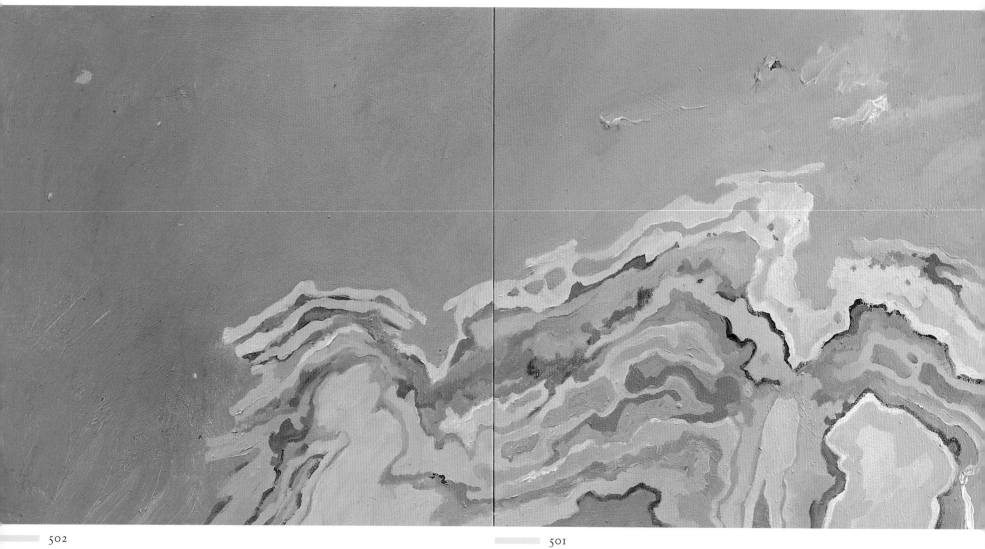

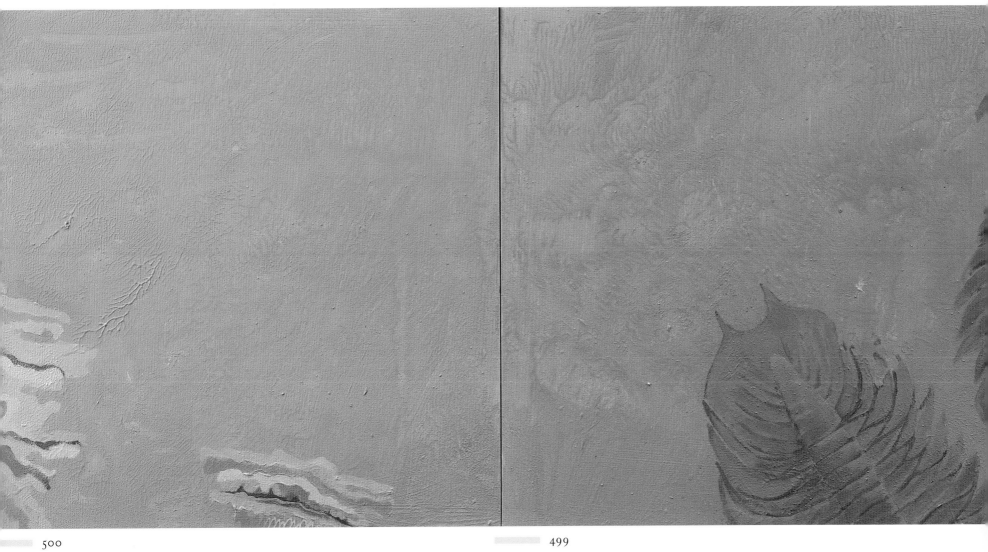

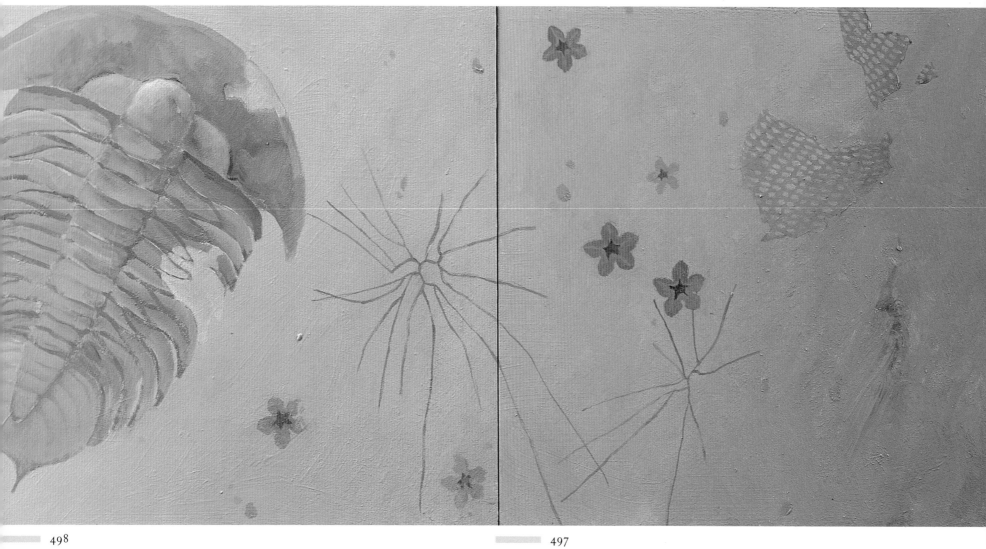

498

497

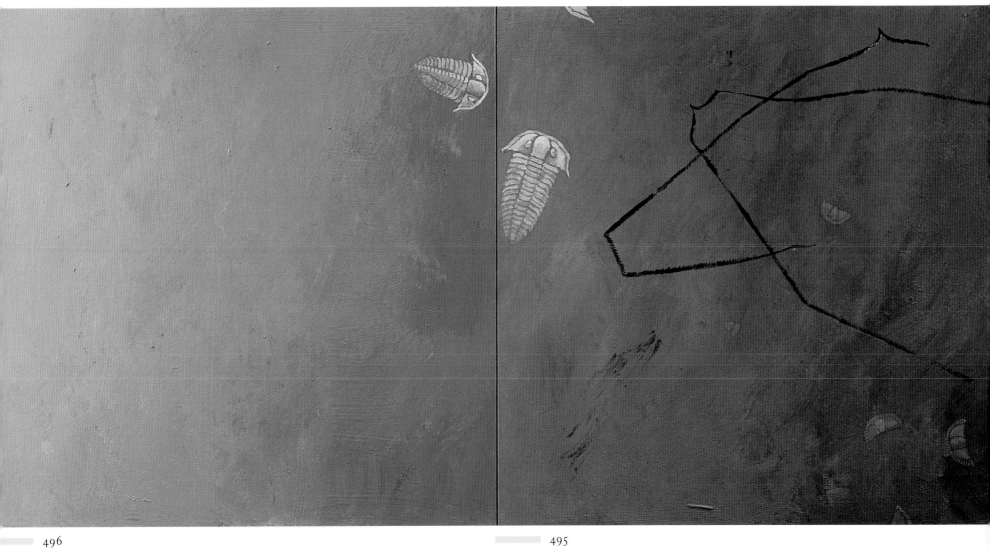

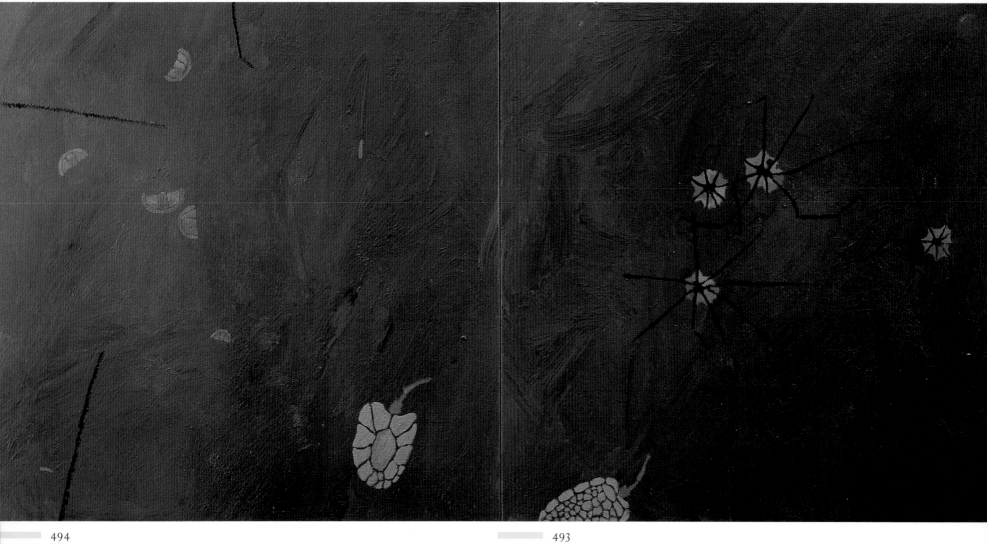

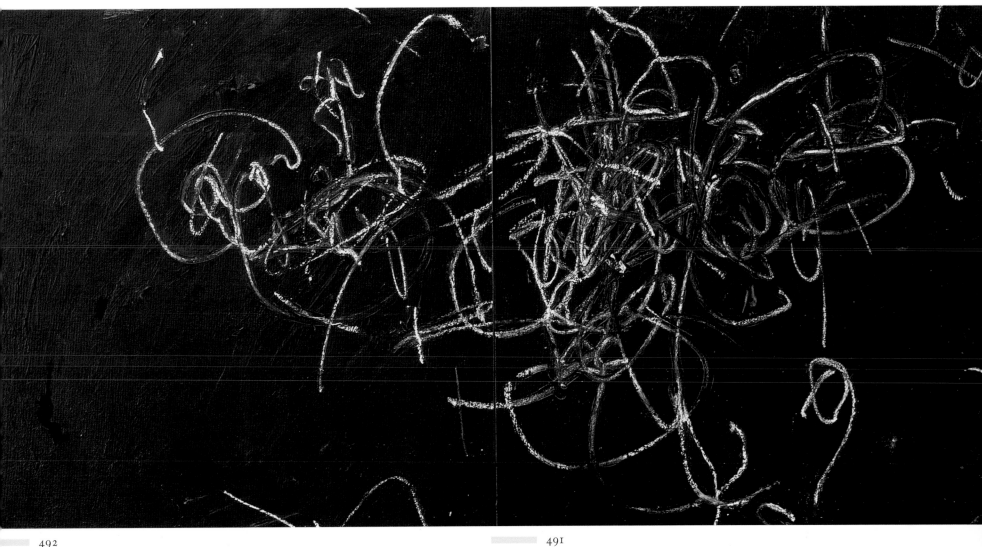

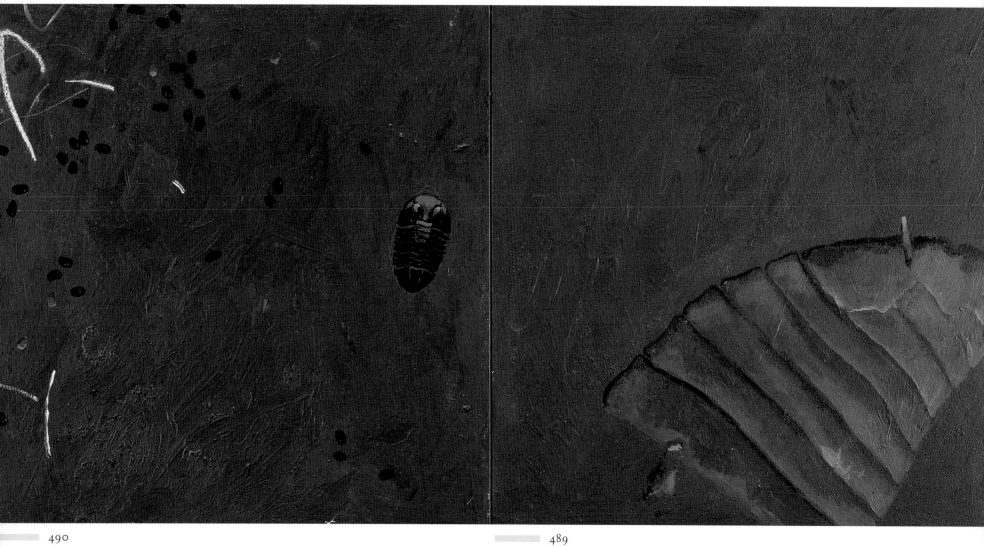

490 489

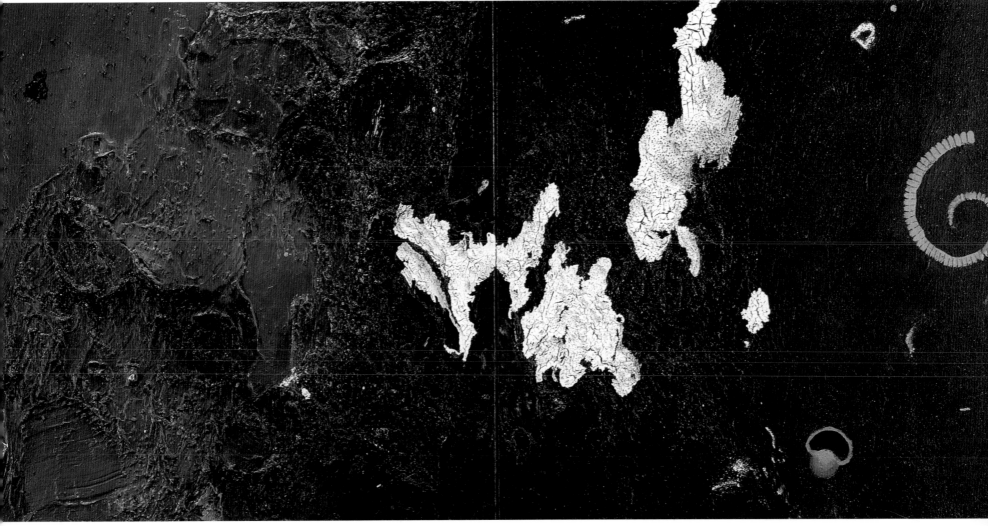

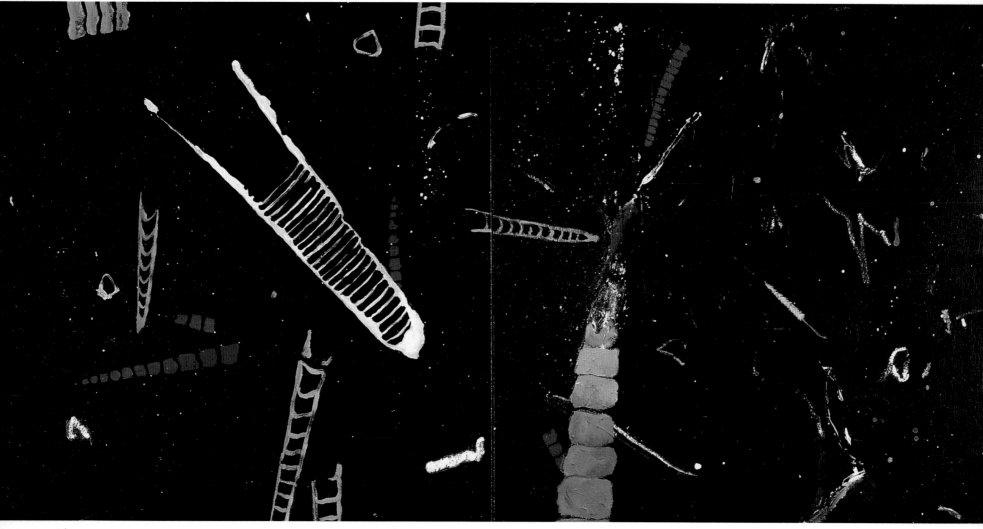

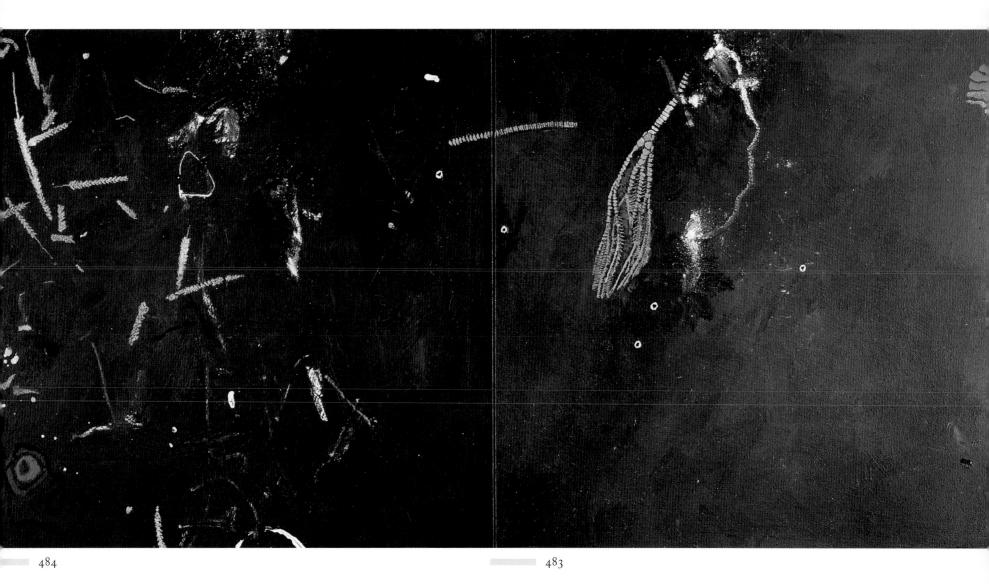

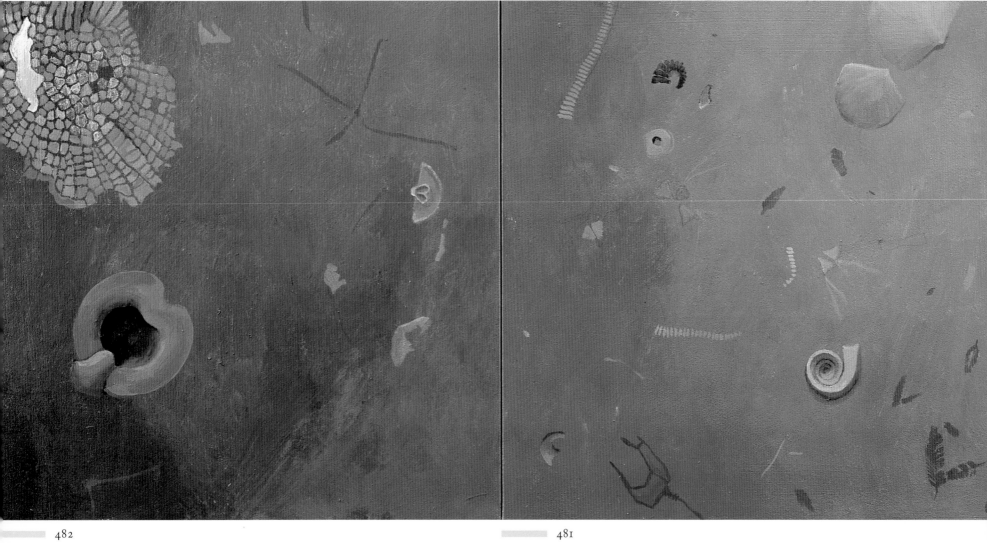

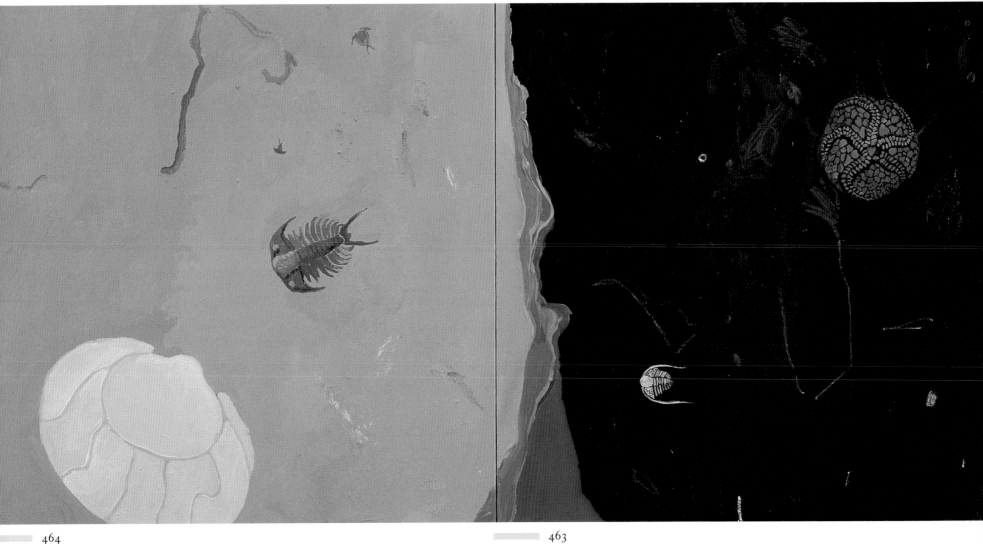

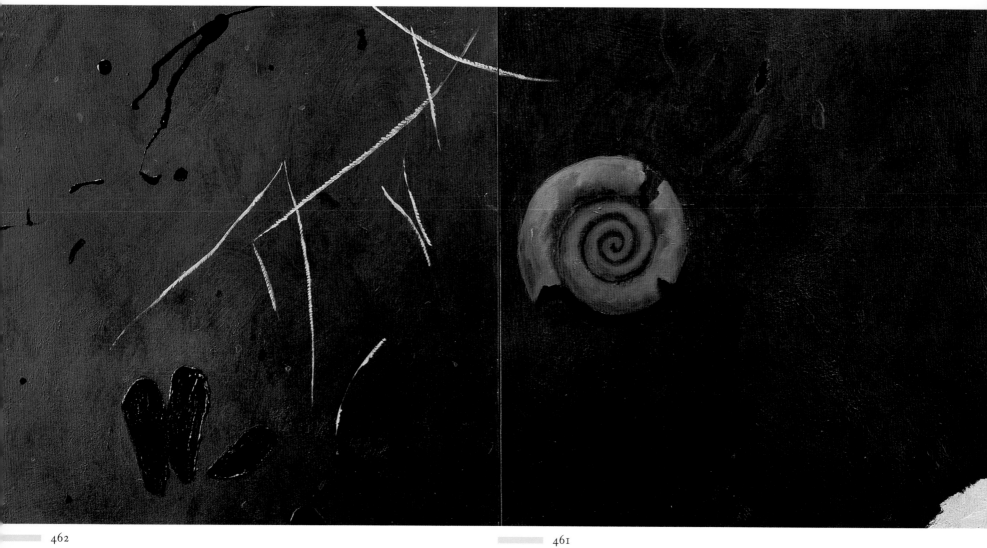

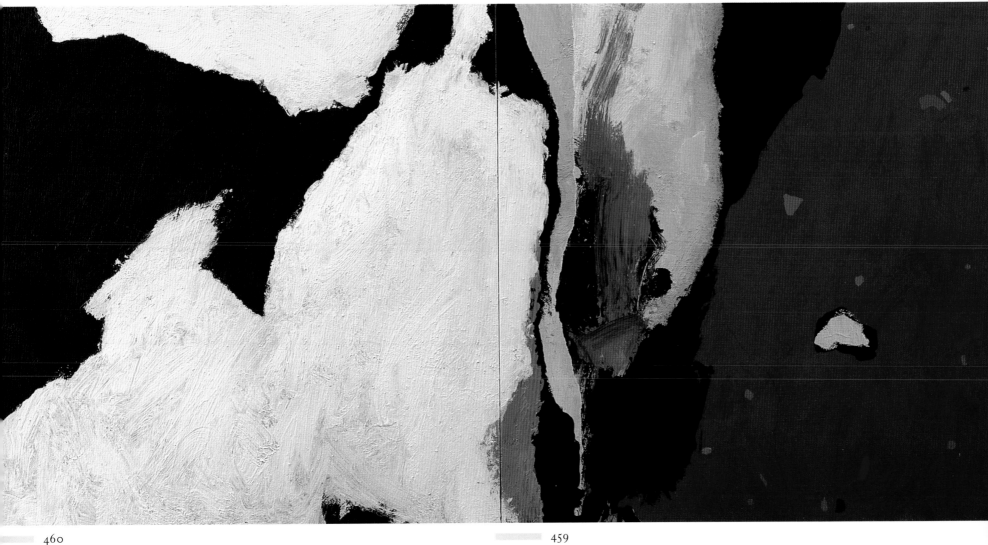

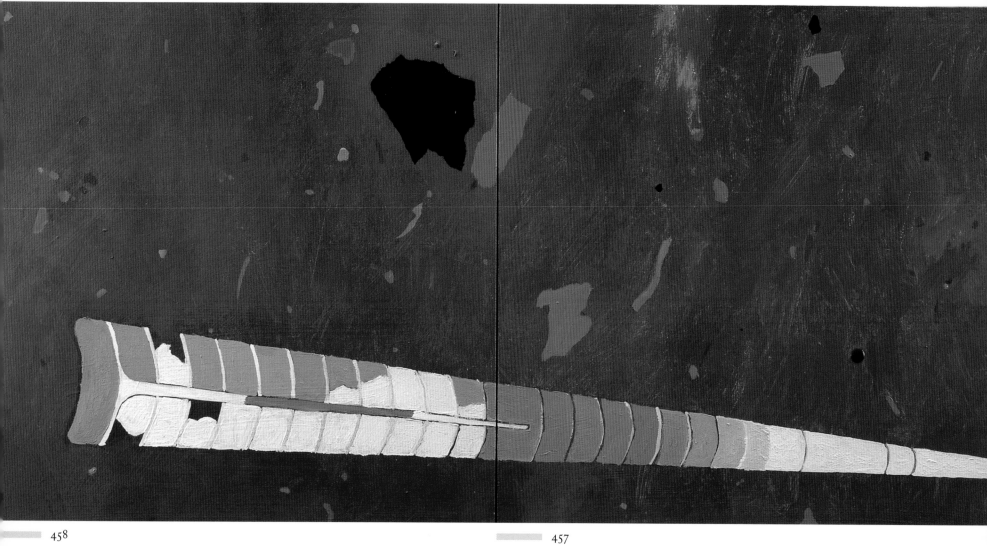

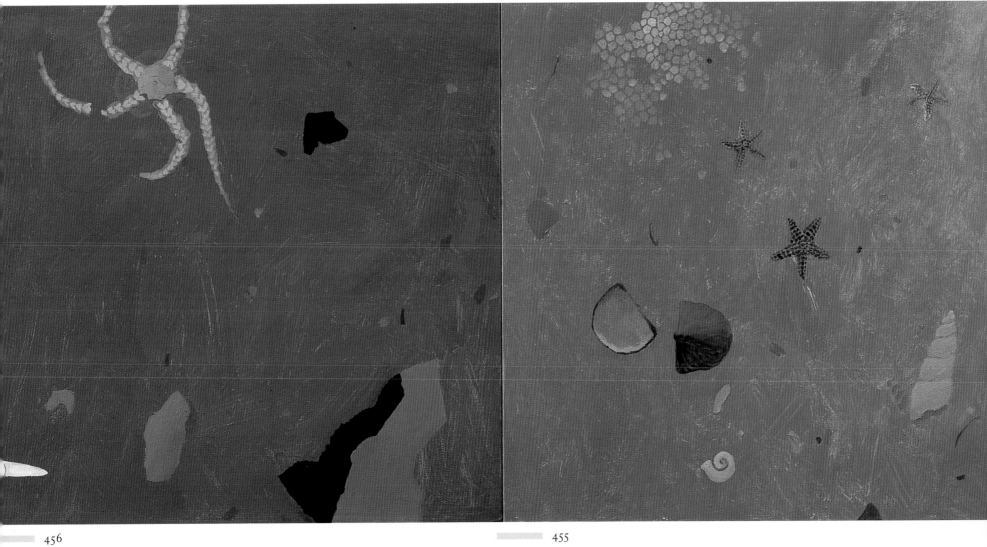

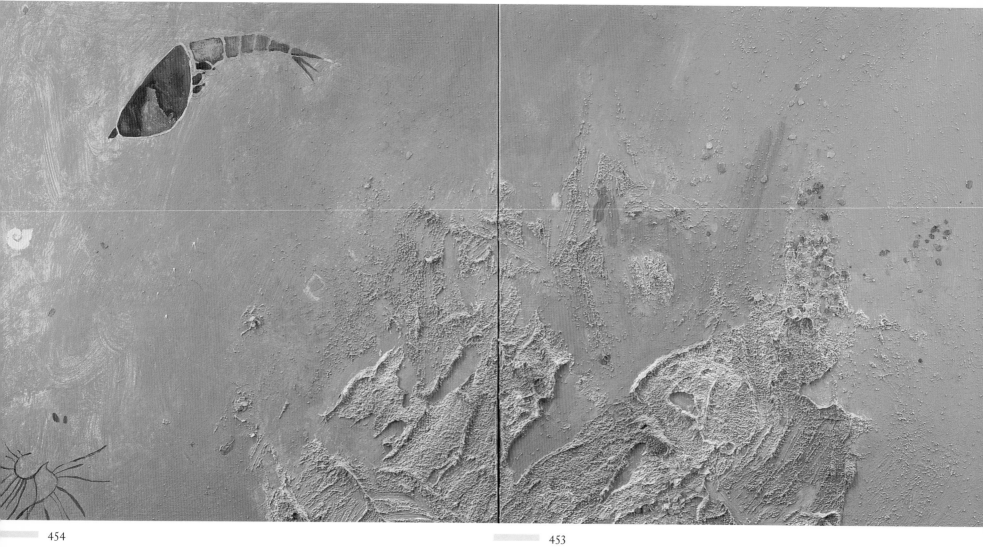

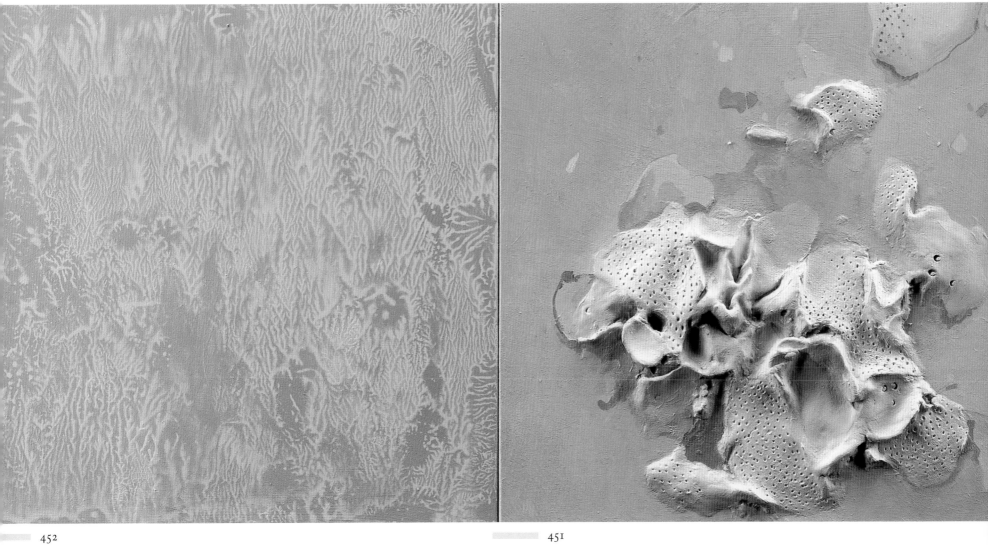

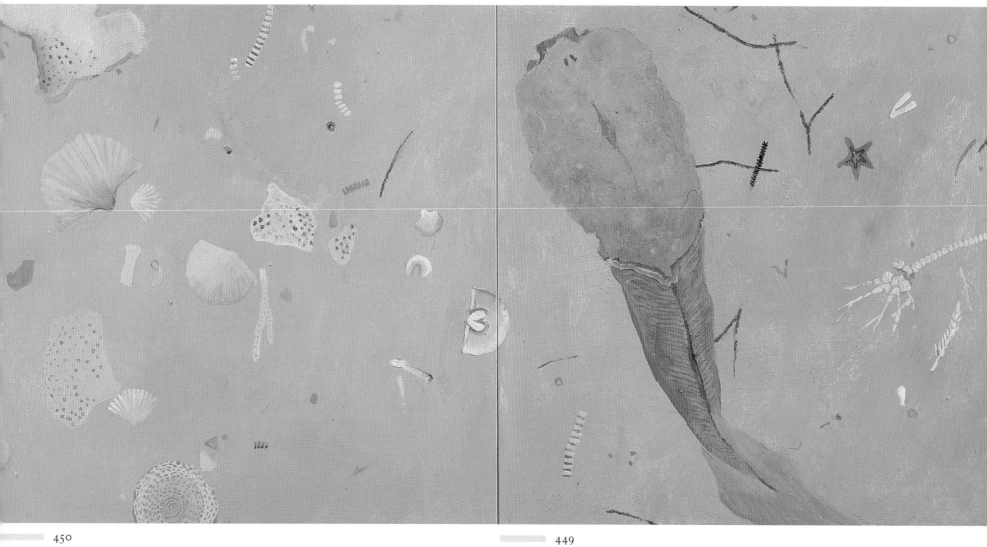

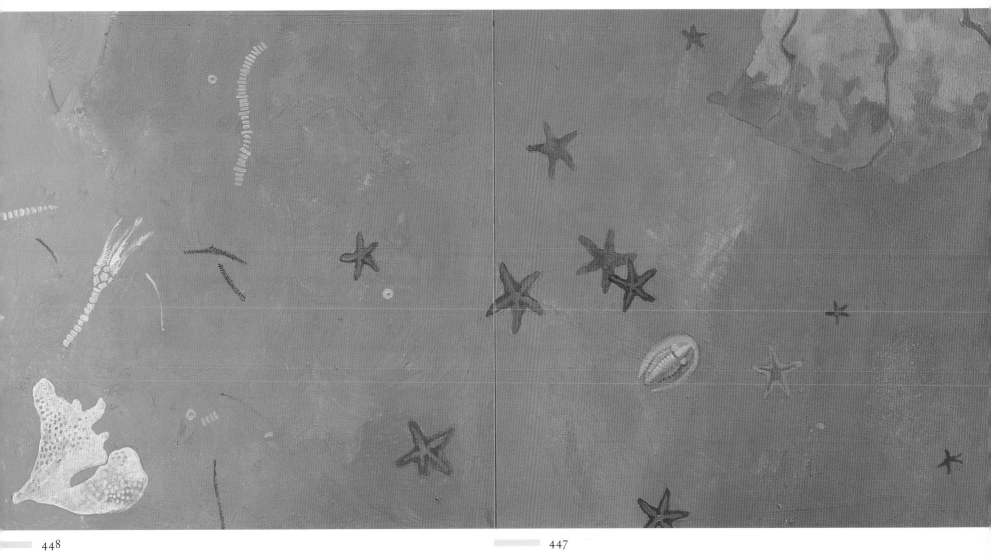

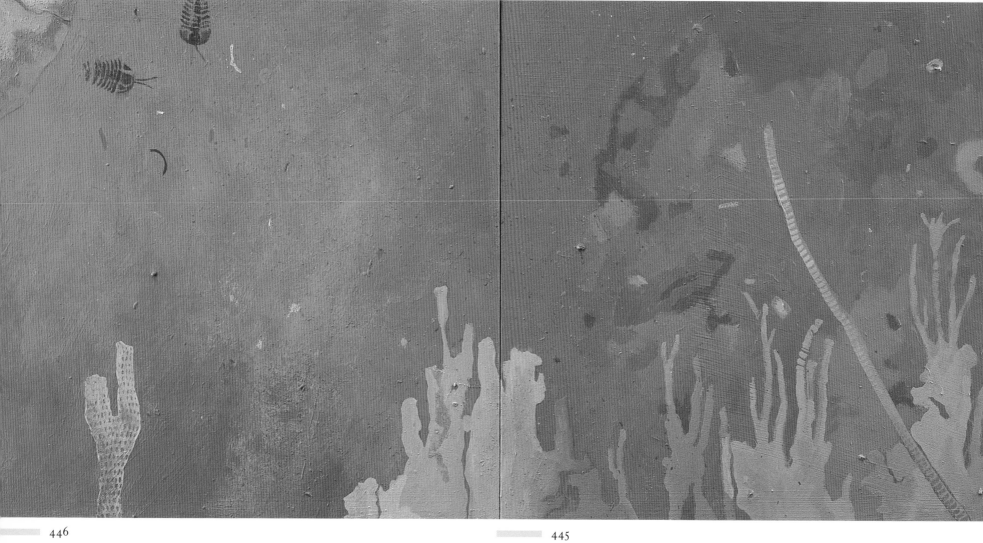

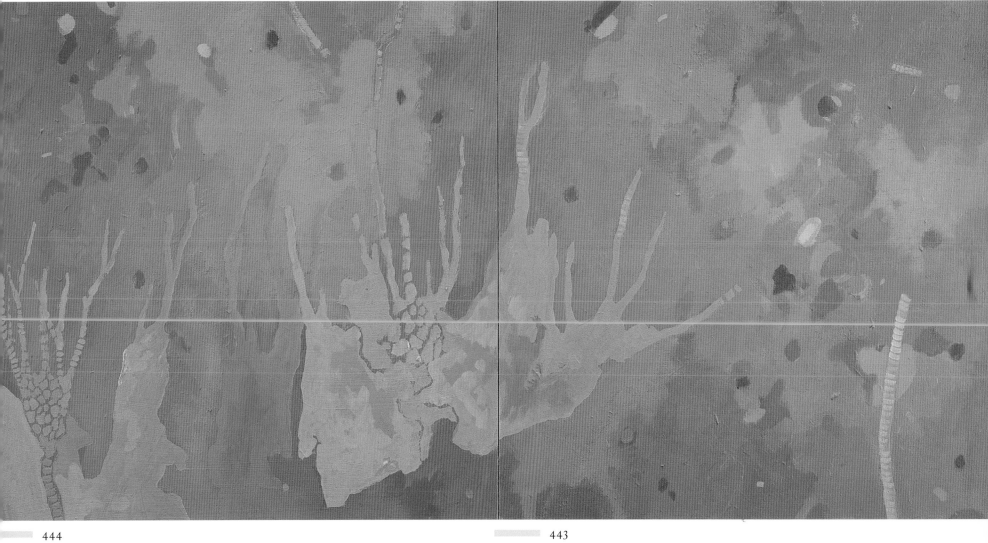

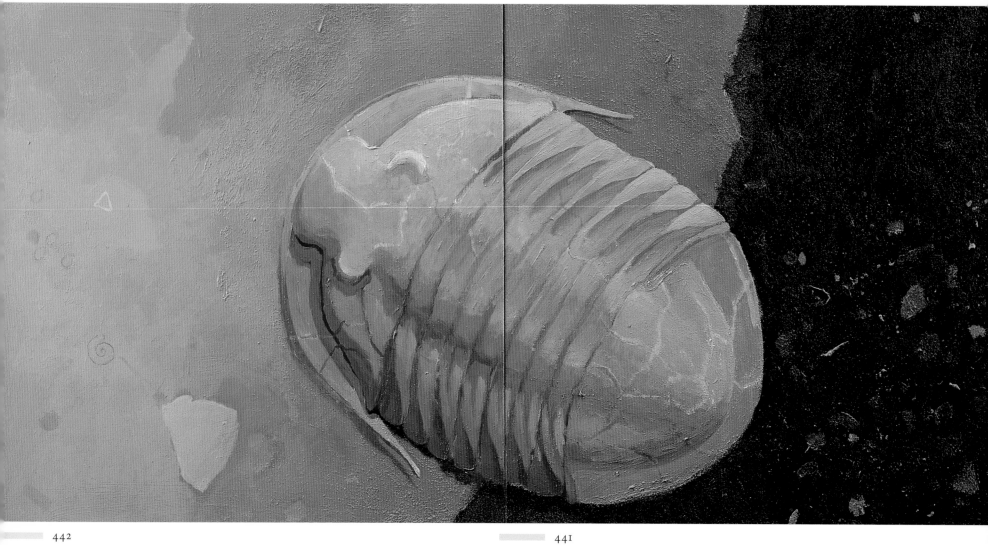

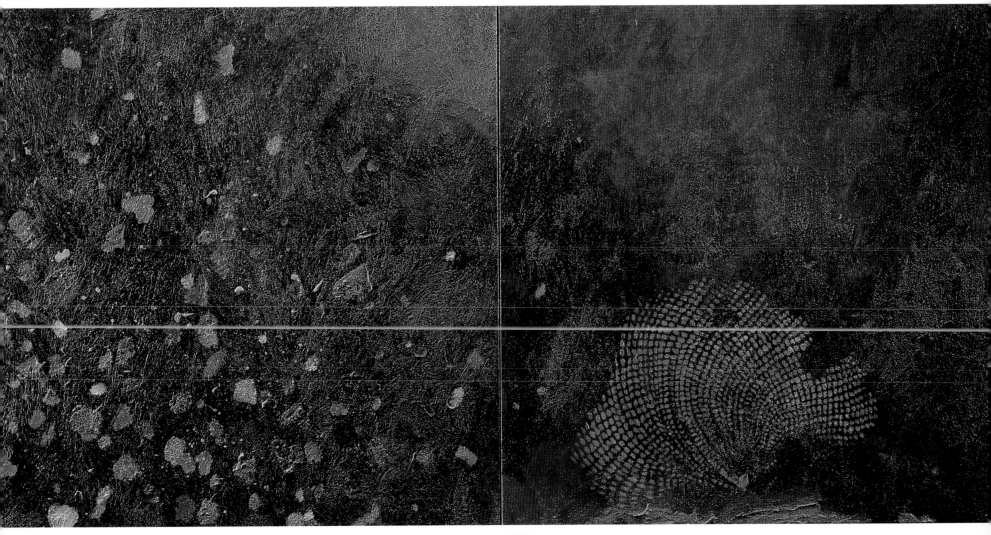

The Silurian

438 409

The New York State Thruway runs almost perfectly east to west, from Albany to Buffalo. It approximately parallels the old Erie Canal, and an even older path frequented by Native Americans. It also passes through layers of rocks dating to the Silurian Period that hold some of the most spectacular fossils in the world. Between 440 and 400 million years ago, an extinct group of animals related to modern horseshoe crabs—the sea scorpions or eurypterids—were among the dominant animals of sea and near-shore brackish water environments. These animals were not closely related to modern scorpions but shared their general body form. Most of the eurypterid fossils in the Silurian rocks of central New York are relatively small, but some are among the largest animals without backbones that have ever lived, attaining lengths of nine feet or more. These animals had large claws, well-adapted for seizing and holding prey. They were one of several groups of new predators that increased in abundance and diversity during the Silurian Period, and probably had major impact on the evolution of the animals they hunted.

The Silurian was a time of recovery, expansion, and transition. Life recovered from extinction to (but not beyond) the level of diversity that it had displayed before the decimation of the late Ordovician mass extinction event. Some groups of animals showed unprecedented bursts of evolutionary activity, and life, for the first time, moved onto dry (or at least moist) land.

The predatory eurypterids were joined in their feasting by an expanding diversity of fishes, who now developed a startling innovation: jaws. No longer just bottom-suckers, fish were now free to exploit new resources and ways of life, which would have major implications for both their descendants and many other living things.

The Silurian recovery also saw the expansion of many other groups of marine organisms, including nautiloid cephalopods and echinoderms (crinoids, sea stars, and their relatives). The Silurian was also a time of reefs, and in fact saw development of the first true coral reefs, which also included substantial contributions from several kinds of sponges.

The land was probably essentially bare of life at the beginning of Silurian time, but by the end of the period, the first land plants and animals had appeared. Silurian land plants are not impressive; the largest probably stood no more than six inches high. But they were the vanguard of bigger things to come. Insect-like creatures resembling modern silverfish were among the first land-living animals; they were also small but, similarly, were the advance landing party of the main invasion.

The Silurian is named for the Silures, an ancient tribe of southern Wales, where rocks of this age were first seriously studied by the English geologist Roderick Impey Murchison in the 1820s and 1830s. Fossil-rich Silurian rocks are also well-known in the upper Midwestern United States and central Europe.

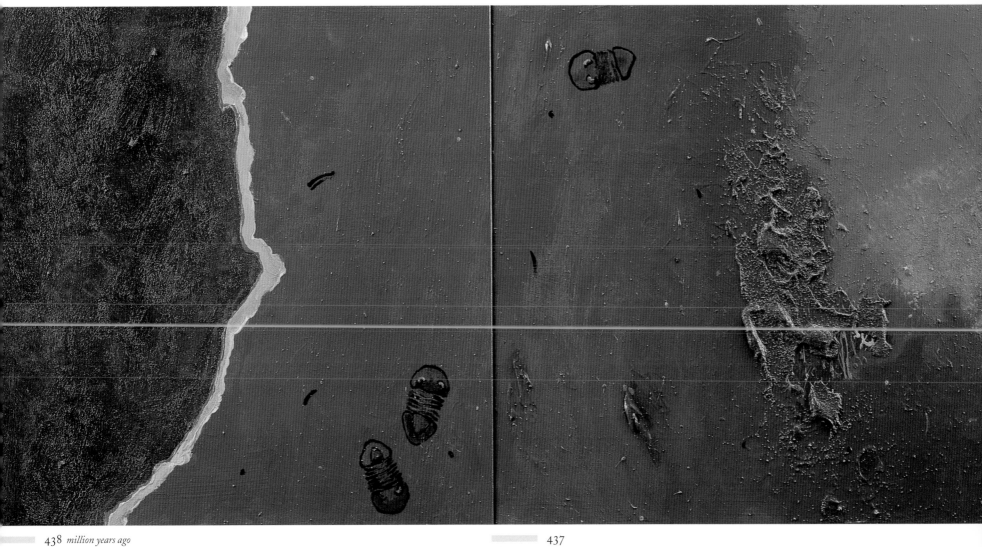

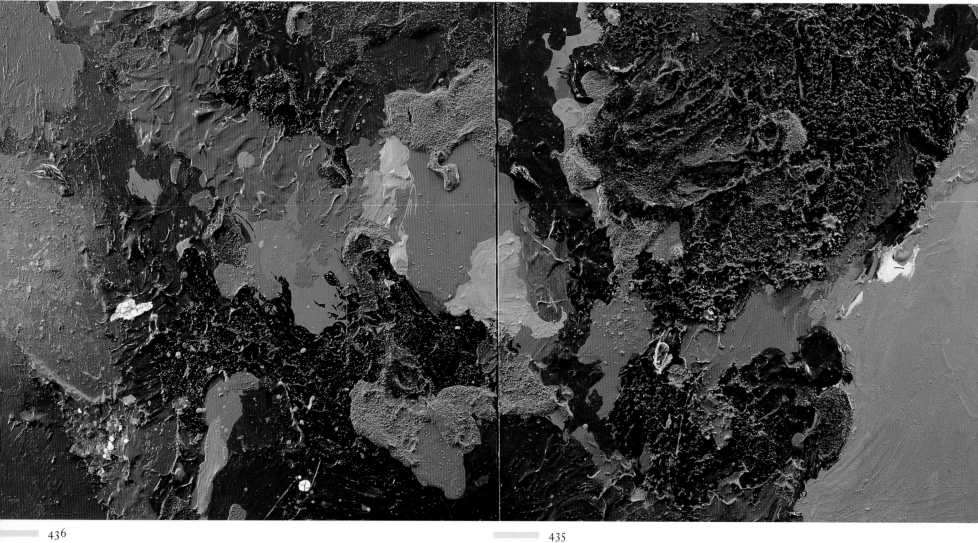

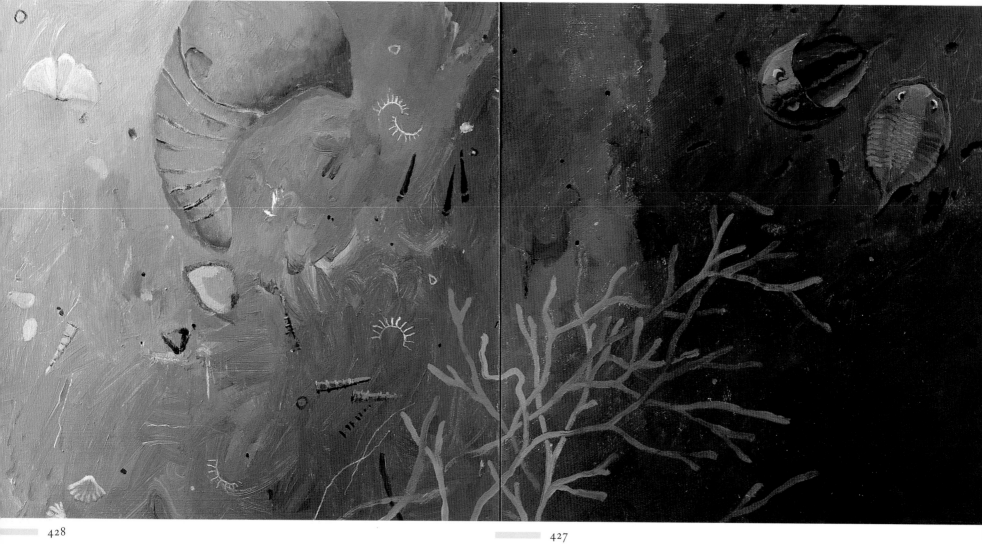

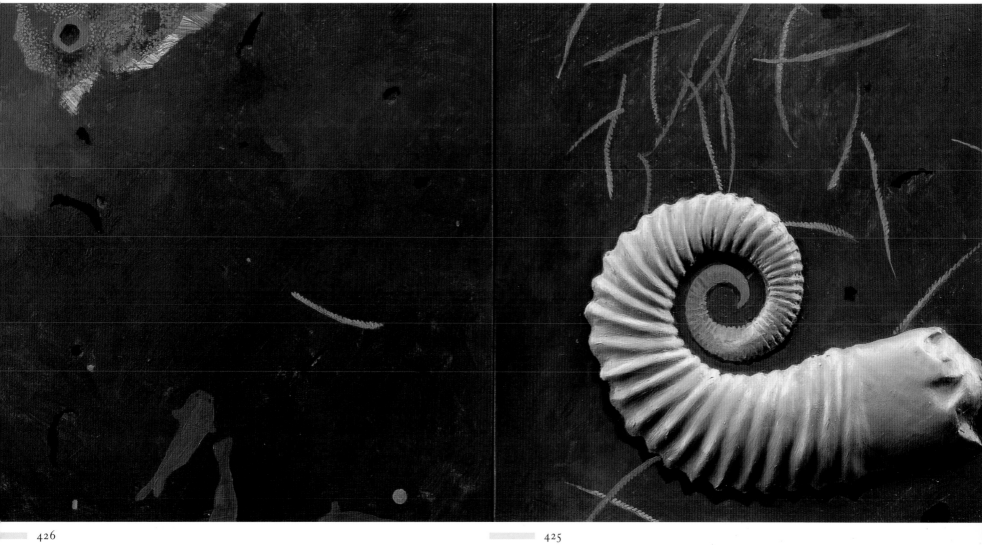

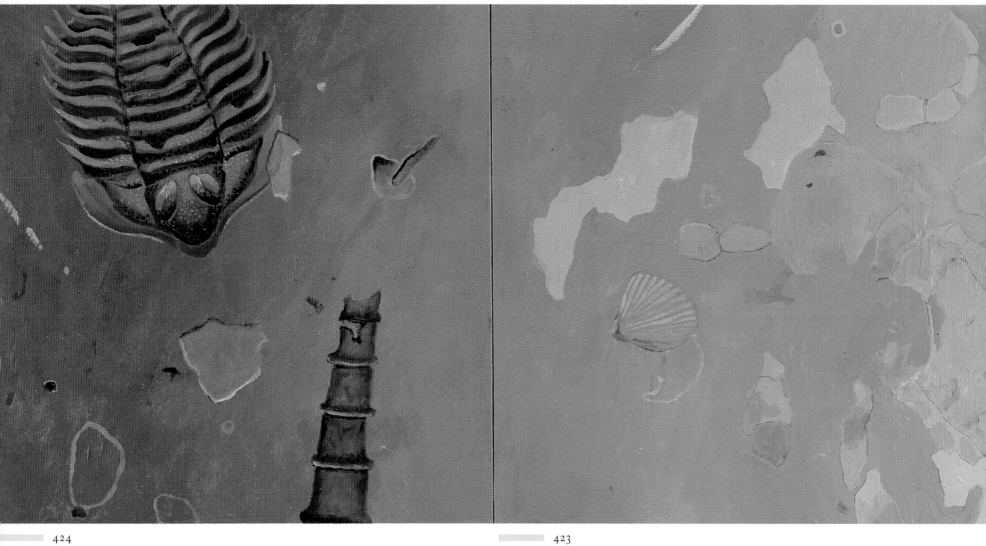

424

423

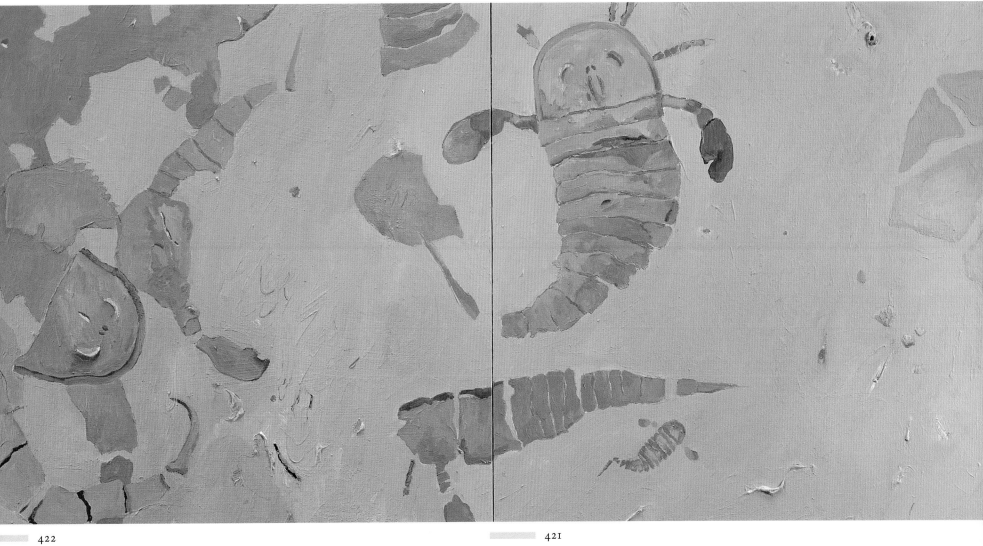

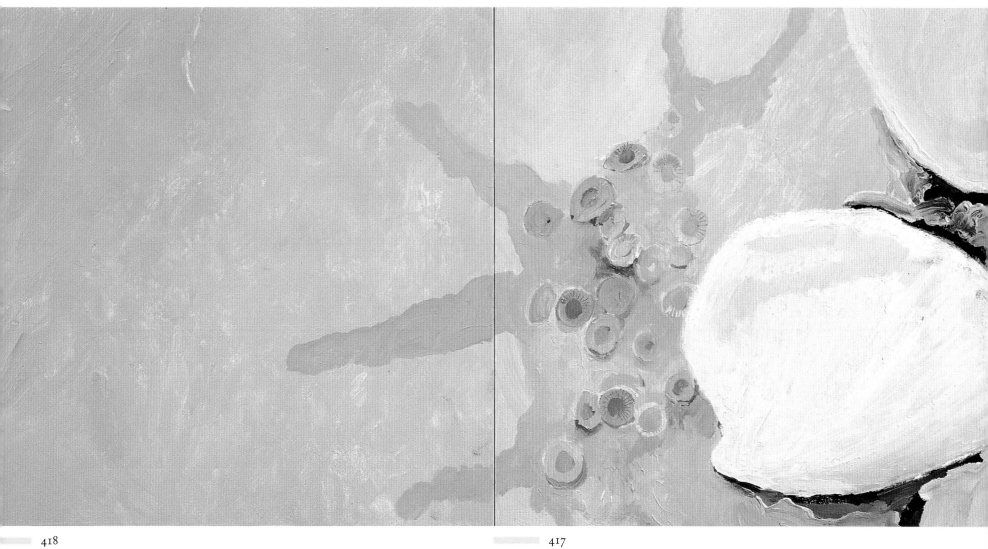

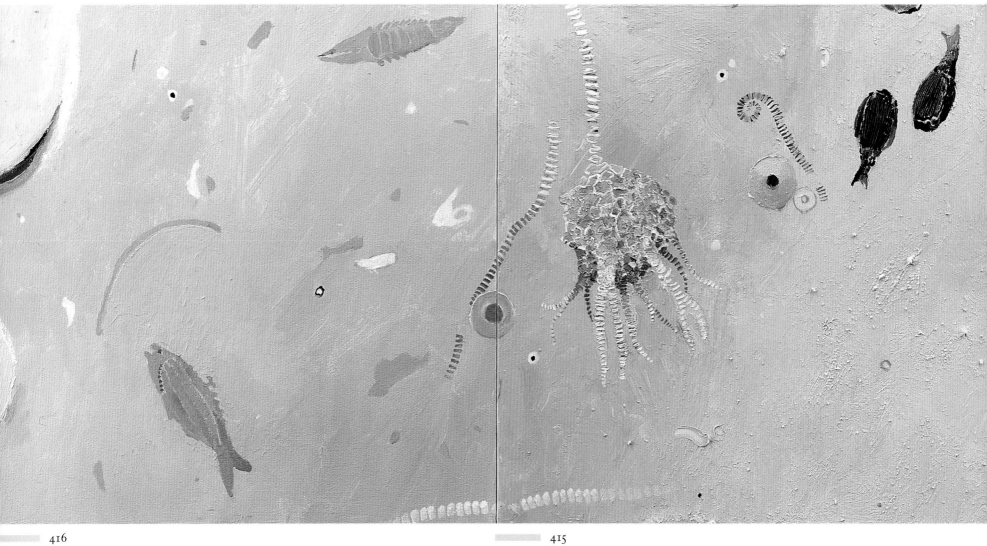

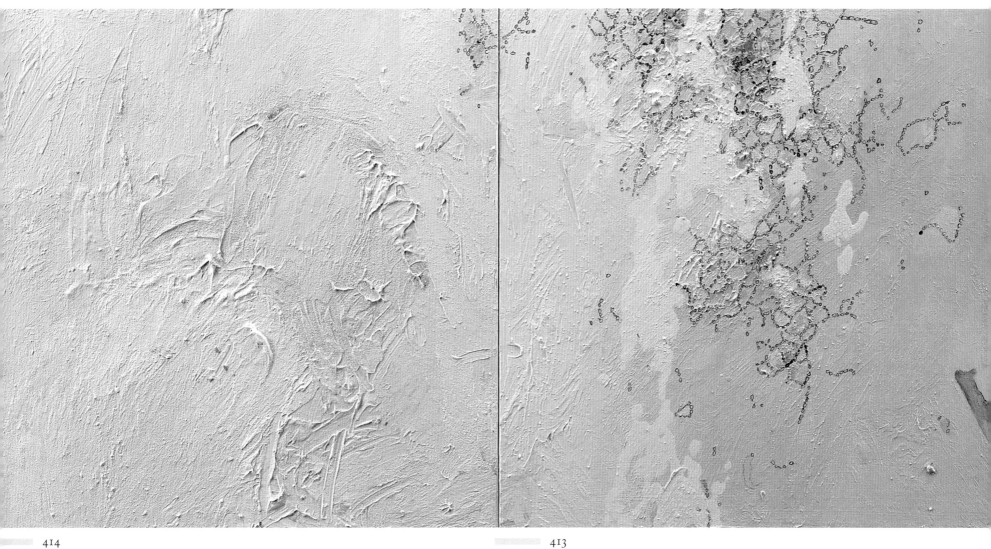

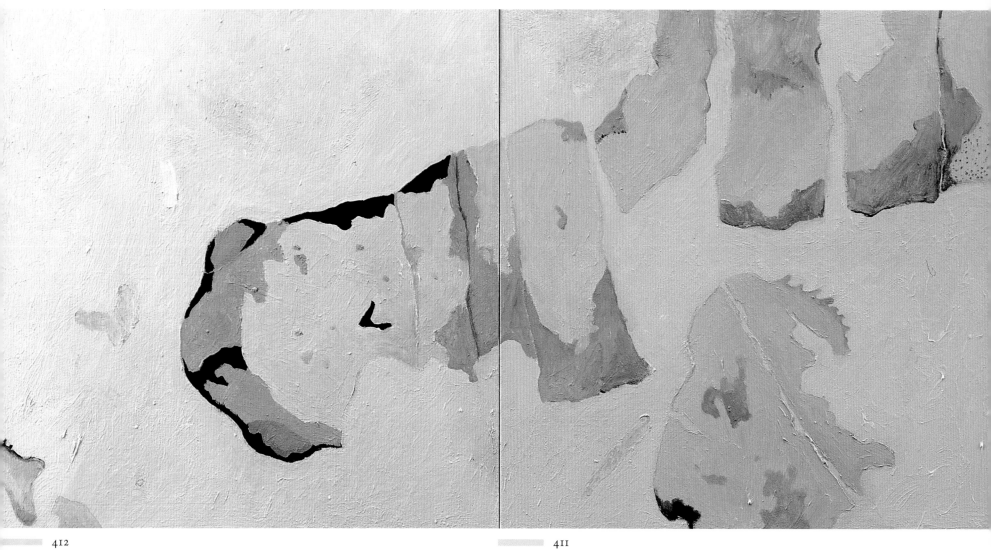

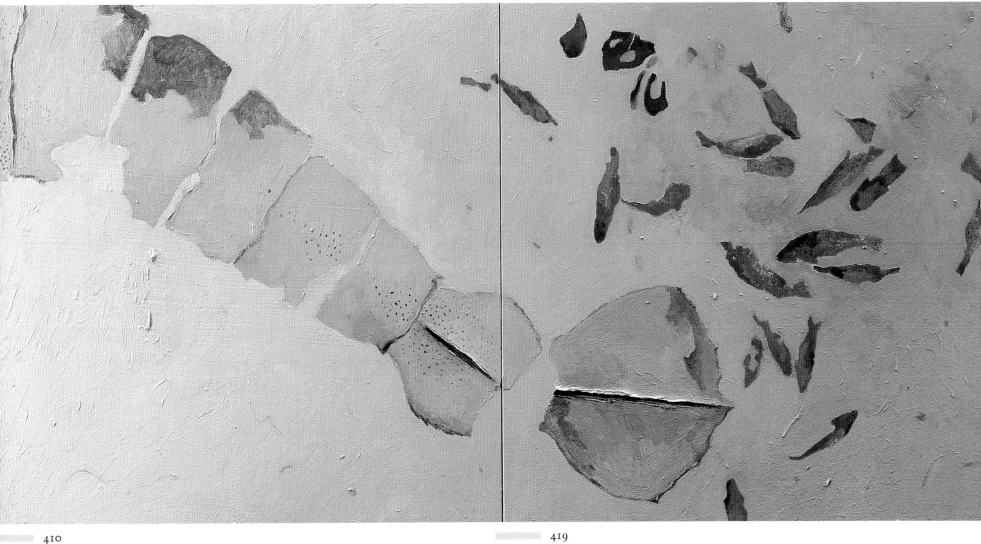

The Devonian

408 361

The "Old Red Sandstone" is a layer of rock exposed across parts of Scotland. Its coarse sands were deposited by streams and rivers that eroded a massive mountain range to the west. Similar rocks make up the Catskill Mountains of eastern New York and Pennsylvania, but they formed from erosion of mountains to the east. That mountain range, called the Appalachians in America and the Calledonides in Britain, formed when the European and American continents collided around 380 million years ago. The Atlantic Ocean later split this supercontinent, and the mountain range, apart. In the 1830s, British geologists concluded that the Old Red Sandstone was the same age as rocks exposed farther south, in Devon, and they called these rocks Devonian.

Our personal appreciation of time is relative; we perceive time as sometimes moving more slowly and sometimes more quickly, depending on what is happening around us. In human history, there are intervals we recognize as times of greater activity or significance. The early 1940s or 1968 come to mind. Similarly, in geological time, some intervals just seem busier than others. The Devonian was such a time; it was a period of major evolutionary events in many groups of organisms that were to have significant effects on the subsequent history of life.

Fishes exploded in diversity, and the Devonian is sometimes called "the age of fishes." Sharks and bony fish of several sorts proliferated. A group of armor-plated fishes known as placoderms, which included animals up to thirty feet long, ruled the seas before becoming extinct at the end of the Devonian. Lungfishes and lobe-finned fishes diversified. During the late Devonian, about 365 million years ago, individuals from at least one, and probably more than one group of lobe-finned fishes made the risky but momentous move onto land. Eventually, their fins became limbs and they became the first amphibians. Exactly why this transformation occurred is not clear. It must have offered new opportunities, perhaps a refuge from predators or a new source of food.

In the seas, a new kind of cephalopod, the ammonoids, appeared and quickly branched into many different types. Reefs surpassed their already impressive Silurian development to form truly giant structures made of corals, sponges, and other organisms. The Devonian sea was also becoming a more dangerous place, due in part to the continuing expansion of fishes and cephalopods. Animals with and without backbones began to show features that appear to have offered anti-predator protection. Many trilobites, for example, developed spikes and prongs on their bodies.

Back on land, plants increased dramatically in diversity and size. By the late Devonian, the world's first trees were standing in the world's first forests. Insects expanded with land plants, probably providing food for the first amphibians.

As the Devonian drew to its close, another mass extinction decimated life in the oceans. Brachiopods, nautiloids, graptolites, and especially trilobites were hard hit. Coral reefs almost completely disappeared. The cause or causes of this event have been much debated. Almost all evidence now points to a sudden and major drop in temperature; some experts believe that this cooling was the result of impact—extraterrestrial objects such as comets or meteorites striking the Earth's surface.

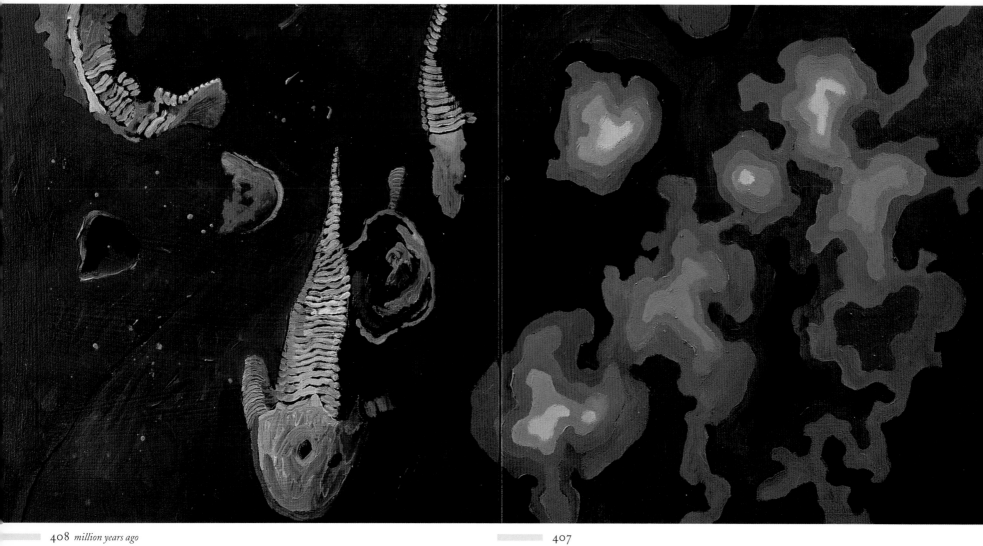

408 *million years ago* 407

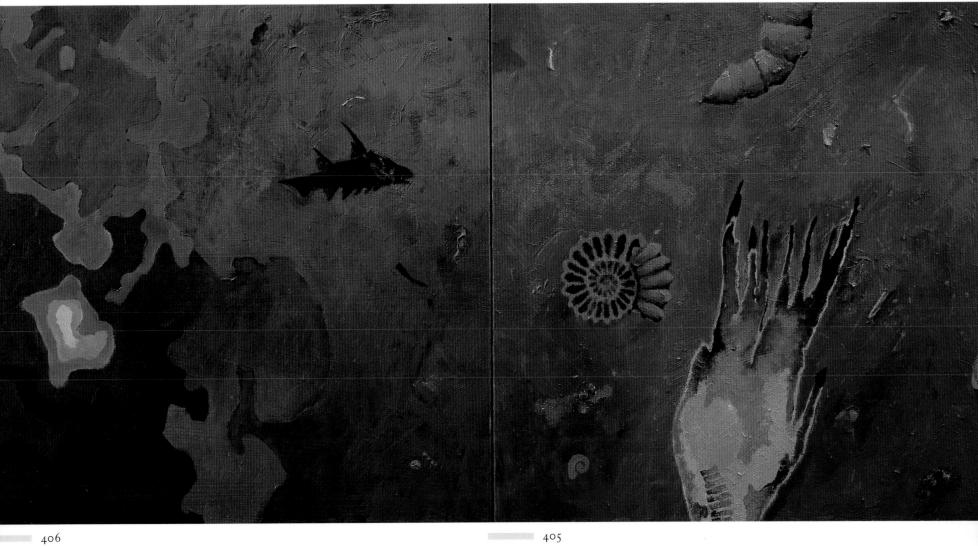

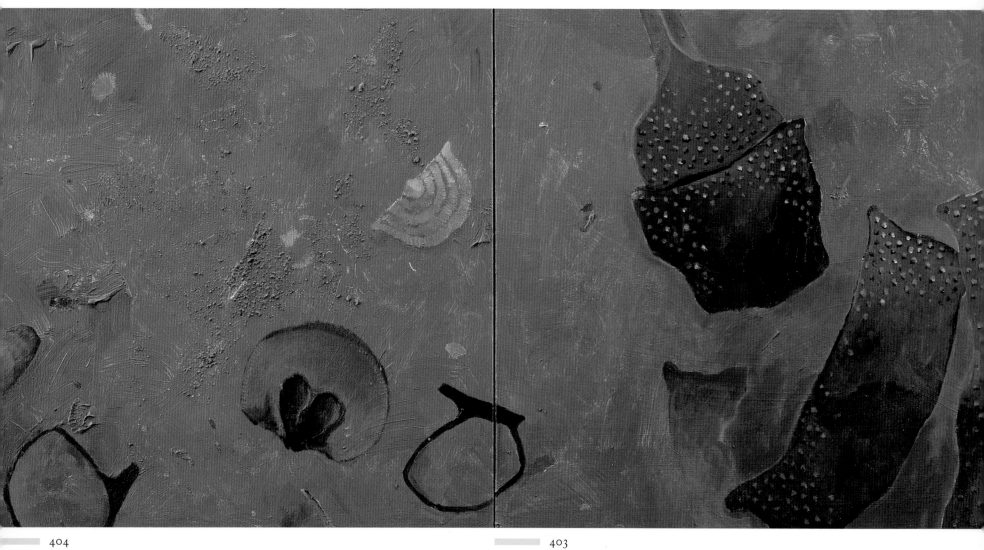

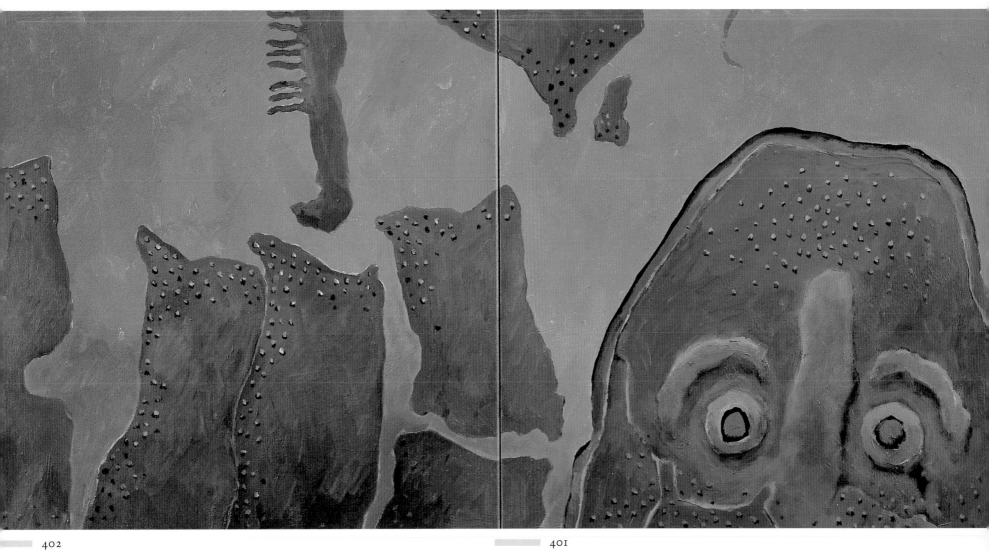

402 401

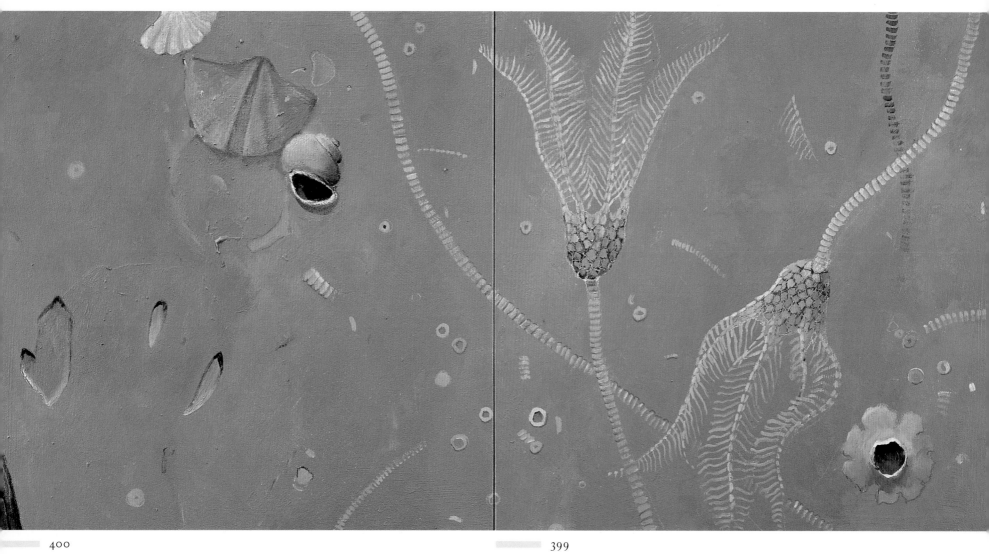

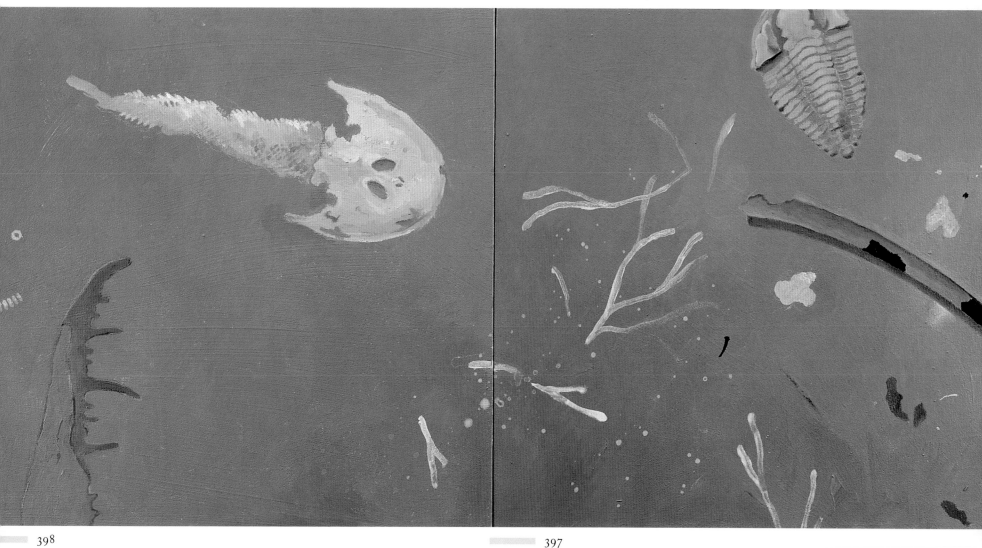

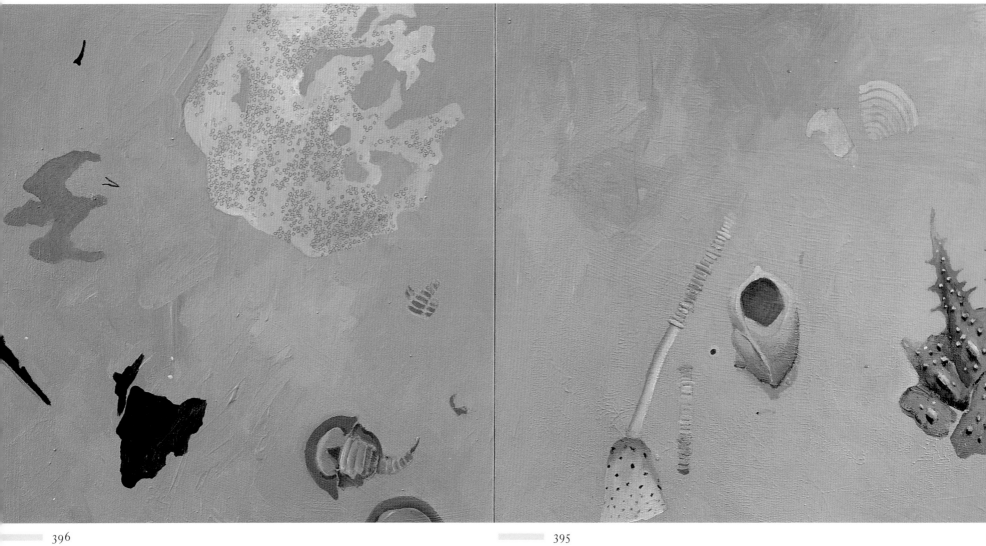

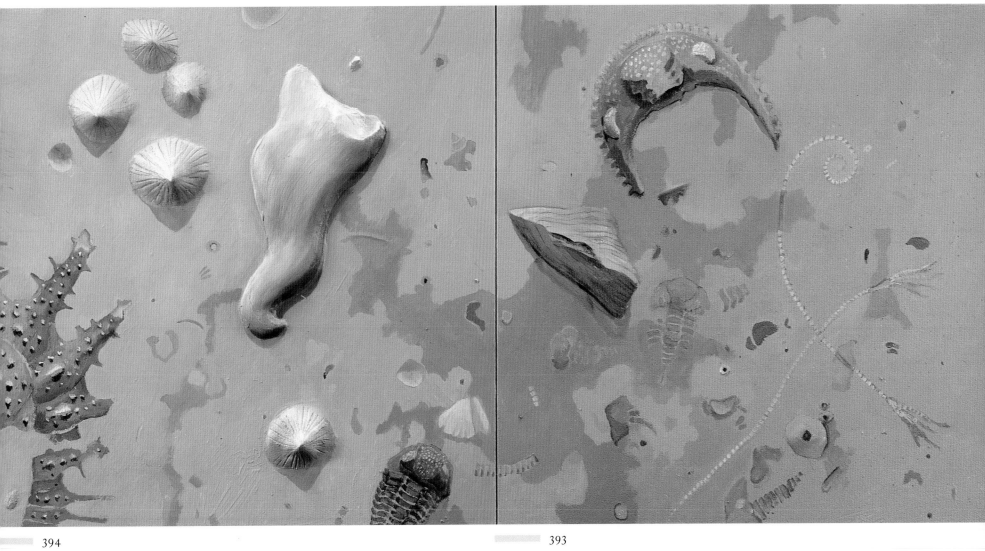

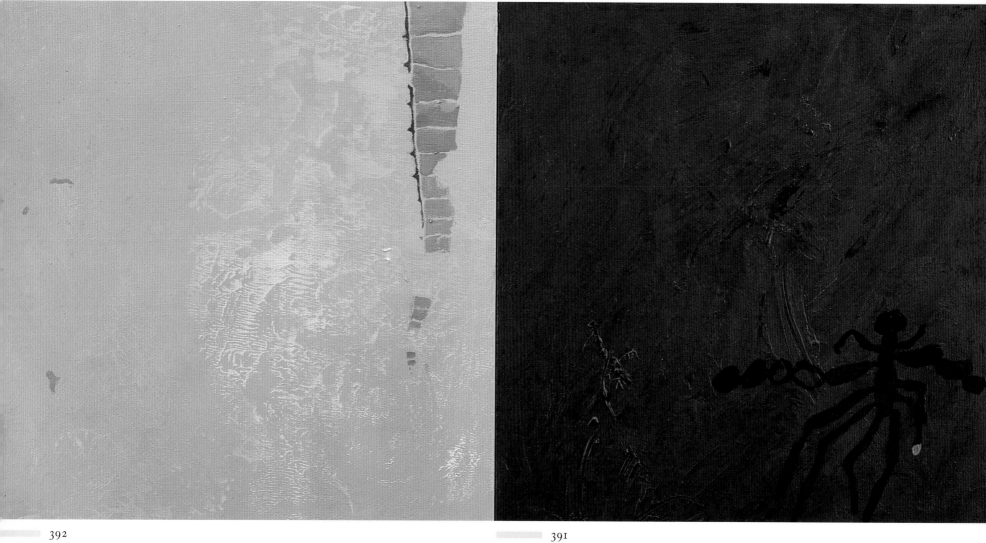

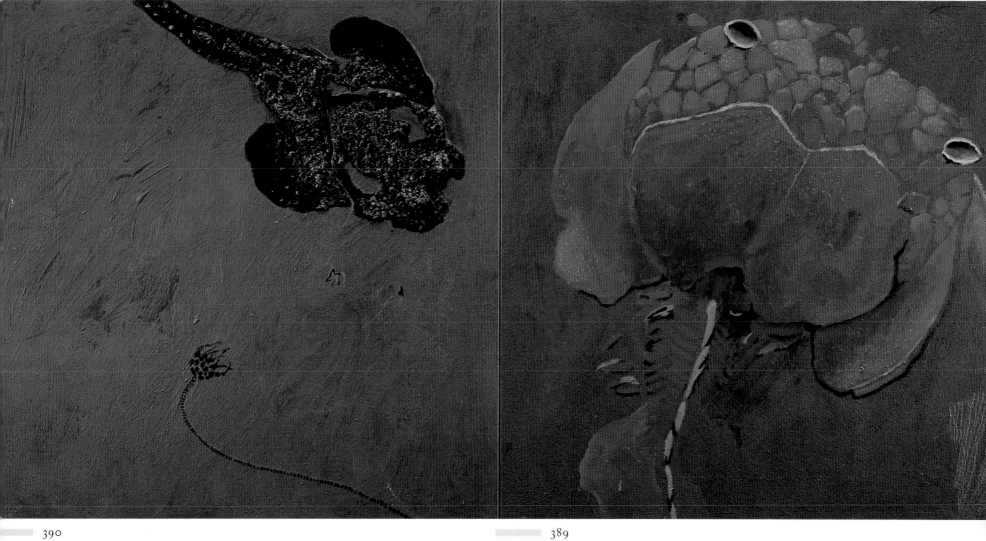

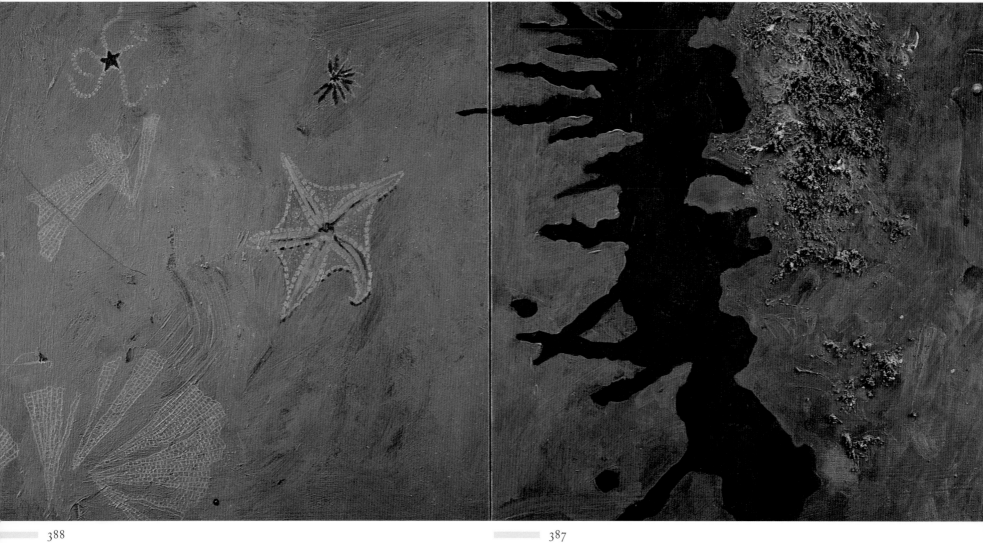

388

387

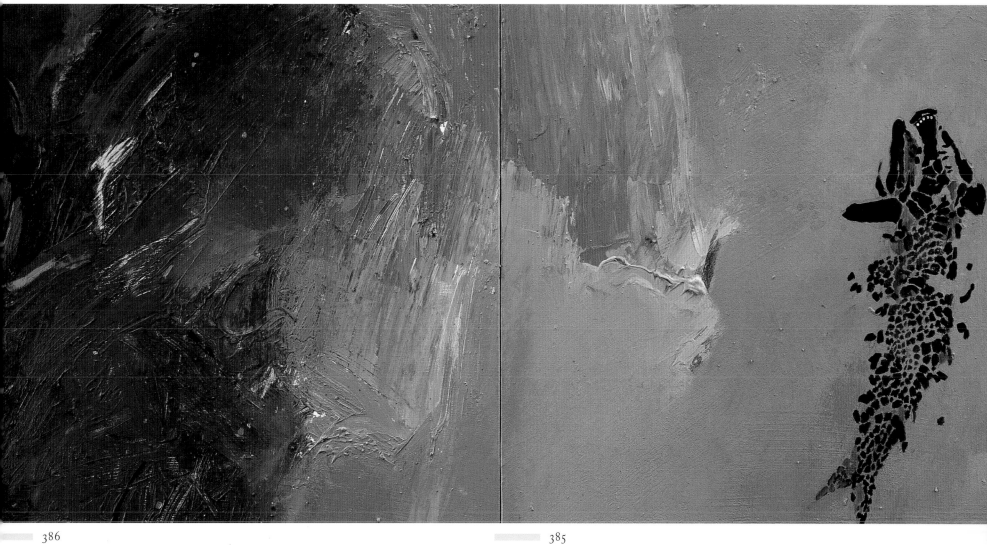

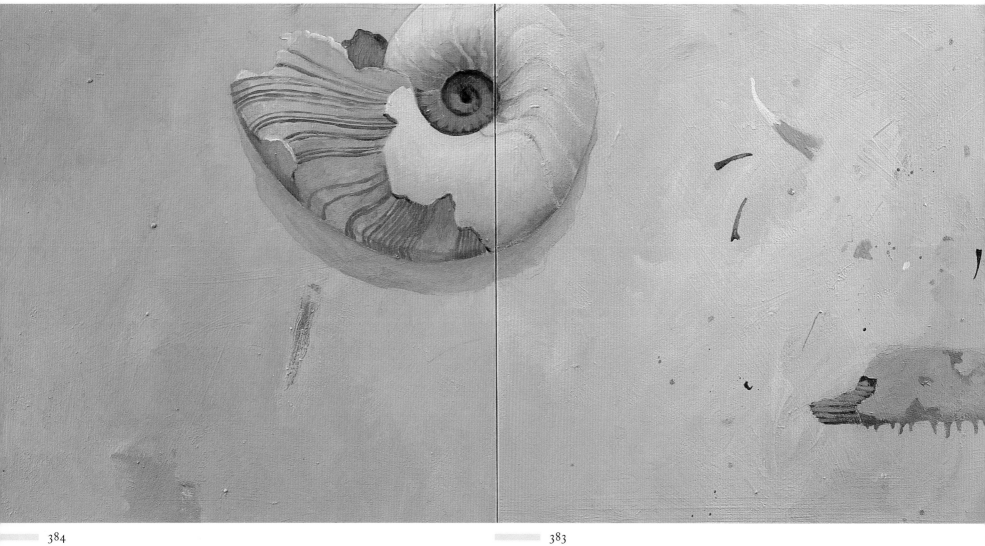

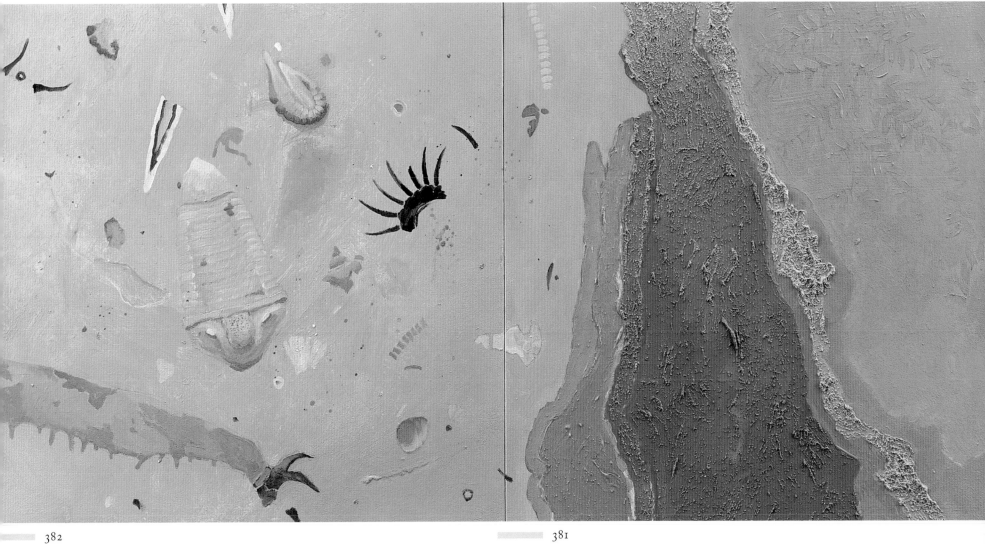

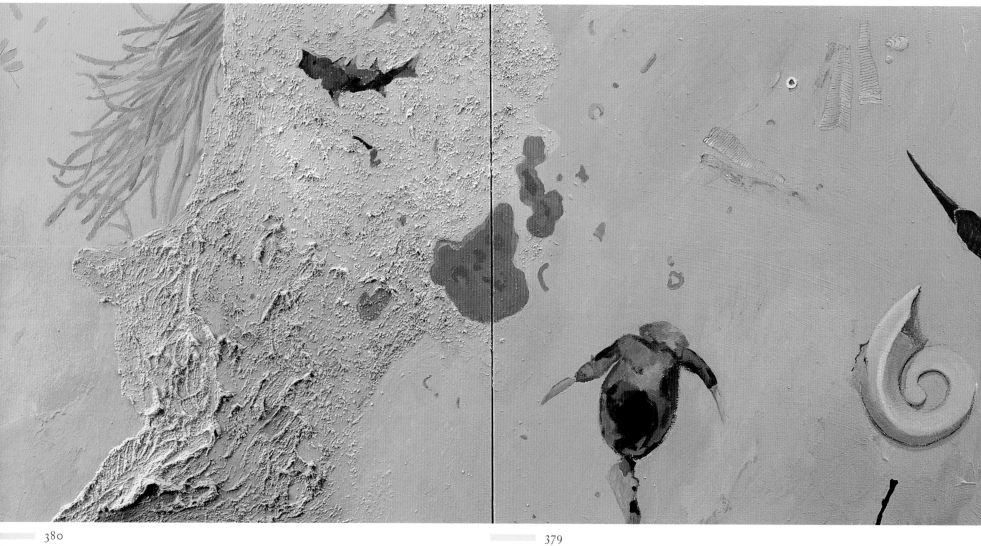

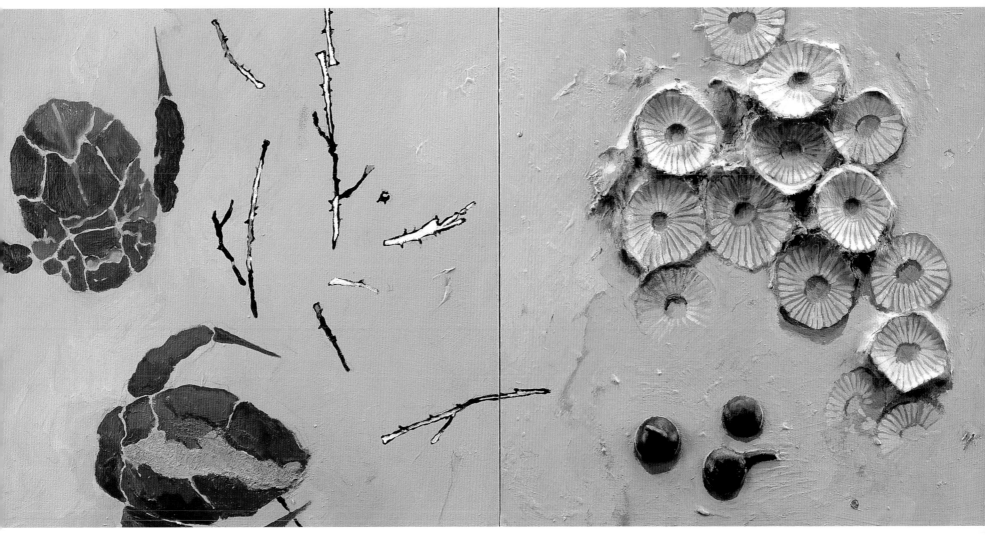

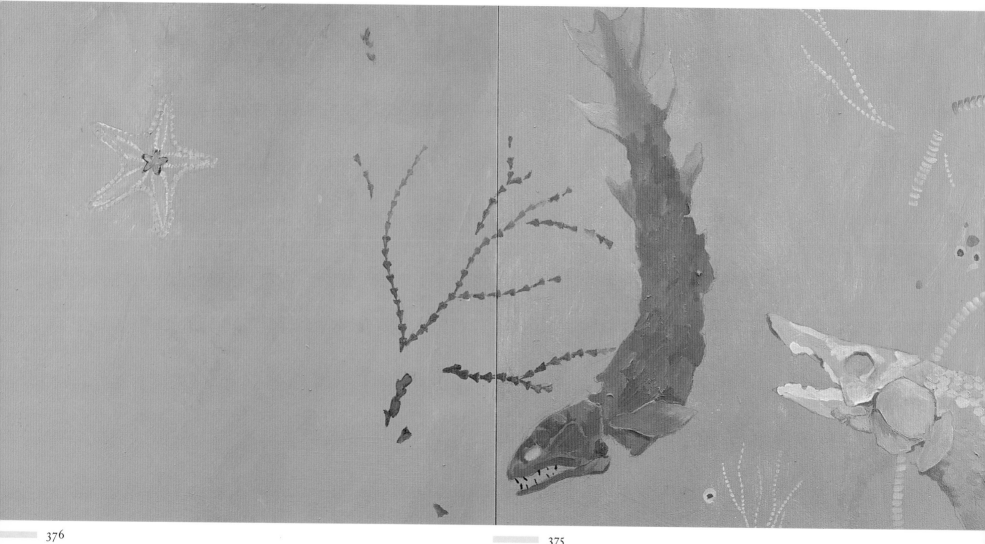

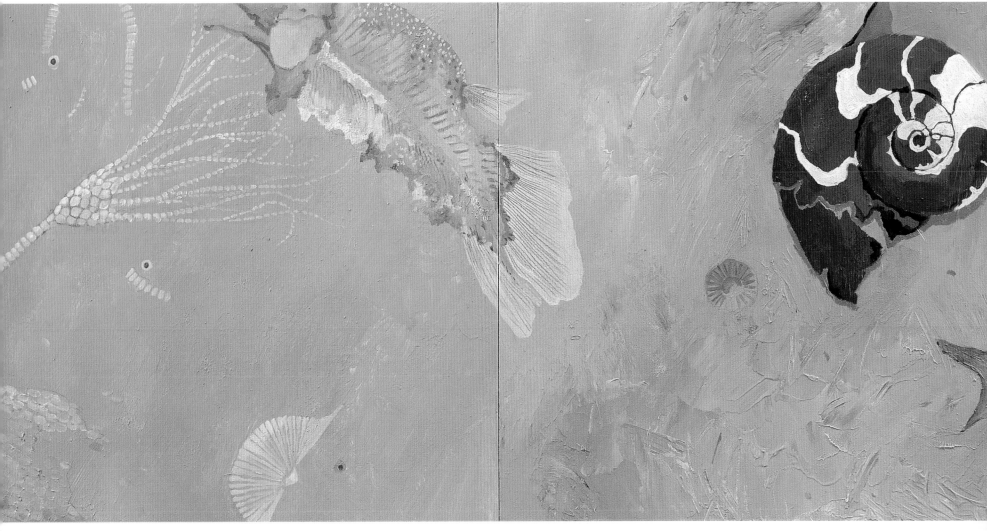

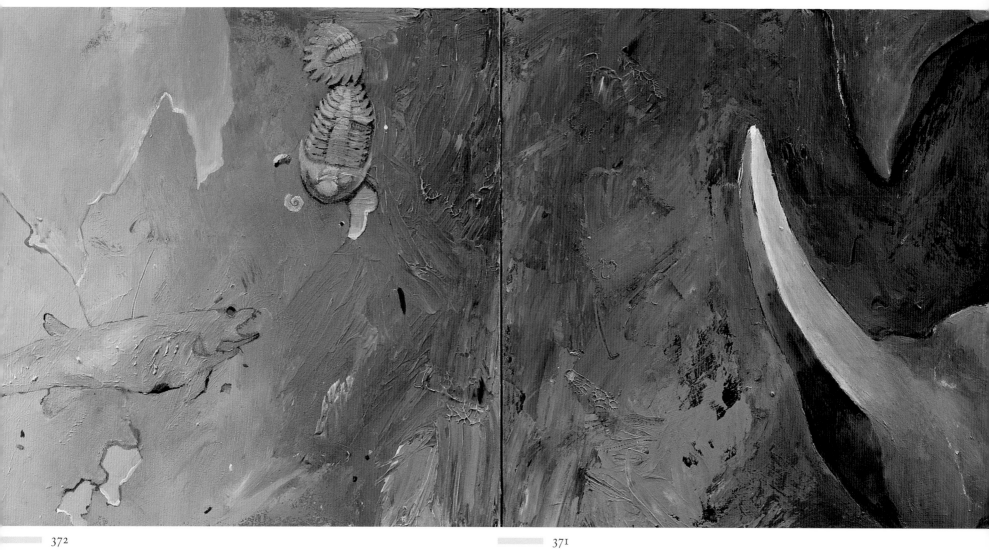

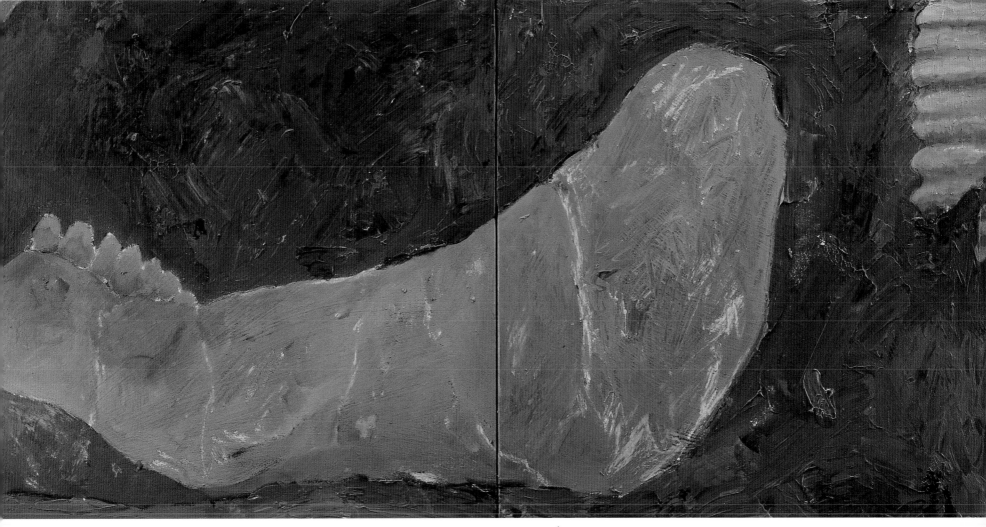

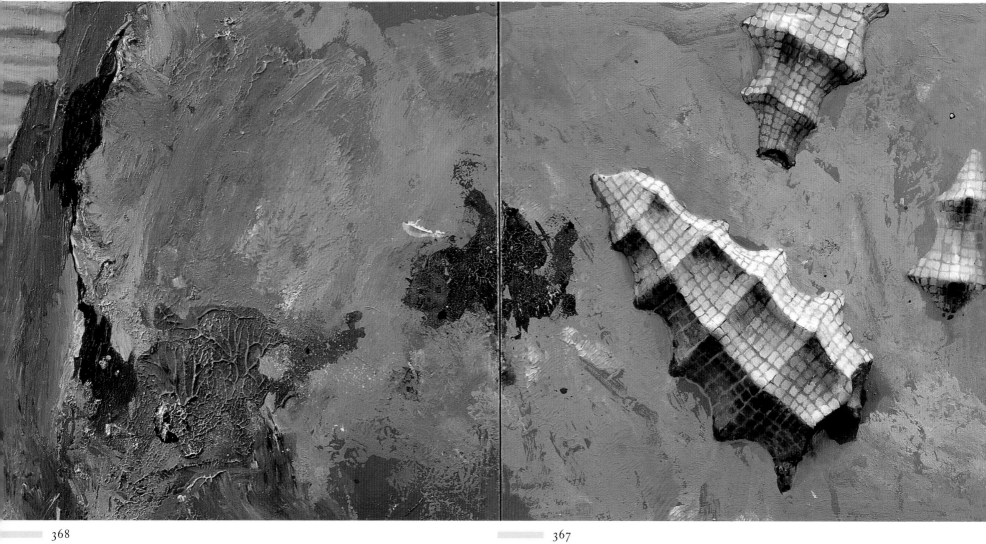

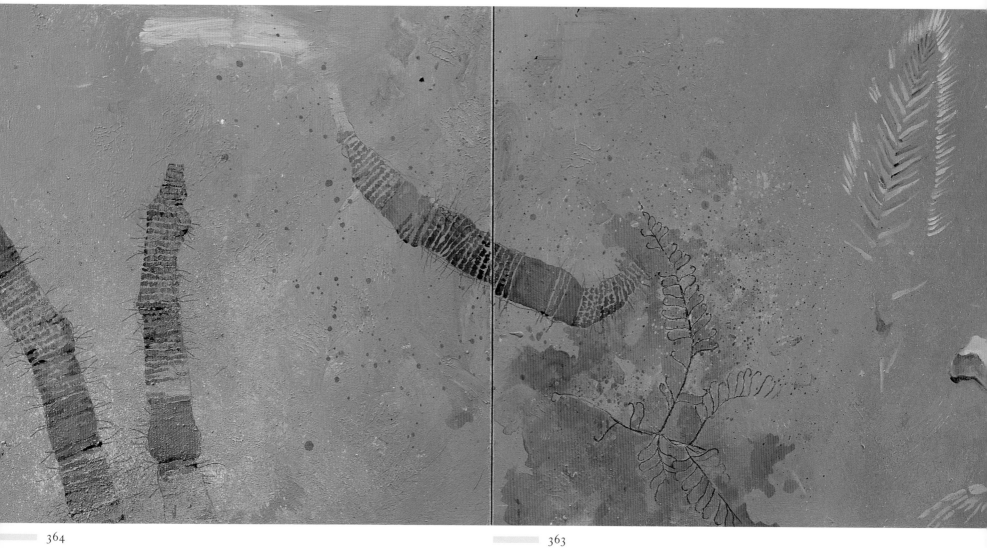

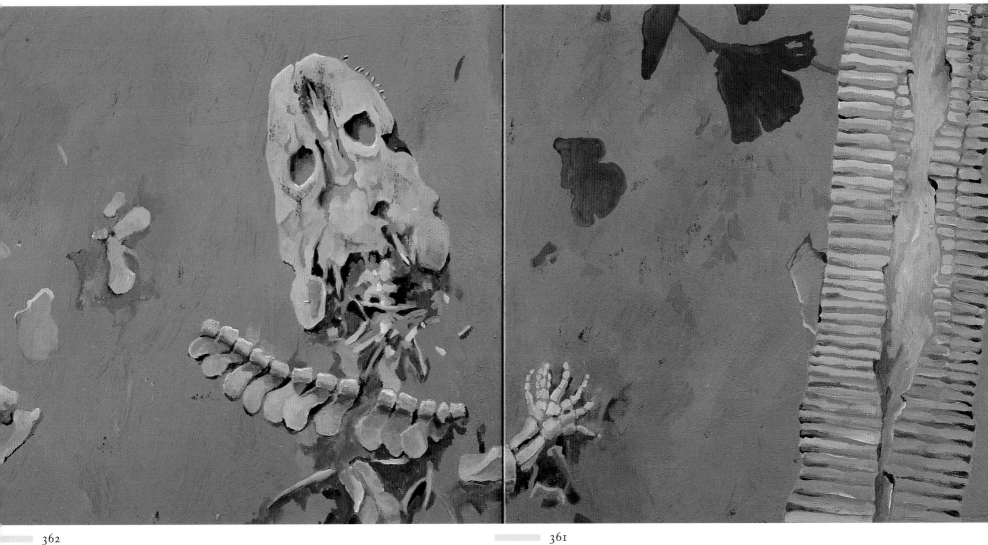

The Carboniferous

360 290

In the early nineteenth century, one of the most important motivations for the early development of the young field of geology was the search for coal. Across much of western Europe, and particularly in Britain, the search for fuel for the emerging industrial revolution put a premium on the ability to predict where coal-bearing layers could be found. British geologists quickly learned that most such layers—called "coal measures"—could be found above rocks containing distinctive fossils known as Silurian and Devonian, and below rocks containing distinctive fossils known as Permian. These carbon-bearing or "carboniferous" layers defined a period of Earth history.

Similar coal measures were also soon recognized in the United States, and appeared to be of approximately the same age. These layers were first studied in detail in Pennsylvania. Geologists then noted a set of limestone layers farther to the west, in the area of the upper Mississippi River valley in what is now Indiana, Illinois, and Iowa. These layers seemed to be below, or older than, the coal-bearing rocks to the east. In the 1890s Cornell geology professor Henry Shaler Williams formally proposed calling the younger rocks Pennsylvanian and the older rocks Mississippian. The terms were widely adopted in North America but never elsewhere in the world, where equivalent-aged rocks continue to be called Carboniferous.

The rich coal deposits for which the Carboniferous period was named formed from the remains of vast swampy forests. As trees and other vegetation died, they piled up in stagnant water, eventually forming peat. After millions of years, the weight of overlying layers of rock turned this peat into coal. At one time, geologists speculated that the entire world was a tropical swamp during this period. In fact, it appears that low swampy conditions were characteristic mostly of western Europe and eastern North America, which were located close together near the equator at that time. Here on the low sloping plains near the sea shore, vast tropical forests grew in coastal swamps. In northern Illinois near Chicago, a layer of rock called the Mazon Creek, which was exposed in coal mines, yields the beautifully preserved fossils of creatures that inhabited this world where the forest met the sea. Among the ferns and other plants crawled new species of amphibians as well as millipedes up to six feet long. Insects expanded dramatically and made their first forays into the air, culminating in dragonflies the size of large model airplanes. Probably on slightly higher ground, the first reptiles—backboned animals that could lay eggs on dry land—appeared.

Elsewhere on Earth, conditions were very different. For at least part of the time there was glacial ice at the poles. The waxing and waning of these icecaps may have driven the rising and falling of the seas at the equator, producing cyclical deposits of coal and marine sediments.

In the seas, some groups of animals never recovered from the late Devonian extinction, but ammonoids, brachiopods, and sharks diversified significantly. Crinoids reached their highest diversity and abundance ever during the Carboniferous. Some early Carboniferous limestone is made of virtually nothing but the body plates of crinoids.

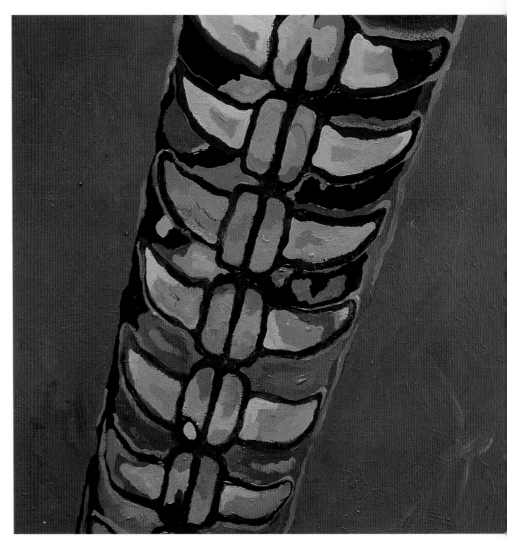

360 *million years ago*

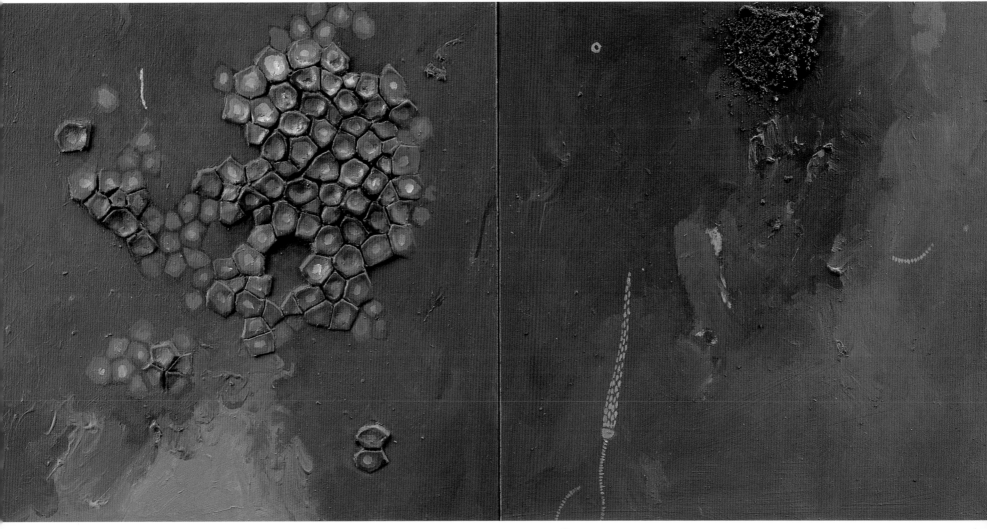

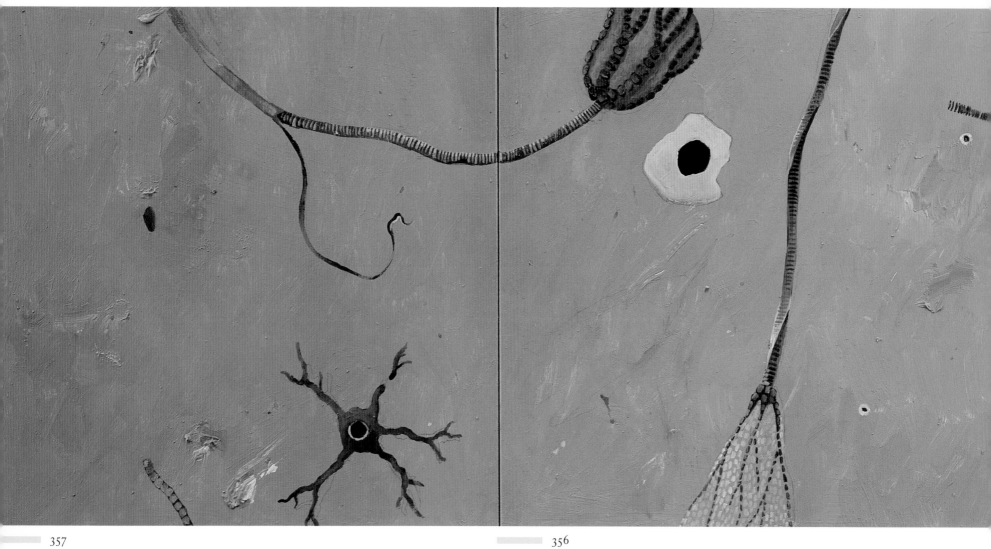

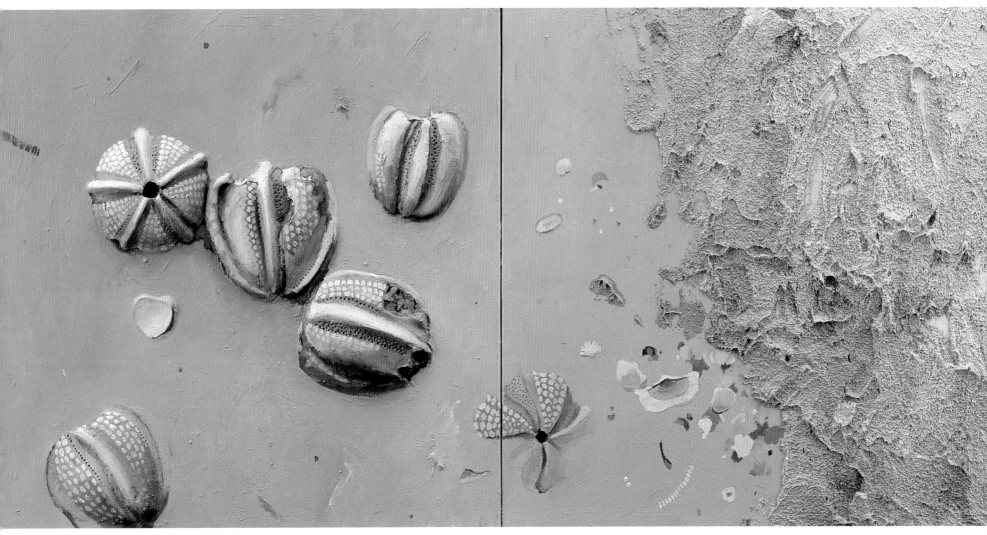

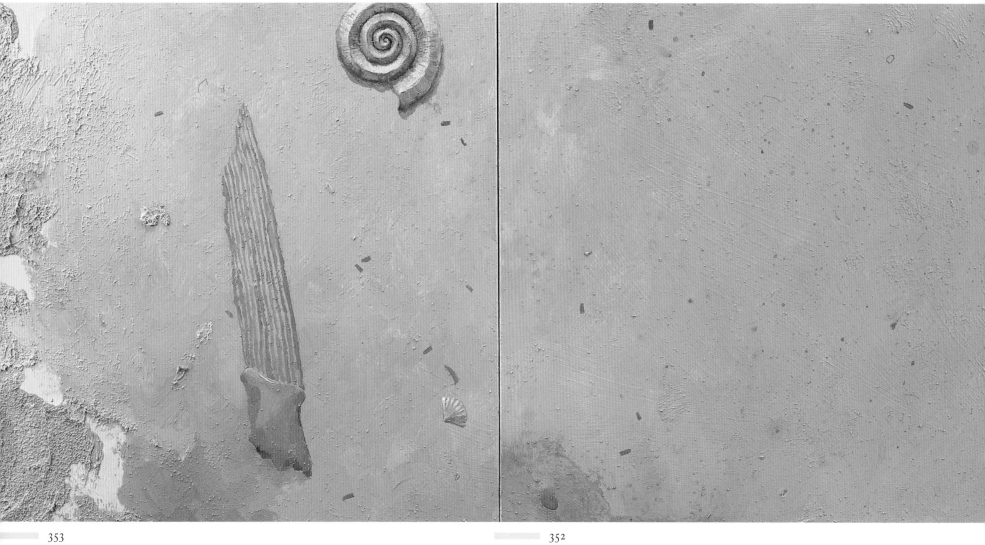

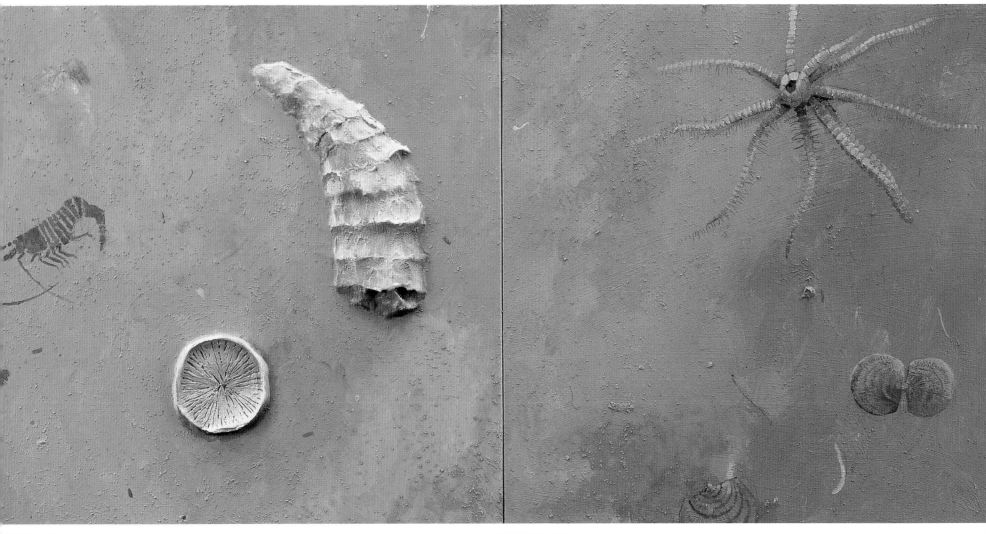

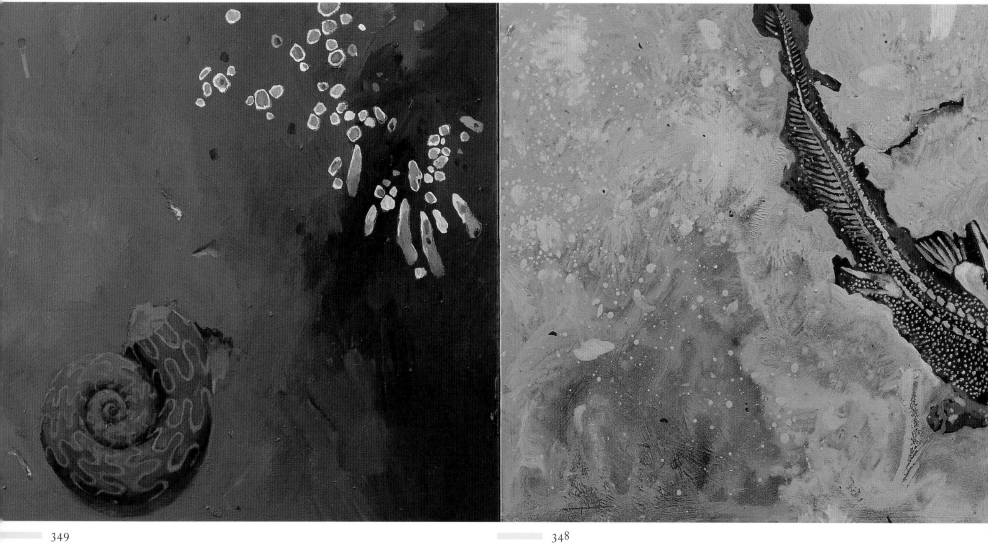

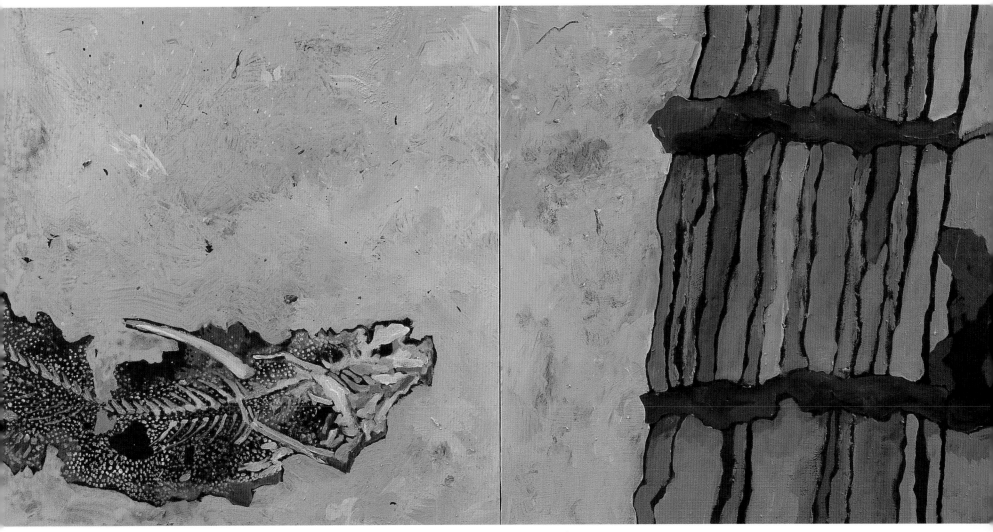

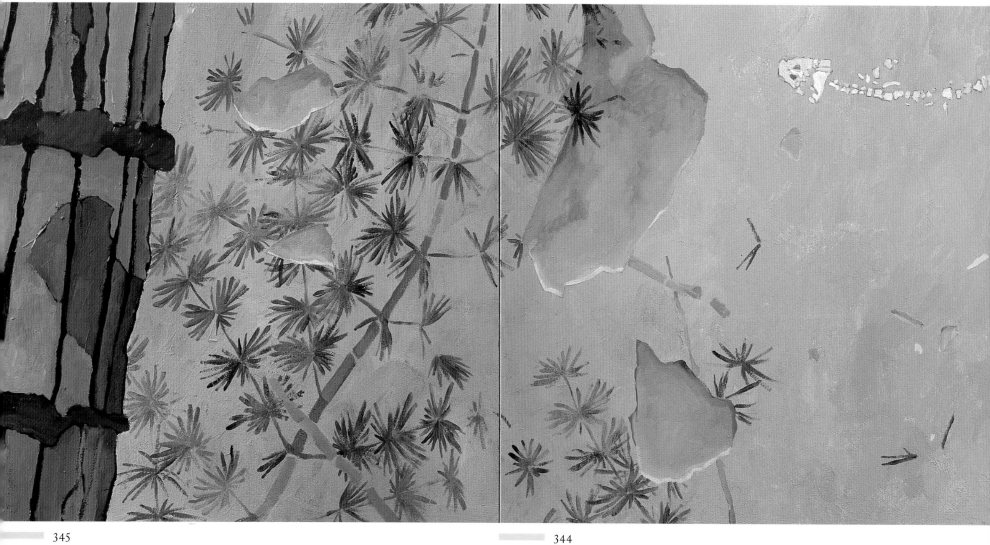

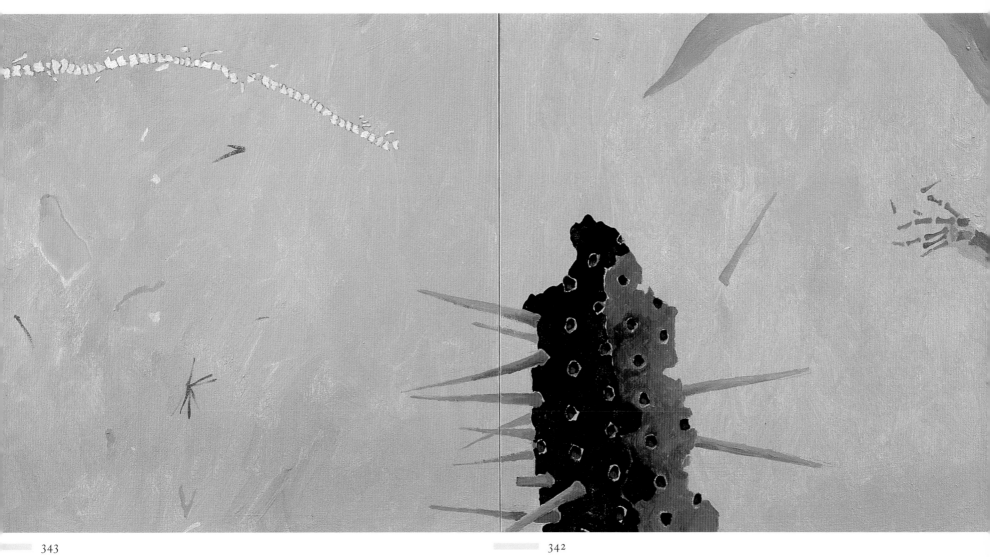

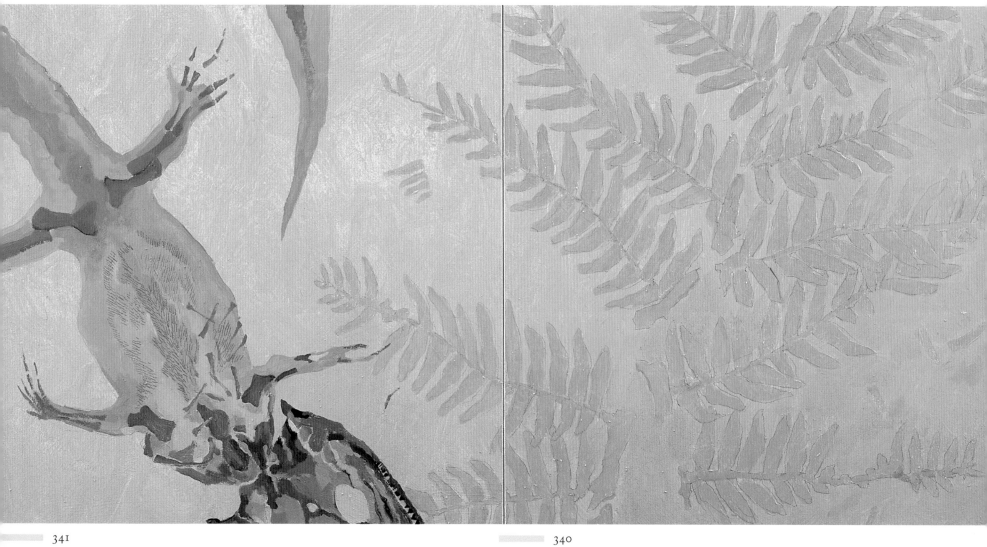

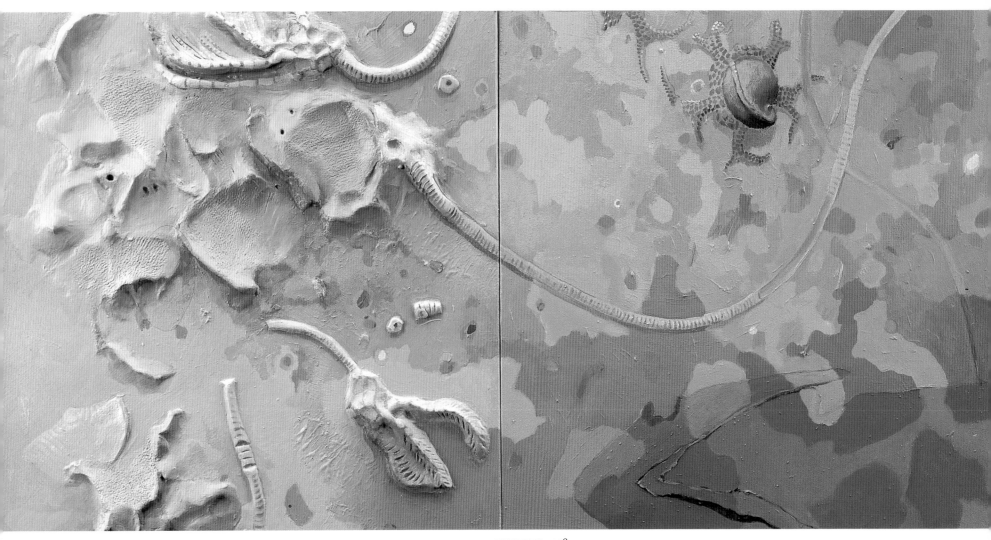

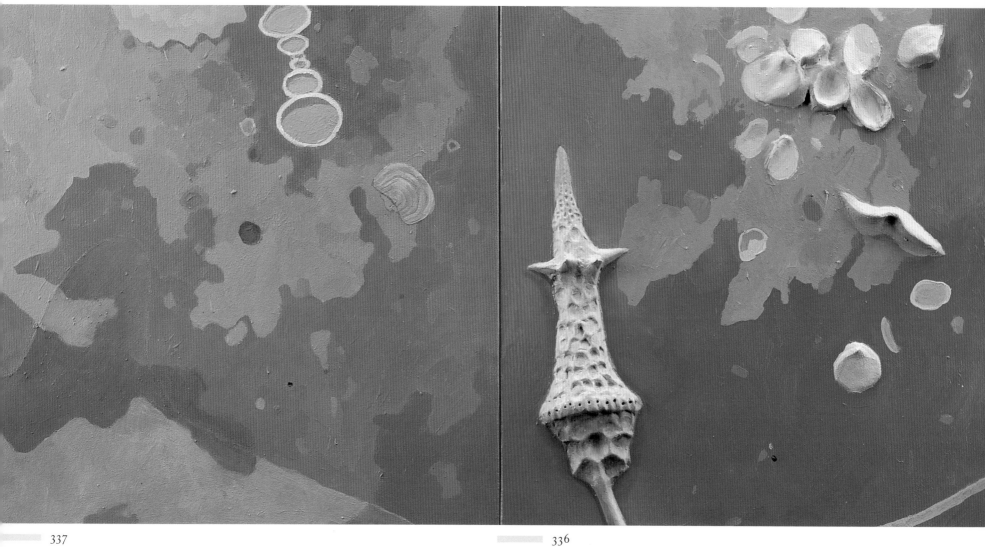

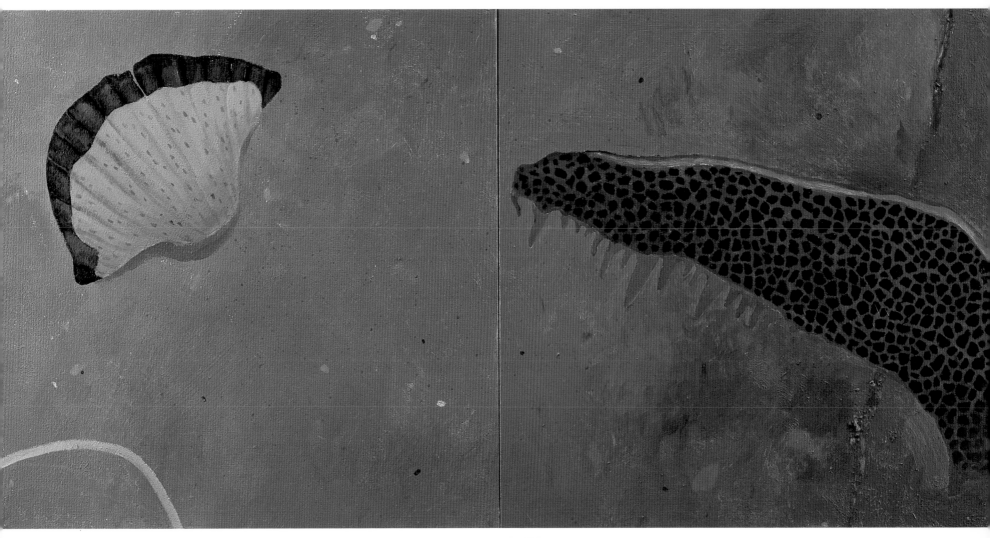

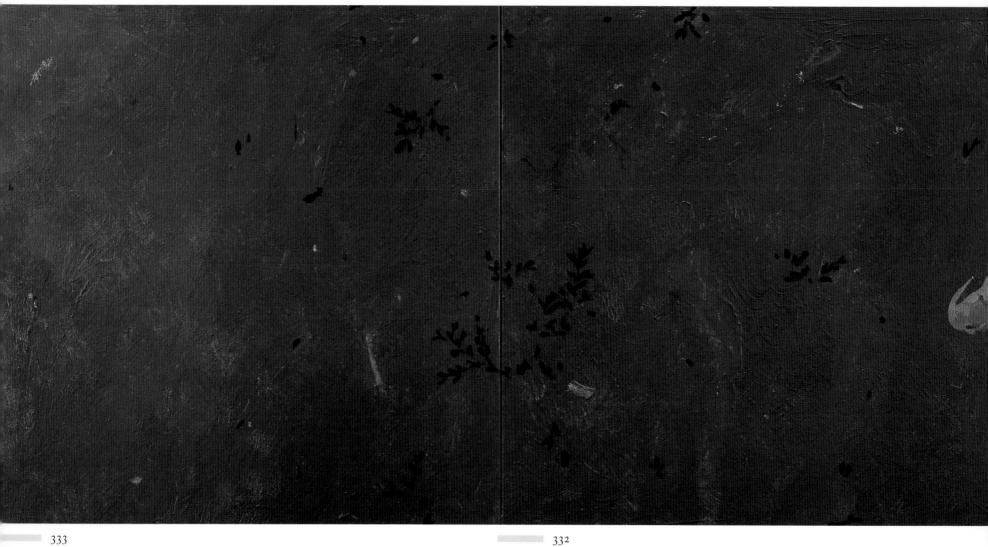

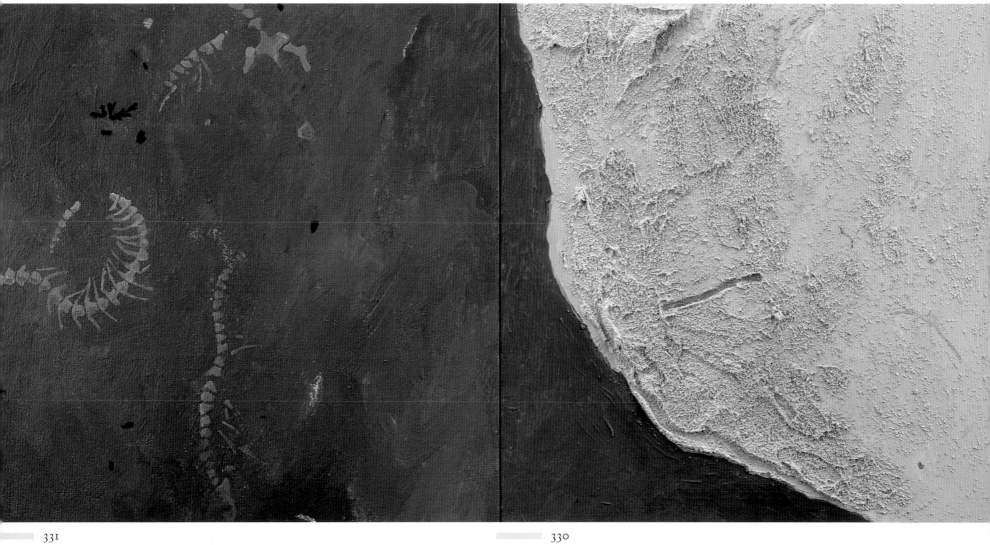

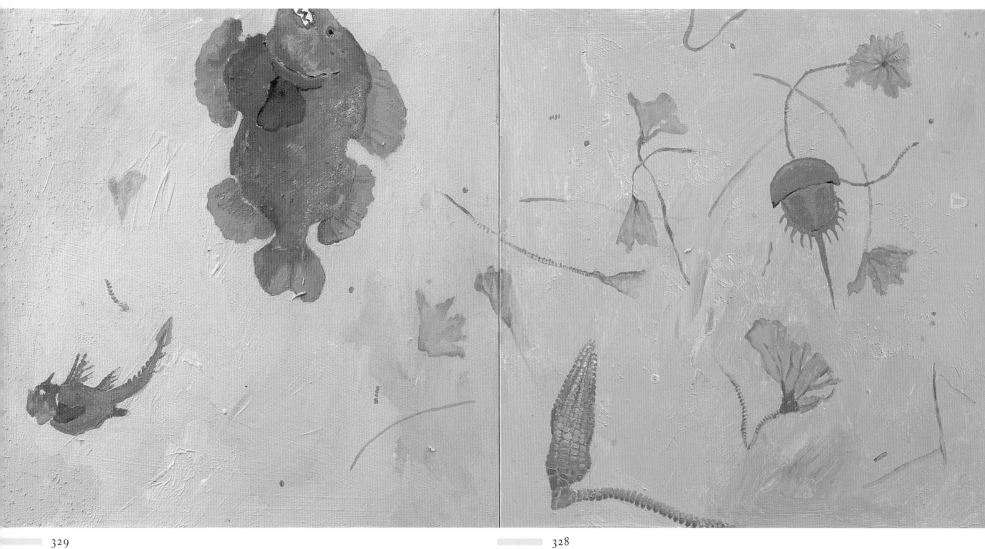

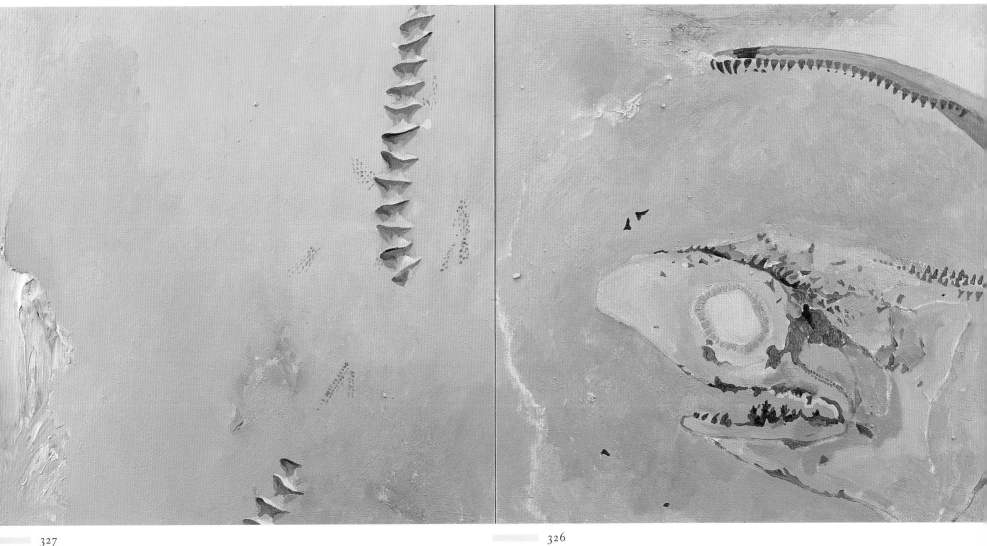

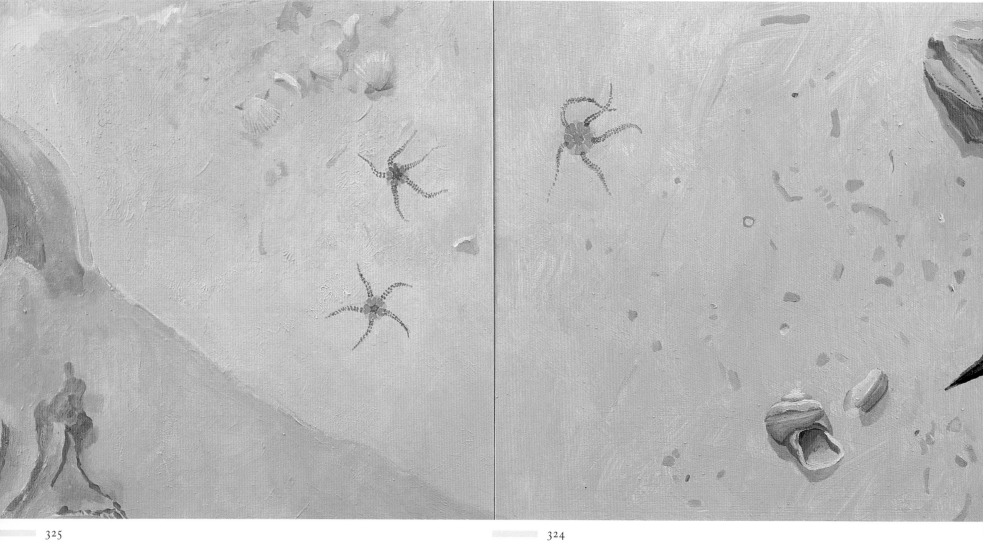

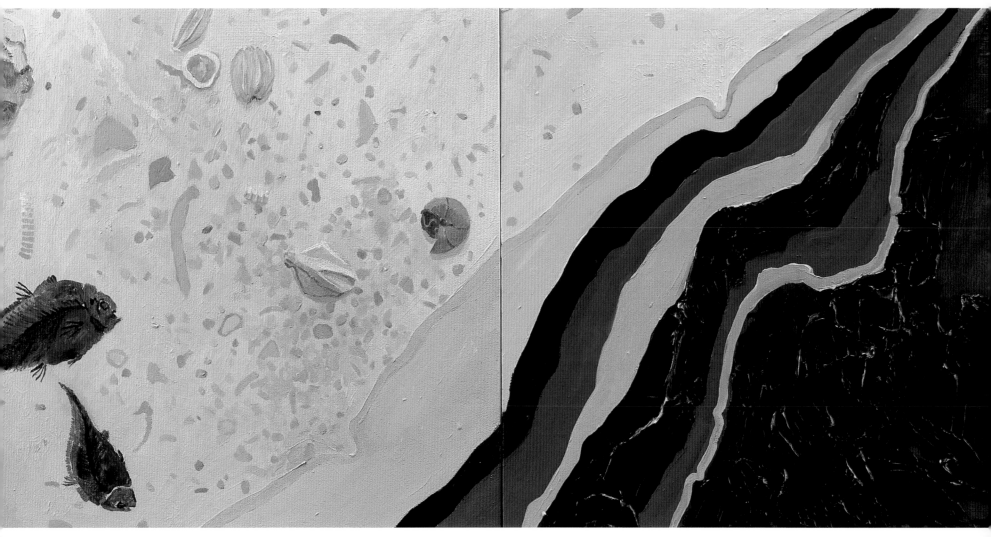

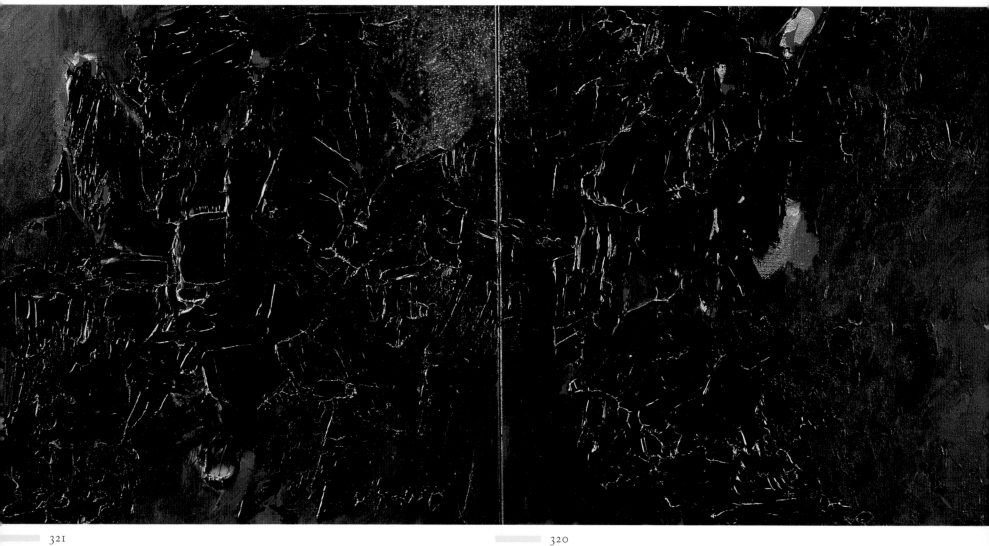

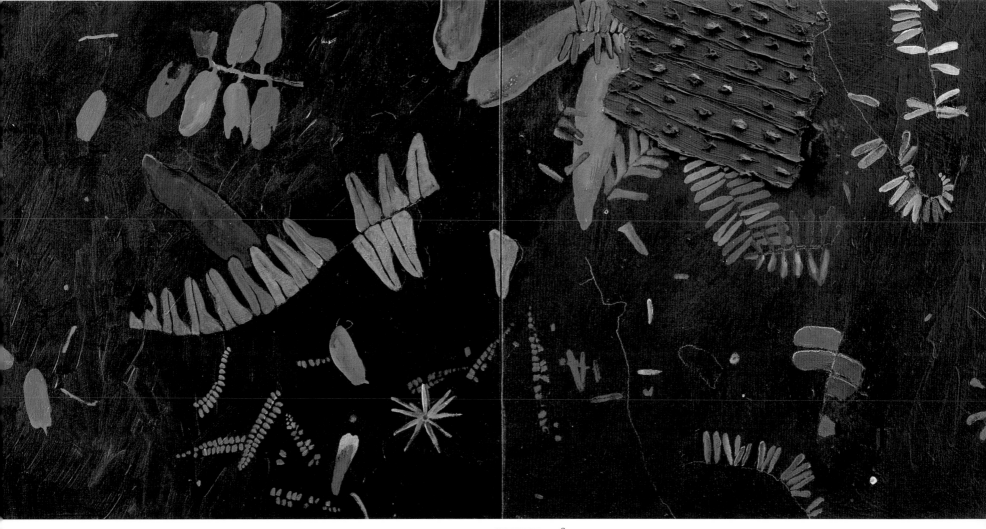

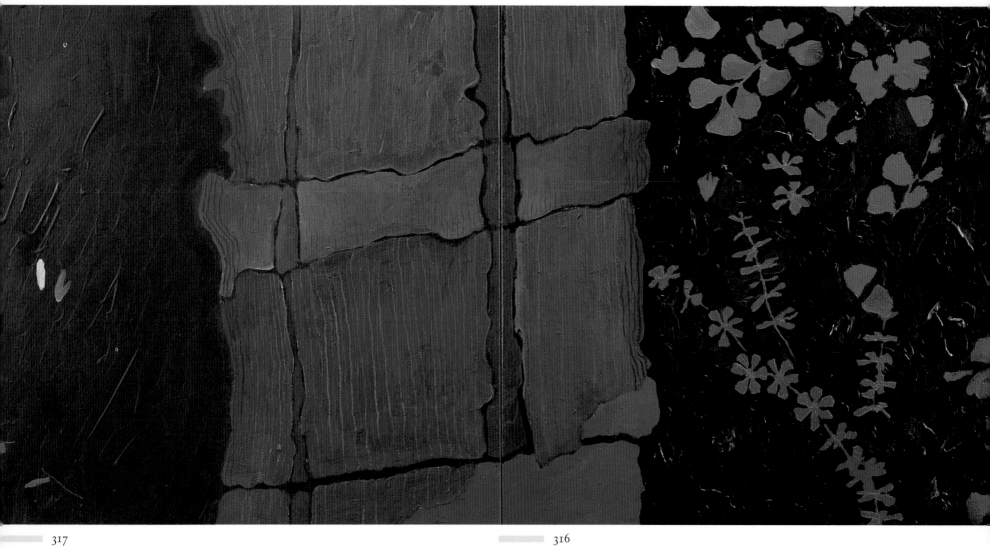

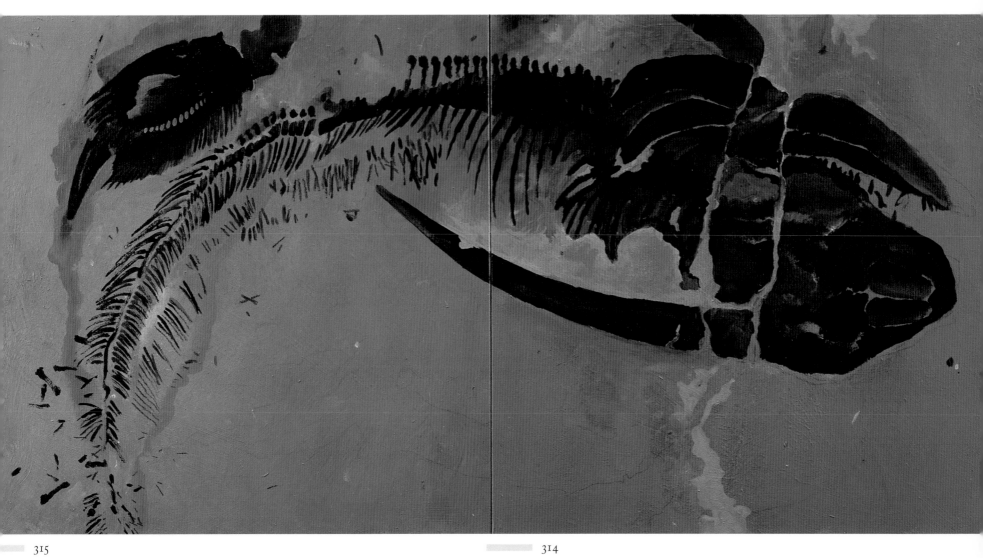

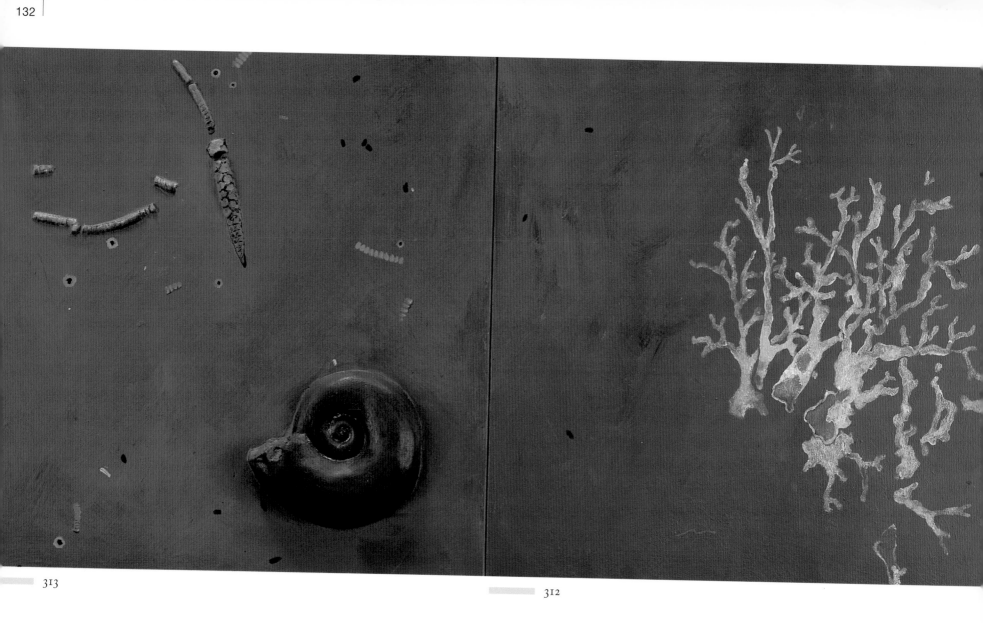

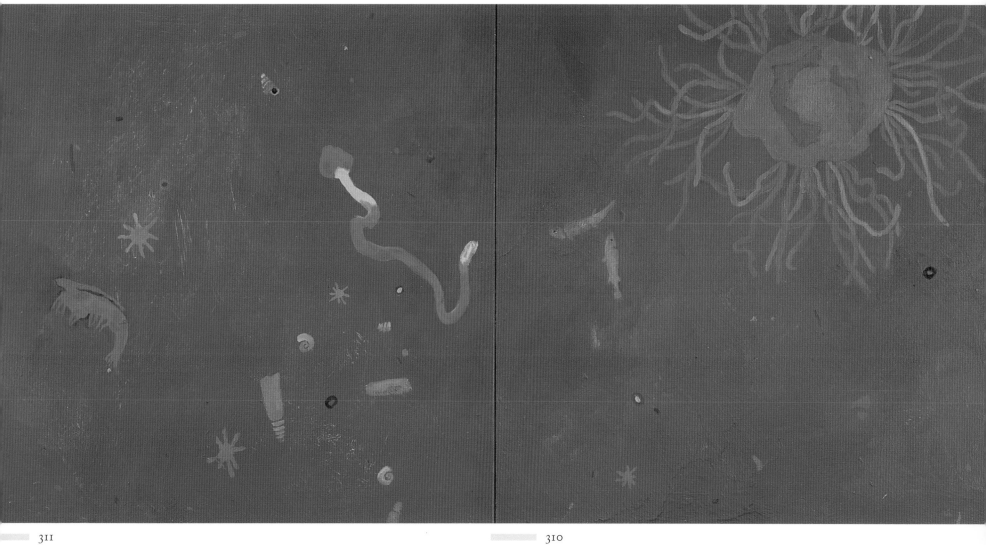

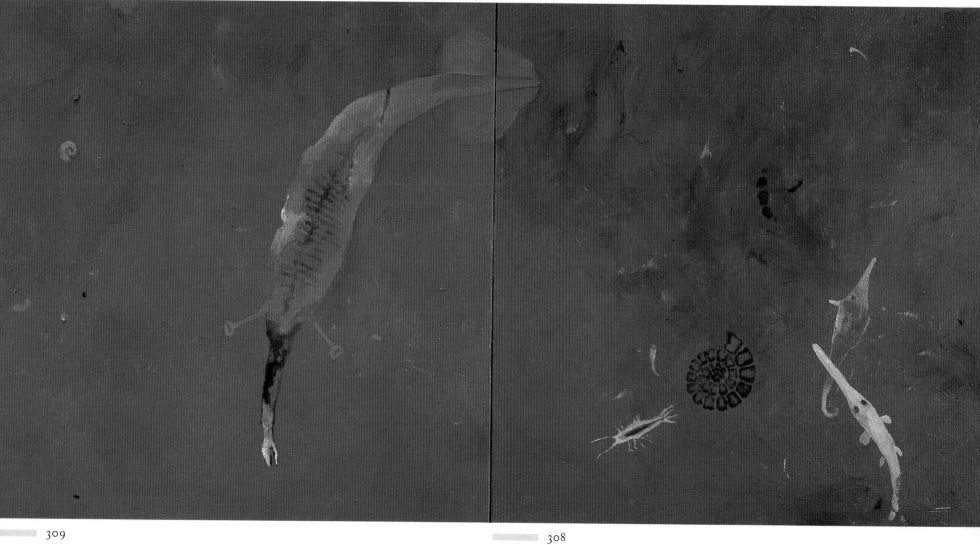

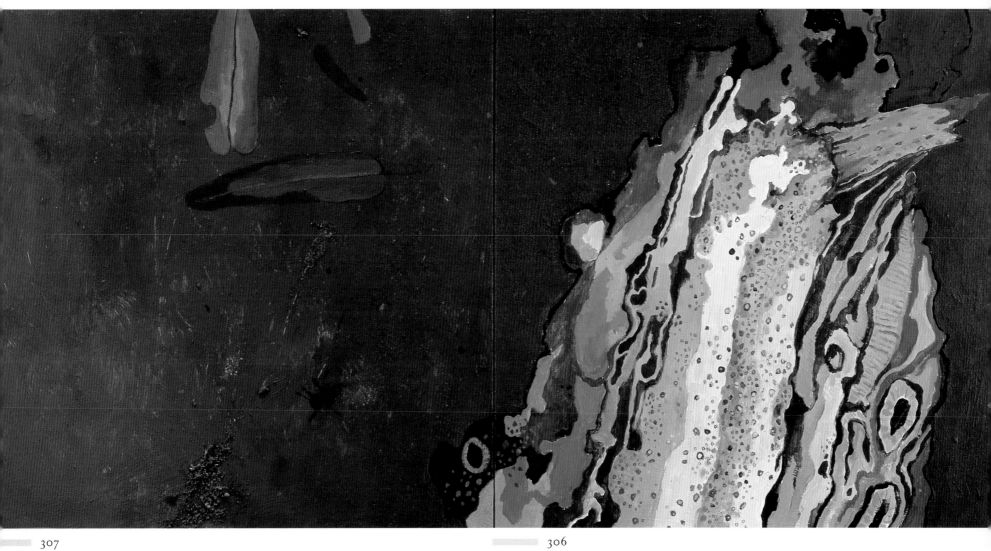

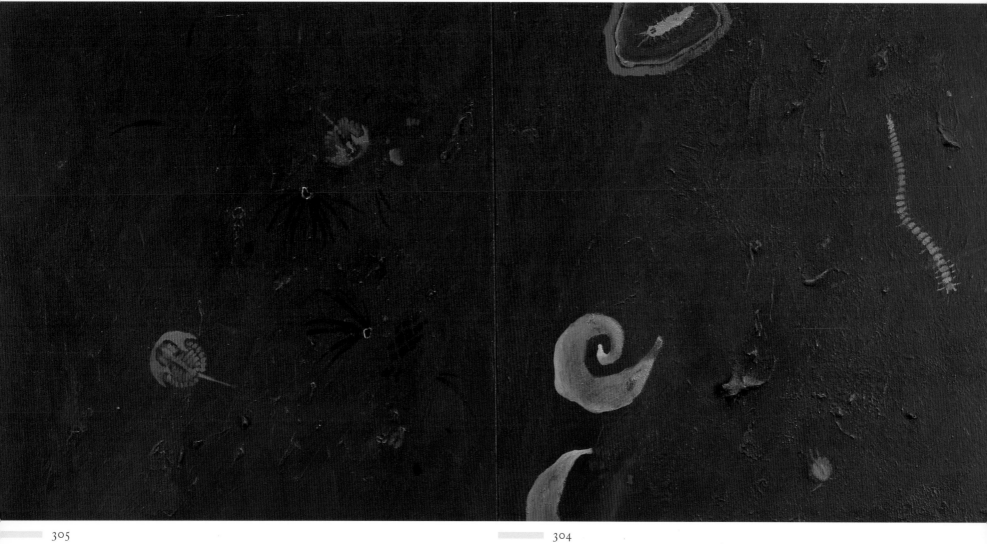

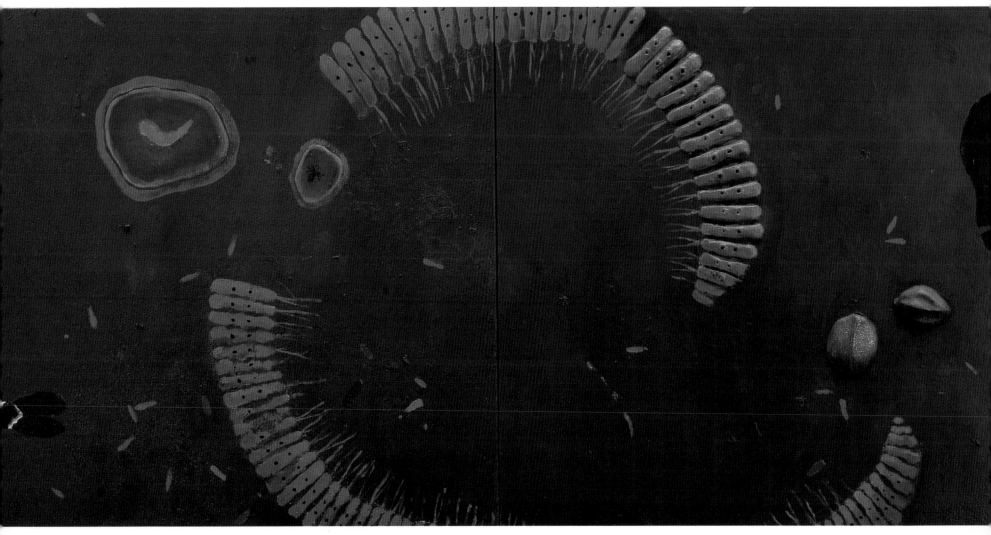

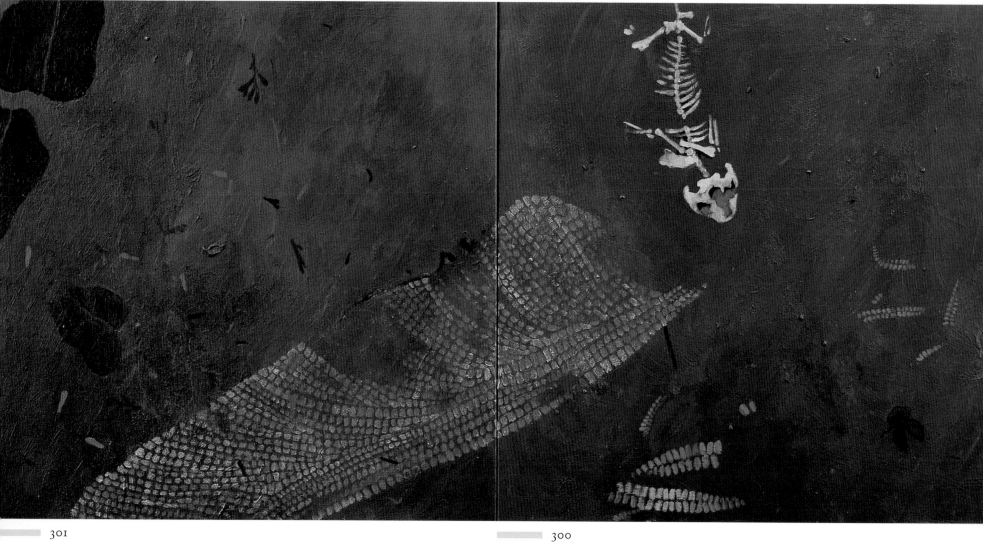

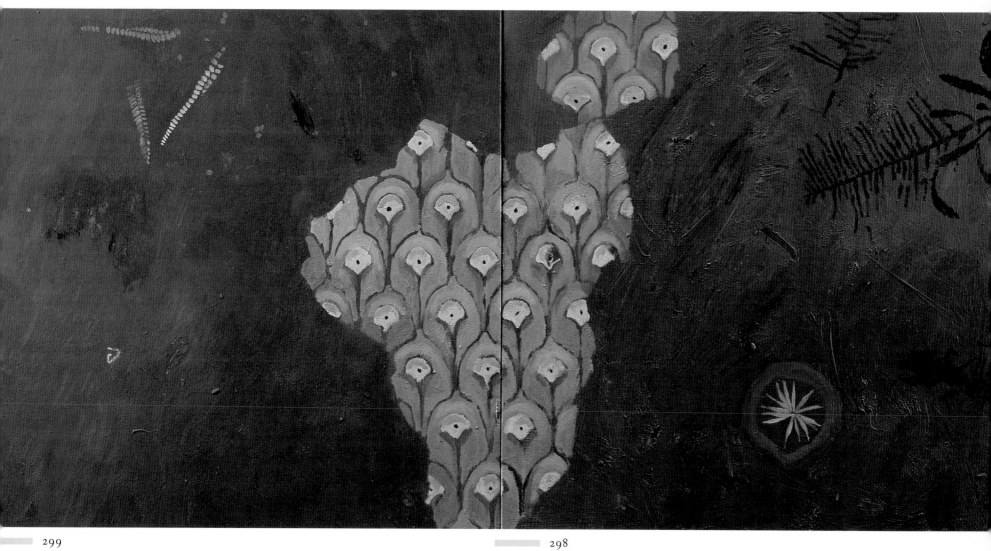

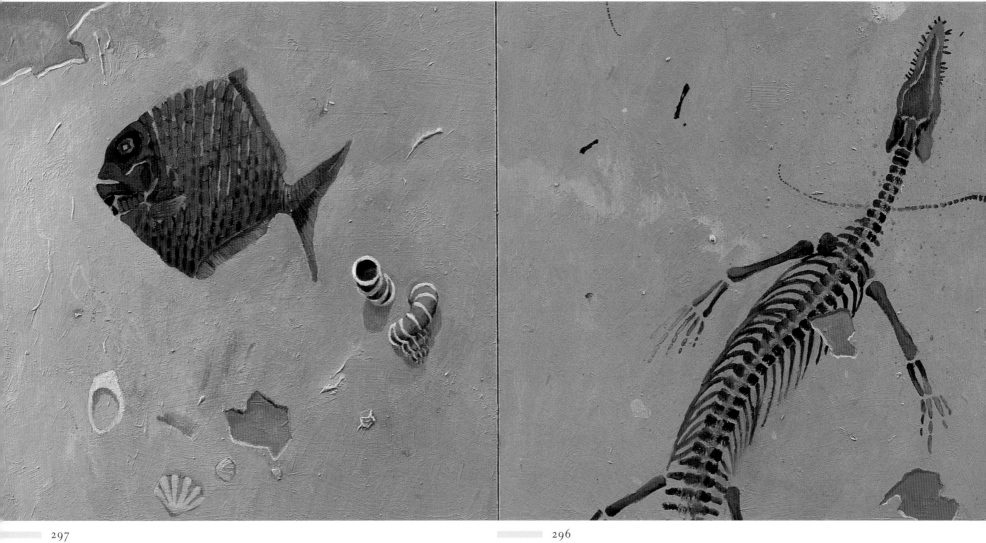

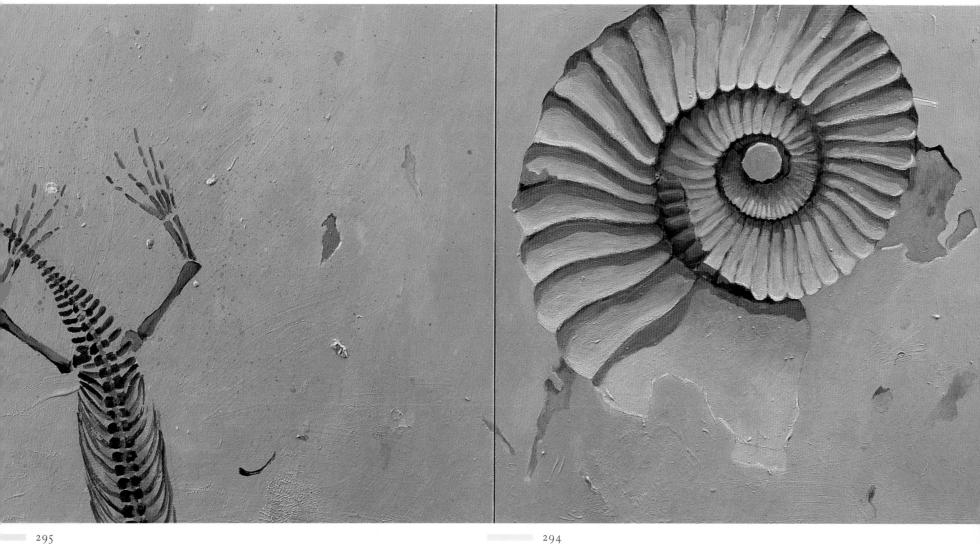

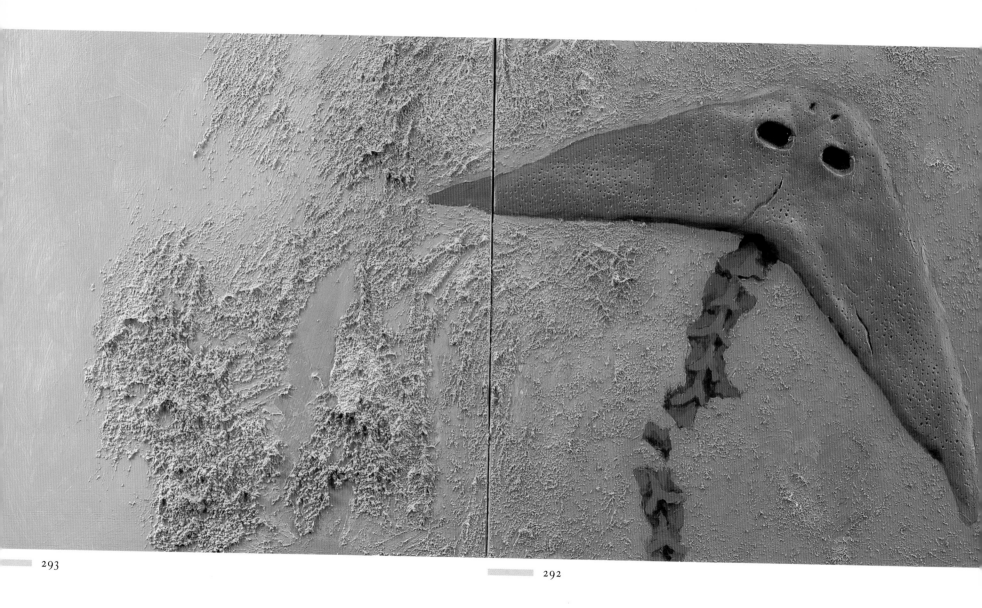

The Permian

289 245

Throughout the late Paleozoic, the continents continued to move together until at last they formed one large "supercontinent" known as Pangaea. It is likely that this enormous landmass affected in one way or another virtually all life on Earth during the Permian, the final period of the era.

One effect of this collision of continents was that sea level fell worldwide. Once they were jammed together, the continents could no longer move, and the hot mid-ocean ridges that drive continental drift collapsed, effectively deepening the ocean basins. Another effect was the development of extreme "continental" climates, characterized by high temperatures and marked seasonality. These conditions contributed to some of the most characteristic Permian sediment types. Beds of salt and gypsum, which form through the evaporation of seawater, and "red beds," which probably form in very hot, dry climates, are widespread in the geological record from this time.

Despite all of these environmental changes, life thrived throughout most of the Permian. The seas were filled with extensive reefs, and brachiopods, cephalopods, and corals expanded during the period. On land, large amphibians persisted but were eventually replaced as the dominant land-dwellers by reptiles, which themselves branched into several large groups. One group of reptiles, called the diapsids, included a wide variety of forms, among them the ancestors of dinosaurs, crocodilians, and birds. (One of the oddest of Permian diapsids was *Coelosauravus*, whose ribs were greatly elongated apparently adapting it to gliding flight. This body form evolved independently at least two other times later in the history of reptiles.) Another group, called the synapsids, included the familiar sail-back *Dimetrodon* and its relatives (which are usually thought of as dinosaurs but aren't), as well as the therapsids, the ancestors of mammals. Therapsids diversified dramatically during the Permian and became the dominant land-dwellers for a large part of the period. Land plants were also in transition, from the old assortment that had dominated the coal swamps to the new floras comprised mostly of conifers, seed ferns, and their allies.

The Permian ended with the largest crisis in the history of life. It seems to be no exaggeration to say that life in the sea almost disappeared completely during a narrow interval between 250 and 245 million years ago, when between eighty and ninety-five percent of all species in the oceans became extinct. Life on land appears to have suffered much less. In the oceans, brachiopods, snails, cephalopods, crinoids and their relatives, fish, and single-celled organisms were particularly devastated. Corals, eurypterids, and trilobites disappeared completely. Reefs vanished.

The causes for this catastrophe are still unclear. A leading theory is that the Earth's climate warmed significantly and suddenly, due to a combination of volcanic eruptions and falling sea level. If true, this idea suggests that the Earth simply had the bad luck to have several things go wrong at once. In any case, by killing off so many kinds of organisms so quickly, the end-Permian mass extinction fundamentally and permanently altered the face of life on Earth.

The Permian is named for the Russian city of Perm, just west of the Ural Mountains. The same Roderick Murchison who named the Silurian traveled to Russia in 1840 and 1841 and found fossil-bearing rocks that appeared to be intermediate between the coal measures of western Europe and the overlying Triassic rocks. By the end of the nineteenth century, fossil-rich rocks of Permian age had also been studied in Pakistan, Indonesia, and Texas. The famous oil-producing Permian Basin of west Texas is named for rocks that date from this period.

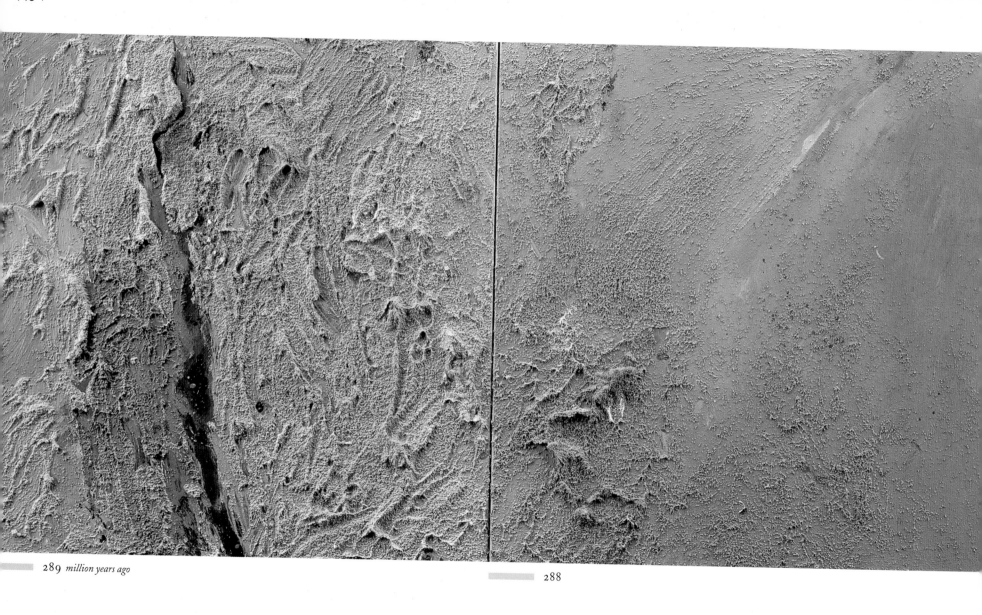

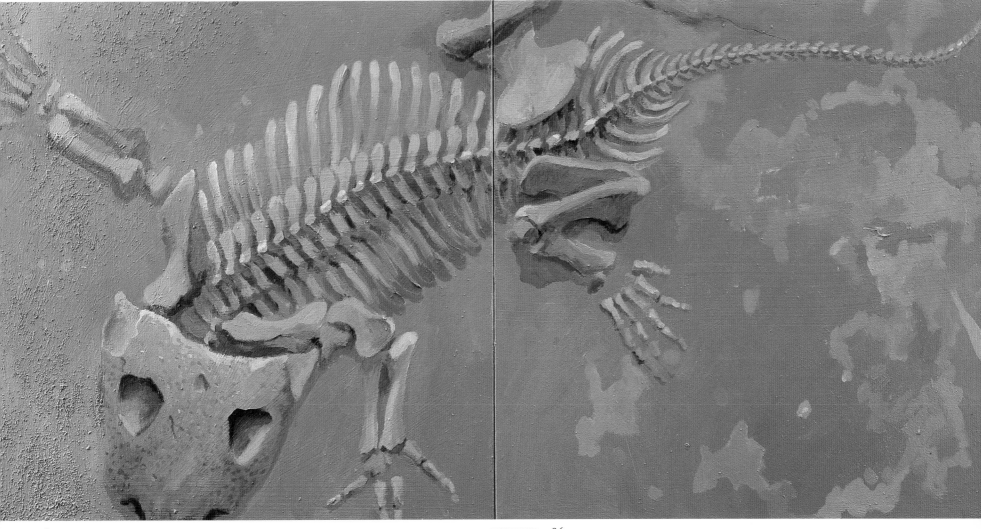

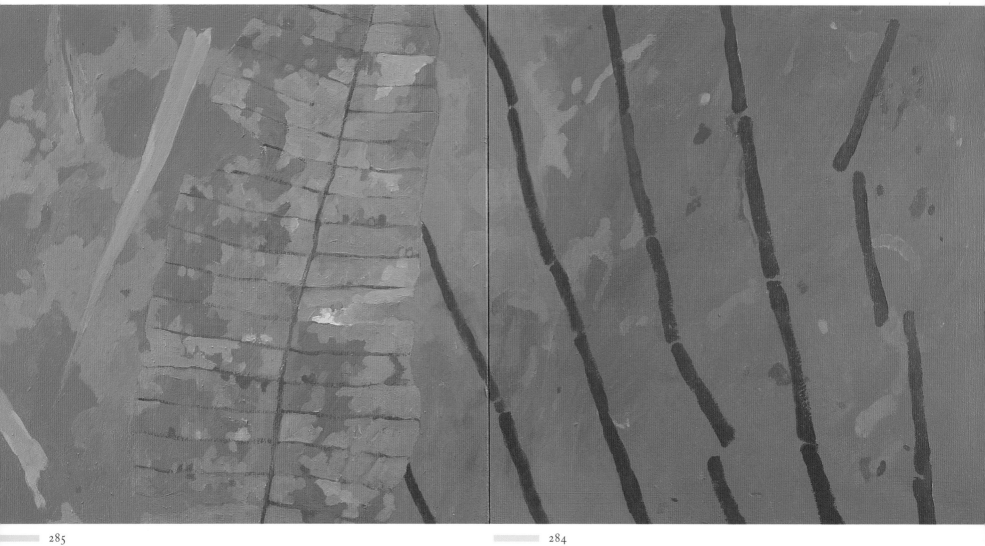

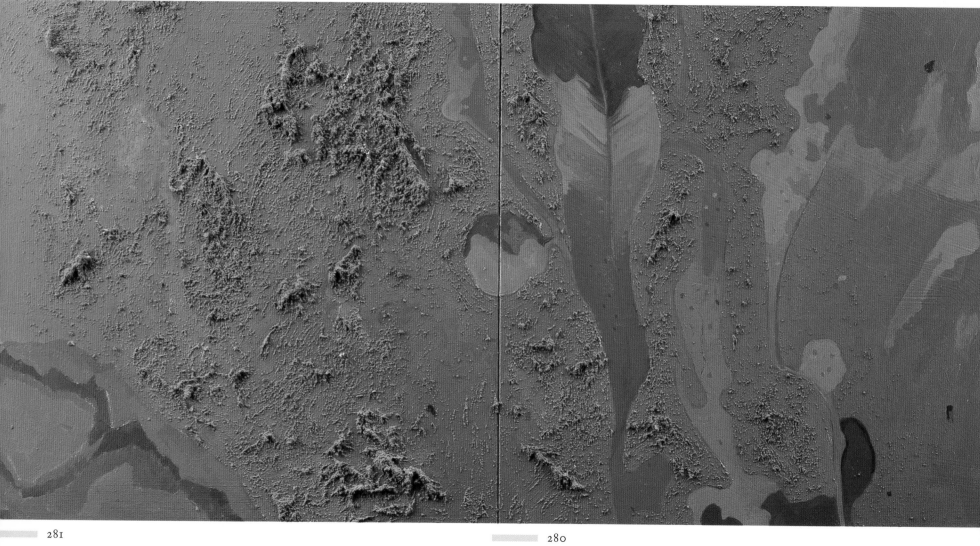

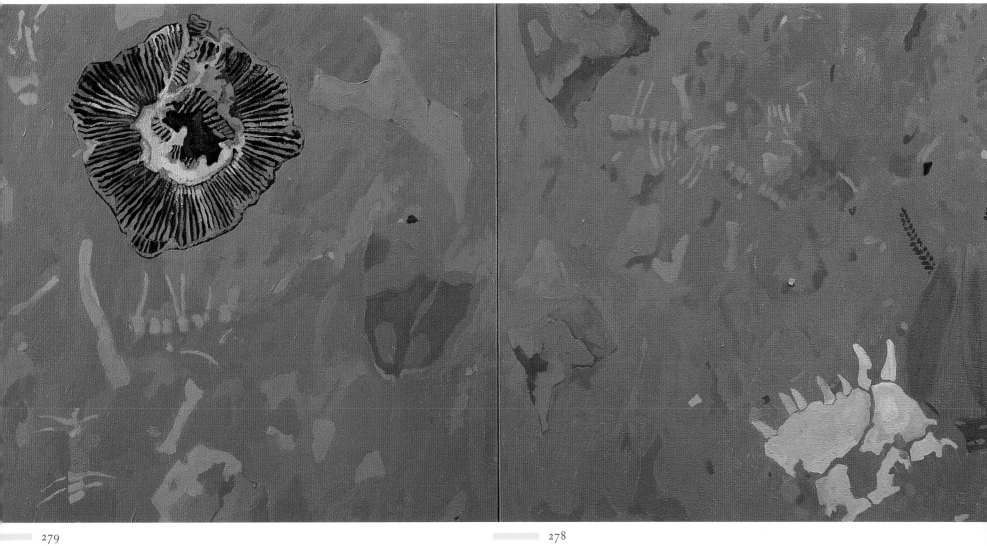

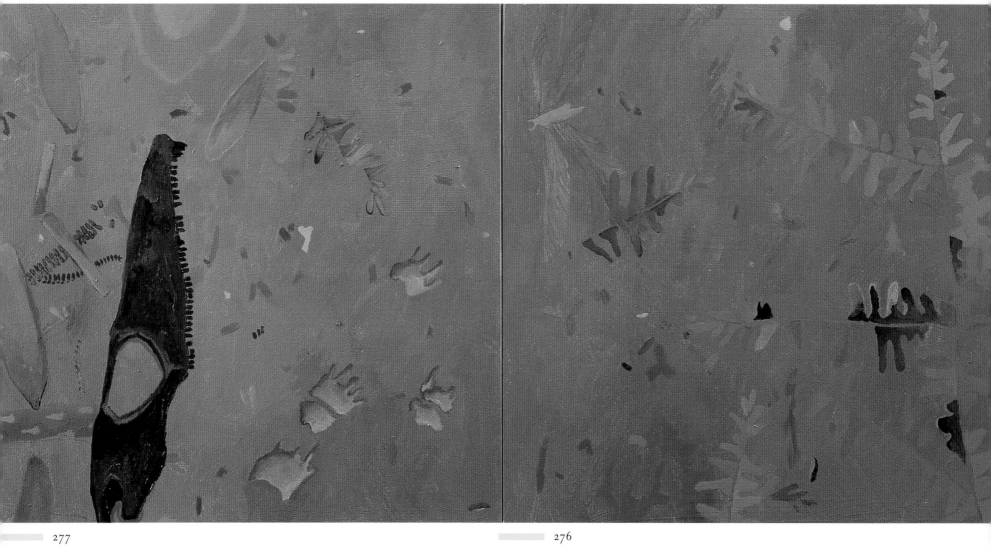

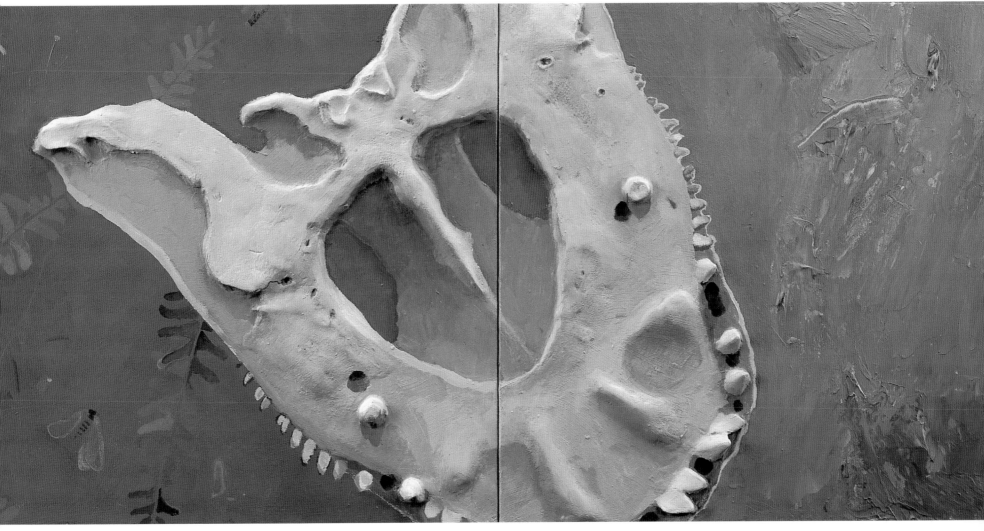

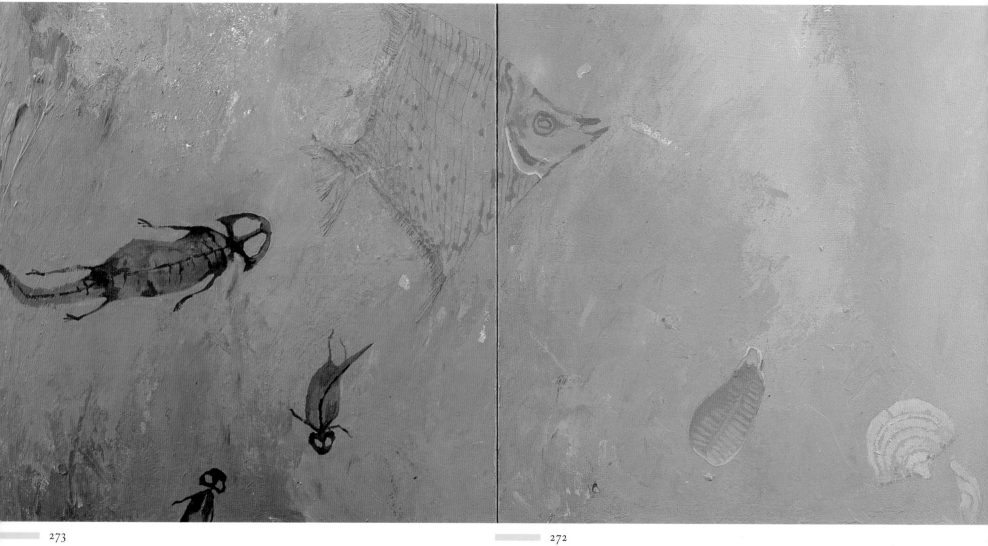

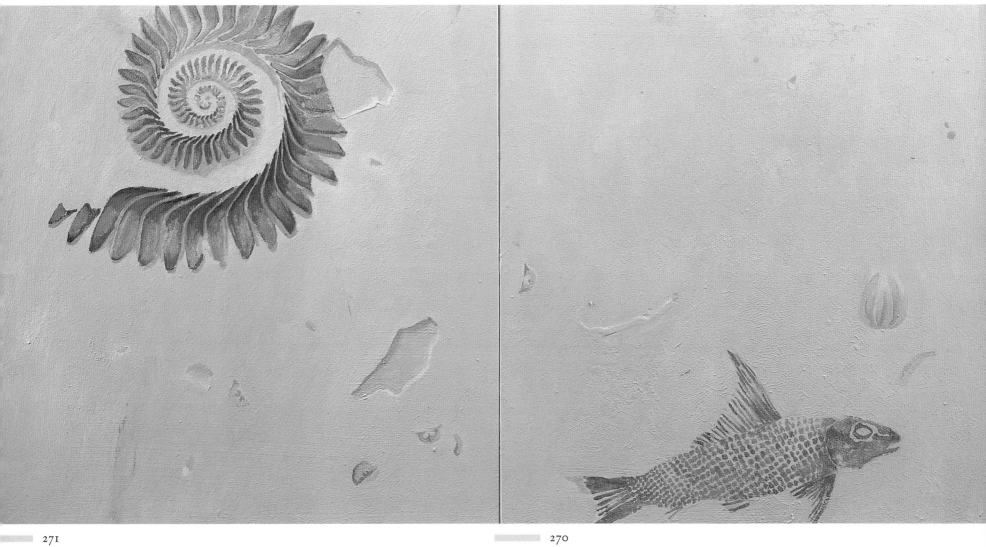

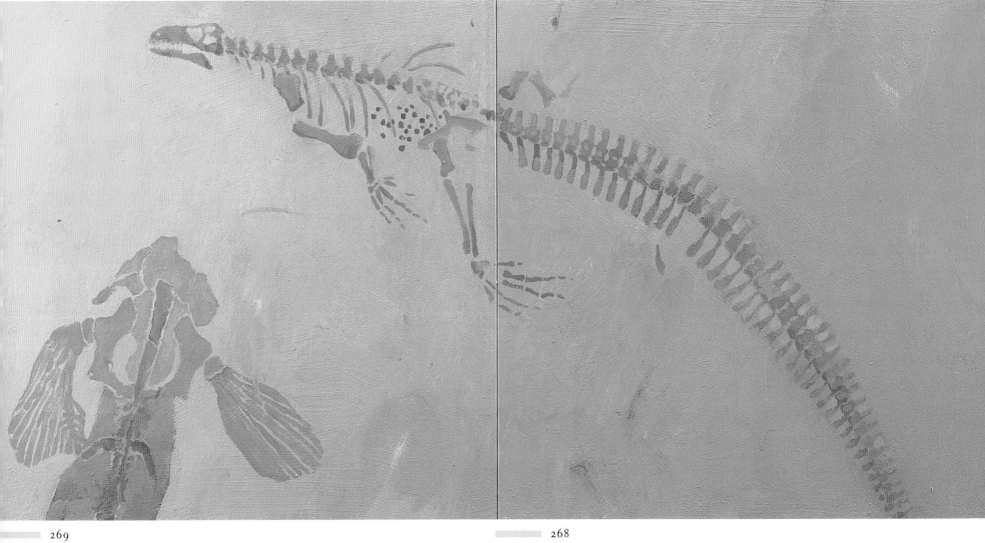

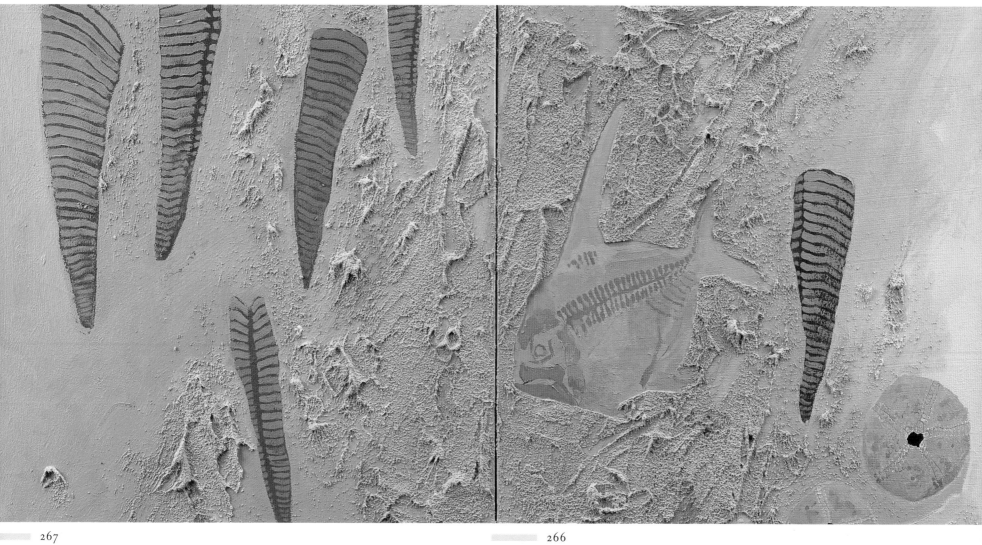

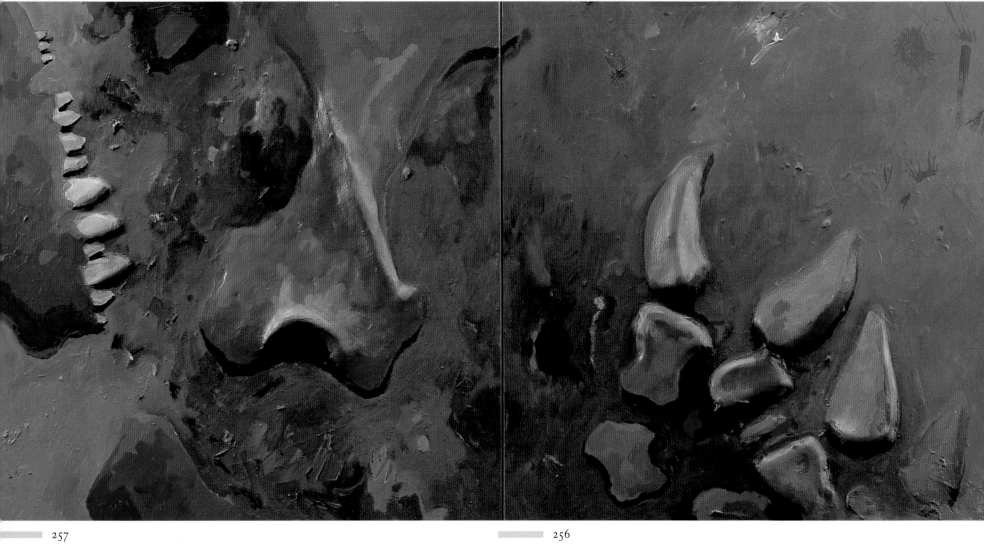

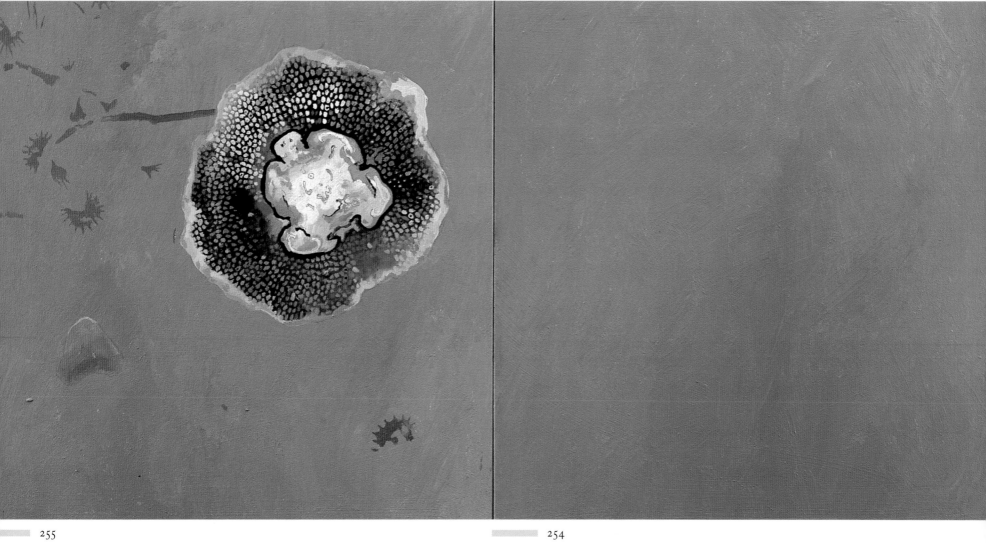

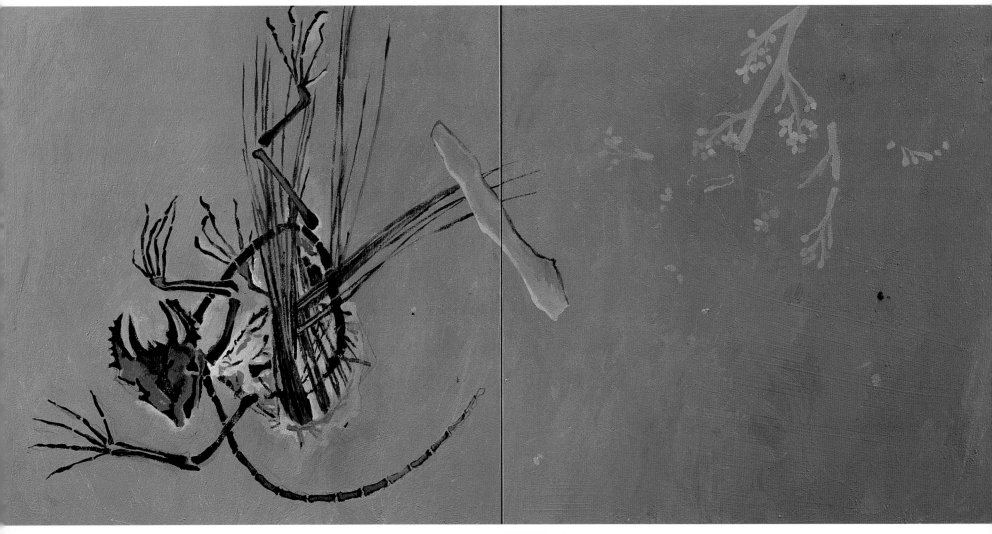

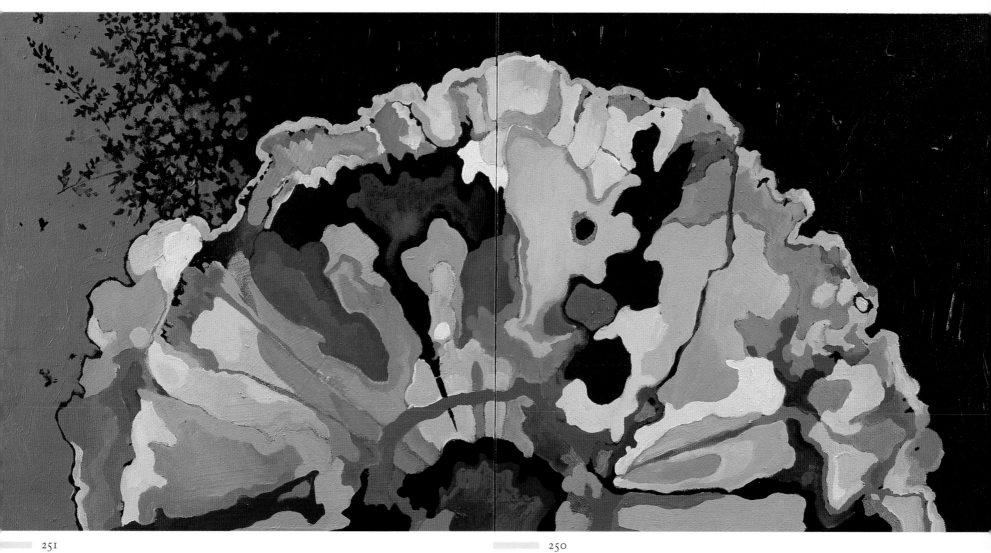

The Triassic

244 205

The end of the Permian was literally the end of one era and the beginning of another. So profound was the change wrought by the end-Permian extinctions that the boundary between the Permian and Triassic periods is second in profundity only to the Cambrian explosion. The Permian extinctions created a new world—the Mesozoic (meaning "middle life"). Gone for good are the trilobites, the sea scorpions, the rugose and tabulate corals, as well as many large groups of cephalopods, brachiopods, and arthropods. Gone are the beds of brachiopods and the "gardens" of stalked crinoids. The world of the post-Paleozoic oceans would be ruled by predators and filled with prey that would dig actively into the seafloor, rather than lying passively attached to it.

But this would take time. The Triassic oceans initially appear to have been very empty. Marine rocks that date to the beginning of the period tell the story of a very simple biological world, one with little diversity. As time passed, the survivors appear to have sorted themselves and each other out. By the middle of the period, sea life was dominated by groups that had been in the shadows during the Paleozoic. New kinds of ammonoids, snails, and clams proliferated. And new corals developed. No fossil corals at all are known from the early Triassic. All post-Paleozoic corals, including those that build the great reefs of today, are evidently the descendants not of Permian corals but of non-coral, anemone-like ancestors. Perhaps in their place, giant layered mounds of mud built by mats of bacteria and algae, called stromatolites, experienced a short-lived bloom. Reptiles also invaded the sea and branched out into several forms, including the porpoise-shaped ichthyosaurs, that would go on to dominate the oceans for much of the remainder of the Mesozoic era.

On land, the Triassic saw the origination of two groups of animals that were eventually to have enormous impact: dinosaurs and mammals. Dinosaurs appear to have gotten the upper hand early on, for they went on to dominate life on land for the next 140 million years or so. Dinosaurs quickly split into two great groups, distinguished on the basis of their hip bones: the ornithischians (or "bird-hipped") and the saurischians (or "lizard-hipped"). By the end of the Triassic, dinosaurs were modestly diverse across much of the world. Mammals persisted from the Triassic onward, but none got much larger than a shoebox throughout the Mesozoic. Crocodiles, turtles, and flying reptiles (pterosaurs) also appeared in the Triassic. Cycads, conifers, and ginkos dominated terrestrial vegetation.

The Triassic began with all of the continents together in Pangaea. During this period the supercontinent gradually began to break up, but continental conditions still prevailed across much of the world. Triassic rocks in several areas, including the western U.S. and Britain, contain red beds similar to those formed in the Permian. These red layers form one of the three divisions of the Triassic rocks in Germany, for which the period is named.

The Triassic ended with yet another episode of mass extinction, but this one was much less severe than the one that marked the beginning of the period. The event struck life on both land and sea. Most affected in the oceans were the ammonoids and clams, of which few survived, as well as snails, sponges, and marine reptiles. On land, several groups of reptiles that had been very successful throughout the Triassic disappeared or were much diminished. The end-Triassic extinction may actually have been more than a single event; two or even three episodes of extinction may have occurred in rapid succession. The causes remain unclear; changes in climate, sea level, and ocean currents, as well as extraterrestrial impact, have all been blamed.

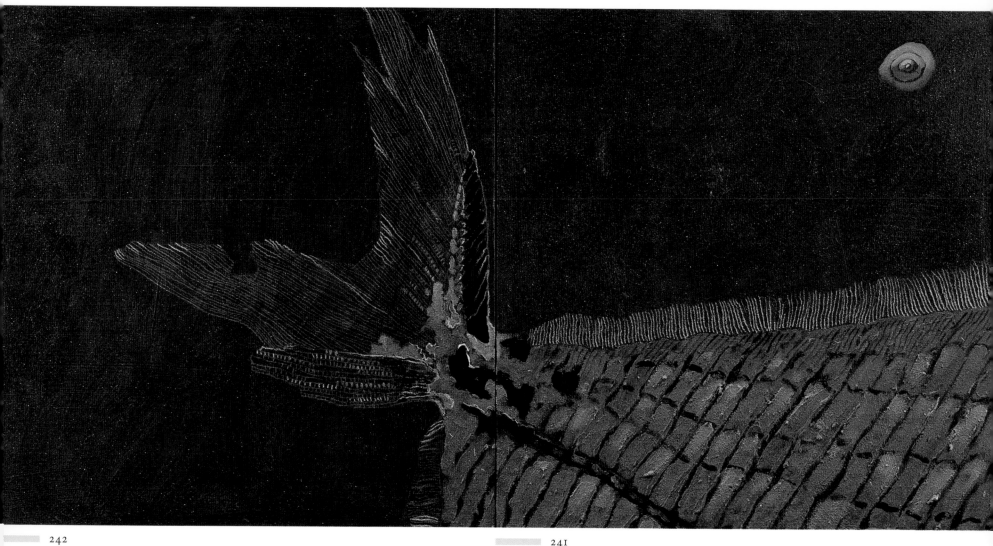

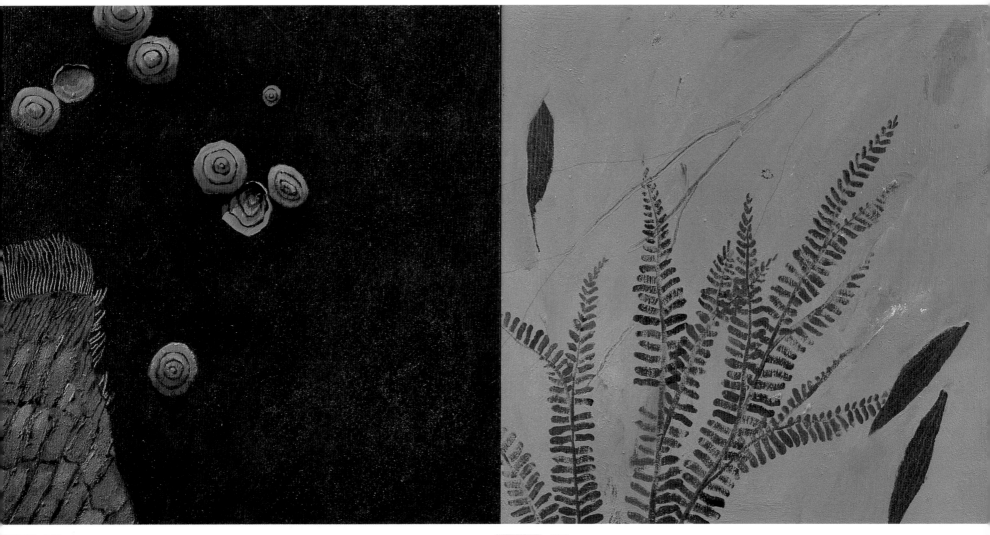

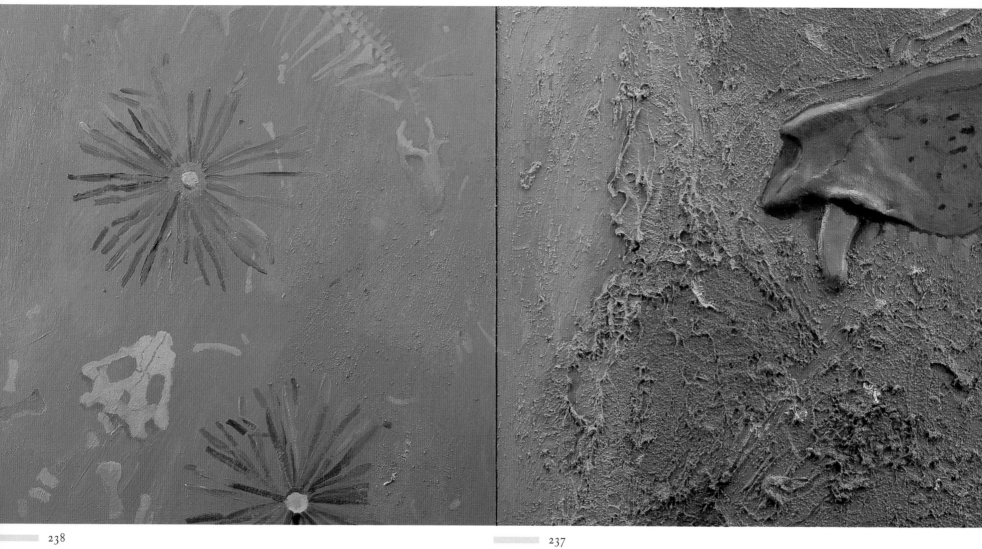

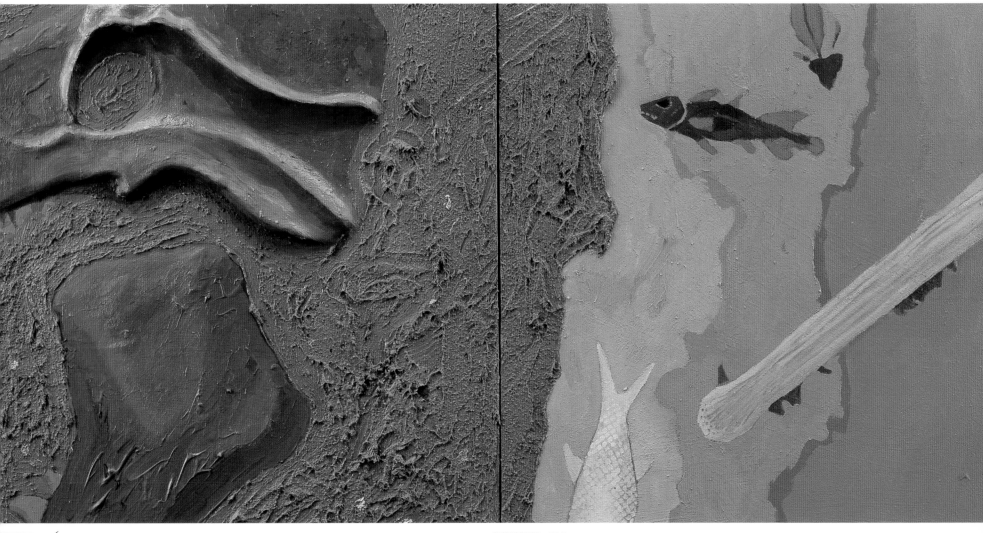

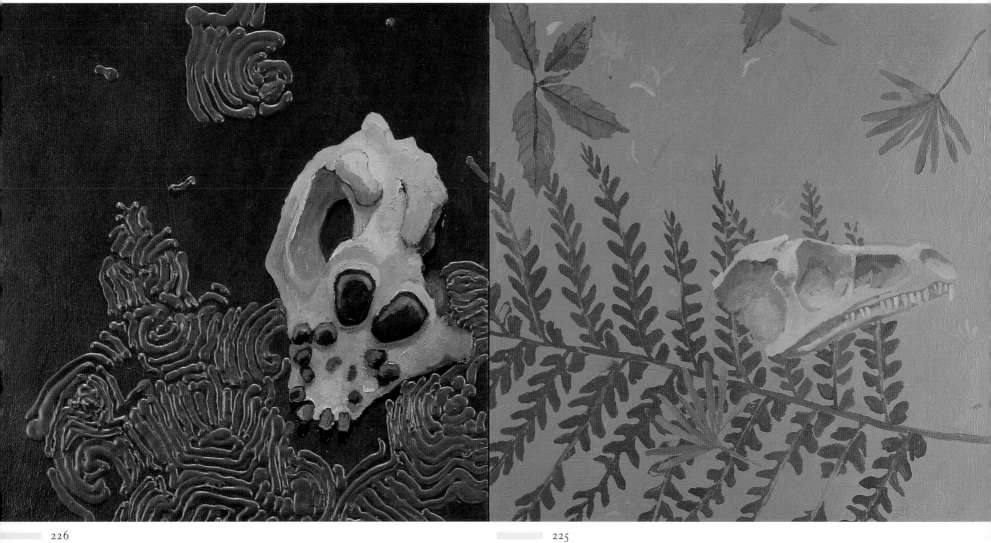

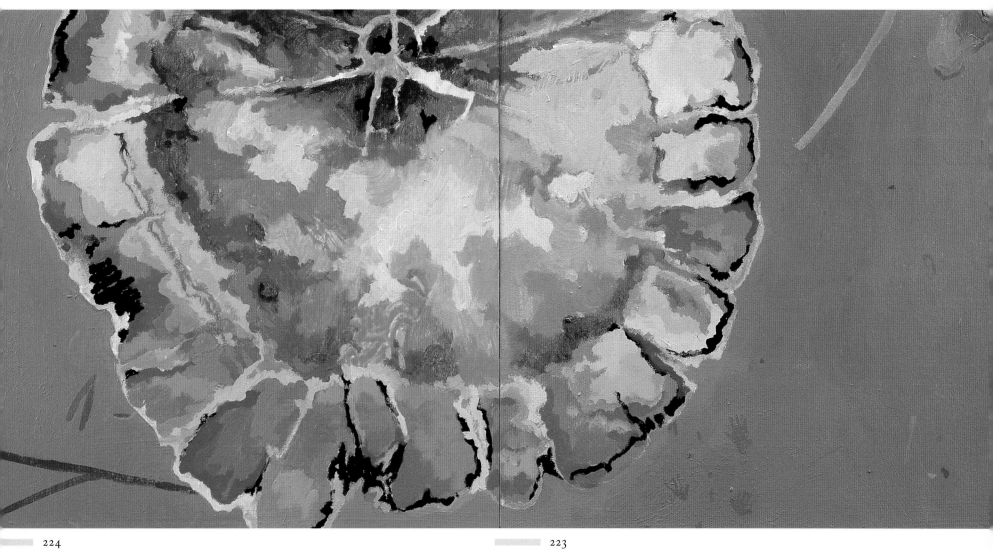

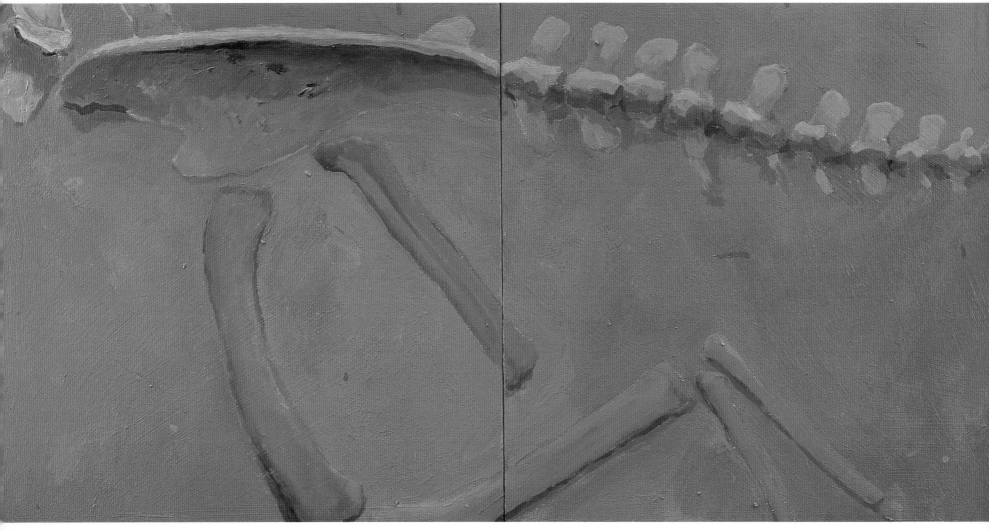

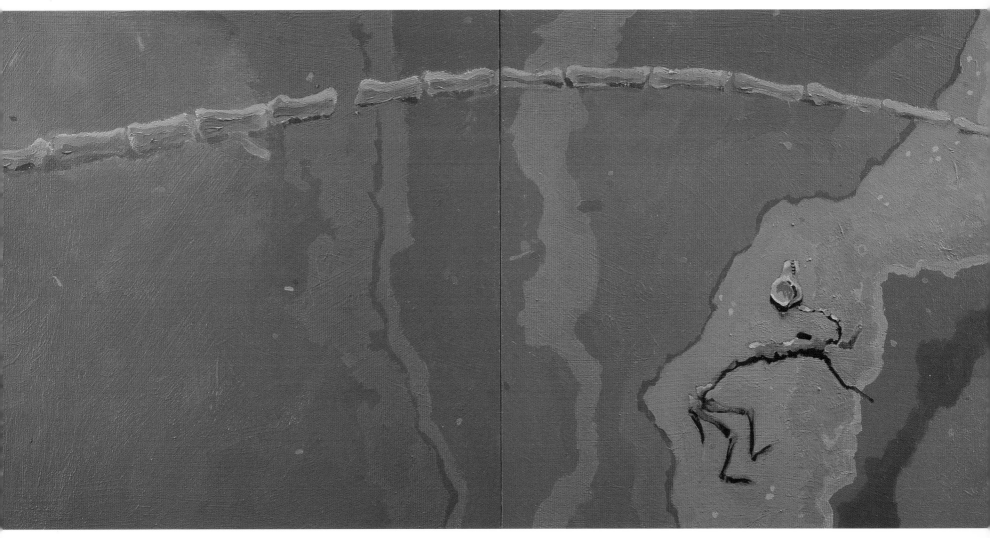

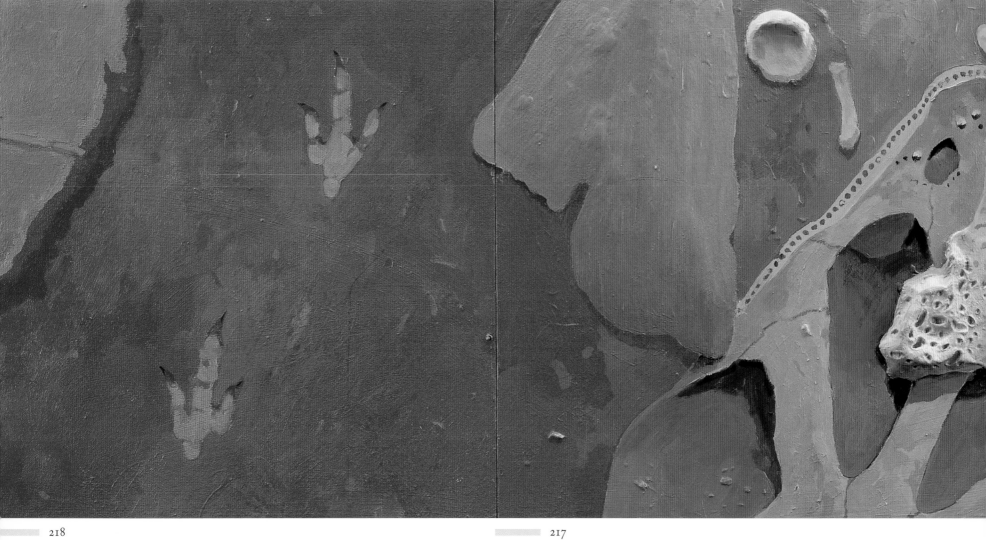

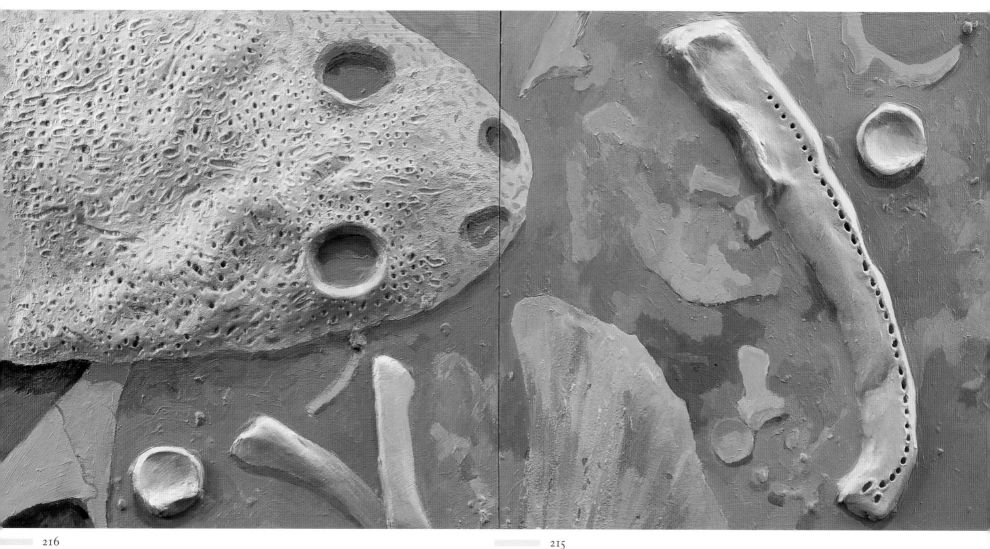

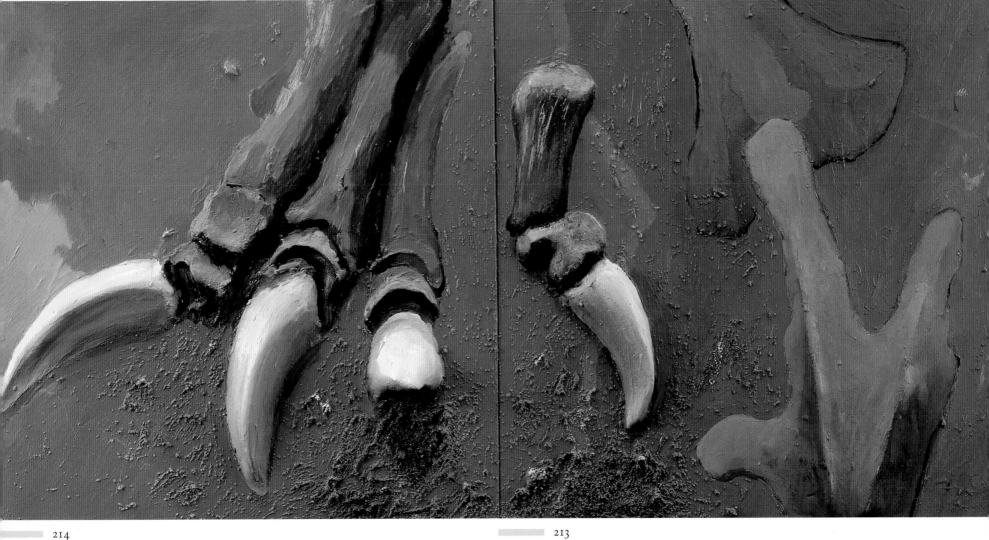

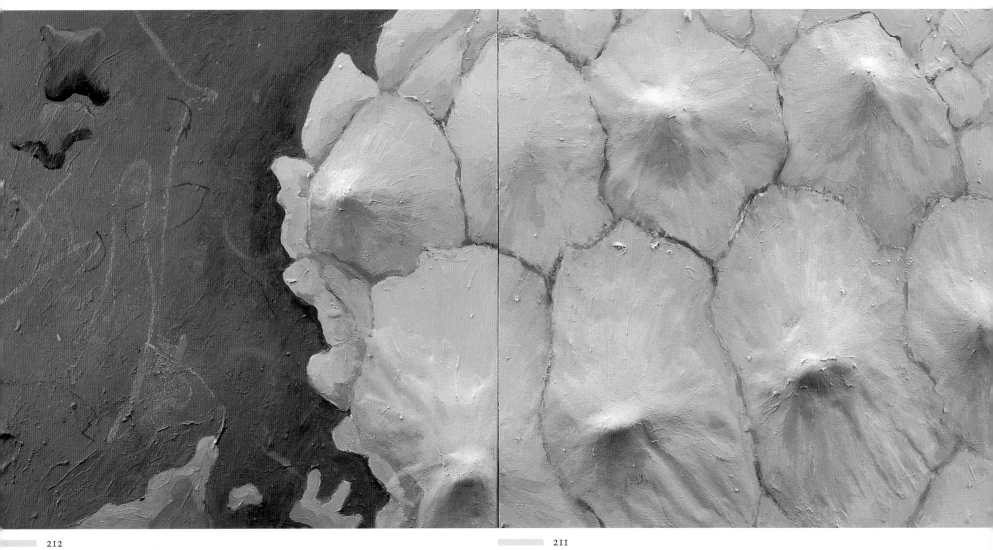

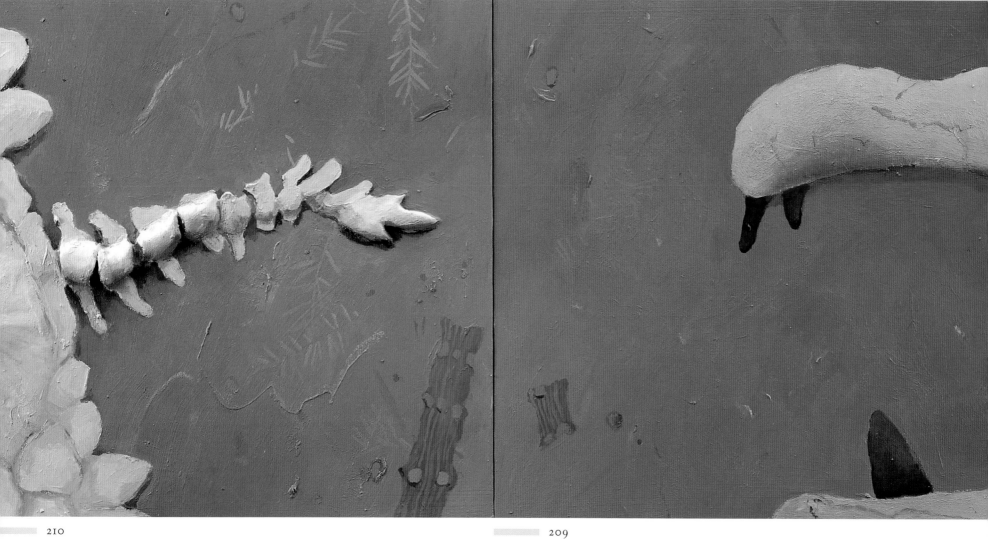

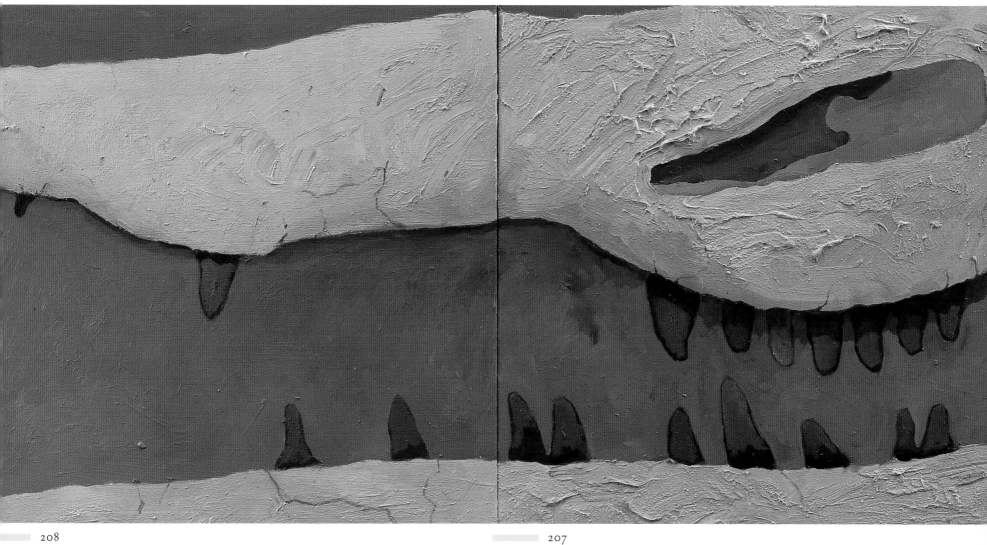

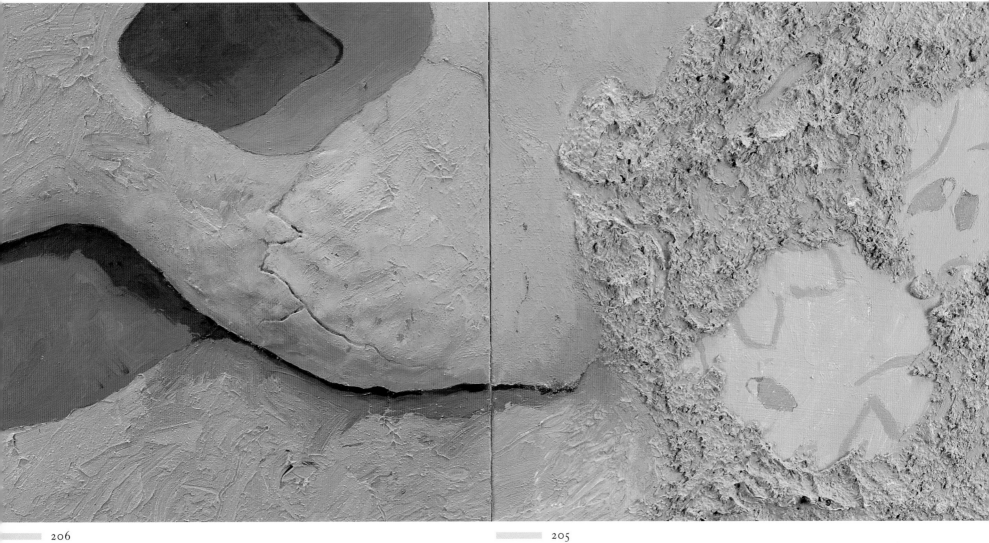

The Jurassic

204 141

As the supercontinent of Pangaea continued its breakup, volcanic material was pushed up from the ocean floors that appeared as the continents moved apart. This raised sea levels around the world, flooding much of the continental surfaces of the Earth. The limestone and other rocks that form the Jura Mountains of Switzerland were laid down in these shallow seas, and the mountains give their name to the Jurassic Period. As Pangaea broke apart, a set of cracks developed along what is now the east coast of North America; these cracks went on to form the valley of the Connecticut River and other elongate valleys as far south as New Jersey and Virginia. Lakes filled these valleys; in the lakes lived a great diversity of fish and along their shores walked herds of dinosaurs. Fossils of these fish and dinosaurs may be found today in Connecticut and western Massachusetts.

The Jurassic is perhaps best known as the time of the gigantic long-necked sauropods and other dinosaurs, and indeed it was the heyday for these enormously successful creatures. More than 600 kinds of dinosaurs have been discovered and named by scientists, surely only a fraction of what actually existed. They range from the size of a crow to that of a blue whale. They lived on every continent, from Alaska to Madagascar to Antarctica. One of the most dinosaur-rich layers of rock ever found is the Jurassic-aged Morrison Formation, exposed along cliffs and buttes in Wyoming, Colorado, and Utah. The sediments of the Morrison accumulated along the flood plains of meandering rivers that were flowing into the sea. Dinosaurs lived, died, and were buried along these rivers, and we can see their skeletons today at Dinosaur National Park on the Colorado-Utah border, in almost the same condition they were in when they died.

From one branch of dinosaurs (probably small carnivorous saurischians) evolved a group of animals with feathers and adapted for flight. The oldest known fossil bird, *Archeopteryx*, was discovered in a German limestone quarry in 1860. The limestone had accumulated in a shallow lagoon near the end of the Jurassic Period, approximately 150 million years ago. The fossils in this fine-grained limestone are so well-preserved that even delicate features such as feathers are visible. The limestone—called Solnhofen—is one of the world's most spectacular fossil deposits.

During the Jurassic, flowers appeared for the first time on Earth, although they apparently did not become very widespread until the Cretaceous Period.

Pterosaurs greatly increased in size and variety during the Jurassic, as did the many kinds of marine reptiles, including ichthyosaurs and the long-necked plesiosaurs. Also in the sea, the ammonoids and clams recovered from the late Triassic extinction and developed new forms and many varieties. Oceanic plankton, the base of all modern marine food chains, expanded considerably. Sea urchins began to burrow in the seafloor in addition to just crawling around on top of it.

The world the Jurassic dinosaurs and their contemporaries inhabited had a warm and equitable climate from equator to pole. High sea levels led to low circulation in the shallow waters covering the continents, which in turn led to the formation of great expanses of stagnant ocean. There was little oxygen at the bottom of these areas, and the muds that accumulated there were black with unoxidized carbon and formed thick layers of rock, known as black shale. Fossils preserved in Jurassic black shale—including beautiful ichthyosaurs and plesiosaurs—are some of the most well-preserved anywhere in the geological record.

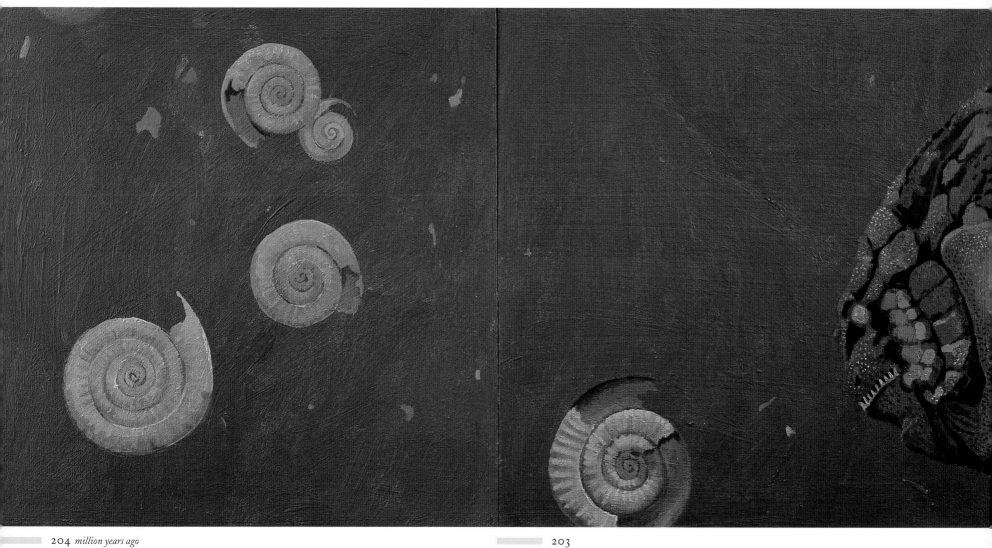

204 *million years ago*

203

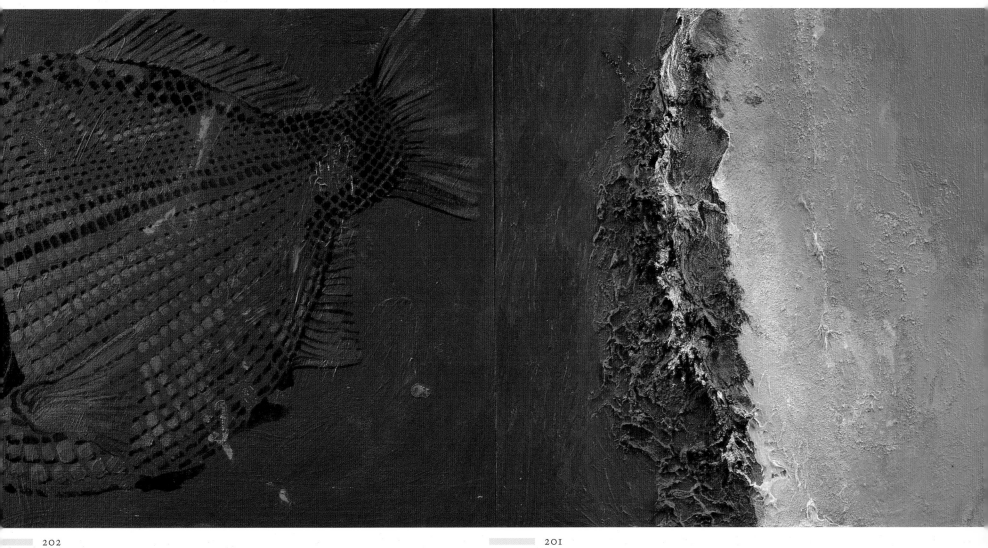

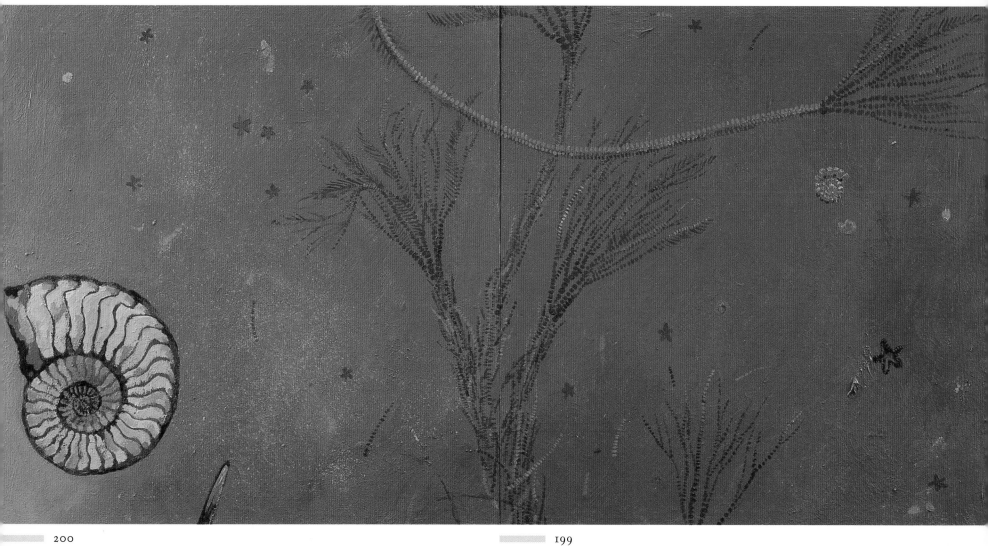

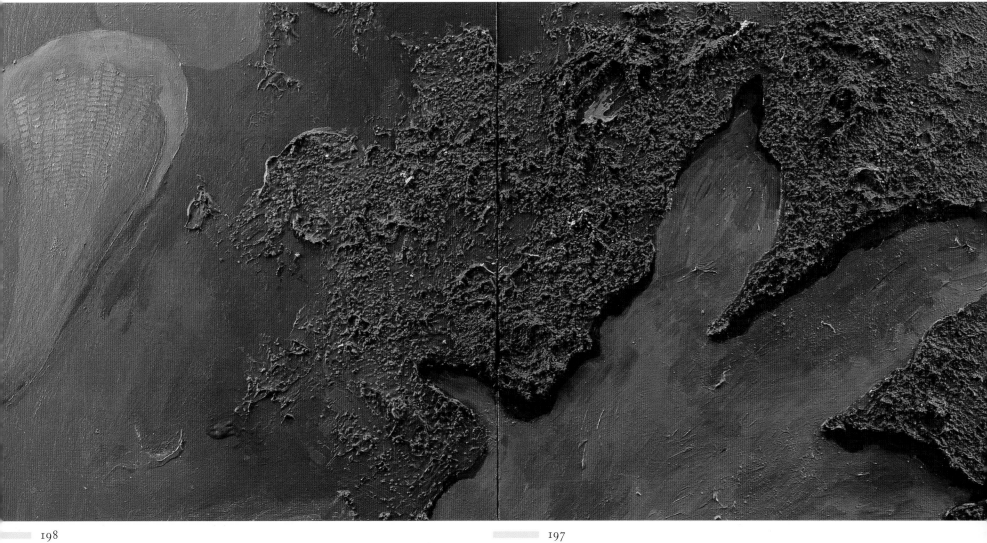

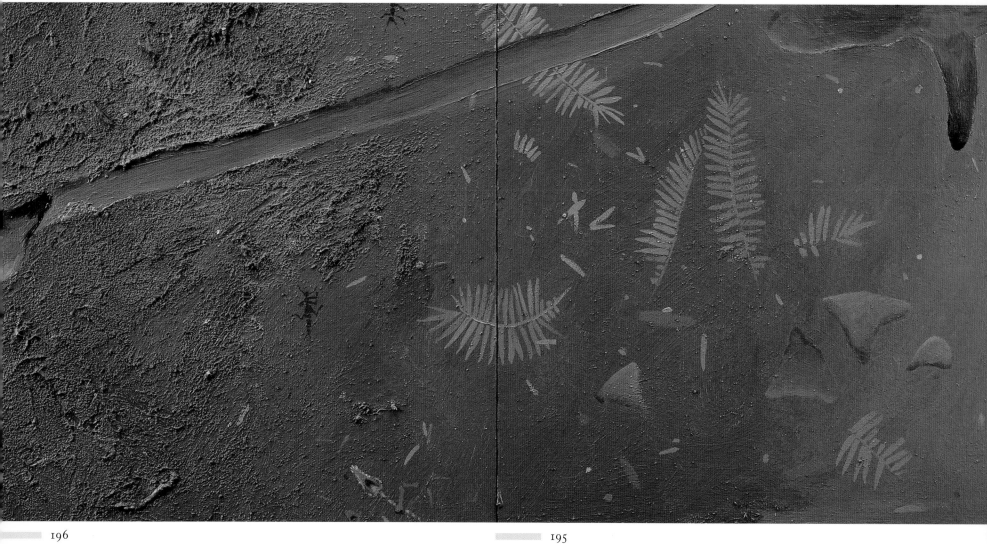

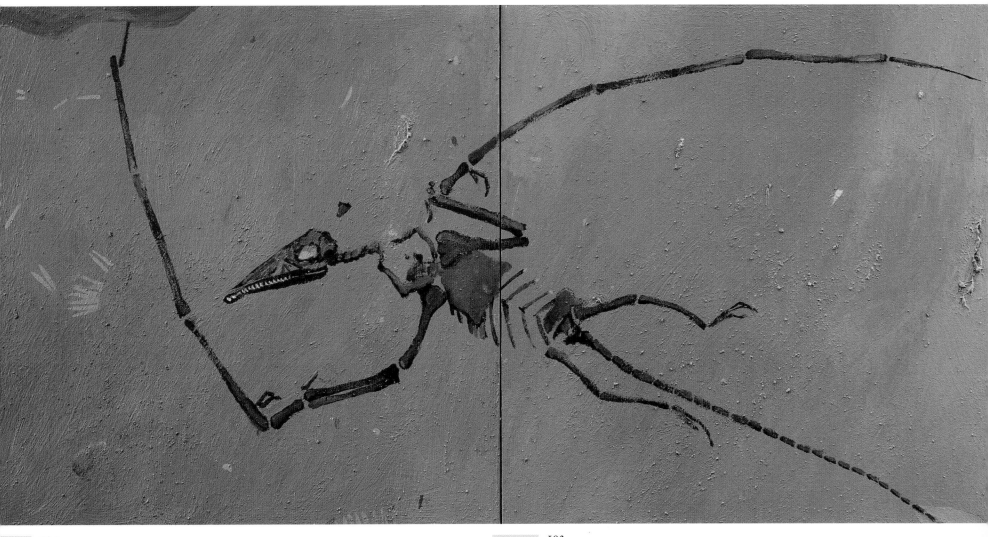

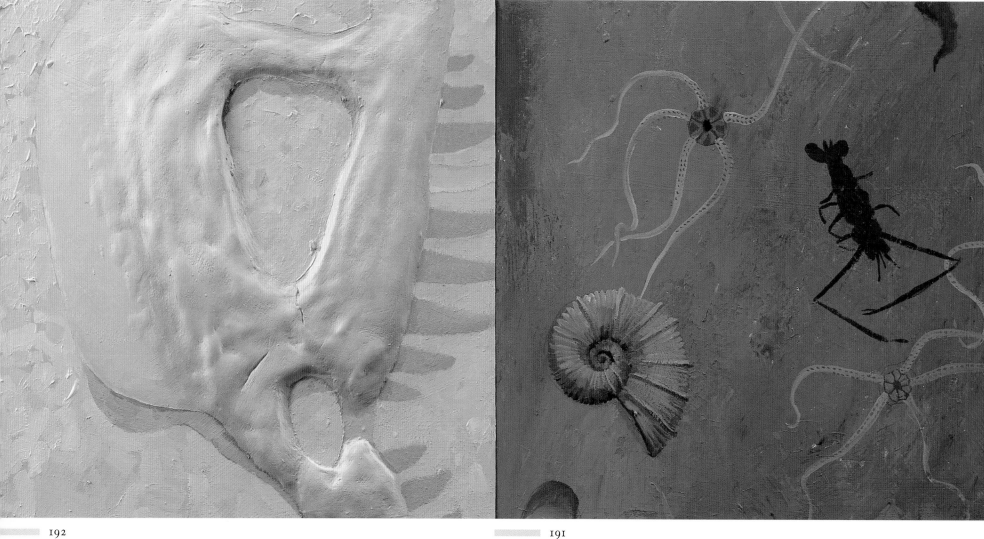

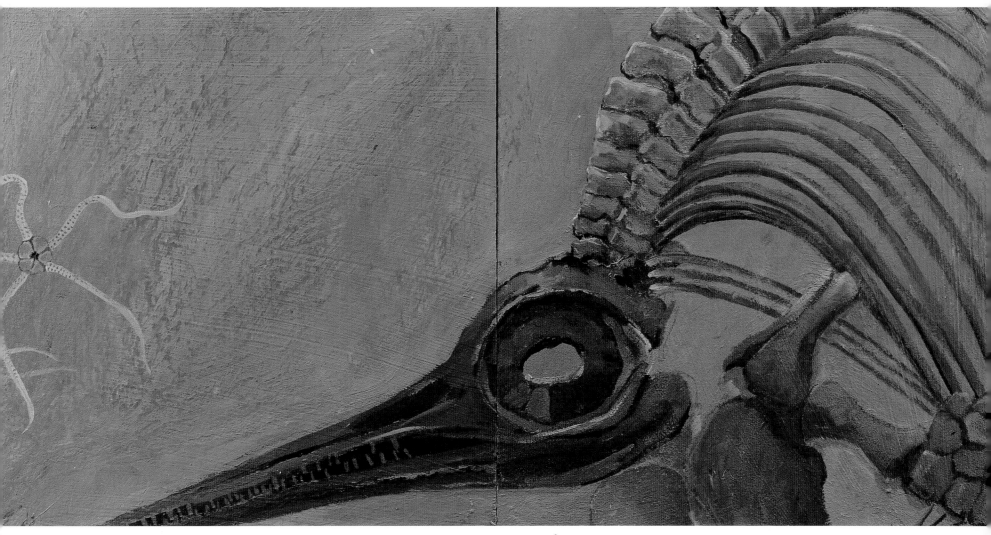

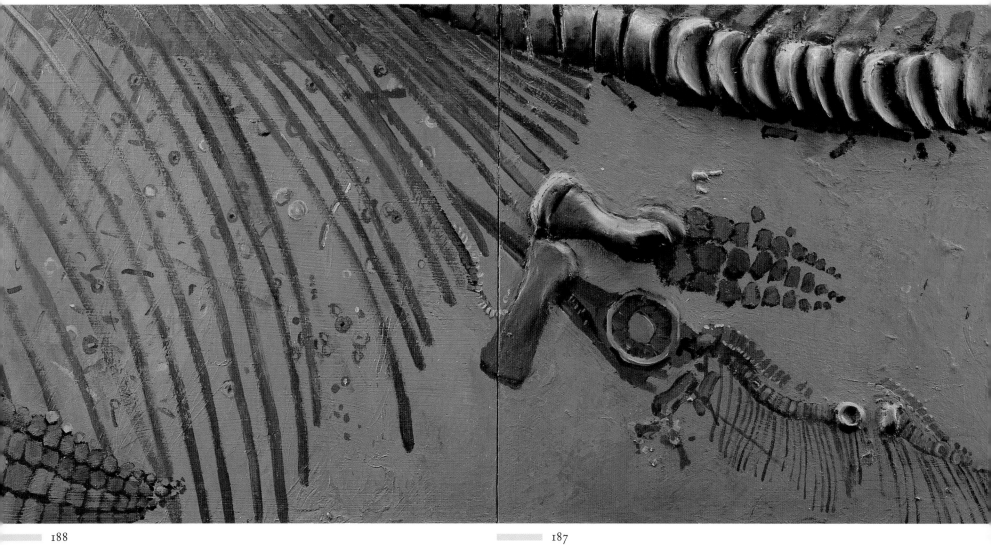

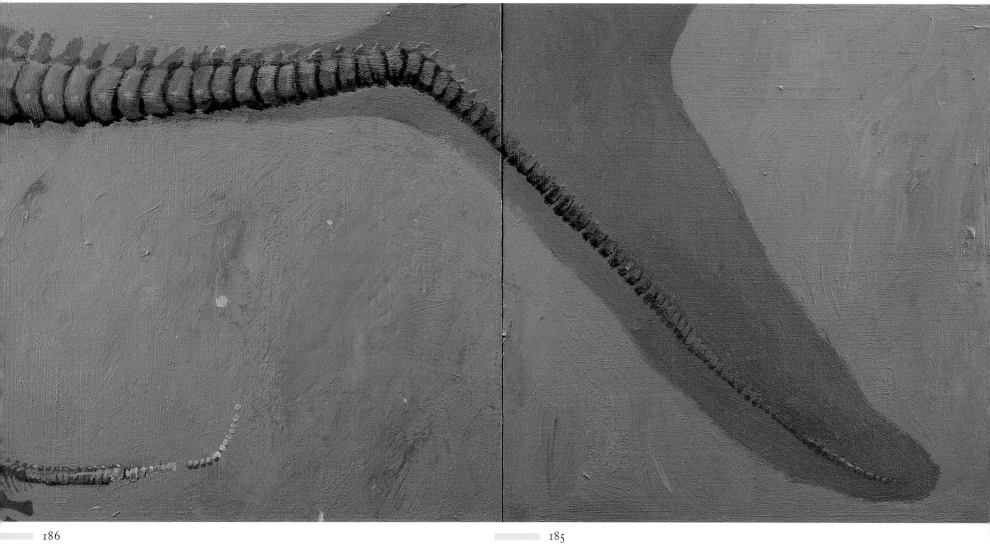

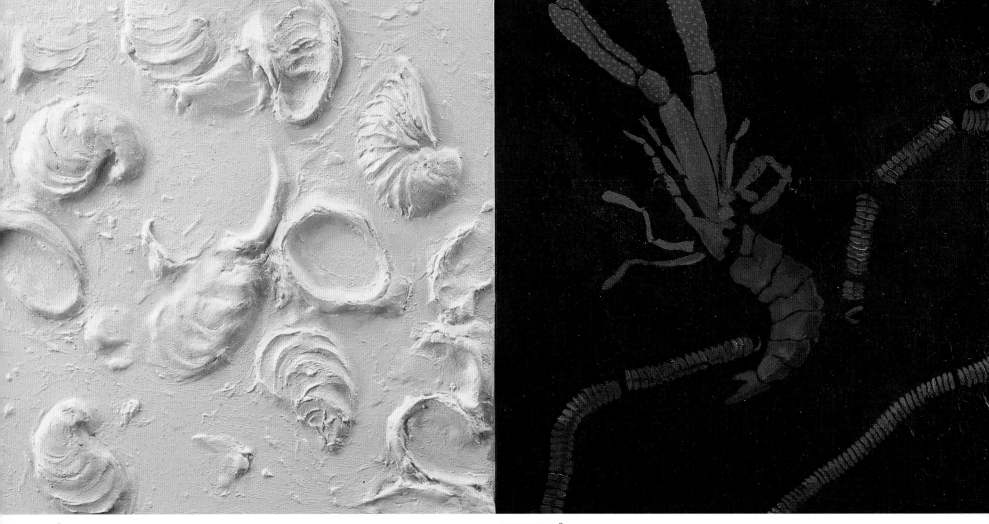

184

183

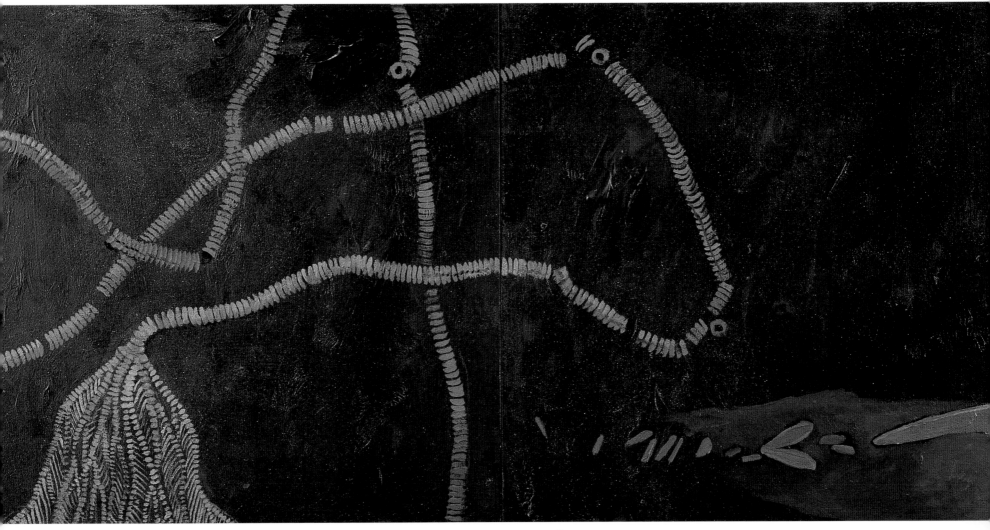

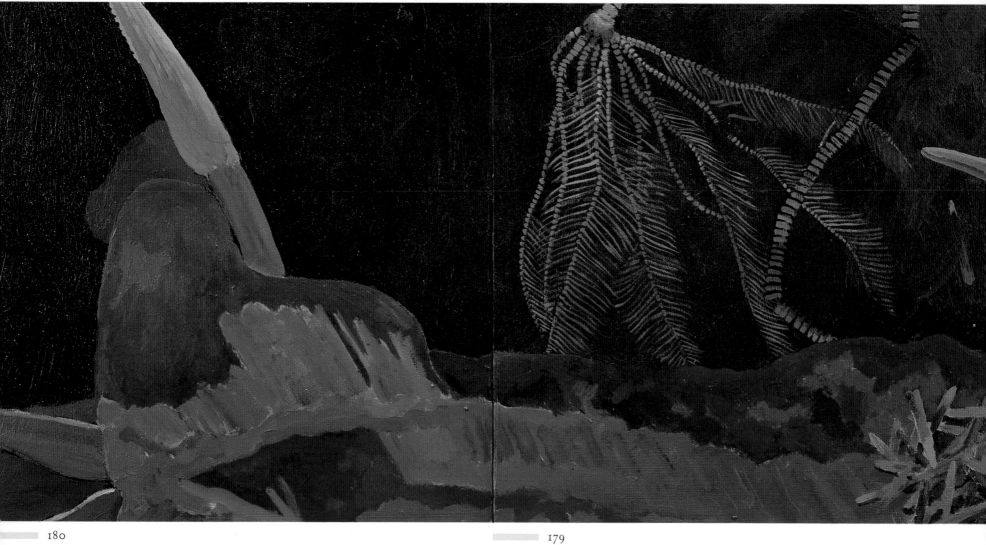

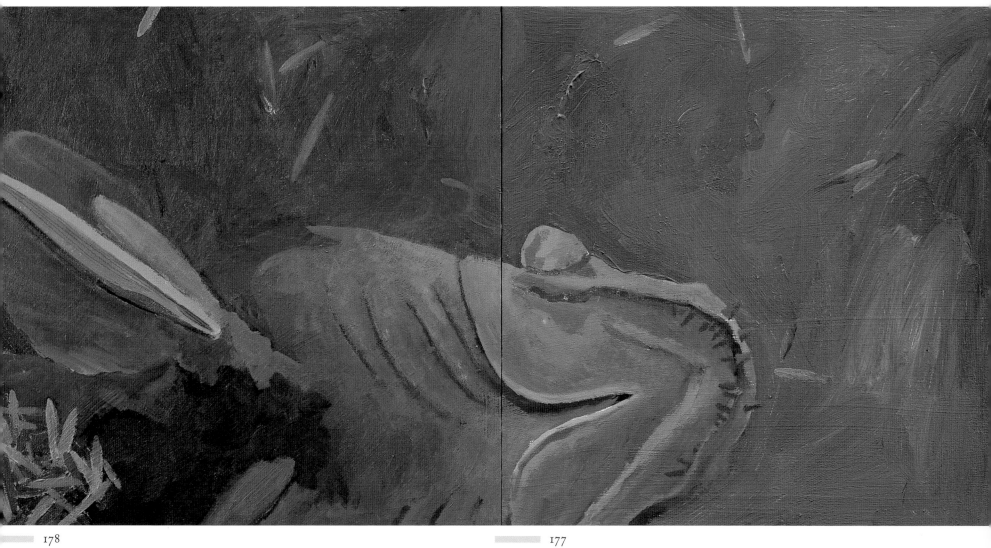

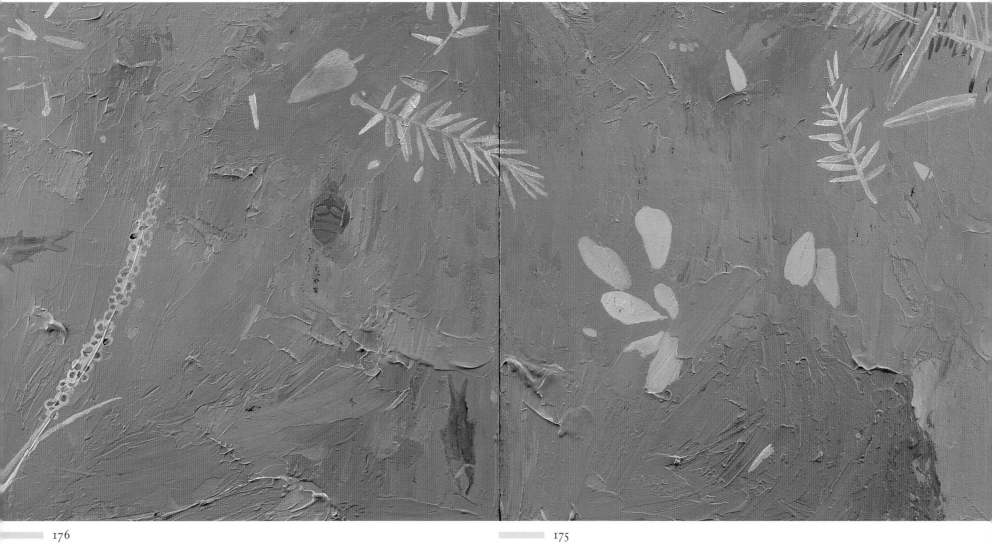

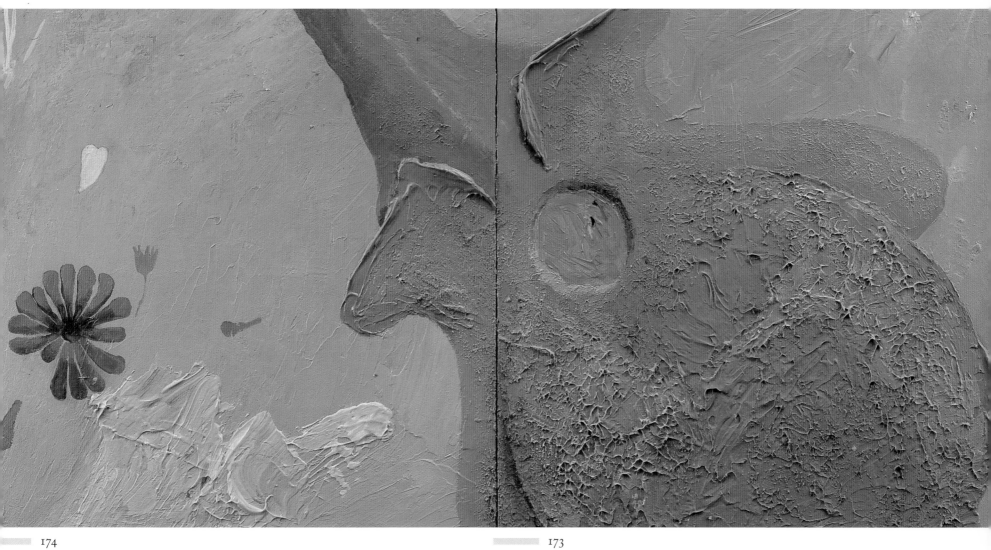

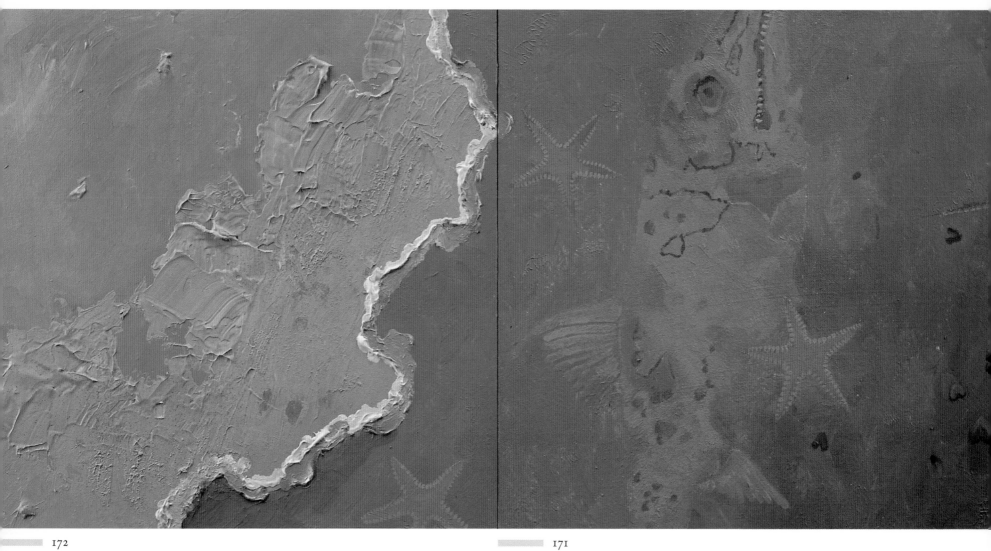

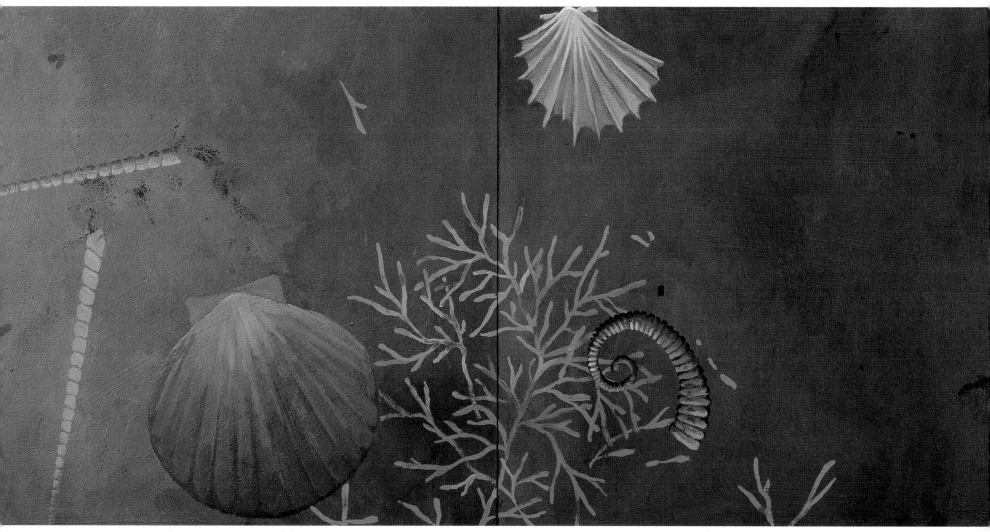

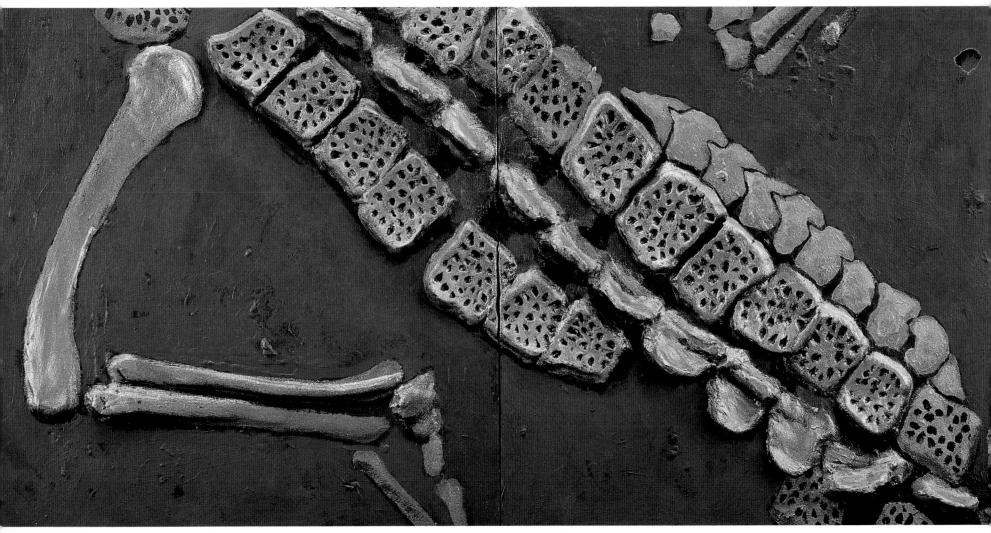

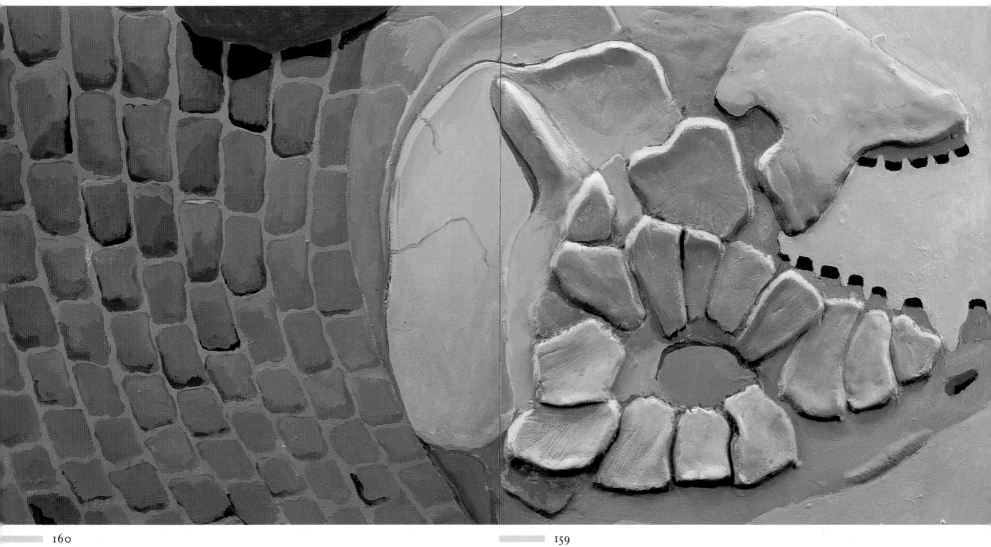

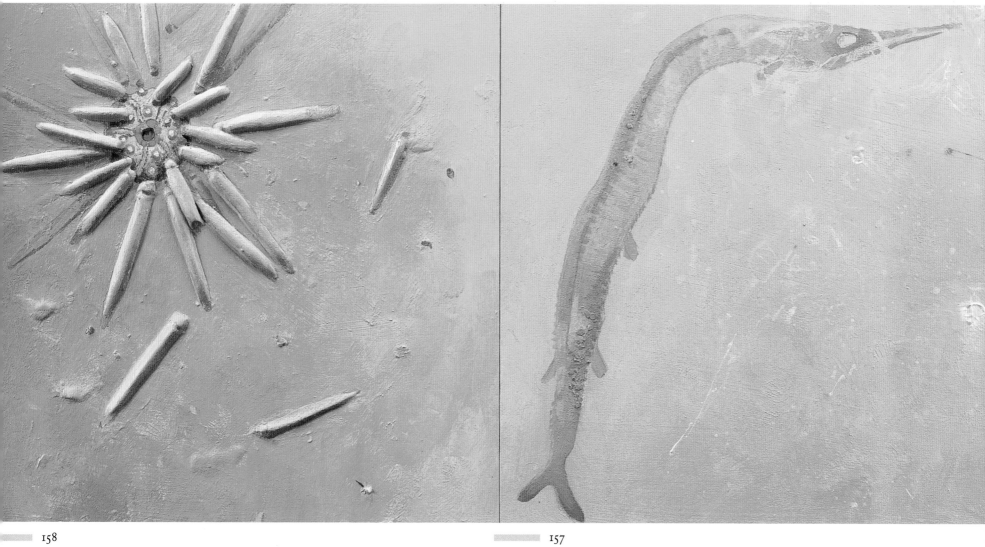

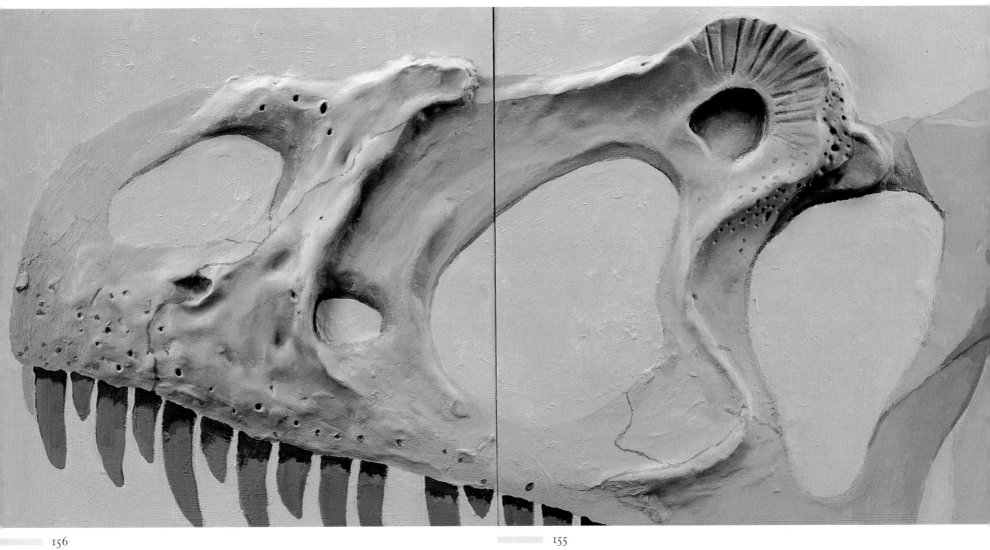

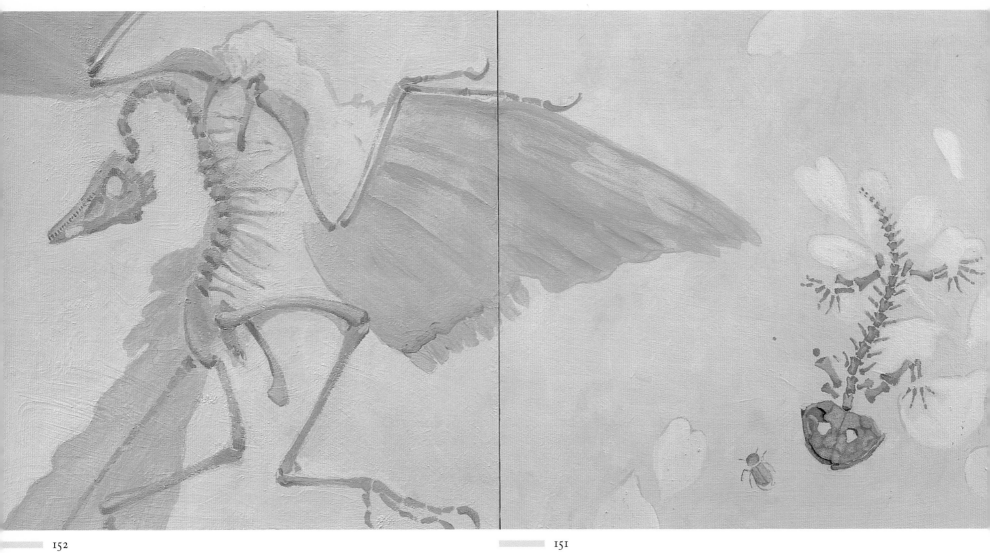

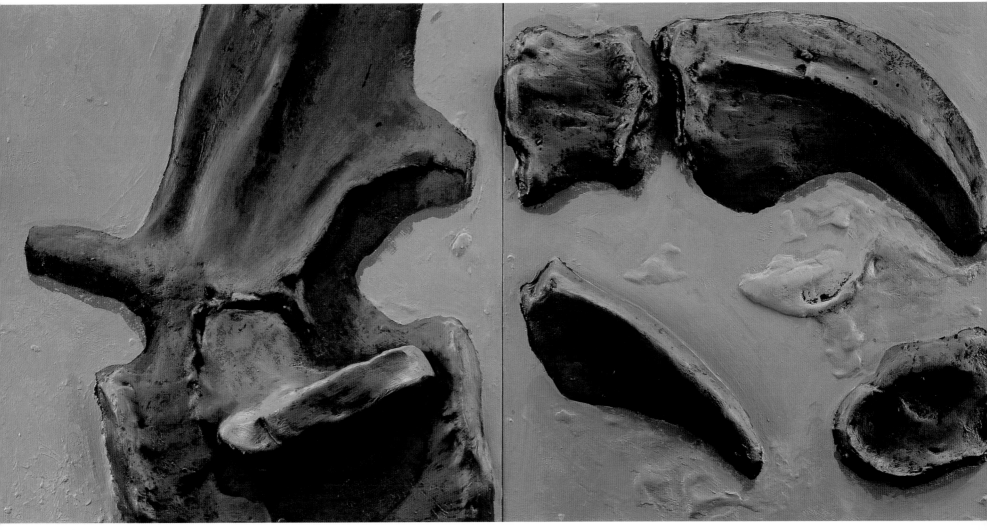

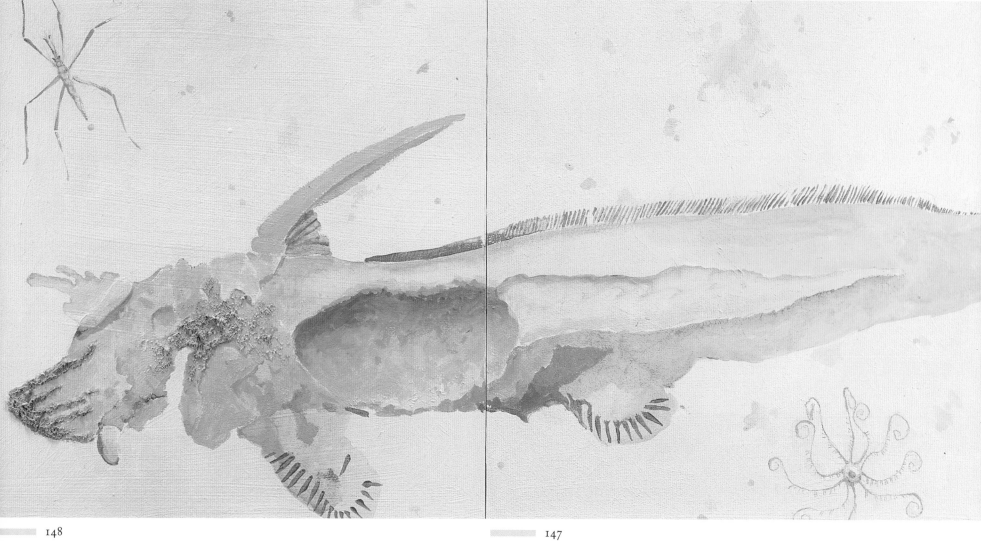

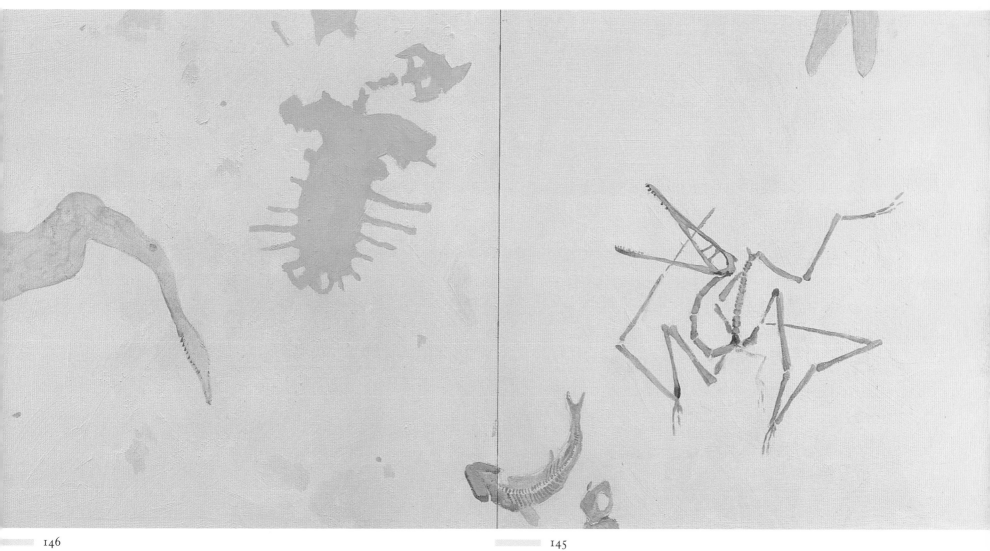

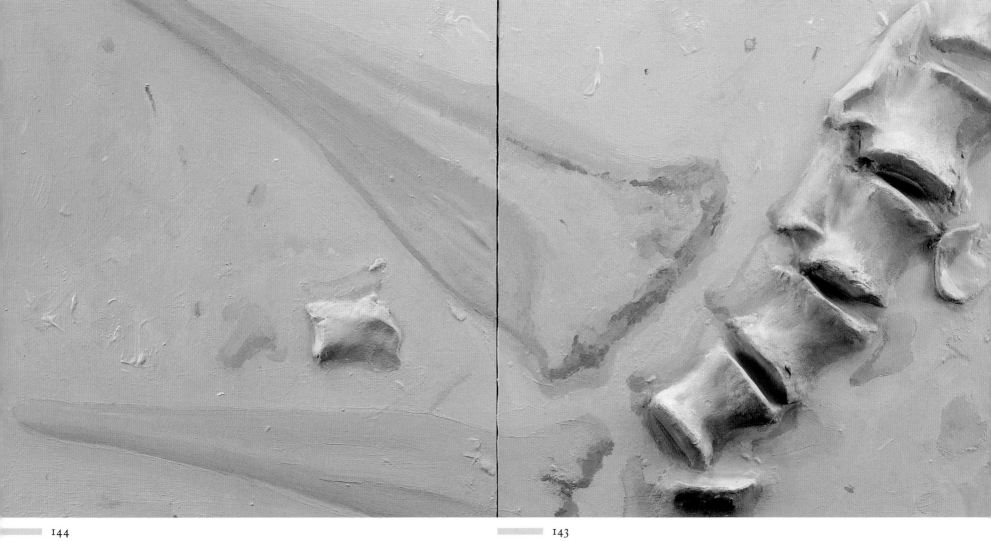

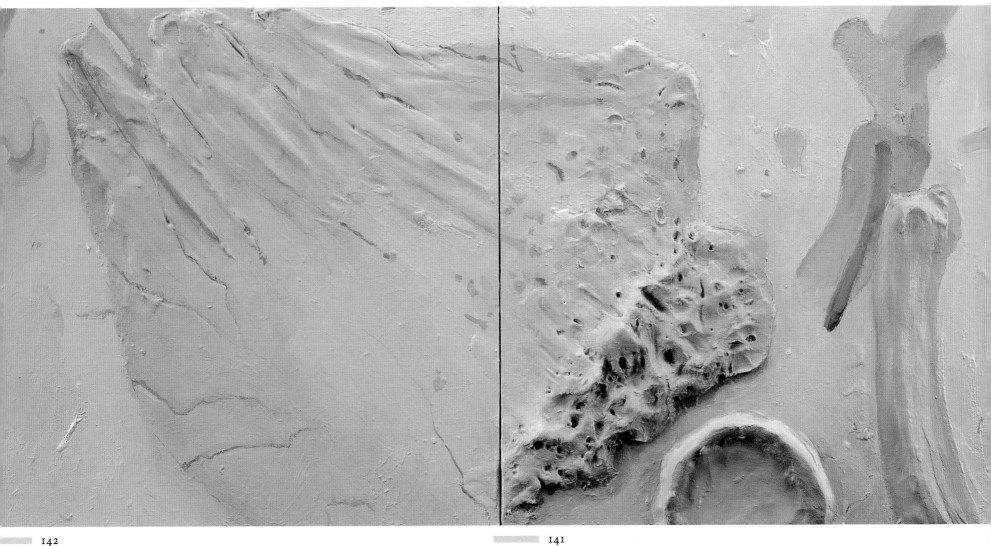

142 141

The Cretaceous

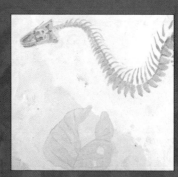

140　　65

Every moment in Earth history is unique; this is one of geology's most profound messages. No two mountain ranges or brachiopods or mammals are the same. Each event depends on what happened previously and determines, at least in part, what follows. So it is a truism to say that one or another period was "unique" or "different from the present." Nevertheless, if one were forced to choose a time that was most different from the present, one might well choose the Cretaceous.

The continental breakup that began in the Triassic and Jurassic accelerated. Volcanic activity was at a peak. The climate was substantially warmer than at present, perhaps by as much as 5 degrees Celsius. There was probably no ice anywhere on Earth. This contributed to what may have been the highest sea levels throughout all history. Huge areas of the continents were covered with shallow seas—a shallow seaway extended across North America from the Gulf of Mexico to Alaska. Black shales even more extensive than those that formed during the preceding Jurassic Period extended across large areas of sea floor. The organic material in these rocks was eventually converted into "fossil fuels" such as the petroleum found in areas like the modern Persian Gulf. Elsewhere in these huge shallow seas, plankton thrived. When their tiny skeletons dropped to the seafloor by the hundreds of billions, they formed a fine-grained sediment that today we call chalk. The Cretaceous takes its name from the Latin (and French) words for "chalk." The famous white cliffs of Dover in southern England are made of Cretaceous chalk.

The seas would have struck us as very weird (and probably very frightening) places had we been there to see them. There were vast schools of predatory ammonoids, perhaps swimming and feeding much as fish do today. Clams that looked like corals formed reefs. Ichthyosaurs declined but plesiosaurs diversified, and were joined by giant sea-going lizards called mosasaurs. All of these marine reptiles appear to have been voracious predators on fish and ammonoids alike.

But something else was happening in the oceans, something that was a preview of things to come. Clams, snails, fish, and crabs were expanding. Predators were putting pressure on prey, which were adapting by evolving defenses to crushing and breaking. This was the beginning of a revolutionary change in the way sea life was to evolve and look for a hundred million years.

On land, it was the very peak of the dominance of dinosaurs. Familiar characters such as the carnivorous *Tyrannosaurus rex* and the horned *Triceratops* shared the period with less famous forms such as the duckbills *Parasaurolophus* and *Iguanodon*, the horned *Centrosaurus*, the ostrich-like *Struthiomimus* and many others. Recent discoveries of extremely well-preserved Cretaceous fossils in China suggest that some dinosaurs that were very close relatives of birds may themselves have had feathers. Birds expanded dramatically from their modest Jurassic beginnings to include many forms that lived on land as well as in the sea. Mammals also expanded, although they remained very small throughout the period. And there were flowers. From their start in the late Jurassic, flowering plants exploded in diversity and abundance across the Cretaceous landscape, joined by an apparent surge in insects which fed on and distributed pollen from the new flowers.

All of this came to an end with what may have been one of the most abrupt and catastrophic events in all of Earth's 4.5 billion year history. Evidence is now overwhelming that one or more comets or meteorites struck the Earth about 65 million years ago, releasing energy equivalent to thousands of nuclear weapons and rapidly altering the Earth's environment by throwing dust into the atmosphere, causing tidal waves, wildfires, and perhaps volcanic eruptions. Within a very short period—probably no more than a few years—as many as half the species on Earth vanished. The casualties included, most famously, the dinosaurs, but just as significantly nearly all the plankton in the ocean, all of the ammonoids, and many kinds of clams, snails, and other marine life.

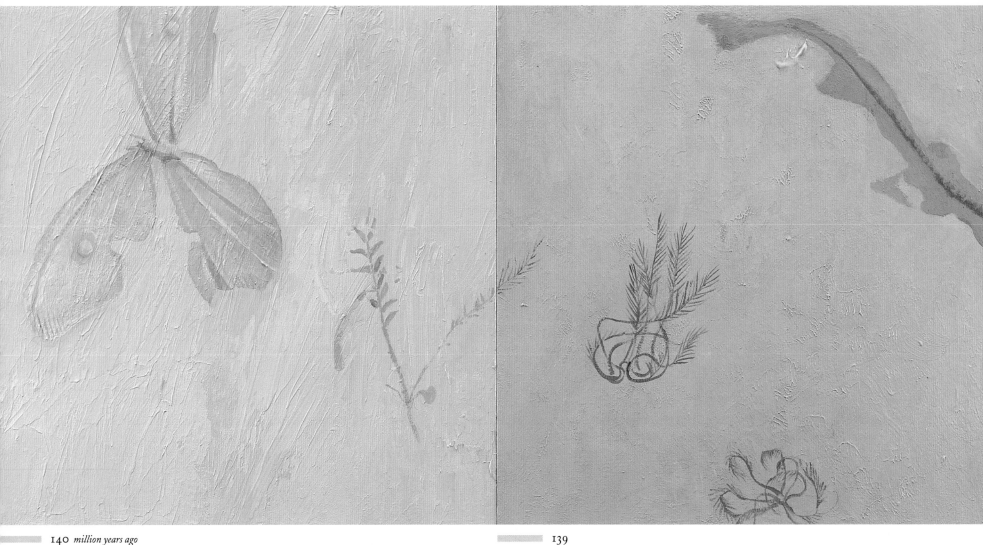

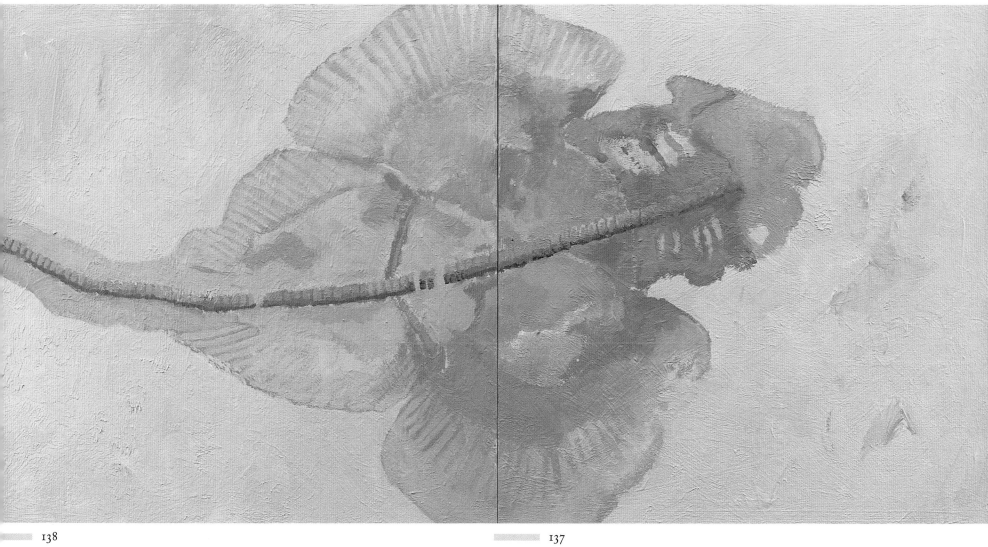

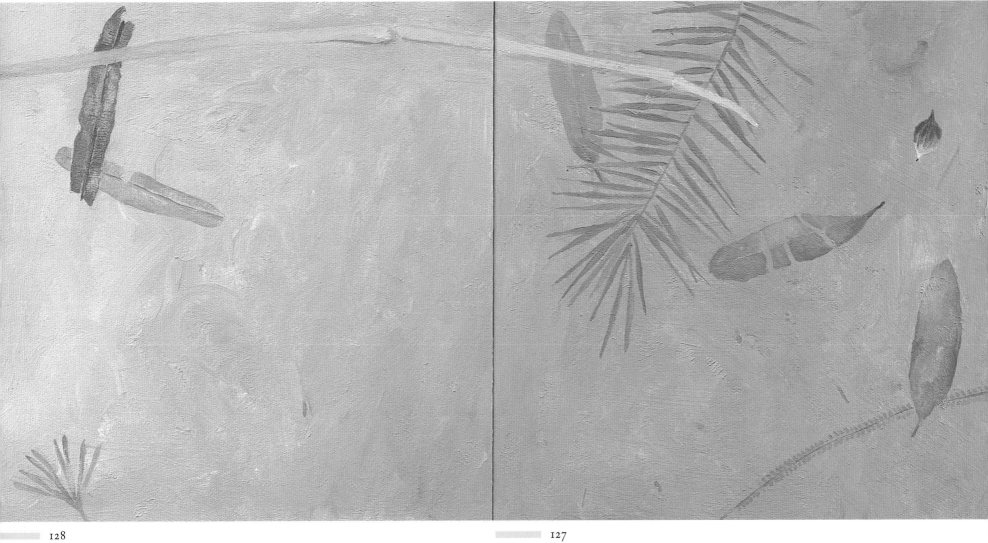

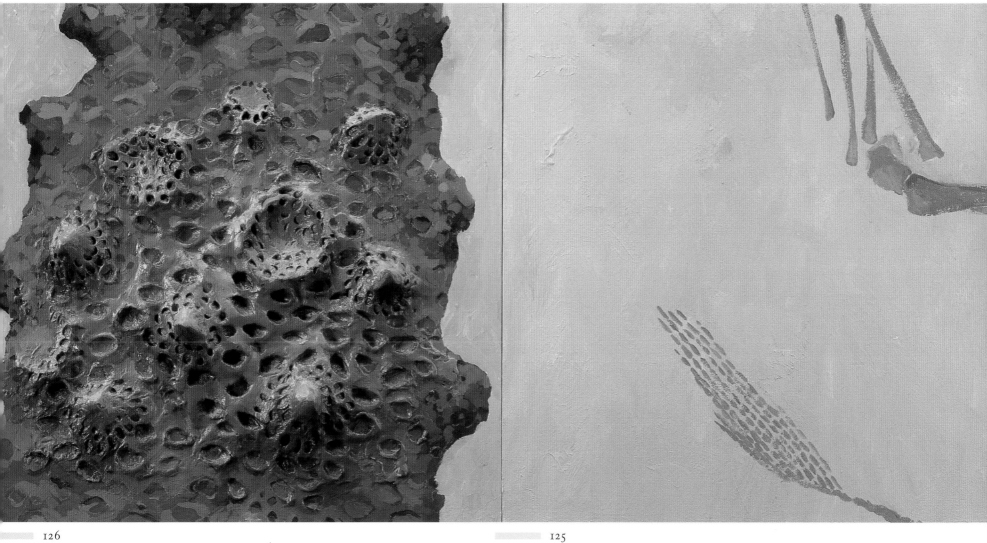

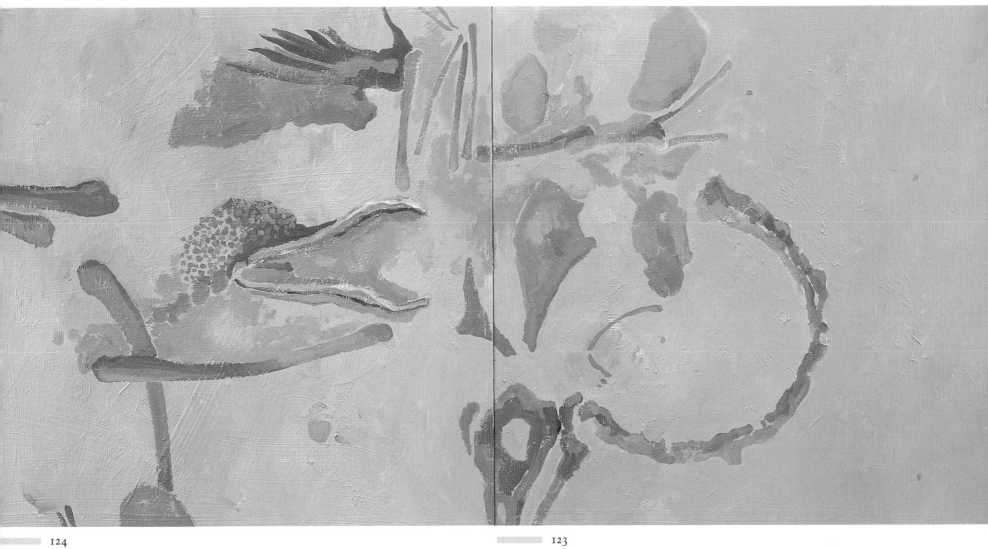

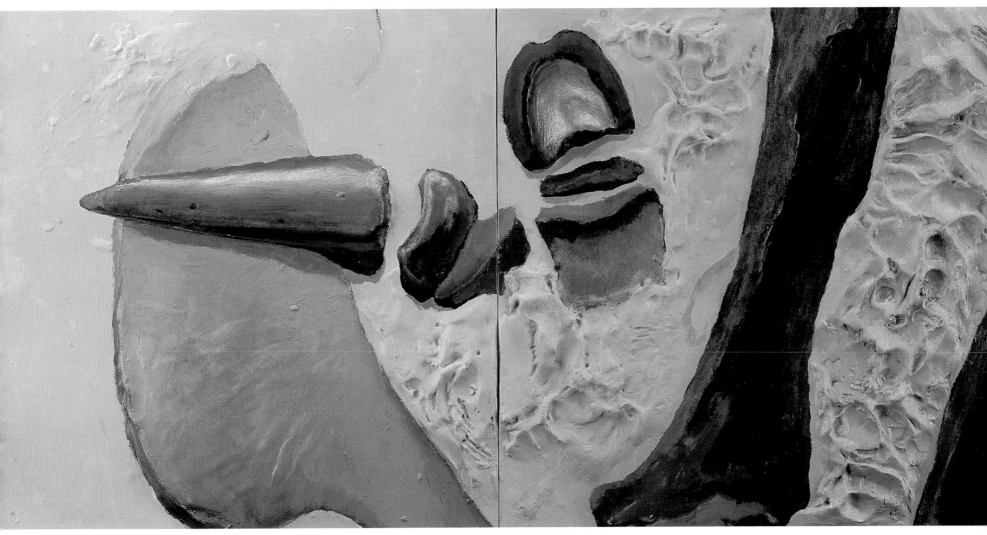

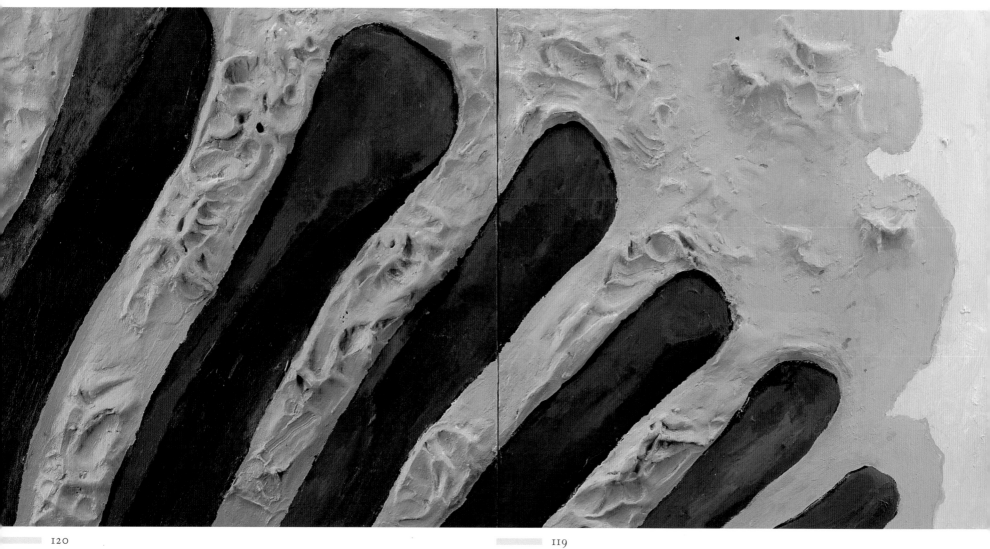

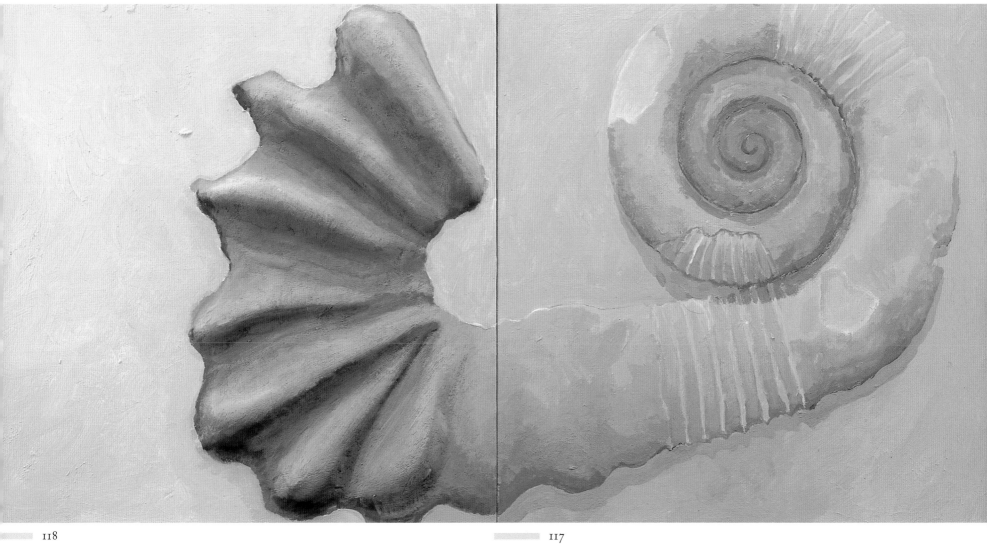

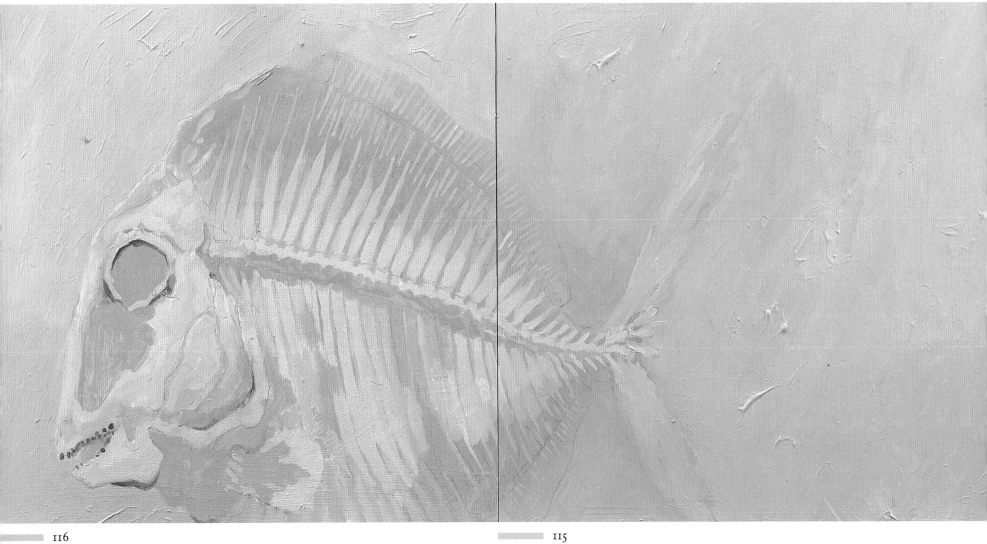

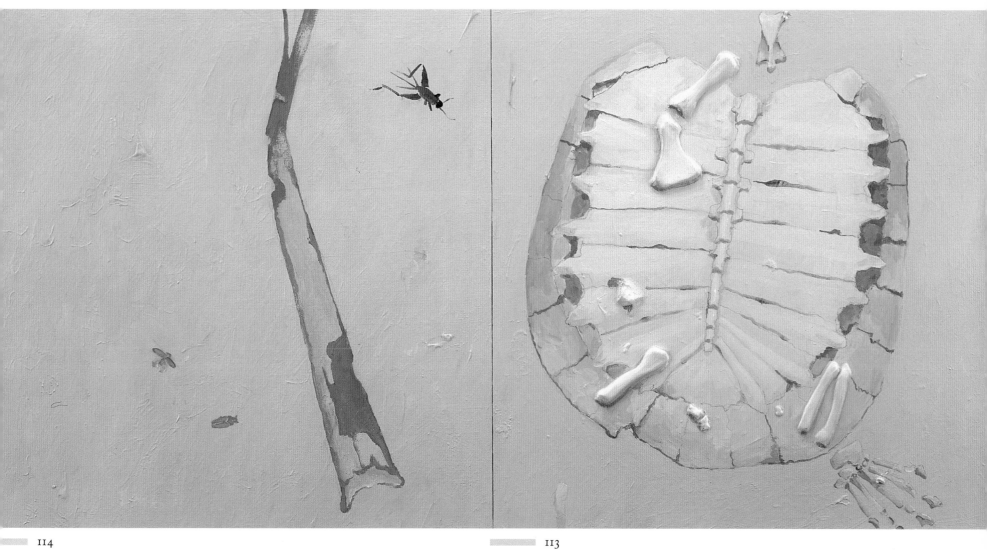

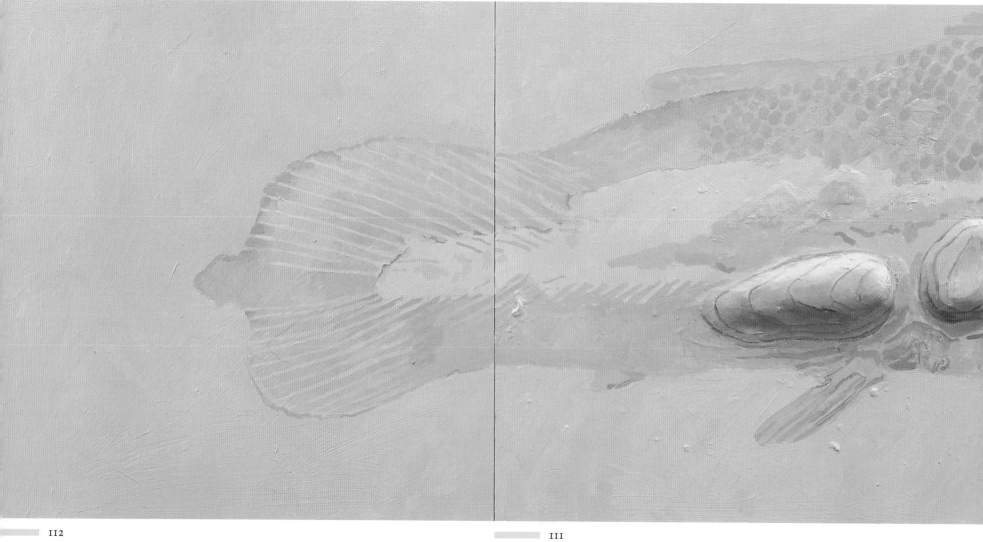

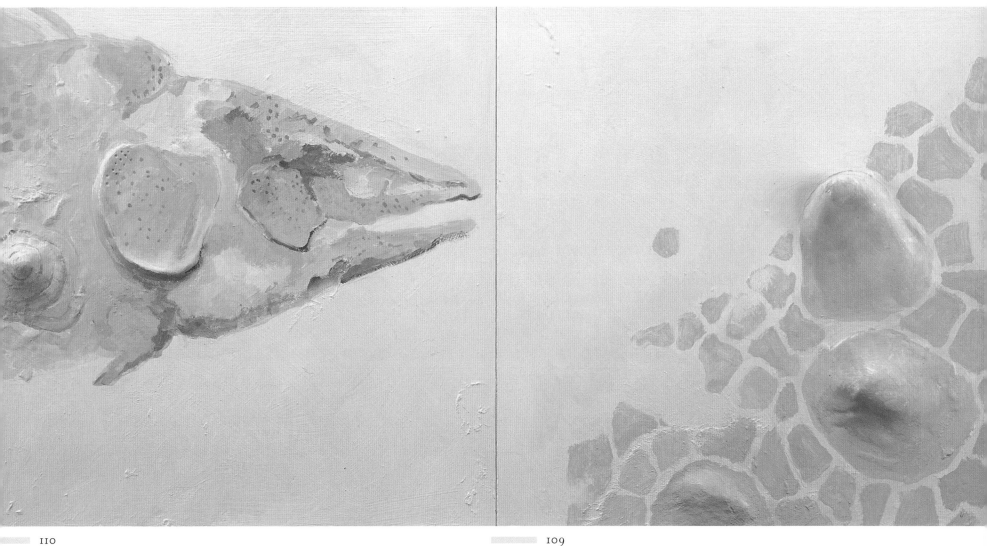

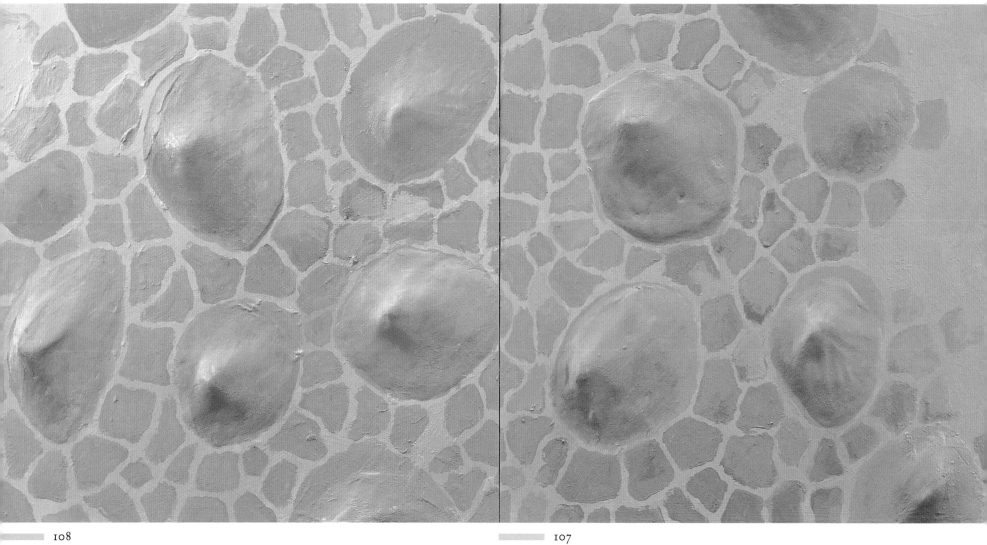

108 107

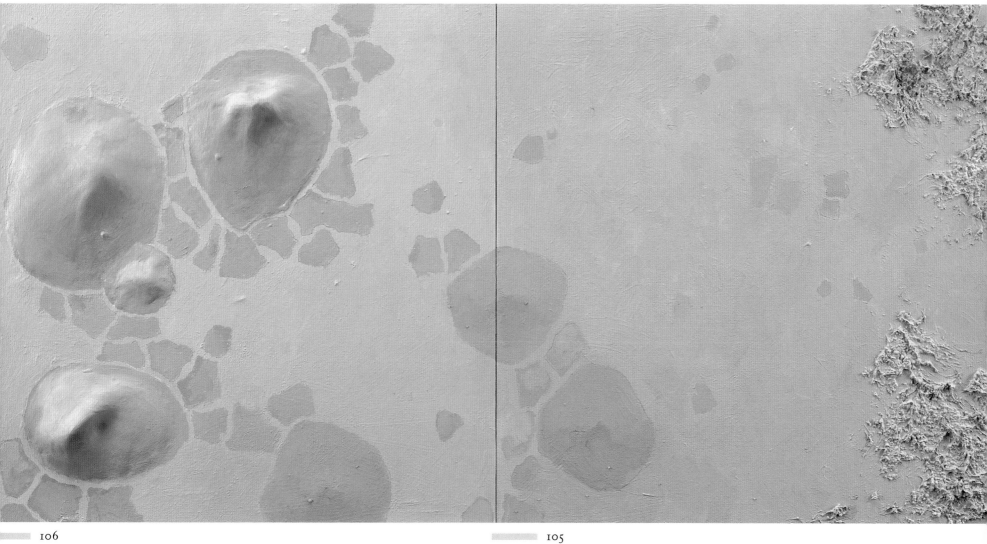

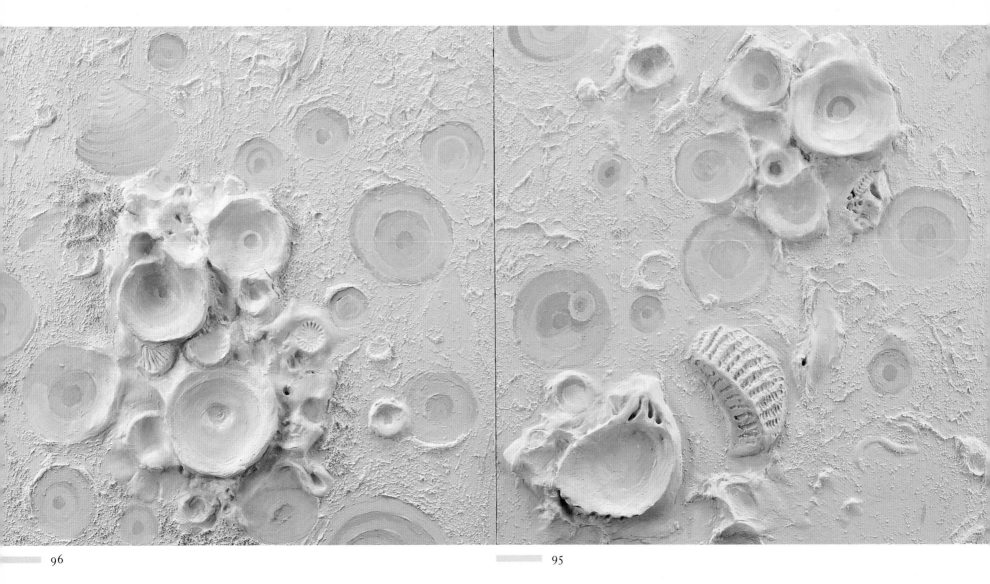

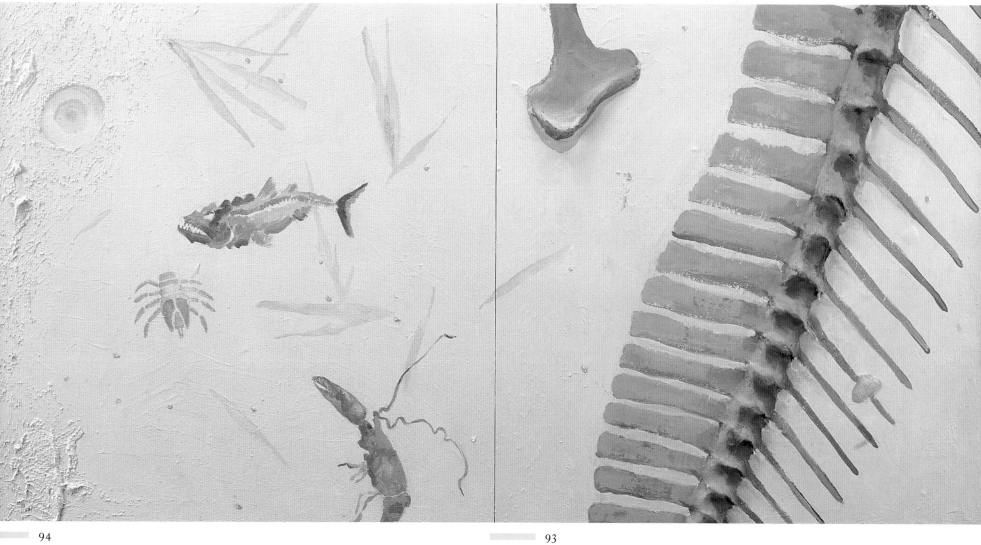

94

93

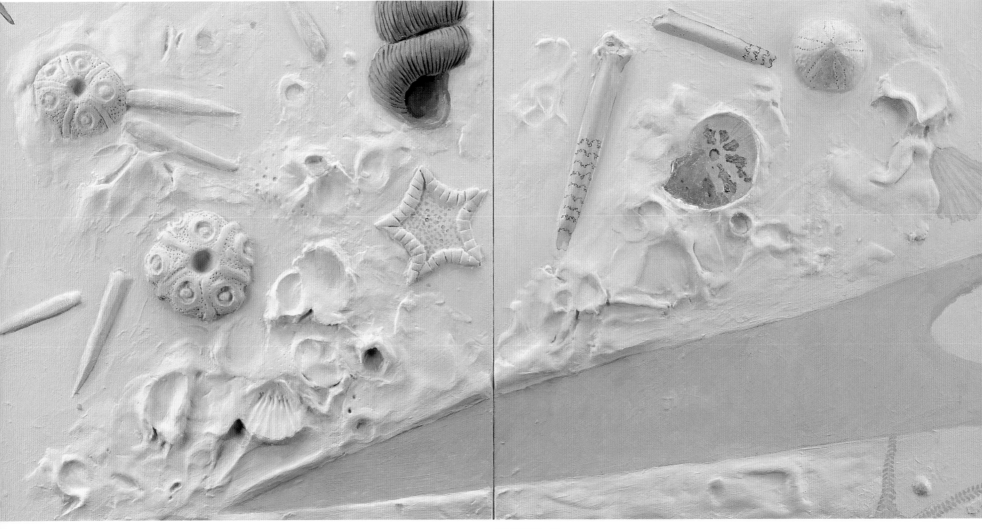

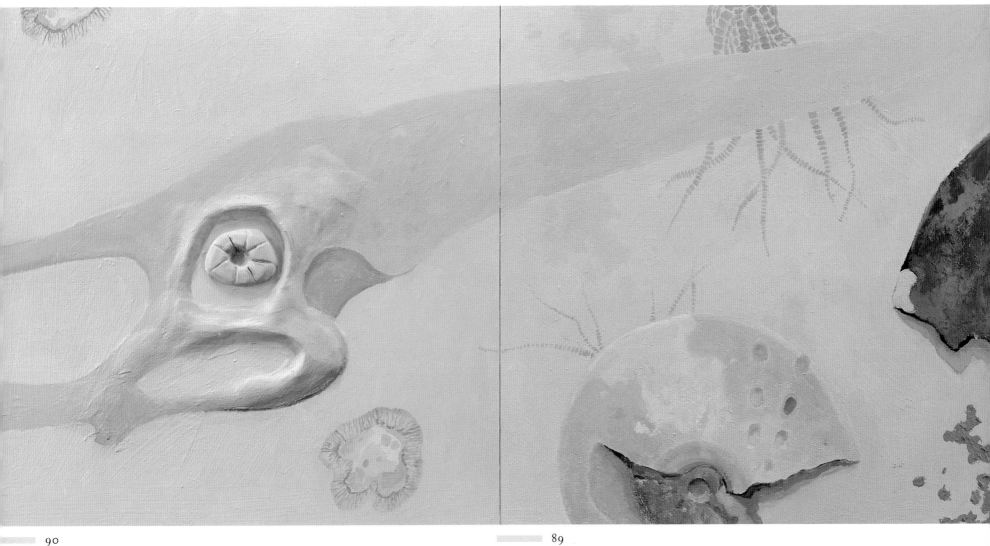

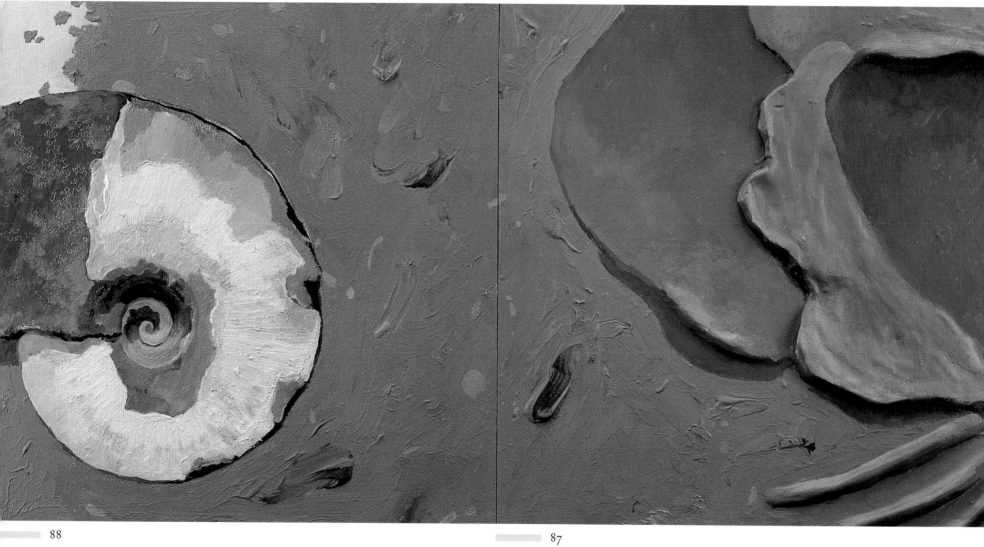

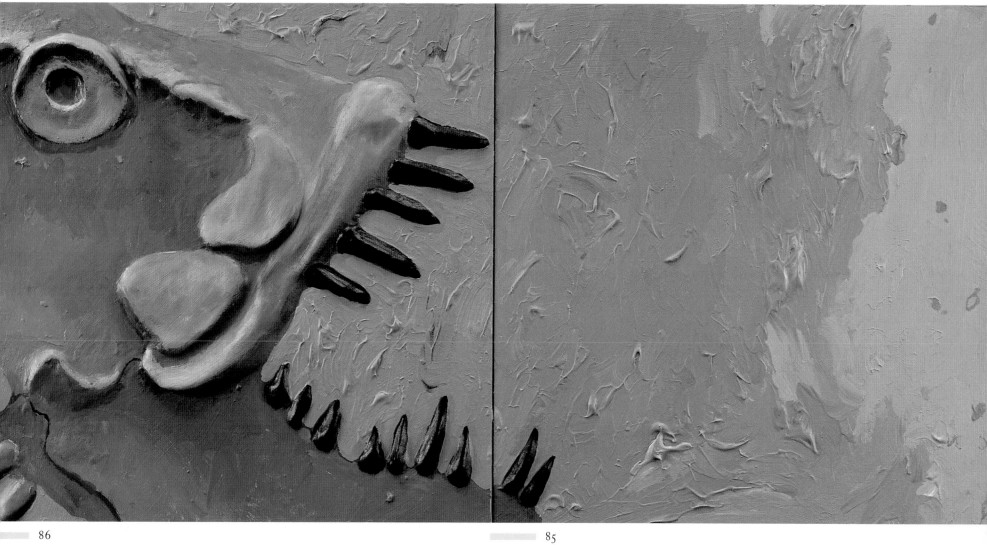

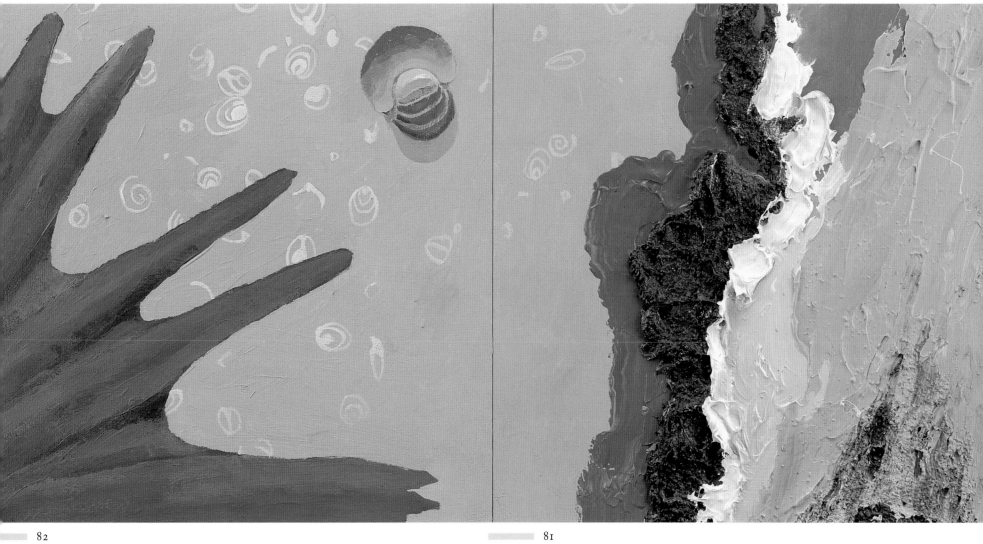

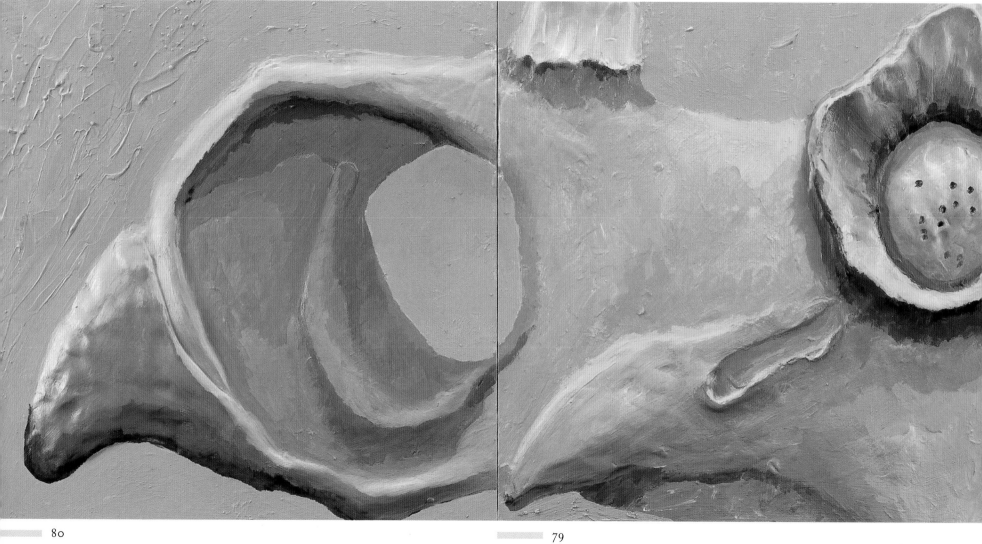

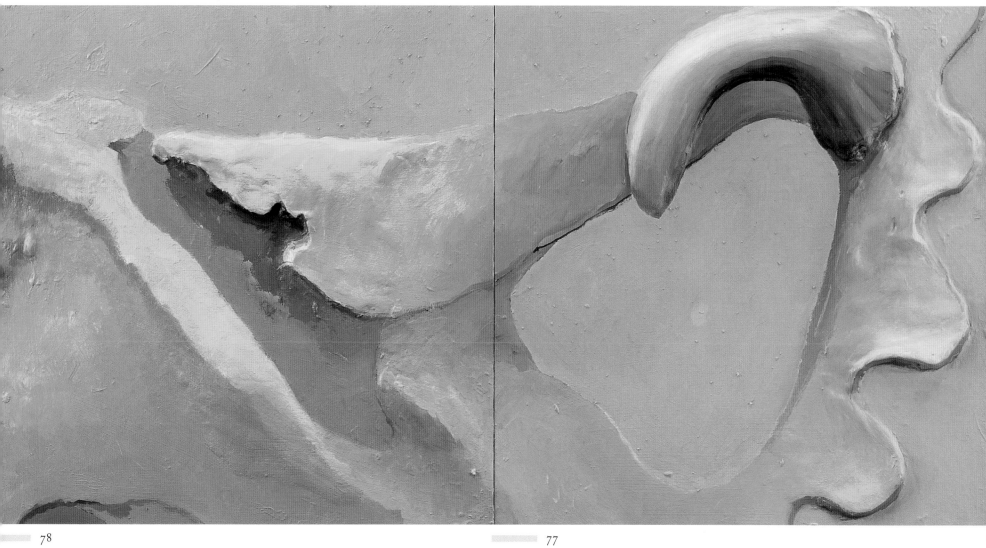

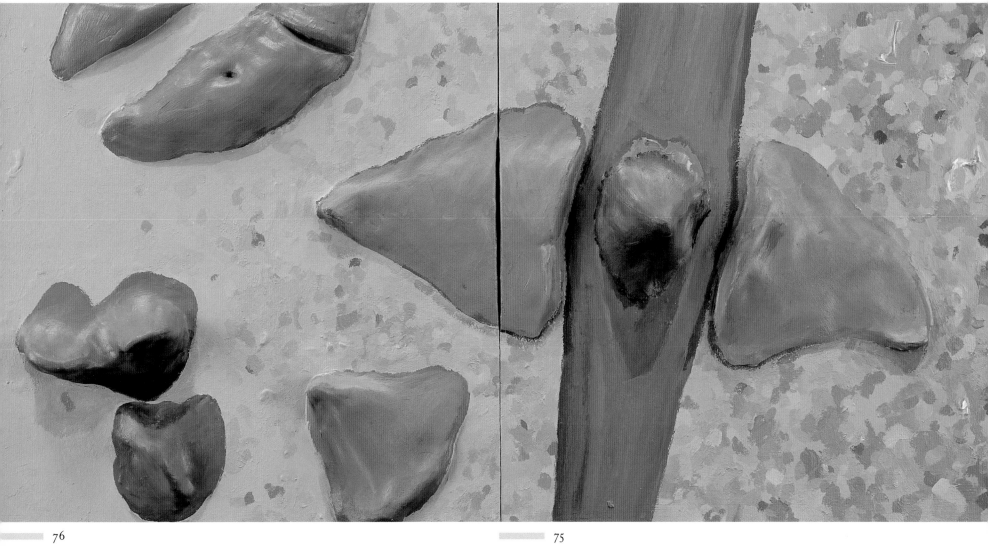

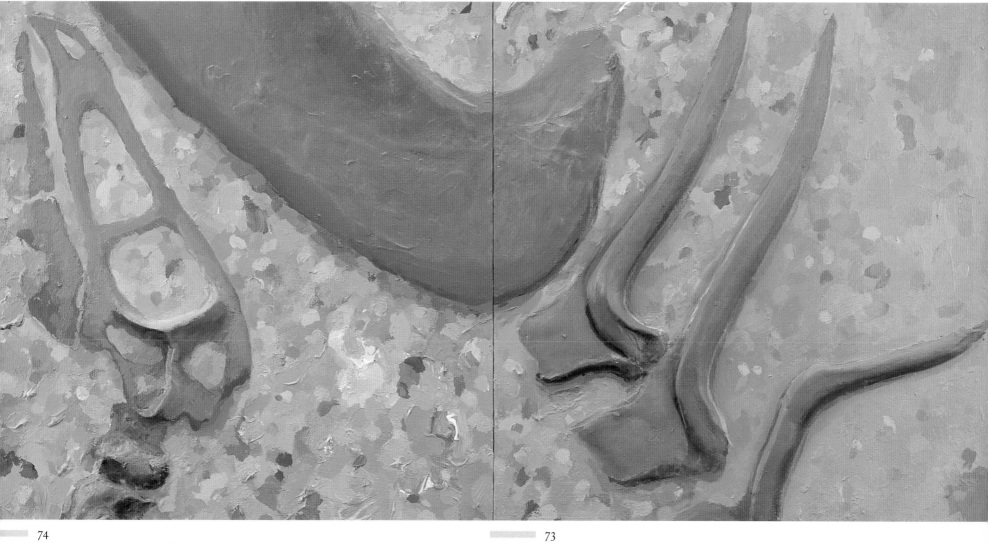

74

73

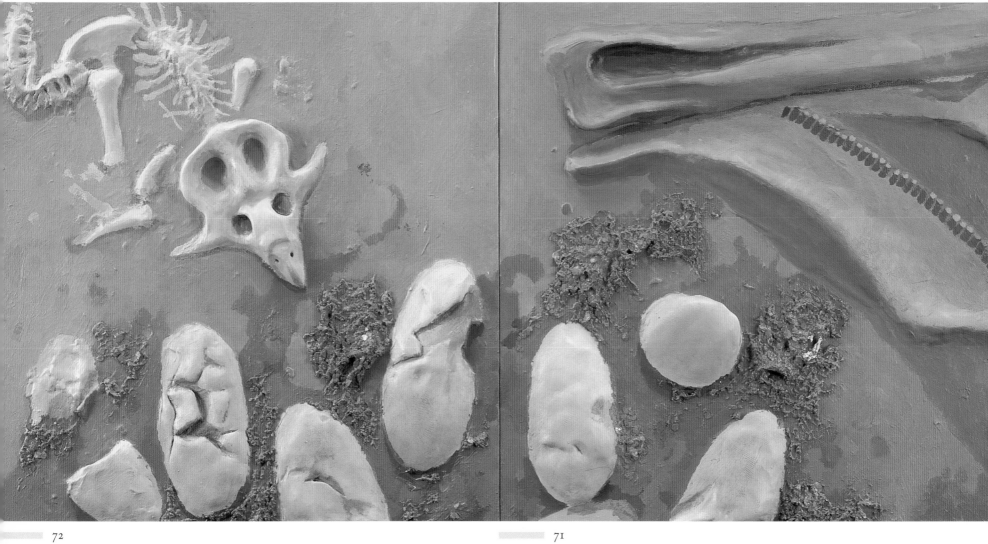

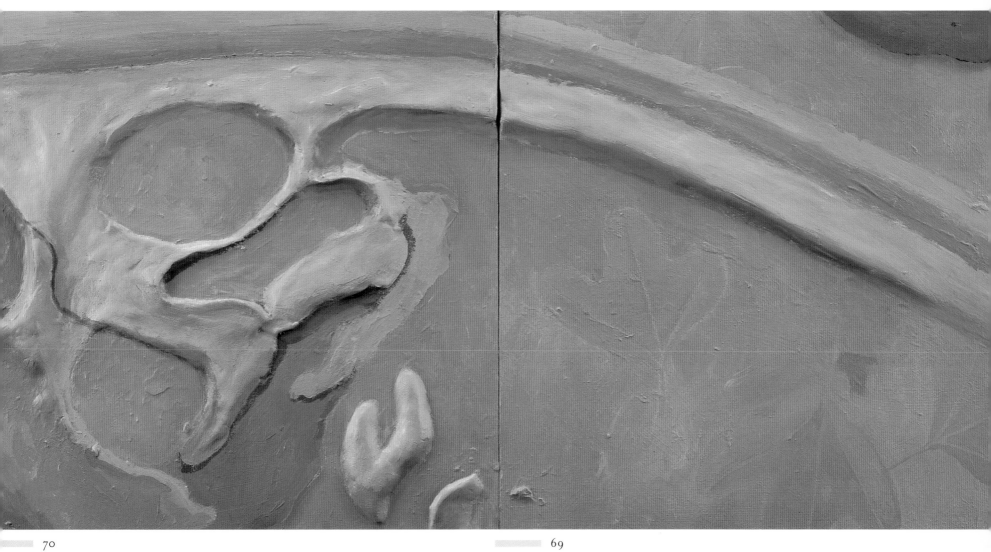

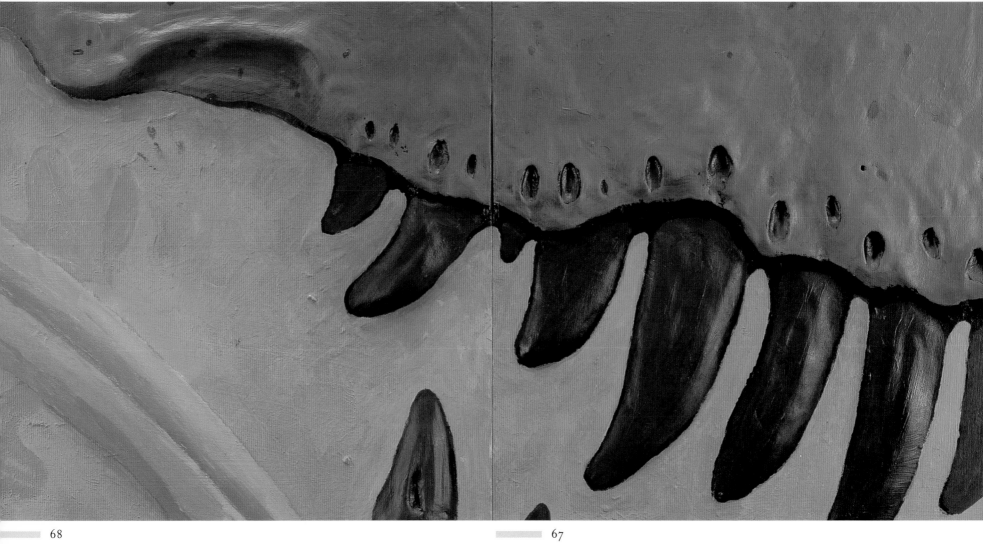

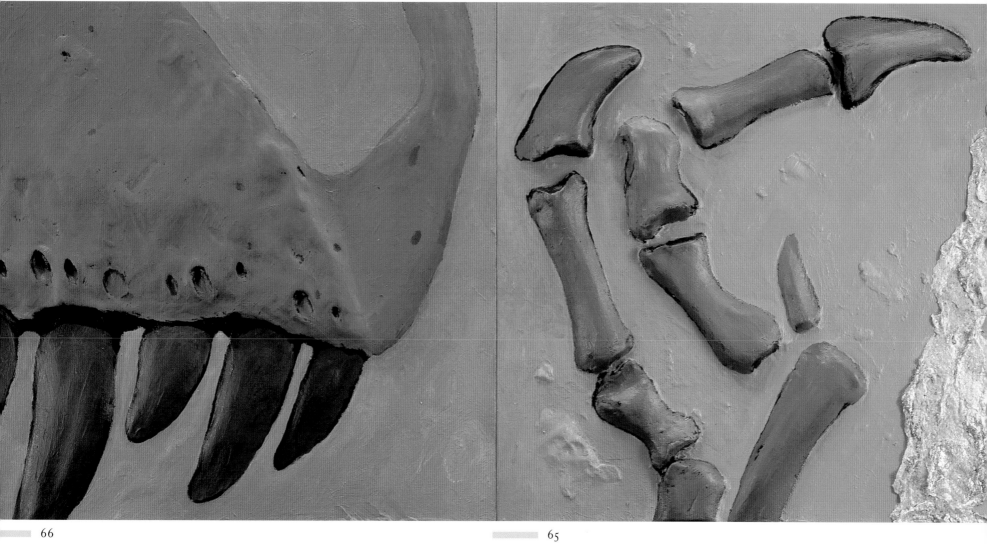

66

65

The Tertiary

If the Cretaceous ended with the impact of a comet or meteorite, what did the world look like "the day after"? Perhaps as if nuclear war had devastated the landscape. It is possible that in most places on Earth in the first days, months, and years of the Cenozoic era and the Tertiary period, it was a scene of death and destruction. Life and evolution went on, but it apparently was not for several million years that life regained the level of diversity it had enjoyed in the late Cretaceous. Thereafter, however, big things happened. Although it is less than 65 million years in duration (shorter than the Cretaceous), the Cenozoic and its two periods, the Tertiary and Quaternary, have witnessed dramatic change in the Earth and its life.

On land, the extinction of the dinosaurs removed the competition that mammals had experienced for their first 140 million years, and their evolution accelerated enormously. Within 10 million years mammals diversified from small rat-like creatures to animals as different as whales and bats. Mammals eventually came to dominate almost every ecological niche once held by reptiles, giving the Cenozoic era its nickname "the age of mammals."

It had also, however, been the age of flowers. Flowering plants completed their takeover of land, a process that began during the Cretaceous period. Today flowering plants comprise three-quarters of all plant species. Flowers are everywhere, from the oceans to the mountaintops. A branch of the flowering plants, the grasses, appeared around 50 million years ago, during the Eocene, and dramatically expanded about 25 million years later during the Miocene to form one of the most distinctive and important of modern habitats—the grassland.

Despite the extinction of so many sea creatures, such as the ammonoids that had long been so abundant, the arms race that had begun in the Cretaceous continued and accelerated. Tertiary snails and clams had thicker, stronger, spinier shells than their Mesozoic precursors, and Tertiary crabs and fish were more adept at breaking them. Even more than the Mesozoic, the Cenozoic world is one of rapidly burrowing clams and thorny snails and starfish, of ravenous crabs and snapping fish, a world in which more vulnerable animals like brachiopods and crinoids live in hidden and out-of-the way places.

Along with these dramatic changes in life came dramatic changes in the Earth's climate. The early Tertiary was a warm time across most of the globe, but as the continents continued to separate from one another this situation was altered. As Antarctica separated from the other continents and moved over the south pole, ice began to form there. This changed the climate of the entire world. The new unstable climate may have driven some of the evolutionary changes, and may have led to several major extinction episodes in the late Paleocene, late Eocene, and Pliocene.

The name "Tertiary" itself is a vestige of a previous system for naming divisions of the Phanerozoic. The three eras were originally called "Primary" (now called Paleozoic), Secondary (now called Mesozoic), and Tertiary. Only the last term remains in use, for a period within the Cenozoic (meaning "recent life"). The changes in marine life during the Cenozoic are reflected in the terminology for its subdivisions. These divisions or epochs were first introduced by English geologist Charles Lyell in the 1830s, based on the proportion of fossil species (mainly mollusks such as clams and snails) that are identical to modern species. These proportions are lower in older layers, and higher the closer we get to the present. Eventually six epochs were defined in this way: Paleocene (from the Greek meaning "old recent"), Eocene ("early recent"), Oligocene ("less recent"), Miocene ("middle recent"), Pliocene ("more recent"), and Pleistocene ("most recent").

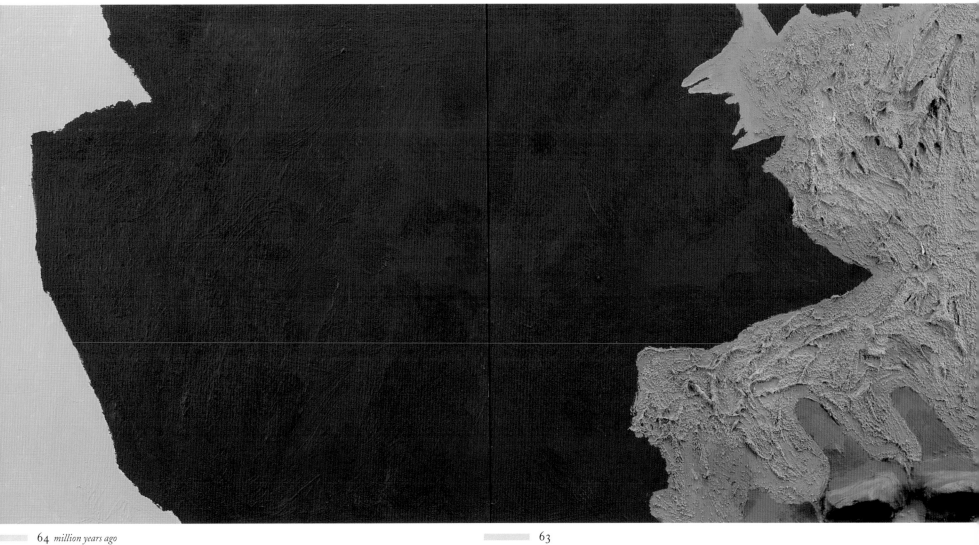

64 *million years ago*

63

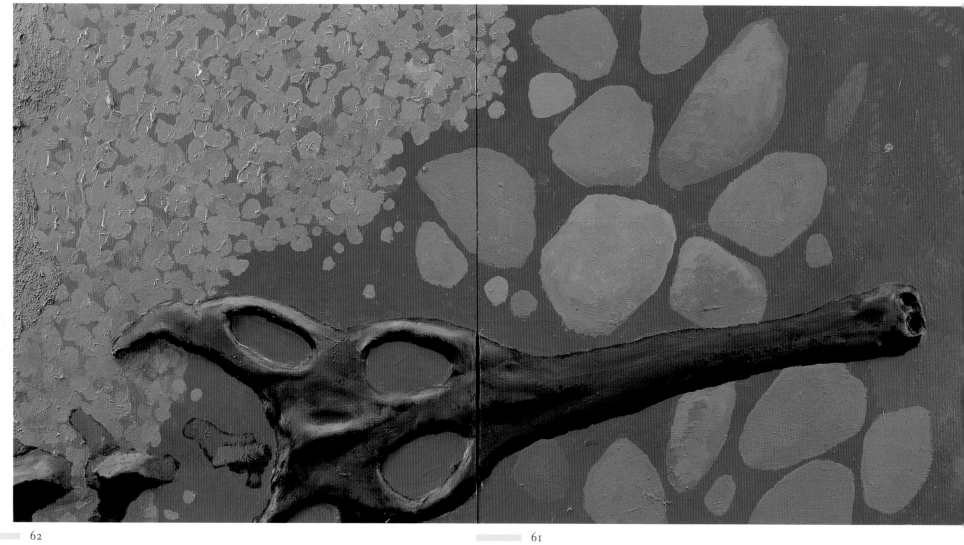

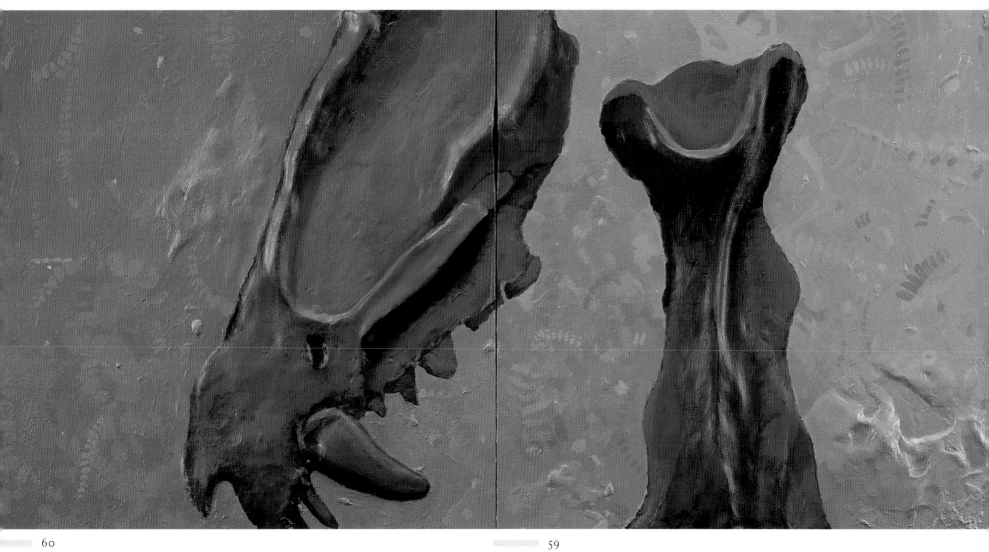

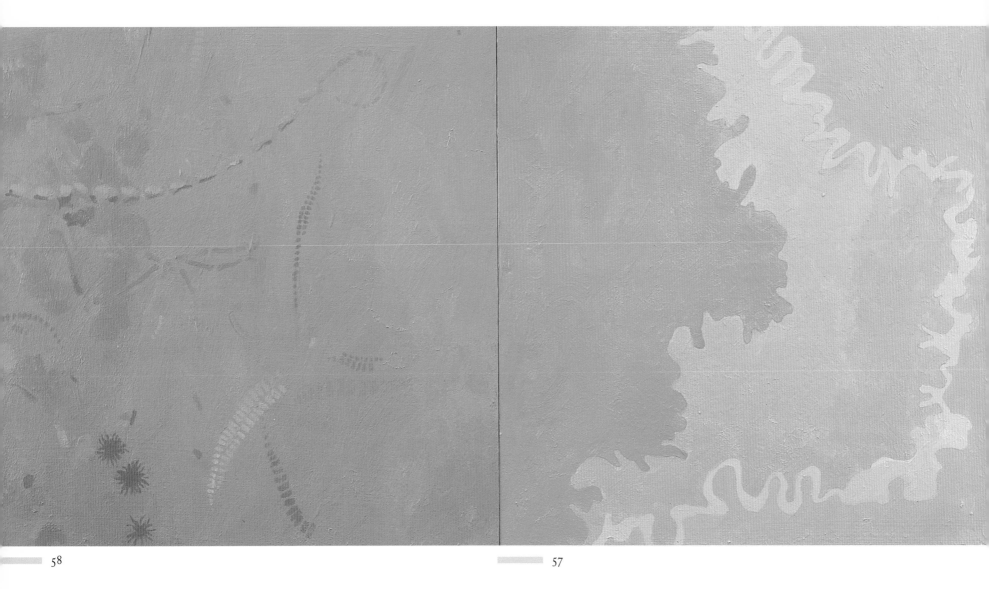

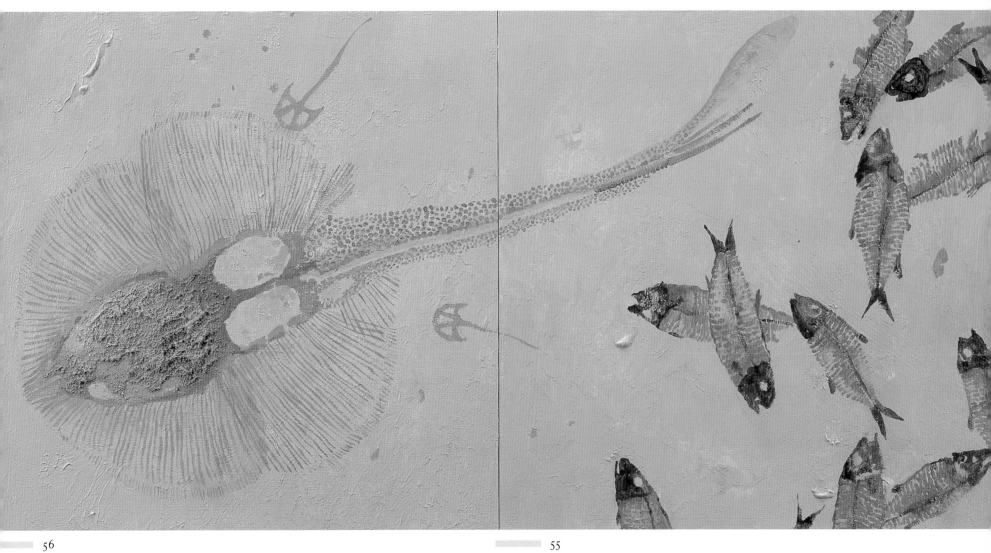

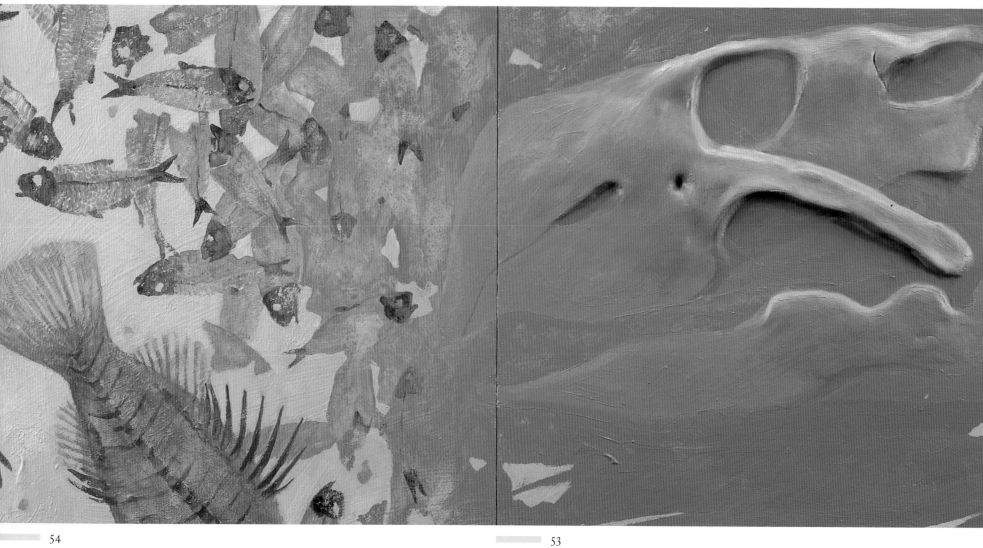

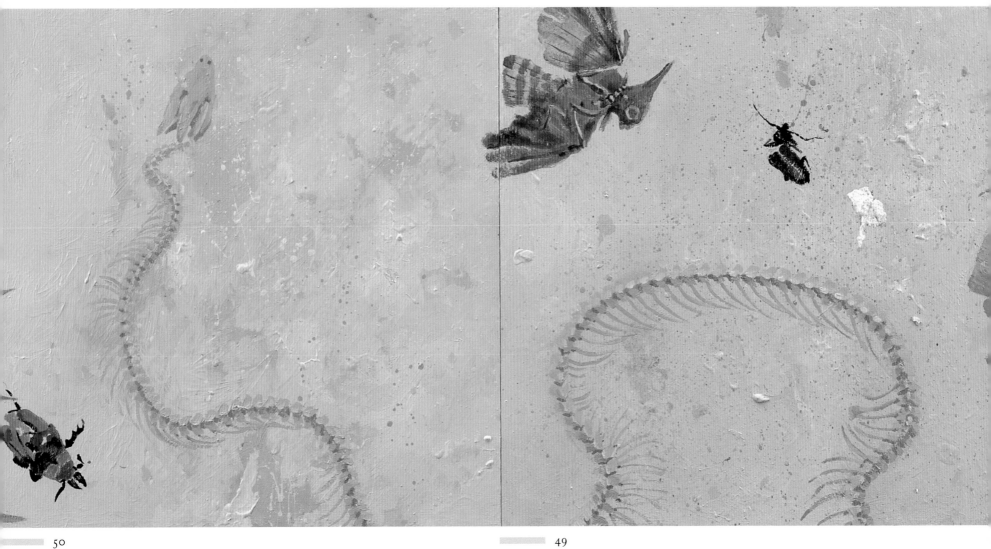

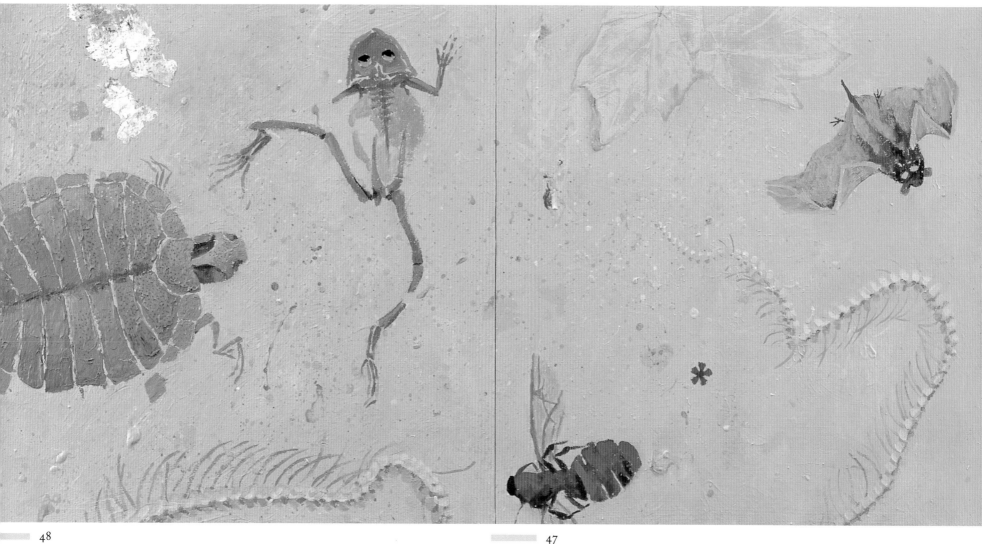

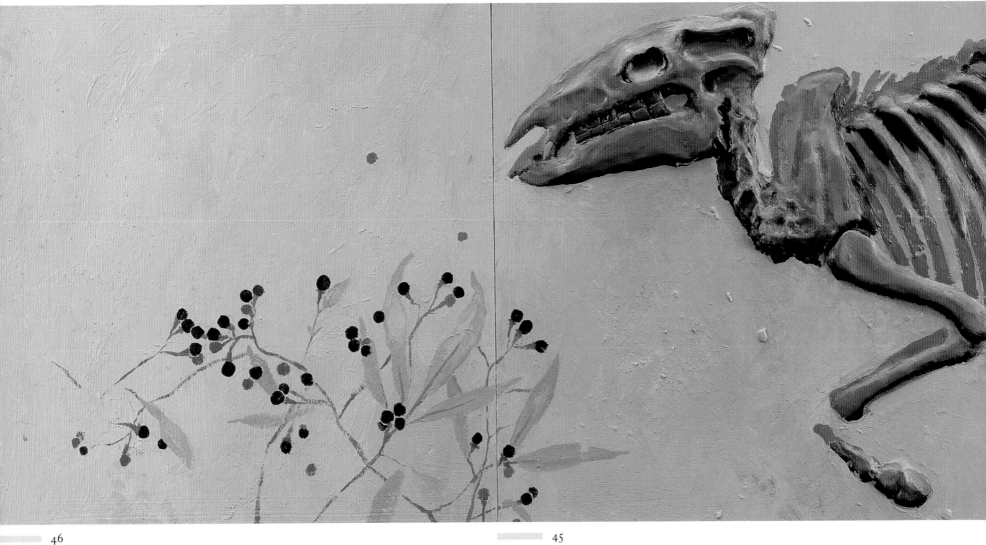

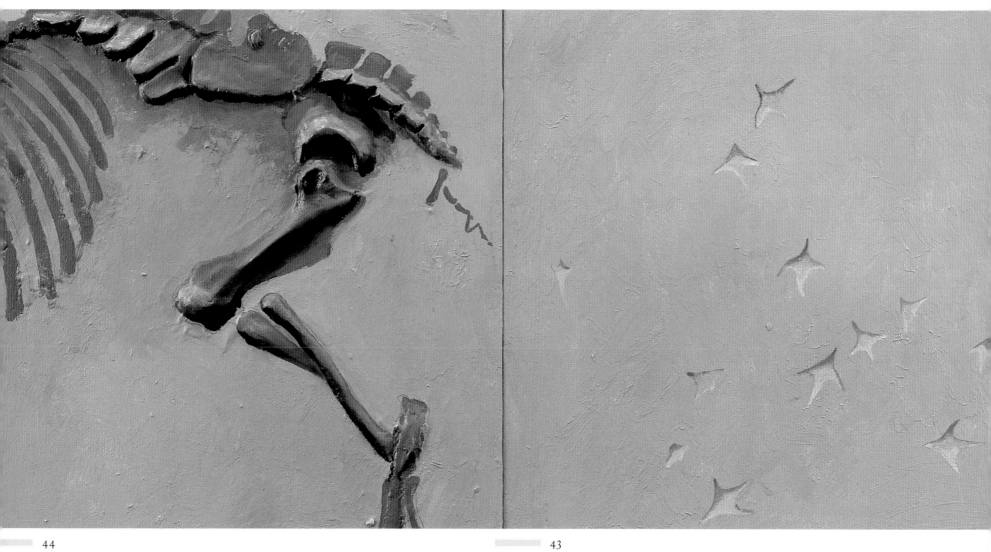

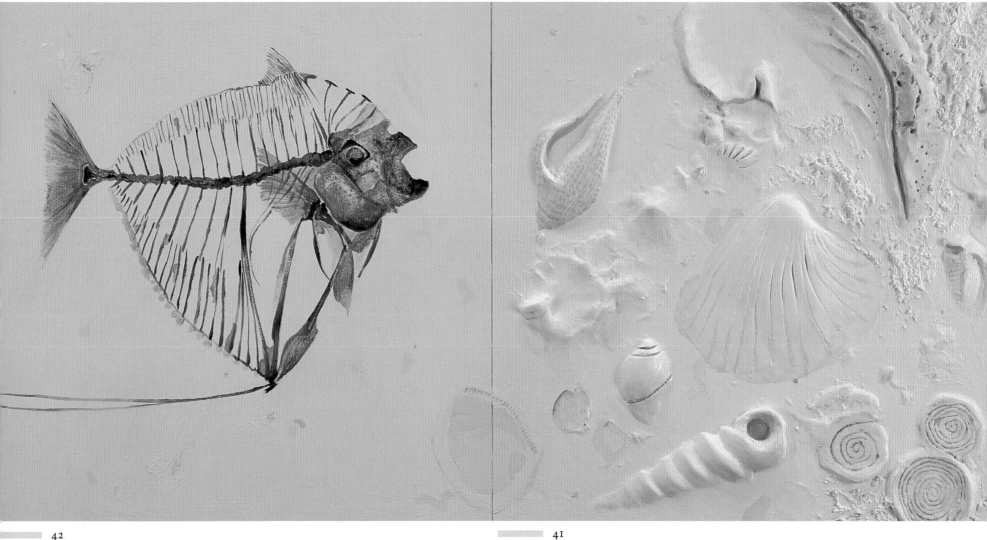

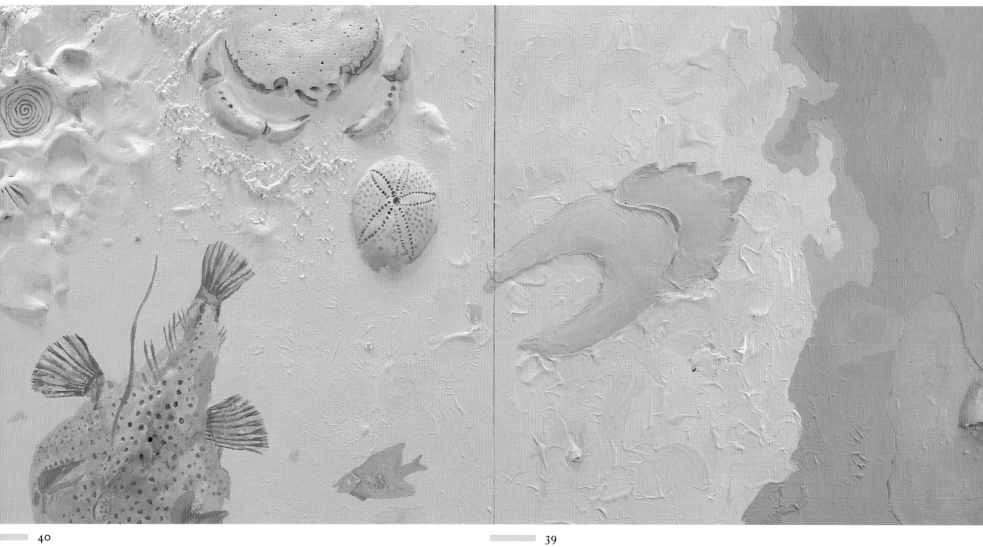

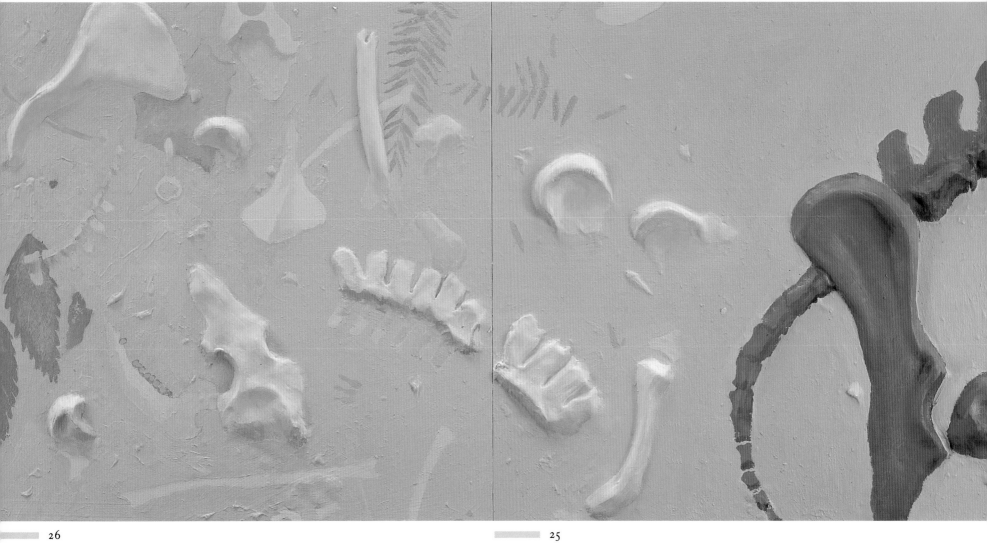

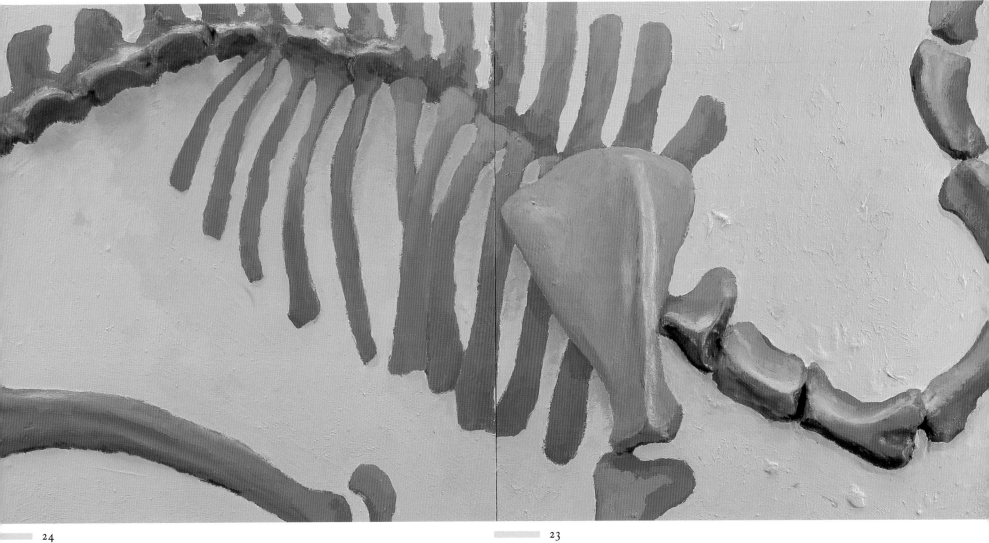

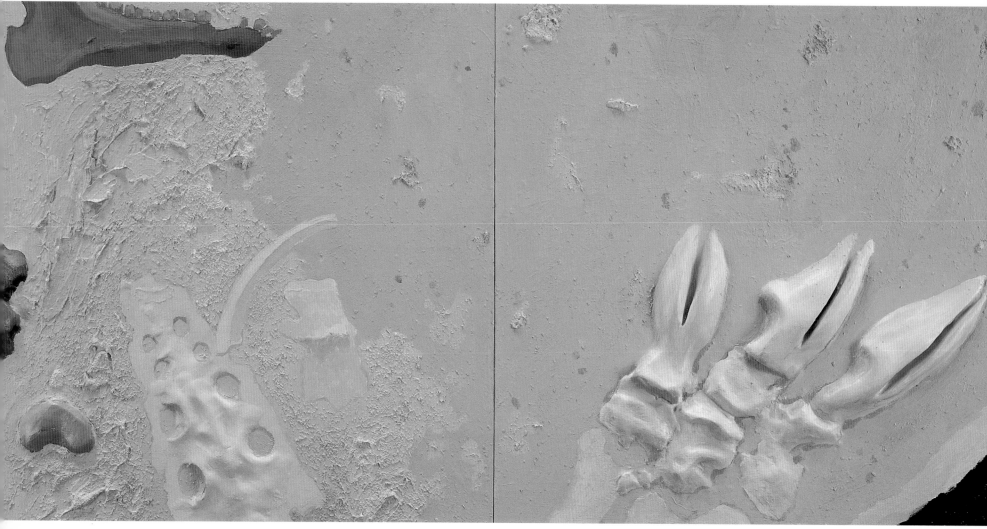

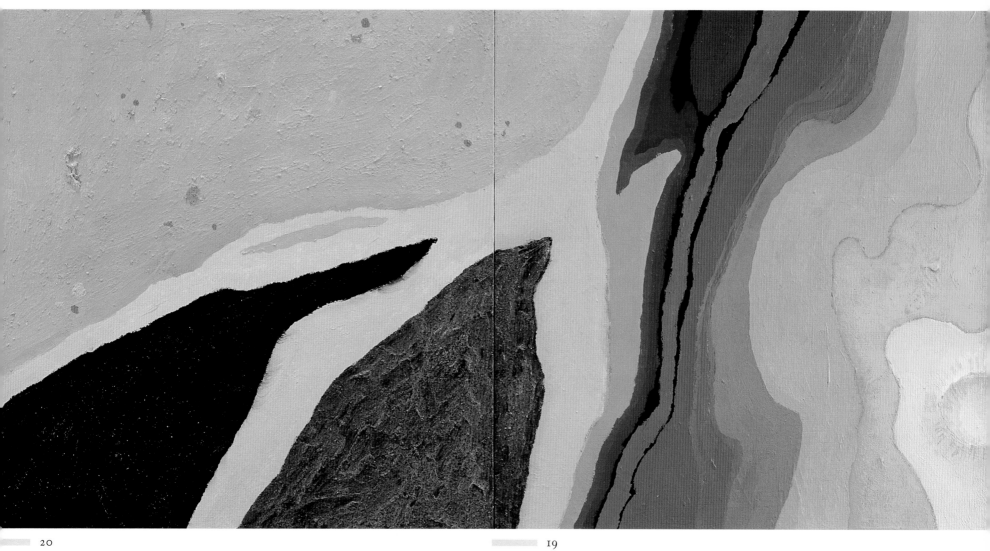

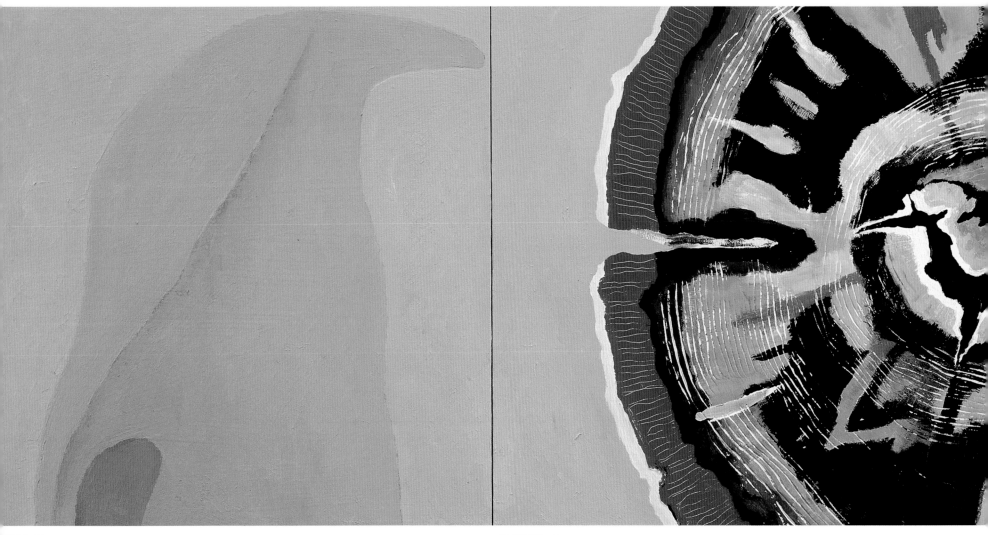

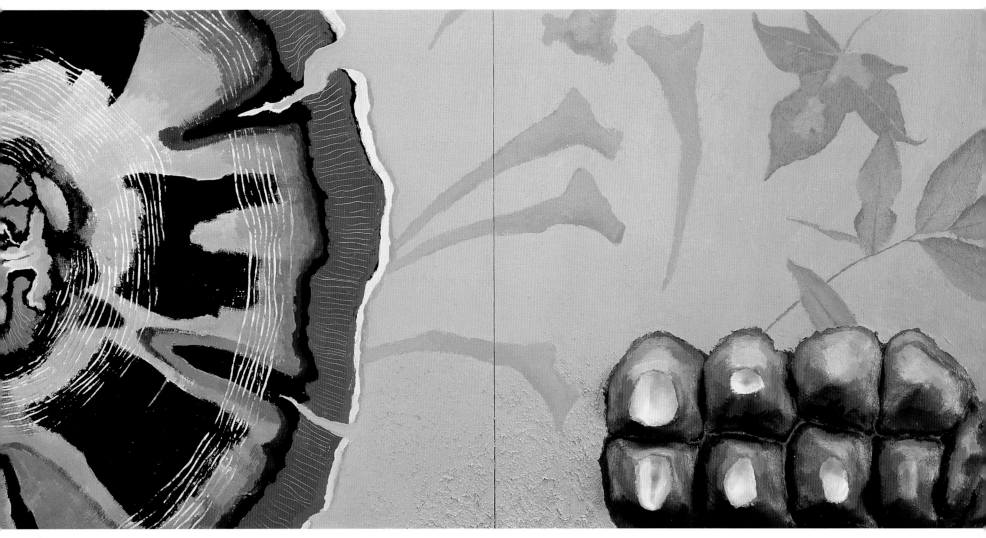

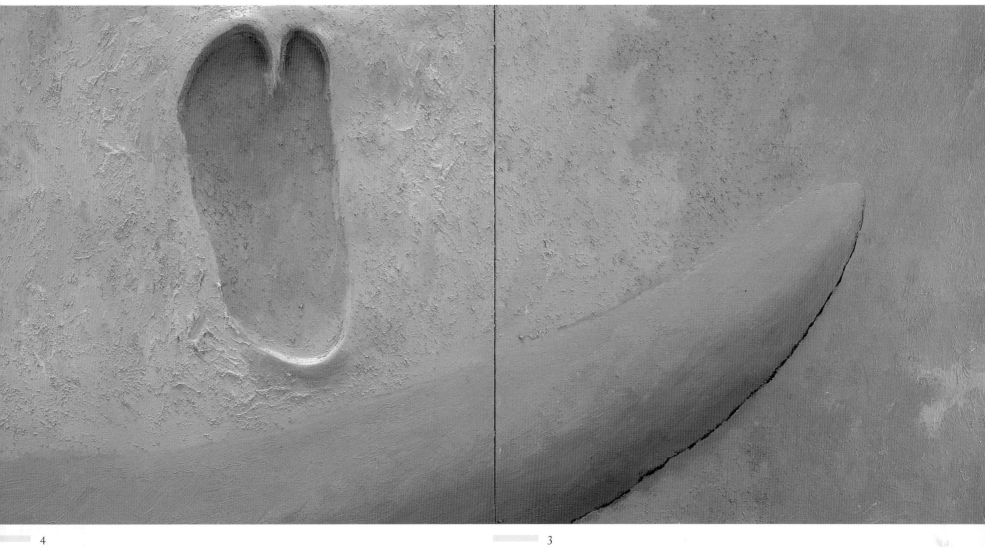

The Quaternary

"Man is the measure of all things," said Protagoras, but geology teaches us that this is not true. More than ninety-nine percent of Earth history passed before anything resembling a human being appeared. A case could be made that "man is the measure of almost nothing." Nevertheless, the last two million years or so, referred to as the Quaternary, witnessed two very different, but interestingly related phenomena: the expansion of glaciers and the evolution of humans. Both of these events have and promise to have far-reaching effects on the planet.

Approximately three and a half million years ago, the Earth's temperature fell, and ice at the north and south poles expanded. In the northern hemisphere, glaciers moved down over much of North America, Europe, and northern Asia. Climates throughout the world were affected as rainfall and temperature changed. This glacial development accelerated around two and a half million years ago, and since then glaciers have moved southward and retreated again to the north dozens of time, withdrawing most recently about 10,000 years ago.

The ice profoundly affected life throughout the world. To the north, new species of large mammals evolved and thrived. To the south, not only did temperatures cool, but each glacial advance was a drier time, each retreat wetter. In this swiftly changing environment, evolution occurred rapidly among a group of African primates. Formerly denizens of the forest, these creatures ventured farther out into the spreading grasslands, and developed the upright posture and larger brain size that were advantageous in such circumstances. A number of different kinds of these creatures evolved, and at one time in Africa as many as three or four species may have lived within sight of each other. Eventually, at least one of these species moved out of Africa. Their tools and culture became more sophisticated and their brains grew in size. Somewhere in Africa approximately 50,000 years ago, or approximately one-thousandth of one percent of the amount of time that has passed since the beginning of the Cambrian, a group of these creatures evolved into what we recognize today as modern humans.

Even if we accept, as not everyone does, that "history" includes time and events before the appearance of humans, we usually write that history as the inevitable story leading to us. The significance of most events is often measured by its relevance to humans. In some larger sense, however, geologists measure the events of geological time by their significance on a far-longer time scale. We note the coming and going of mountains, continents, oceans, and species by the consequences they have for later ages. By this measure, what is the significance of humans in time and history?

Like all species, humans are unique. But we also appear to differ in a new and qualitative way: as far as we can determine, we are the only animals ever to have evolved consciousness. The sheer evolutionary novelty of this feature (and perhaps our own hubris) has led some authors to label the modern age with terms like "Anthropozoic" and "Psychozoic."

The average mammal species lasts approximately 2 million years. Thus humans themselves will in all likelihood pass away after a relatively short period on the Earth's stage. Our effects on the world beyond ourselves are harder to assess, and may not become apparent for thousands or even millions of years. Human-caused extinctions and environmental changes may prove (literally) epochal or relatively minor. Right now it is looking like they will be large, and that we will be responsible for the extinction of thousands of species, massive alteration of environments, and significant increase in global temperatures. Humans may not be the measure of all things, but we may turn out to have an immeasurable effect on all things.

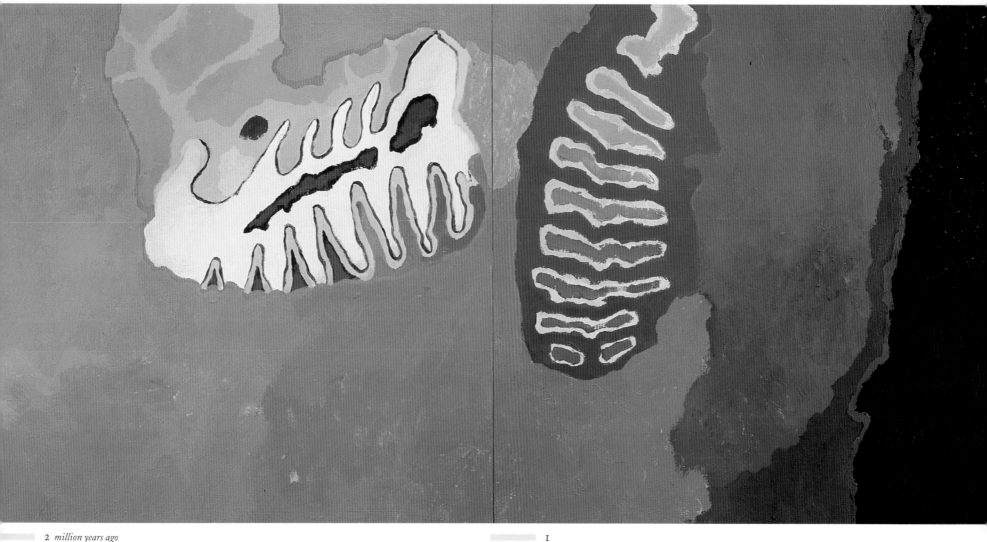

Rock of Ages, Sands of Time: An Overview

THE CAMBRIAN (543–507 mya)

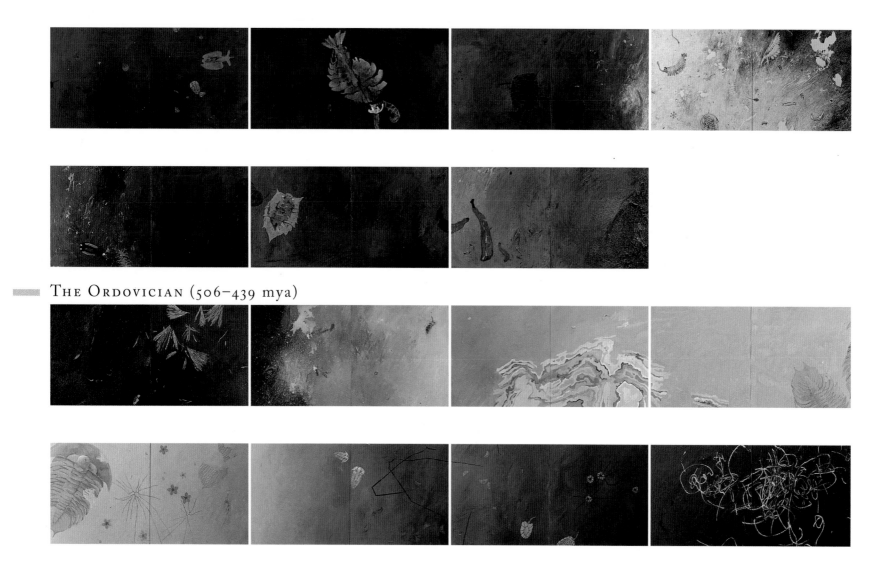

THE ORDOVICIAN (506–439 mya)

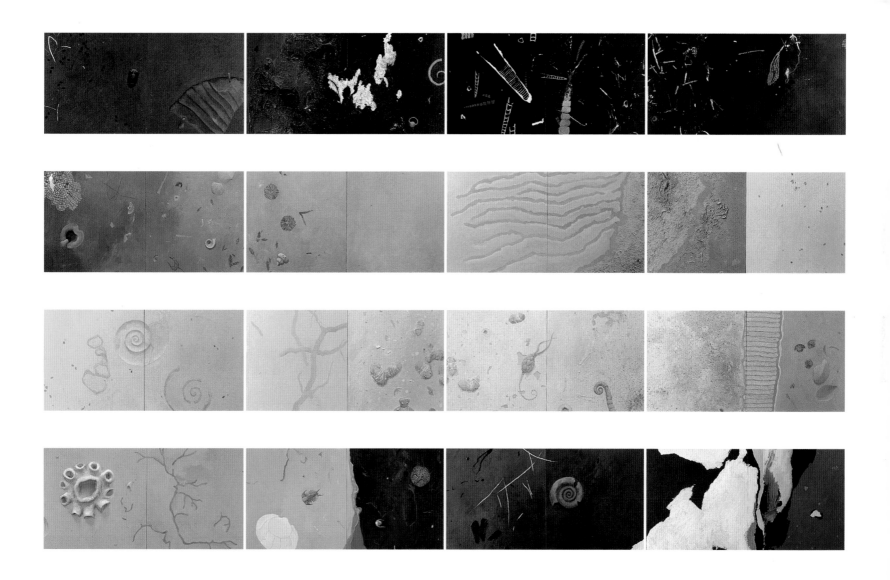

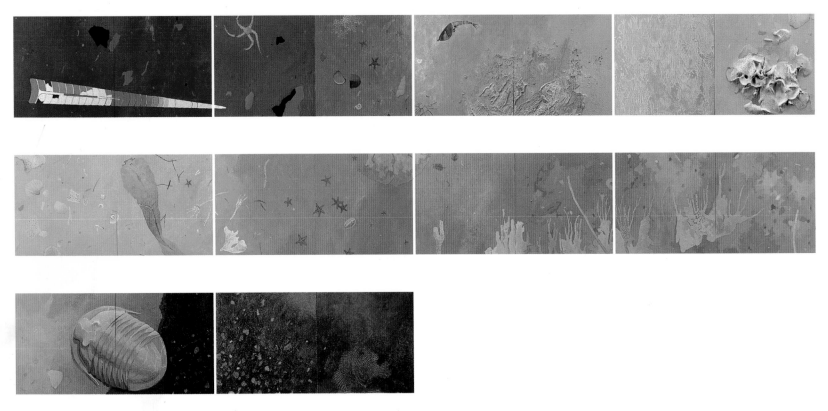

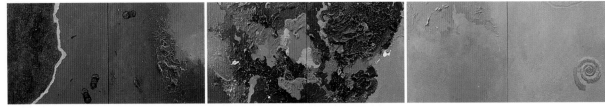

The Silurian (438–409 mya)

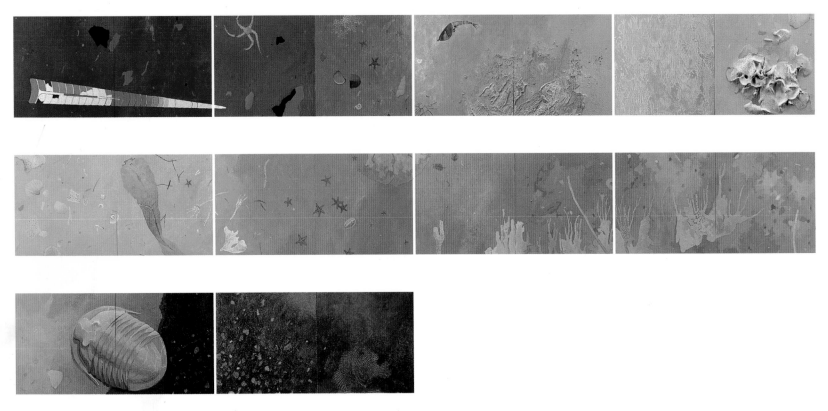

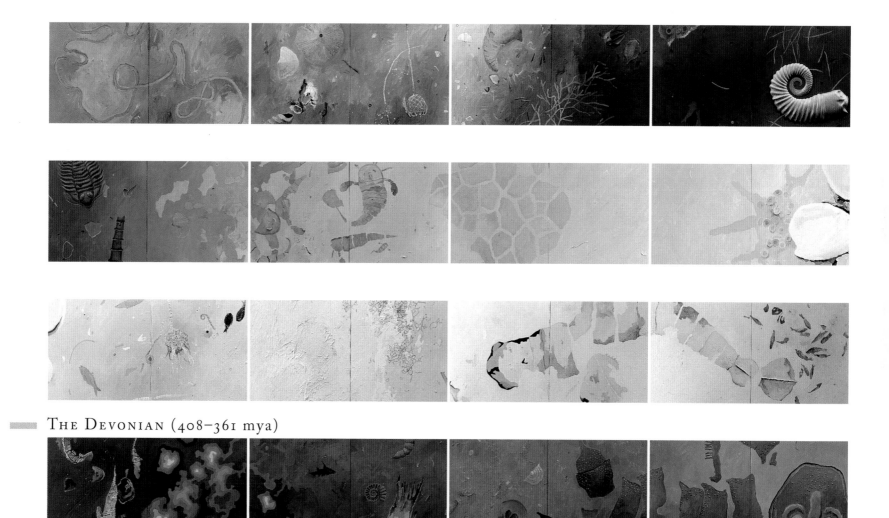

THE DEVONIAN (408–361 mya)

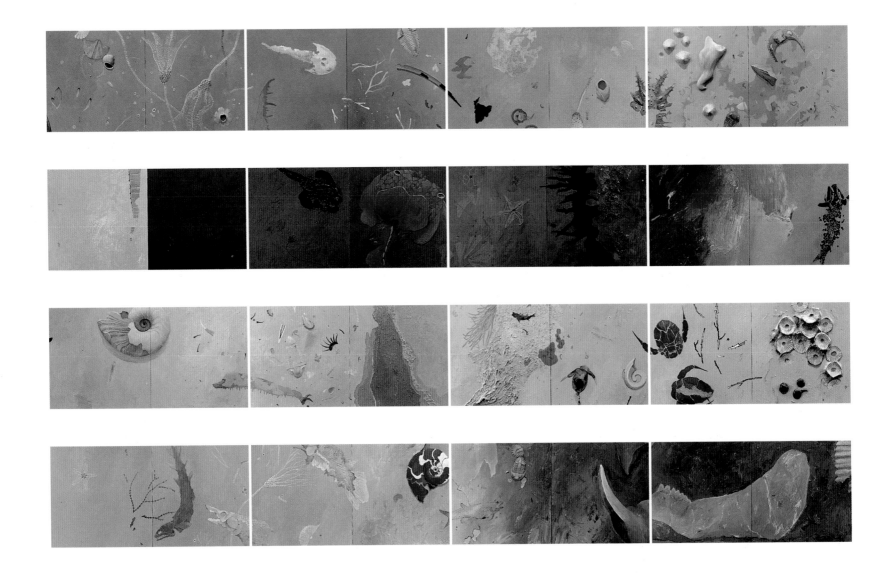

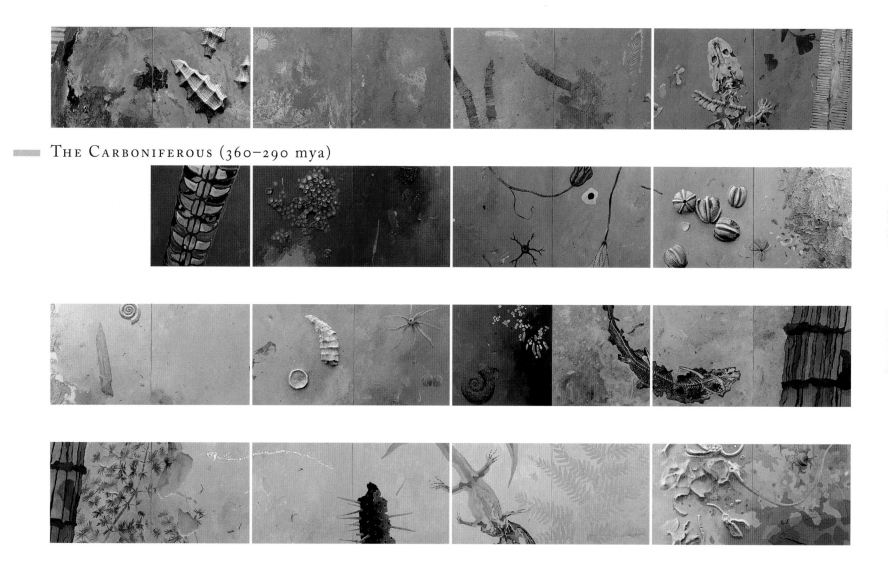

The Carboniferous (360–290 mya)

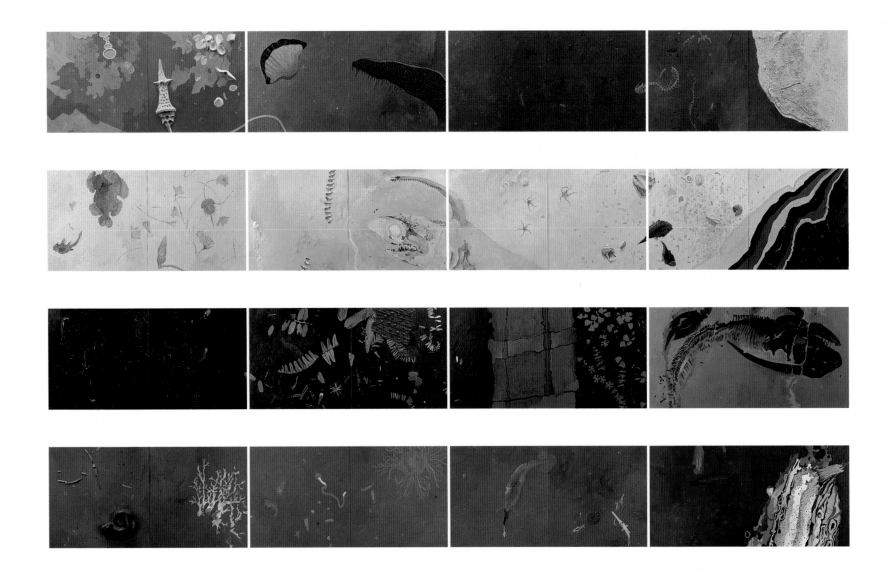

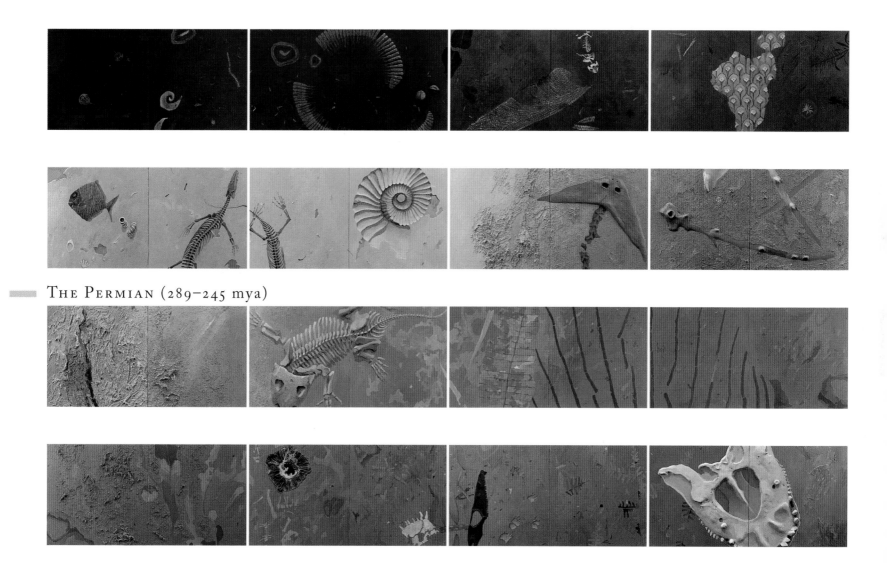

THE PERMIAN (289–245 mya)

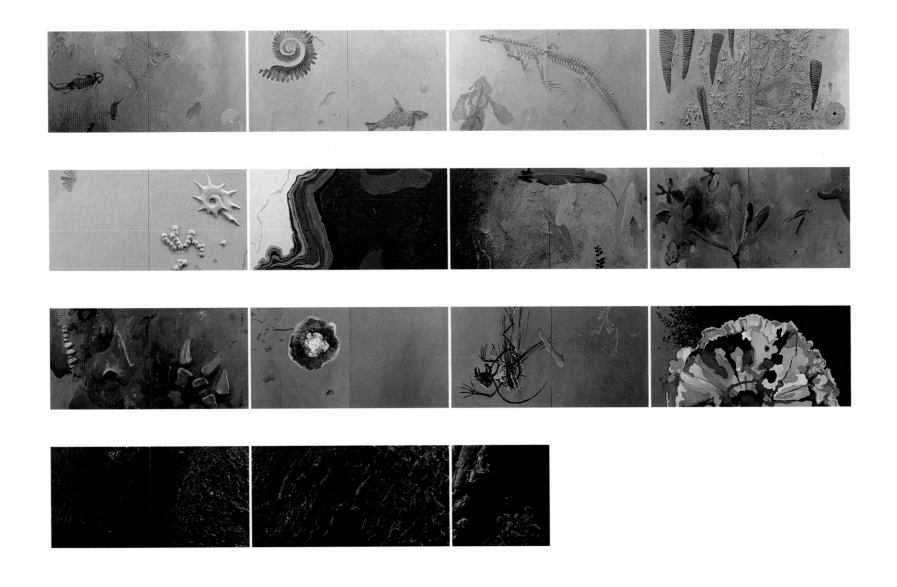

THE TRIASSIC (244–205 mya)

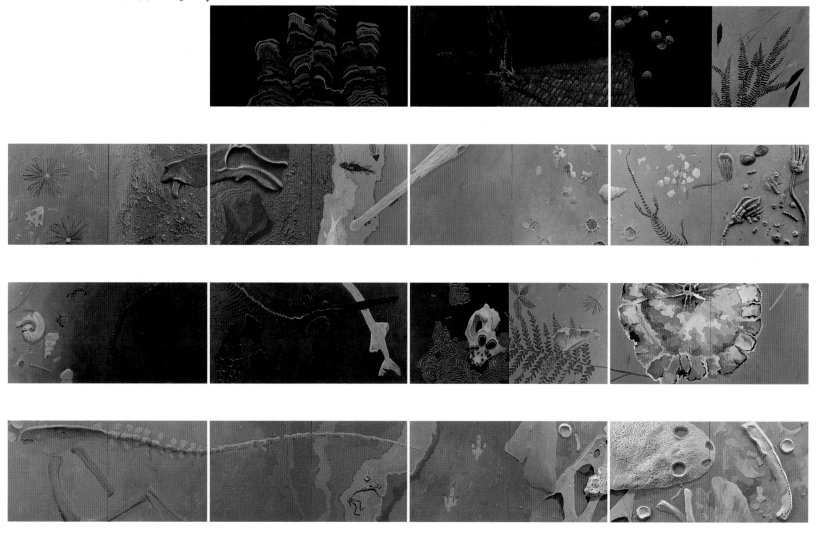

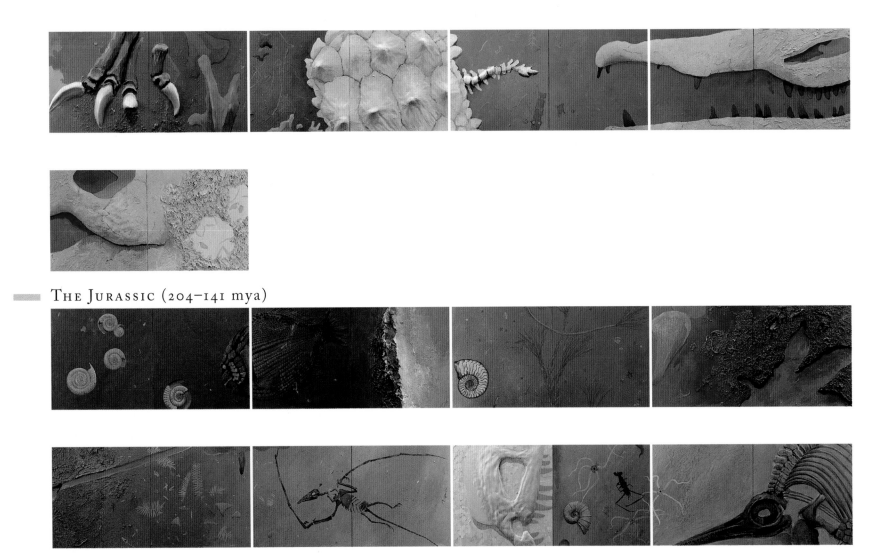

THE JURASSIC (204–141 mya)

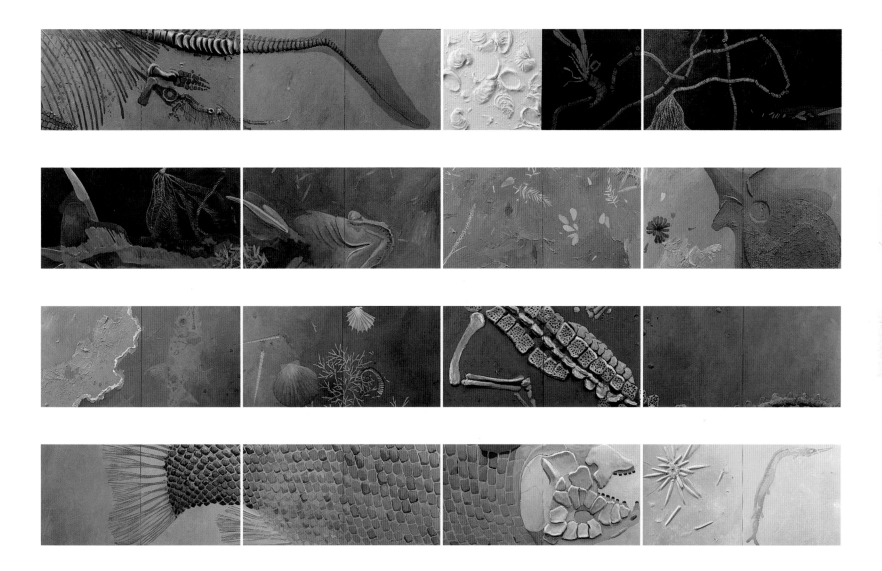

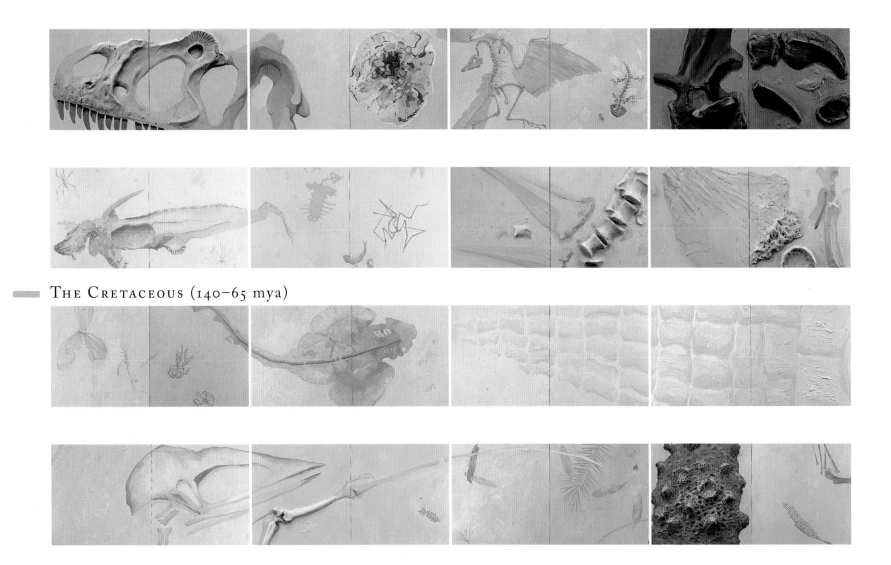

The Cretaceous (140–65 mya)

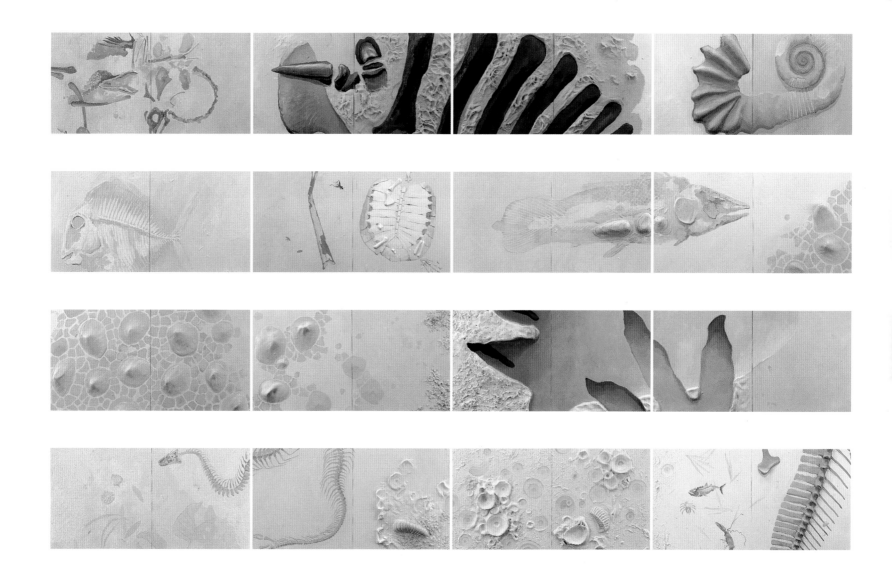

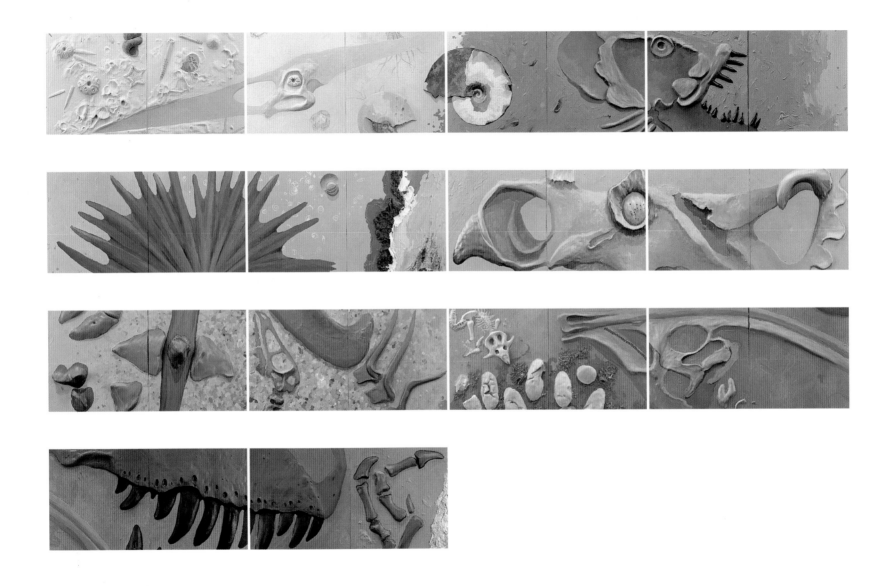

The Tertiary (64–3 mya)

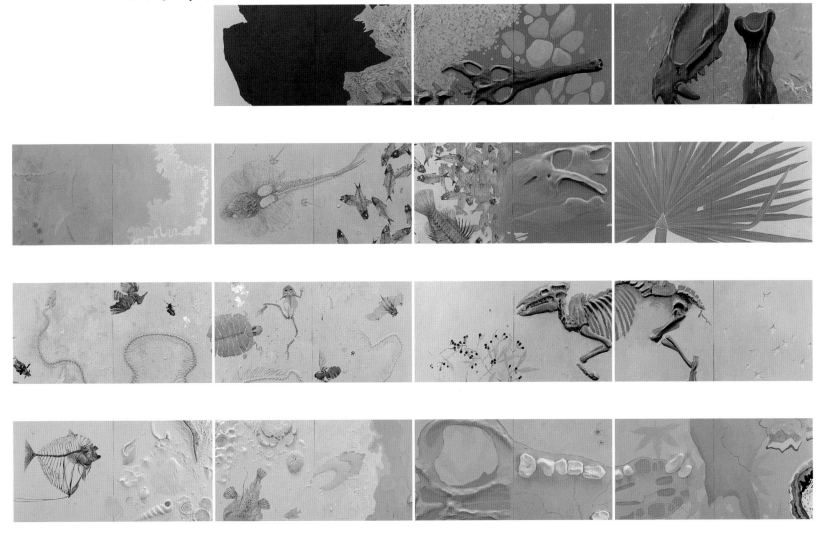

THE QUATERNARY (2–0 mya)

Appendix: Key to Species in Paintings

These lists contain notes on the identity of most of the fossil images in the 544 color plates. They list genus and species (in italics) where these are available (the abbreviation "sp." means species undetermined), as well as the higher biological group (in parentheses) to which the fossil belongs. The term "problematica" is used by paleontologists for fossils of unknown biological affinities. The lists are based on identifications provided on specimen labels or published photo captions, updated or corrected as much as possible by consultation with appropriate specialists; they are not, however, to be considered as authoritative or completely up-to-date with regard to matters of taxonomic nomenclature or details of systematic paleontology. Readers should consult the more specialized references listed in Further Reading for more information.

CAMBRIAN PERIOD 543–507 MILLION YEARS AGO

539–536	unidentified archaeocyathid (extinct sponge-like organism)
535	"small shelly fauna" (problematica)
534	"small shelly fauna" (problematica)
	Dalyia racemata (alga)
533	*Dalyia racemata* (alga)
	Pycnoidocyathus occidentalis (archeocyathid)
532	*Olenellus clarki* (trilobite)
	Halichrondrites elissa (sponge)
531	*Eldonia ludwigi* (holothurian echinoderm or "sea cucumber")
	Dinomischus isolatus (problematica)
	Hazelia delicatula (sponge)
530	*Anomalocaris* sp. (appendage of this problematic arthropod)
	Dinomiscus isolatus (problematica)
	Microdictyon sp. (onychophoran or "velvet worm")
	Eldonia ludwigi (sea cucumber)

529 *Facivermis* sp. (problematica)

Naraoia compacta (trilobite)

Jianfengia sp. (arthropod)

528 *Tuzoia burgessensis* (arthropod)

Choia carteri (sponge)

Margaretia dorus (alga)

527 *Choia carteri* (sponge)

Nisusia burgessensis (brachiopod)

Thaumaptilon walcotti (penatulacean cnidarian or "sea pen")

526 *Selkirkia columbia* (priapulid worm)

Eiffelia globosa (sponge)

Branchiocaris pretiosa (arthropod)

Vauxia gracilenta (sponge)

Nisusia burgessensis (brachiopod)

525 *Dactyloides* sp. (jellyfish)

524 *Dactyloides* sp. (jellyfish)

Paradoxoides gracilis (trilobite)

523 *Haplophrentis carinatus* (hyolithid, a problematic group)

Aysheaia pedunculata (arthropod)

522 *Ancalgon minor* (priapulid worm)

Sanctacaris uncata (arthropod)

Scenella amii (monoplacophoran mollusk)

Echmatocrinus brachiatus (crinoid)

521 *Canadaspis perfecta* (arthropod)

Emeraldella brocki (arthropod)

520 *Canadaspis perfecta* (arthropod)

Hazelia conferta (sponge)

Elrathia kingii (trilobite)

Louisella pedunculata (priapulid worm)

519 *Louisella pedunculata* (priapulid worm)

Elrathia kingii (trilobite)

Peronopsis interstricta (trilobite)

Odaraia alata (arthropod)

Dinomiscus isolatus (problematica)

518–517 *Anomalocaris canadensis* (problematic arthropod)

Wiwaxia corrugata (problematica)

516 *Sidneyia inexpectans* (arthropod)

Yohoia tenuis (arthropod)

Vauxia gracilenta (sponge)

515 *Ptychagnostus praecurrens* (trilobite)

Vauxia gracilenta (sponge)

Marrella splendens (arthropod)

514 *Opabinia regalis* (problematica)

Louisella pedunculata (priapulid worm)

Dactyloides sp. (jellyfish)

Diraphora bellicostata (brachiopod)

Gogia radiata (cystoid echinoderm)

Olenoides serratus (trilobite)

Burgessia bella (arthropod)

Pagetia bootes (trilobite)

Capsospongia undulata (sponge)

Micromitra burgessensis (brachiopod)

513 *Molaria spinifera* (arthropod)

Leanchoilia superlata (arthropod)

Hallucigenia sparsa (onychophoran or "velvet worm")
Marrella splendens (arthropod)
Amiskwia sagittiformis (problematica)
Perspicaris dictynna (arthropod)
Naraoia compacta (trilobite)
Pikaia gracilens (chordate)
512 *Waptia fieldensis* (arthropod)
Odaraia alata (arthropod)
Portalia mira (problematica)
511 *Louisella pedunculata* (priapulid worm)
510 *Ogygopsis klotzi* (trilobite)
Helmetia expansa (arthropod)
Dalyia racemata (alga)
508 *Ottoia prolifica* (priapulid worm)
Burgesschaeta setigera (polychaete or "bristle worm")
Haplophrentis carinatus (hyolithid, a problematic group)
Paterina zenobia (brachiopod)

ORDOVICIAN PERIOD 506–439 MILLION YEARS AGO

505 *Dictyonema flabelliforme* (graptolite)
502–500 stromatolite (layered mound built by bacterial mats)
499 *Dikelokephalina* sp. (trilobite)
498 *Dikelokephalina* sp. (trilobite)
Villebrunaster thorali (starfish)
Loganograptus logani (graptolite)

497 *Loganograptus logani* (graptolite)
Villebrunaster thorali (starfish)
Stictoporella sp. (bryozoan)
496 *Schzuanella* sp. (trilobite)
495 *Schzuanella* sp. (trilobite)
Didymograptus extensus (graptolite)
Trinucleus concentricus (trilobite)
494 *Didymograptus extensus* (graptolite)
Trinucleus concentricus (trilobite)
Mitrocystites mitra (carpoid echinoderm)
493 *Mitrocystites mitra* (carpoid echinoderm)
Dichograptus octobrachiatus (graptolite)
492–491 *Leptograptus* sp. (graptolite)
Leperditia canadensis (ostracod)
490 *Leperditia canadensis* (ostracod)
Asaphus gigas (trilobite)
489 *Cassinoceras grande* (nautiloid)
487 *Sinuites* sp. (snail)
Ecculiomphalus triangulatus (snail)
486 *Orthoceras* sp. (nautiloid)
485 *Endoceras distans* (nautiloid)
Orthograptus gracilis (graptolite)
484 *Orthograptus gracilis* (graptolite)
483 *Ottawacrinus typus* (crinoid)
482 *Favosites* sp. (tabulate coral)
Salpingostoma boulli (crinoid)
Tetragraptus quadribrachiatus (graptolite)
Sowerbyella sp. (brachiopod)

481 *Macrosystella* sp. (eocrinoid)
 Cyrtolites ornatus (snail)
 Cothurnocystis elizae (carpoid echinoderm)
 Lecanospira compacta (snail)
 Strophomena sp. (brachiopod)
 Phyllograptus typus (graptolite)
480 *Phyllograptus typus* (graptolite)
 Ambeophyllum profundum (sponge)
 Hormotoma sp. (snail)
478–477 ripple marks
475 *Eoleperditia fabulites* (ostracod)
474 *Eoleperditia fabulites* (ostracod)
 Maclurites magnus (snail)
473 *Maclurites magnus* (snail)
472 *Paleophycus tubularis* (alga)
471 *Homotelus bromidensis* (trilobite)
470 *Homotelus bromidensis* (trilobite)
 Dinorthis holdeni (brachiopod)
 Echinosphaerites aurantium (cystoid echinoderm)
 Pleurocystites filitextus (cystoid echinoderm)
469 *Echinosphaerites aurantium* (cystoid echinoderm)
 Lituites litmus (nautiloid)
467 *Endoceras* sp. (nautiloid)
 Cryptolithus tesselatus (trilobite)
 Ambonychia bellistriata (clam)
466 *Brachiospongia digitata* (sponge)
 Buthotrephis flexuosa (alga)

465 *Buthotrephis flexuosa* (alga)
464 *Endoceras proteiforme* (nautiloid)
 Ceraurus pleurexanthemus (trilobite)
463 *Tretaspis seticornis* (trilobite)
 Edrioaster bigsbyi (echinoderm)
 Triarthus beckii (trilobite)
462 *Modiolopsis concentrica* (clam)
 Schizograptus sp. (graptolite)
461 *Centrotarphyceras seeleyi* (snail)
458–457 *Orthoceras chinense* (nautiloid)
456 *Hallaster cylindricus* (starfish)
455 *Favistella stellata* (rugose coral)
 Rafinesquina alternata (brachiopod)
 Hudsonaster incomptus (starfish)
 Liospira micula (snail)
 Hormotoma sp. (snail)
454 *Nemagraptus gracilis* (graptolite)
 Ceratiocaris papilio (arthropod)
452 unidentified bryozoans (colonial marine animals)
451 *Heterotrypa frondosa* (bryozoan)
450 *Platystrophia ponderosa* (brachiopod)
 Dinorthis pectinella (brachiopod)
 Ischadites iowensi (sponge)
 Glyptorthis insculpta (brachiopod)
 Trematis millipunctata (brachiopod)
 Heterorthis sp. (brachiopod)

449 *Sacabambaspis* sp. (jawless fish)
 Dicranograptus nicholsoni (graptolite)
 Saltaster sp. (starfish)
 Glyptocrinus decadactylus (crinoid)
448 *Glyptocrinus decadactylus* (crinoid)
 Peronopora decipiens (bryozoan)
 Amplexograptus amplexicaulis (graptolite)
 Stenaster obtusus (starfish)
447 *Stenaster obtusus* (starfish)
 Paraharpes hornei (trilobite)
 Maclurina manitobensis (snail)
446 *Maclurina manitobensis* (snail)
 Triarthus eatoni (trilobite)
 Constellaria florida (bryozoan)
445–443 unidentified crinoids
442 *Cyclonema bilex* (snail)
 Isotelus maximus (trilobite)
441 *Isotelus maximus* (trilobite)
439 *Receptaculites oweni* (sponge)

SILURIAN PERIOD 438–409 MILLION YEARS AGO

438–437 *Bumastus trentonensis* (trilobite)
433 *Poleumita discors* (snail)
432–431 trace fossils (snails?)

430 *Hormatoma whiteavesi* (snail)
 Fardenia subplana (brachiopod)
 Dictyonema retiformis (graptolite)
429 *Atrypa hemispherica* (brachiopod)
 Caryocrinus ornatus (crinoid)
 Lingula cuneata (brachiopod)
428 *Spirifer radiatus* (brachiopod)
 Tentaculites gyracanthus (problematica)
 Atrypa hemispherica (brachiopod)
 Phragmoceras angustum (nautiloid)
 Rastrites magnus (graptolite)
 Buthotrephis gracilis (alga)
427 *Buthotrephis gracilis* (alga)
 Dalmanites limuloides (trilobite)
426 *Favosites* sp. (tabulate coral)
 Thelodus scoticus (scale of jawless fish)
425 *Monograptus clintonensis* (graptolite)
 Bickmorites bickmoreanus (nautiloid)
424 *Arctinurus boltoni* (trilobite)
 Huronia vertebralis (nautiloid)
423 *Conchidium* sp. (brachiopod)
 Mixopteris kiaeri (eurypterid or sea scorpion)
 Eurypterus remipes (eurypterid or sea scorpion)
422 *Mixopteris kiaeri* (eurypterid or sea scorpion)
 Eurypterus remipes (eurypterid or sea scorpion)
421 *Eupypterus remipes* (eurypterid or sea scorpion)
 Eocoelia curtsi (brachiopod)

420–419	mud cracks
417	*Acervularia* sp. (hexagonarian or rugose coral)
	Megalomoidea canadensis (clam)
416	*Megalomoidea canadensis* (clam)
	Anaglaspis sp. (heterostracan, a jawless fish)
415	*Sagenocrinus clarki* (crinoid)
	Birkenia elegans (anaspid, a jawless fish)
	Athenaegis sp. (heterostracan, a jawless fish)
413	*Halisites catenularius* (tabulate coral)
412–410	*Pterygotus buffaloensis* (eurypterid or sea scorpion)
409	*Tremataspis mammillata* (jawless fish)
	Phlebolepis sp. (jawless fish)

DEVONIAN PERIOD 408–361 MILLION YEARS AGO

408	*Hemicyclaspis murchisoni* (osteostracan, a jawless fish)
407	*Stromatopora concentrica* (stromatoporoid, a sponge)
406	*Stromatopora concentrica* (stromatoporoid, a sponge)
	Parexus incurvus (acanthodian or "spiny shark")
405	*Centroceras* sp. (nautiloid)
	Zaphrenites roemeri (rugose coral)
	Thelodus scoticus (jawless fish)
404	*Rensselaeria marylandica* (brachiopod)
	Leptocoelia fimbriata (brachiopod)
	Hipparionyx proximus (brachiopod)

	Strophomena rugosa (brachiopod)
	Avicula securiformis (clam)
403–401	*Stylonurus excelsior* (eurypterid or sea scorpion)
400	*Spirifer plicatus* (brachiopod)
	Macropleura macropleura (brachiopod)
	Holopea macrostomus (snail)
399	*Melocrinus nobilissimus* (crinoid)
398	*Cephalaspis* sp. (osteostracan, a jawless fish)
	Acutiramus cummingsi (claw of eurypterid or sea scorpion)
397	unidentified alga
	Calymene platys (trilobite)
	Machairacanthus sp. (spine of acanthodian or "spiny shark")
396	*Favosites helderbergiae* (rugose coral)
	Legrandella lombardii (arthropod)
395	*Melocrinus williamsi* (crinoid)
	Turbonopsis shumardi (snail)
	Grammysiodea sp. (clam)
	Terataspis grandis (trilobite)
394	*Terataspis grandis* (trilobite)
	Craniops pulchella (trilobite)
	Platyceras spirale (snail)
	Phacops rana (trilobite)
393	*Corycephalus regalis* (trilobite)
	Goniophora alata (clam)
	Phacops rana (trilobite)
	Melocrinus paucidactylus (crinoid)
392	*Orthoceras nuntium* (nautiloid)

391 *Palaeoisopus* sp. (pycnogonid arthropod or "sea spider")
390 *Gemuendina shuertzi* (placoderm, an extinct group of fish)
 Cardiacrinus schultzei (crinoid)
 Furcaster decheni (starfish)
389 *Drepanaspis gemuendinensis* (heterostracan, a jawless fish)
388 *Ophiura primigenia* (brittle star)
 Fenestella sinistralis (bryozoan)
 Furcaster decheni (starfish)
 Helianthaster rhenanus (starfish)
 Euzonosoma sp. (brittle star)
387 *Drepanophycus spinaeformis* (alga)
386 *Mesothyra oceani* (arthropod)
385 *Osteolepis macrolepidotus* (lobe-finned fish)
384 *Agoniatites vanuxemi* (ammonoid)
383 *Agoniatites vanuxemi* (ammonoid)
 Onychodus sigmoides (jaw of lobe-finned fish)
382 *Onychodus sigmoides* (lobe-finned fish)
 Dipleura dekayi (trilobite)
381 *Archaeopteris hibernica* (progymnosperm plant)
380 *Baragwanathia* sp. (lycopod or "club moss")
 Diplacanthus striatus (acanthodian or "spiny shark")
379 *Pterichthyodes milleri* (placoderm, an extinct group of fish)
 Conularia continens (conularid, a problematic group)
 Discina sp. (brachiopod)
 Pleuronotus decewi (snail)
378 *Bothriolepis* sp. (placoderm, an extinct group of fish)
 Sawdonia ornata (zosterophyte, an extinct group of plants)

377 *Heliophyllum confluens* (rugose coral)
 Sphaerocystites multifasciatus (cystoid echinoderm)
376 *Aspidosoma fishbeinianum* (starfish)
 Armstrongia oryz (alga)
375 *Eusthenopteron foordii* (lobe-finned fish)
 Griphognathus whitei (lung fish)
 Dactylocrinus sp. (crinoid)
374 *Fleurantia denticulata* (lung fish)
 Dactylocrinus sp. (crinoid)
 Mucrospirifer mucronatus (brachiopod)
373 *Manticoceras intumescens* (ammonoid)
372 *Howqualepis rostridens* (ray-finned fish)
 Greenops boothii (trilobite)
371–370 *Gorgonichthys* sp. (jaw of placoderm fish)
369 *Gorgonichthys* sp. (placoderm fish)
 Ceratodictya carpenteri (sponge)
367 *Hydnoceras tuberosum* (glass sponge)
366 *Lepidasterella* sp. (starfish)
364 *Colpodexylon deatsii* (lycopod or "club moss")
363 *Colpodexylon deatsii* (lycopod or "club moss")
 Archaeopteris halliana (progymnosperm plant)
 Acanthostega gunnari (tail of amphibian)
362 *Acanthostega gunnari* (amphibian)
361 *Acanthostega gunnari* (amphibian)
 Archaeopteris sp. (progymnosperm plant)
 Lepidodendron sp. (giant lycopod or "club moss")

CARBONIFEROUS PERIOD (MISSISSIPPIAN)
360–323 MILLION YEARS AGO

360	*Rayonnoceras giganteum* (nautiloid)
359	*Actinocyathus crassiconicus* (rugose coral)
358	*Synbathionus wachsmithi* (crinoid)
357	*Onychocrinus ulrichi* (crinoid)
	Agariocrinites splendens (crinoid)
356	*Agariocrinites splendens* (crinoid)
	Platycrinites hemisphericus (crinoid)
355	*Melonechinus multiporus* (echinoid echinoderm or "sea urchin")
354	*Melonechinus multiporus* (echinoid echinoderm or "sea urchin")
	Leptagonia analoga (brachiopod)
	Pustula pustulosa (brachiopod)
353	*Sphenacanthus hydoides* (fin of acanthodian or "spiny shark")
	Straparolus pentangulatus (snail)
	Pugnoides sp. (brachiopod)
	Lingula mytilloides (brachiopod)
352	*Tealliocaris woodwardii* (shrimp)
351	*Tealliocaris woodwardii* (shrimp)
	Paleosmilia murchisoni (rugose coral)
	Lingula mytilloides (brachiopod)
350	*Aesiocrinus magnificus* (crinoid)
	Posidonia bakeri (clam)
349	*Merocanites henslowi* (ammonoid)
	Siphondendron lithostrotium (rugose coral)
348–347	*Hamiltonichthys* sp. (shark)

346	*Callixylon* sp. (progymnosperm plant)
345	*Callixylon* sp. (progymnosperm plant)
	Annularia stellata (sphenopsid or "horsetail")
344	*Annularia stellata* (sphenopsid or "horsetail")
	Lethiscus sp. (amphibian)
343	*Lethiscus* sp. (amphibian)
342	*Stigmaria ficoides* (root of Lepidodendron, a giant lycopod or "club moss")
	unidentified temnospondyl (amphibian)
341	unidentified temnospondyl (amphibian)
	Senftenbergia sp. (fern)
340	*Senftenbergia* sp. (fern)
339	*Leptaena analoga* (brachiopod)
	Hypselocrinus sp. (crinoid)
	Lyropora subquadrans (bryozoan)
338	*Goniasteroidocrinus tuberosus* (crinoid)
	Platyceras sp. (snail)
	Caseodus sp. (shark)
337	*Caseodus* sp. (shark)
	Porcellia puzo (snail)
	Aulacophoria keyserlingiana (brachiopod)
336	*Uperocrinus nashvillae* (crinoid)
	Camarotoechia mutata (brachiopod)
	Spirifer lateralis (brachiopod)
335	*Gigantoproductus giganteus* (brachiopod)
334	*Megalocephalus pachycephalus* (jaw of amphibian)
331	unidentified microsaur (amphibian)

329 *Echinochimaera meltoni* (chimaera, a shark-like fish)
Belantsea montana (shark)
328 unidentified crinoids
Halysiocrinus nodosus (crinoid)
Paleolimulus sp. (arthropod)
327 *Archimedes worthii* (bryozoan)
326 *Damocles serratus* (shark)
325 *Damocles serratus* (shark)
Aviculopecten tenuicollis (clam)
Aganaster gregarius (starfish)
324 *Aganaster gregarius* (starfish)
Rhineoderma radula (snail)
Pentremites sulcatus (blastoid echinoderm)
323 *Allenypterus* sp. (coelacanth)
Schizoblastus sayi bellulus (blastoid echinoderm)
Pentremites welleri (blastoid echinoderm)
Cravenoceras hesperium (ammonoid)

Carboniferous Period (Pennsylvanian)
322–290 MILLION YEARS AGO

321–320 coal
319 *Odontopteris callosa* (seed fern)
Alethopteris serlii (seed fern)
Pecopteris unita (seed fern)
Annularia stellata (sphenopsid or "horsetail")

318 *Neuropteris scheuchzeri* (seed fern)
Sorocladus sp. (seed fern)
Sigillaria elongata (bark of lycopod or "club moss")
Neuropteris gigantea (seed fern)
317 *Calamites* sp. (stem of giant sphenoposid or "horsetail")
316 *Calamites* sp. (sphenopsid or "horsetail")
Rhacopteris ovata (seed fern)
Sphenophyllum verticillatum (sphenopsid or "horsetail")
315–314 *Pleuracanthus* sp. (shark)
313 *Protencrinus atoka* (crinoid)
unidentified fusulinid foraminiferan (shelled protists)
Gastrioceras excelsum (ammonoid)
312 unidentified hydrozoan
311 *Belotelson magister* (arthropod)
Octomedusa pieckorum (jellyfish)
Naticopsis sp. (snail)
Bactrites sp. (nautiloid)
Hypselentoma sp. (gastropod)
Achistrum sp. (holothurian echinoderm or "sea cucumber")
310 unidentified haplolepid (primitive ray-finned fish)
Anthracomedusa turnbulli (jellyfish)
Octomedusa pieckorum (jellyfish)
309 *Tullymonstrum gregarium* (problematica)
308 *Acanthotelson stimsoni* (arthropod)
Gastrioceras sp. (ammonoid)
Similihariotta dabasinskasi (chimaera, a shark-like fish)
Bandringa rayi (shark)

307 *Neuropteris scheuchzeri* (seed fern)

 Curculoides sp. (weevil)

306 *Medullosa noei* (seed fern)

305 *Euproops rotundatus* (horseshoe crab)

 Lepidodendron sp. (leaves of giant lycopod or "club moss")

304 *Trichiulus armitiformis* (millipede)

 Fossundecima konecniorum (annelid worm)

 Cyclus americanus (arthropod)

 Mazoscolopopendra richardsoni (millipede)

303 *Paleoblatta paucinervis* (cockroach)

 Coprinoscolex ellogimus (problematica)

 Graeophonus analicus (spider)

 Euphoberia sp. (millipede)

302 *Euphoberia* sp. (millipede)

 Trigonocarpus trilocularia (seed of seed fern)

 Neuropteris inflata (seed fern)

301 *Neuropteris inflata* (seed fern)

 Sphenopteris elegans (seed fern)

 Meganeura monyi (dragonfly)

300 *Meganeura monyi* (dragonfly)

 Amphibamus lyelli (amphibian)

 Pecopteris sp. (seed fern)

 Dipeltis diplodiscus (cockroach)

299 *Pecopteris* sp. (seed fern)

 Lepidodendron sp. (bark of giant lycopod or "club moss")

298 *Lepidodendron* sp. (lycopod or "club moss")

 Annularia stellata (sphenopsid or "horsetail")

 Walchia piniformis (conifer)

 Lafonius lehmani (amphibian)

297 *Amphicentrum* sp. (primitive ray-finned fish)

 Enteletes lamarcki (brachiopod)

 Helminthozyga vermicula (snail)

296–295 *Mesosaurus tumidus* (aquatic reptile)

294 *Titanoceras ponderosum* (nautiloid)

292 *Diplocaulus magnicornis* (amphibian)

291–290 *Edaphosaurus* sp. (pelycosaur)

PERMIAN PERIOD 289–245 MILLION YEARS AGO

287–286 *Seymouria baylorensis* (amphibian)

285 unidentified leaf

284–281 *Dimetrodon limbatus* (pelycosaur)

280 *Gangamopteris cyclopteroides* (glossopterid seed fern)

279 *Calamodendron striatum* (giant sphenopsid or "horsetail")

 Trimerorachis insignis (amphibian)

278 *Trimerorachis insignis* (amphibian)

 Russellites sp. (seed fern)

277 *Russellites* sp. (seed fern)

 Pecopteris sp. (seed fern)

 Archeria crassidisca (amphibian)

 Chelichnus (tracks of amphibian)

276 *Typus gracilis* (dragonfly)

 Callipteris conferta (seed fern)

275 *Callipteris conferta* (seed fern)

 Eryops megacephalus (amphibian)

 Permotipula sp. (insect)

274 *Eryops megacephalus* (amphibian)

273 *Branchiosaurus* sp. (amphibian)

Pelosaurus laticeps (amphibian)

Ebenaqua ritchiei (primitive ray-finned fish)

272 *Ebenaqua ritchiei* (primitive ray-finned fish)

Leptodus americanus (brachiopod)

Derbyia crassa (brachiopod)

271 *Helicoprion bessonowi* (tooth whorl of shark)

Chonetes sp. (brachiopod)

270 *Chonetes* sp. (brachiopod)

Platysomus gibbosus (primitive ray-finned fish)

Schizoblastus coronatus (blastoid echinoderm)

269 *Xenacanthus decheni* (freshwater shark)

Hovasaurus sp. (aquatic reptile)

268 *Hovasaurus* sp. (aquatic reptile)

267 *Aviculopinna peracuta* (clam)

266 *Dorypterus* sp. (ray-finned fish)

Aviculopinna peracuta (clam)

Meekechinus elegans (echinoid echinoderm or "sea urchin")

265 *Neospirifer cameratus* (brachiopod)

264 *Girtyocoelia dunbari* (sponge)

Cooperoceras texanum (nautiloid)

262 *Endothiodon angusticeps* (therapsid or "mammal-like reptile")

261–260 *Glossopteris linearis* (glossopterid seed fern)

259 *Glossopteris walkomii* (glossopterid seed fern)

Plumsteadia ampla (fruit of seed fern)

258–257 *Scutosaurus* sp. (pareiasaur reptile)

256 *Scutosaurus* sp. (pareiasaur reptile)

Phyllotheca etheridgei (sphenopsid or "horsetail")

255 *Phyllotheca etherdgei* (sphenopsid or "horsetail")

Psaronius brasiliensis (tree fern)

253 *Coelurosauravus jaekeli* (gliding diapsid reptile)

252 unidentified fern

251–250 unidentified tree trunk

TRIASSIC PERIOD 244–205 MILLION YEARS AGO

244–243 stromatolite (layered mound built by bacterial mats)

242 *Bobastrantia canadensis* (primitive ray-finned fish)

241 *Bobastrantia canadensis* (primitive ray-finned fish)

Discinisca calymene (brachiopod)

240 *Discinisca calymene* (brachiopod)

239 *Dicroidium callipteroides* (seed fern)

238 *Procolophon trigoniceps* (lizard)

Cylomeia undulata (lycopod or "club moss")

Thrinaxodon liorhinus (therapsid or "mammal-like reptile")

237–236 *Cynognathus craternotus* (therapsid or "mammal-like reptile")

235 *Diplurus newarki* (coelacanth)

Dicellopyge macrodentatus (primitive ray-finned fish)

Aphaneramma sp. (amphibian)

234 *Aphaneramma* sp. (amphibian)

233 *Claraia clarai* (clam)

Posidonia wengensis (clam)

Bourguetia saemanni (snail)

Lenticidaris utahensis (echinoid echinoderm or "sea urchin")

232	*Lenticidaris utahensis* (echinoid echinoderm or "sea urchin")
	Pachypleurosaurus edwardsi (aquatic reptile)
	Tetractinella trigonella (brachiopod)
231	*Encrinus lilliformis* (crinoid)
	Lima reticulata (clam)
230	*Encrinus lilliformis* (crinoid)
	Germanonautilus bidorsatus (nautiloid)
	Archaeopalinurus levia (arthropod)
	unidentified shrimp (Penaeidae)
229–228	*Mixosaurus* sp. (ichthyosaur)
227	*Mixosaurus* sp. (ichthyosaur)
	Saurichthys megacephalus (primitive ray-finned fish)
226	*Cyamodus laticeps* (aquatic reptile)
225	*Clathopteris* sp. (seed fern)
	Dicroidium zuberi (seed fern)
	Ginkgoites semirotunda (gingko)
	Eoraptor sp. (theropod dinosaur)
224–223	*Araucarioxylon arizonicum* (conifer wood)
222–220	*Coelophysis bauri* (theropod dinosaur)
219	*Coelophysis bauri* (theropod dinosaur)
	Mussaurus patagonicus (juvenile prosauropod dinosaur)
218	*Grallator* sp. (tracks of dinosaur)
217–215	*Buettneria perfecta* (amphibian)
214–213	*Plateosaurus trossingensis* (prosauropod dinosaur)
212–211	*Proganochelys quenstedti* (turtle)
210	*Proganochelys quenstedti* (turtle)
	Rissikia media (conifer)
	Calamites sp. (sphenopsid or "horsetail")

209–206	*Machaeroprosopus gregorii* (crocodile)
205	*Conchodon infraliasicus* (clam)
	Atropicaris rostrata (arthropod)

Jurassic Period 204–141 million years ago

204	*Psiloceras planorbis* (ammonoid)
203	*Psiloceras planorbis* (ammonoid)
	Dapedium politum (ray-finned fish)
202	*Dapedium politum* (ray-finned fish)
200	*Oxynoticeras oxynotum* (ammonoid)
	Pentacrinites fossilis (crinoid)
199	*Pentacrinites fossilis* (crinoid)
	Bifericeras bifer (ammonoid)
	Tropidaster pectinatus (starfish)
198	*Pinna hartmanni* (clam)
197	*Gigandipus caudatus* (tracks and tail drag of dinosaur)
196	*Gigandipus caudatus* (tracks and tail drag of dinosaur)
	Mesoleuctra gracilis (stone fly)
	Morganucodon sp. (primitive mammal)
	Zamites sp. (cycad)
195	*Zamites* sp. (cycad)
	Scutellosaurus sp. (plates of armored dinosaur)
194	*Campylognathoides* sp. (pterosaur)
193	*Campylognathoides* sp. (pterosaur)
192	*Dilophosaurus wetherilli* (theropod dinosaur)

191　*Lytoceras fimbriatus* (ammonoid)
　　　Palaeocoma egertoni (brittle star)
　　　Coleia mediterranea (arthropod)
190　*Palaeocoma egertoni* (brittle star)
　　　Stenopterygius quadriscissus (ichthyosaur)
189–185　*Stenopterygius quadriscissus* (ichthyosaur)
184　*Gryphaea arcuata* (clam)
　　　Gryphaea navia (clam)
183　*Uncina posidoniae* (arthropod)
　　　Seirocrinus subangularis (crinoid)
182　*Seirocrinus subangularis* (crinoid)
181　*Seirocrinus subangularis* (crinoid)
　　　Hybodus hauffianus (shark)
180　*Hybodus hauffianus* (shark)
179　*Hybodus hauffianus* (shark)
　　　Seirocrinus subangularis (crinoid)
　　　unidentified belemnites (cephalopods)
178–177　*Hybodus hauffianus* (shark)
　　　unidentified belemnites (cephalopods)
176　*Leptolepis talbragarensis* (teleost fish)
　　　Rissikia talbragarensis (cone of conifer)
　　　Agathis jurassica (cone scale of conifer)
　　　Blapsium egertoni (beetle)
　　　Elatocladus planus (conifer)
175　*Sagenopteris rhoifolia* (seed fern)
　　　Agathis jurassica (conifer)
　　　Elatocladus planus (conifer)
　　　Pentoxylon australica (cycad)

174　*Williamsonia gigas* (cone of cycad)
　　　Cetiosaurus leedsi (vertebra of sauropod dinosaur)
173　*Cetiosaurus leedsi* (vertebra of sauropod dinosaur)
172　*Pentasteria cotteswoldiae* (starfish)
171　*Pentasteria cotteswoldiae* (starfish)
　　　Furo orthostomus (ray-finned fish)
　　　Triangope triangulus (clam)
170　*Aptyxiella implicata* (snail)
　　　Pseudopecten equivalis (clam)
　　　Chrondrites bollensis (alga)
169　*Pteria submcconnelli* (clam)
　　　Chrondrites bollensis (alga)
　　　Spiroceras bifurcatum (ammonoid)
168–165　*Mystriosaurus bollensis* (crocodile)
164–159　*Lepidotes* sp. (semionotid fish)
158　*Pseudocidaris durandi* (echinoid echinoderm or "sea urchin")
157　*Belonostomus kochii* (ray-finned fish)
156–154　*Allosaurus fragilis* (theropod dinoosaur)
153　unidentified conifer wood
152　*Archaeopteryx lithographica* (bird)
151　*Archaeopteryx lithographica* (bird)
　　　Sphenozamites latifolius (cycad)
　　　Cerambycinus dubius (longhorn beetle)
　　　Karaurus sp. (salamander)
150　*Apatosaurus excelsus* (vertebra of sauropod dinosaur)
149　*Apatosaurus excelsus* (vertebra of sauropod dinosaur)

148	*Cymatophlebia longialata* (water strider)
	Ischyodus avitus (chimaera, shark-like fish)
147	*Ischyodus avitus* (chimaera, shark-like fish)
	Saccocoma pectinata (brittle star)
146	*Ischyodus avitus* (chimaera, shark-like fish)
	Eurysternum crassipes (turtle)
145	*Leptolepides sprattiformis* (teleost fish)
	Pterodactylus antiquus (pterosaur)
	Libellulium longilatum (wing of dragonfly)
144–141	*Stegosaurus stenops* (tail spikes and plates of armored dinosaur)

Cretaceous Period 140–65 million years ago

140	*Kalligramma haeckeli* (insect)
	Archaefructus liaoningensis (flowering plant)
139	*Pterocoma pennata* (brittle star)
	Pseudorhina alifera (skate)
138–137	*Pseudorhina alifera* (skate)
136–133	*Kronosaurus queenslandicus* (plesiosaur)
132–130	*Tupuxaura leonardii* (pterosaur)
129	*Tupuxaura leonardii* (pterosaur)
	Pitystrobus dunkeri (cone of conifer)
128	*Tupuxaura leonardii* (pterosaur)
	Taeniopteris daintreei (cycad)
	Gingkoites australis (gingko)

127	*Tupuxaura leonardii* (pterosaur)
	Phyllopteroides sp. (tree fern)
	Zamites buchianus (cycad)
	Otazamites bengalensis (cycad)
	Williamsonia sp. (cycad)
126	*Cycadeoidea dacotensis* (cycad)
125–123	*Caudipteryx zovi* (feathered dinosaur)
122–119	*Iguanodon bernissartensis* (ornithopod dinosaur)
118–117	*Australiceras gigas* (ammoniod)
116–115	*Neoproscinetes penalvai* (teleost fish)
114	unidentified cockroach
	unidentified beetle
	unidentified reed
	unidentified cricket
113	*Araripemys barretoi* (side-necked turtle)
112–110	*Axelrodichthys araripensis* (coelacanth)
108–105	*Sauropelta edwardsi* (armor of large nodosaur)
104	*Brontopodus birdi* (footprint of sauropod dinosaur)
103–102	*Brontopodus birdi* (footprint of sauropod dinosaur)
	Footprint of unidentified theropod dinosaur
101	*Brontopodus birdi* (footprint of sauropod dinosaur)
100	*Protomonimia kasai nakajhongii* (flowering plant)
	Priscia reynoldsii (flowering plant)
	Archaeanthus linnenbergeri (flowering plant)
99	*Pachyrhachis problematicus* (marine snake)
	Archaeanthus linnenbergeri (flowering plant)

98 *Pachyrhachis problematicus* (marine snake)
97 *Orbitolina cancava* (foraminiferans)
 unidentified bryozoans
 Hoplites interruptus (ammonoid)
96 *Orbitolina concava* (foraminiferans)
 Inoceramus balticus (clam)
95 *Orbitolina concava* (foraminiferans)
 Trigonia crenulata (clam)
94 *Eurypholis boisseri* (teleost fish)
 unidentified spiny lobster
 Delesserites libanensis (alga)
 Homarus hakelensis (lobster)
93 *Clidastes liodontus* (mosasaur)
92 *Temnocidaris sceptrifera* (echinoid echinoderm or "sea urchin")
 Bostrychoceras sp. (ammonoid)
 Metopaster parkinsoni (starfish)
 Pteranodon ingens (pterosaur)
91 *Pteranodon ingens* (pterosaur)
 Baculites sp. (ammonoid)
 Placenticeras whitfield (ammonoid)
 Conulus albogalerus (echinoid echinoderm or "sea urchin")
 Neithea coquandi (clam)
 Stauranderaster coronatus (starfish)
90 *Hippurites* sp. (rudistid clam)
 Pteranodon ingens (pterosaur)

89 *Pteranodon ingens* (pterosaur)
 Uintacrinus socialis (crinoid)
 ammonoid with mosasaur toothmarks
88 *Placenticeras meeki* (ammonoid)
87–86 *Xiphactinus audax* (giant teleost fish)
84 *Archelon* sp. (ventral plate of giant marine turtle)
83 *Archelon* sp. (giant marine turtle)
 Actaeonella dolium (snail)
82 *Archelon* sp. (giant marine turtle)
 Actaeonella dolium (snail)
 Eutrephoceras dekayi (nautiloid)
80–77 *Centrosaurus apertus* (ceratopsian dinosaur)
76–75 *Saichania* sp. (ankylosaurian dinosaur)
74–73 *Struthiomimus altus* (theropod dinosaur)
72 *Protoceratops andrewsi* (ceratopsian dinosaur)
71 eggs of *Oviraptor philoceratops* (formerly believed to belong to *Protoceratops*)
 Parasaurolophus walkeri (hadrosaurian dinosaur)
70 *Parasaurolophus walkeri* (hadrosaurian dinosaur)
69 *Parasaurolophus walkeri* (hadrosaurian dinosaur)
 Araliopsoides cretacea (flowering plant)
68 *Tyrannosaurus rex* (theropod dinosaur)
 Parasaurolophus walkeri (hadrosaurian dinosaur)
67–65 *Tyrannosaurus rex* (theropod dinosaur)

TERTIARY PERIOD 64–3 MILLION YEARS AGO

62–61	*Champsosaurus* sp. (aquatic reptile)
60	*Coryphodon elephantopus* (primitive hoofed mammal)
59	*Coryphodon elephantopus* (primitive hoofed mammal)
	Ptilodus sp. (multituberculate mammal)
58	*Ptilodus* sp. (multituberculate mammal)
	Macginicarpa glabra (flowering tree)
57	unidentified trace fossil (snail trail?)
56	*Heliobatiodes maloneyi* (freshwater skate)
55	*Heliobatiodes maloneyi* (freshwater skate)
	Knightia eocaena (teleost fish)
54	*Knightia eocaena* (teleost fish)
	Priscacara oxyprion (teleost fish)
53	*Diatryma gigantea* (giant flightless bird)
52–51	*Sabalites powelli* (palm)
50	unidentified stag beetle
	Paleopython sp. (snake)
49	*Messelirrisor* sp. (bird)
	Paleopython sp. (snake)
	unidentified longhorn beetle
48	*Allaeochelys crassesculptata* (turtle)
	Paleopython sp. (snake)
	Eopelobates wagneri (frog)
47	*Formicium giganteum* (giant ant)
	unidentified vine (Menispermaceae)
	unidentified flowering plant (Rutaceae)

	Paleopython sp. (snake)
	Palaeochiropteryx tupaiodon (bat)
46	unidentified berries of flowering plant (Theaceae)
45	unidentified berries of flowering plant (Theaceae)
	Propalaeotherium parvulum (primitive horse)
44	*Propalaeotherium parvulum* (primitive horse)
43	tracks of unidentified wading bird
42	*Mene rhombus* (teleost fish)
	Cucullaea gigantea (clam)
41	*Cucullaea gigantea* (clam)
	Ficopsis penita (snail)
	Pseudoliva sp. (snail)
	Turritella mortoni (snail)
	Venericardia planicosta (clam)
	Ostrea compressirostra (clam)
	Nummulites ghisensis (foraminiferan)
40	*Nummulites ghisensis* (foraminiferan)
	Lophius sp. (teleost fish)
	Harpactocrinus punctulatus (crab)
	Eupatagus antillarum (echinoid echinoderm or "sea urchin")
	Amphistium paradoxum (teleost fish)
39	*Zyghorihiza* sp. (tooth of archeocete whale)
38	*Andrewsarchus* sp. (carnivorous mammal)
37	*Andrewsarchus* sp. (carnivorous mammal)
	Florissanta quilchensis (flowering plant)
36	*Andrewsarchus* sp. (carnivorous mammal)
	Plantanus sp. (flowering plant [sycamore])

35 *Titanotherium* sp. (lower jaw of giant hoofed mammal)

 Palmoxylon sp. (palm)

34 *Palmoxylon* sp. (palm)

 Prodryas persephone (butterfly)

33 *Aegyptopithecus zeuxis* (ape)

32–31 *Arsinotherium zitteli* (horned mammal)

30 unidentified weevil (Curcullionoidea) in amber

 unidentified millipede in amber

 unidentified tree frog in amber

 unidentified scorpion (Buthidae) in amber

29 unidentified spider in amber

 Paraceratherium bugtiense (teeth of giant hornless rhinoceros)

28 *Zelkova* sp. (flowering plant)

 Salix sp. (flowering plant [willow])

 Dinictus felina (false sabretooth cat)

27 *Protoceras celer* (horned mammal)

 Betula sp. (flowering plant [birch])

 Populus sp. (flowering plant [poplar])

26 *Leptomeryx evansi* (deer)

 Fagopsis sp. (flowering plant)

 Sequoia sp. (conifer)

25–22 *Stenomylus* sp. (camel)

21 *Moropus* sp. (clawed mammal)

18 *Colpophyllia* sp. (brain coral)

17 *Ecphora quadricostata* (snail)

 Scutella aberti (sand dollar)

 Rhabdosteus latiradix (rostrum of porpoise)

16 *Rhabdosteus latiradix* (rostrum of porpoise)

 Balanus concavus (barnacle)

 Centriscus heinrichsi (teleost fish [shrimpfish])

15 *Desmostylus* sp. (teeth of marine mammal)

 Carcharocles megalodon (giant shark)

14–11 *Carcharocles megalodon* (giant shark)

10 *Phorusrhachus inflatus* (beak of flightless bird)

9–8 *Quercus* sp. (flowering plant [oak])

7 *Andrias scheuchzeri* (ribs of giant salamander)

 Liquidambar europeanum (flowering plant [sweet gum])

 Laurus nobilis (flowering plant [laurel])

 Mammut americanum (mastodon tooth)

6–5 *Mammut americanum* (mastodon tusk)

4 *Mammut americanum* (mastodon)

 Australopithecus afarensis (hominid primate)

3 *Mammut americanum* (mastodon)

Quaternary Period 2–0 million years ago

2 *Mammuthus* sp. (mammoth tooth)

1 *Mammuthus* sp. (mammoth)

 Cybister explavatus (water beetle)

0 *Homo sapiens* (human)

Further Reading

Bartlett, Jennifer. *Rhapsody*. New York: Harry N. Abrams, Inc., 1985.

Blum, Ann Shelby. *Picturing Nature: American Nineteenth-Century Zoological Illustration*. Princeton, N.J.: Princeton University Press, 1993.

Fenton, Carroll Lane and Mildred. *The Fossil Book*. New York: Doubleday, 1989.

Fortey, Richard. *Life: A Natural History of the First Four Billion Years of Life on Earth*. New York: Alfred A. Knopf, 1998.

Gould, Stephen Jay. *Wonderful Life: The Burgess Shale and the Nature of History*. New York: W. W. Norton, 1990.

Gould, Stephen Jay (general editor). *The Book of Life: An Illustrated History of the Evolution of Life on Earth*. New York: W.W. Norton, 1993.

Harland, W. Brian, Richard Armstrong, Allan Cox, Lorraine Craig, Alan Smith, and David Smith. *A Geologic Time Scale 1989*. Cambridge: Cambridge University Press, 1990.

Jones, P. J., compiler. *AGSO (Australian Geological Survey Organization) Phanerozoic Timescale 1995: Wallchart and explanatory notes*. Oxford: Oxford University Press, 1996.

McPhee, John. *Annals of the Former World*. New York: Farrar, Straus, & Giroux, 1998.

Maisey, John G. *Discovering Fossil Fishes*. New York: Henry Holt and Co., 1996.

Matsen, Brad, and Ray Troll. *Planet Ocean: A Story of Life, the Sea, and Dancing to the Fossil Records*. Berkeley: Ten Speed Press, 1994.

Novacek, Michael. *Dinosaurs of the Flaming Cliffs*. New York: Anchor Books, 1996.

Prothero, Donald R. *Bringing Fossils to Life*. Boston: WCB McGraw-Hill, 1998.

Stanley, Steven M. *Earth System History*. New York: W. H. Freeman and Company, 1999.

Truitt, Anne. *Turn: The Journal of An Artist*. New York: Viking Penguin, Inc., 1986.

Wheelock, Arthur K, Jr. *A Collector's Cabinet*. Washington, D. C.: National Gallery of Art, 1998.

Artist's Acknowledgments

It was the vision of Warren Allmon that inspired me to bring *Rock of Ages, Sands of Time* to its final form. His interest in my project and his belief that I would actually complete it left no choice but to rise to the challenge. I want to thank Warren and the Trustees of the Paleontological Research Institution for their support and extend my appreciation to the staff for allowing me unlimited access to the library and collections.

I have been looking forward to expressing my deepest gratitude to Christina Henry for giving me full consideration from the moment I walked in out of the blue, told her of my work in progress, and proposed shaping it into a book. Her enthusiasm has been unflagging and her encouragement essential. She has guided me through the details of the publishing process with infinite grace, patience, and wisdom.

Many friends have provided invaluable support and hospitality while this project was underway. My thanks go to Joan and Edward Ormondroyd, Virginia Cobey and Dennis Foerster, Marian and Carl Norberg, Ashley Miller and Gene Endres, Lisa Cowden, Paula Horrigan, Rebecca Bedell, Joyce Hawley, Antonia Demas, Amy McCune and David Winkler, Sylvia and Lee Miller, Kevin and Elizabeth McMahon, Laurie Snyder and John Wood, Ellen and Rick Harrison, Marjorie and Howard Zucker, and il Gruppo Italiano. Zena Collier and Gay Daly also served as exemplars for bringing a lengthy creative endeavor to fruition.

I am indebted to those who provided materials, advice, and assistance with scientific aspects of the project, including Amy McCune, Scott Wing, Dan Burgevin, William Crepet, Mark Norell, Howard Evans, Paul Krohn, Jane Lubchenco, and Harry Greene. Archbold Biological Station and Bodega Marine Laboratory gave me working space during my pleasant sojourns there.

A grant from The Community Arts Partnership of Tompkins County enabled me to preserve the initial designs for the project in archival sketchbooks.

The artwork was photographed by Gary Hodges at Jon Reis Studios.

A note of gratitude for the music of Keith Jarrett, Rubén González, the Kronos Quartet, Cesaria Evora, Gladys Knight and the Pips, Charles Mingus, George Cooke, Richard Stoltzman, and Carla Bley, which accompanied me through thousands of solitary hours in the studio.

Unfortunately, my grandmother will never know how often her influence resurfaces in unexpected guises. Her extensive compilation of family genealogy taught me to look to the future with an eye on the past. I have certainly extended that family history back beyond her wildest imaginings. There are no words to contain my gratitude to my immediate predecessors without whose contributions this project would never have happened. My children deserve special mention for introducing constant diversion and small surprises named Frances, Eloise, Noelle, and Andrew into my daily routine. Finally and most profoundly I value the love and companionship of my husband, Richard Root, who has fostered my interest in natural history, listened to my design dilemmas at four o'clock in the morning, and stood by me while I was lost in the Jurassic for weeks on end.